THE ONE SHOW

THE ONE SHOW.

Judged to be Advertising's Best Print, Radio, TV. Volume 15
A Presentation of The One Club for Art & Copy

THE ONE CLUB
FOR ART & COPY

LEE GARFINKEL
President

MARY WARLICK
Executive Director

ALLAN BEAVER
Designer

RYUICHI MINAKAWA
Art Director

NAOMI MINAKAWA
Layout & Production

MARY WARLICK
Editor

JOHN L. MIMS
KRISTIN OVERSON
Assistant Editors

CAILOR/RESNICK
Photographer
Cover, Divider Pages

Published and Distributed by
RotoVision S.A.
Route Suisse 9
CH-1295 Mies
Switzerland
Telephone: 22-755-30-55
Fax: 22-755-40-72
In Association with
The One Club for Art & Copy
32 East 21st Street
New York, NY 10010
Telephone: (212) 979-1900
Fax: (212) 979-5006

Printed and bound in Singapore by
Tien Wah Press, Ltd.

CONTENTS

LEE GARFINKEL

PRESIDENT'S MESSAGE

If you read the messages of past One Club presidents, you discover a common denominator.

Every year seems to have brought some new obstacle created with the simple goal of making the copywriter's and art director's job more frustrating.

We've been through it all. Ridiculous new forms of testing, research methods guaranteed to make any idea dull and mediocre, the era of mergers and acquisitions, a crummy economy, etc.

So what's new?

It's still difficult to come up with a brilliant concept. It always has been and unless you're a liar or a creative genius, it always will be. And while selling a brilliant idea to a client has always been tough, this is where I think the business has gotten tougher. How else do you explain the shortage of breakthrough or even tolerable advertising on TV? Why else would my mother remark, after viewing several particularly lousy commercials, "I can do better than that."?

The sad thing is she probably can.

The sadder thing is that major clients are now starting to believe her. Notice how everybody and his mother and his mother's agent are now getting into the advertising act?

Fortunately, what we see most often on television is not representative of the entire idustry. If someone never watched television and only read this year's One Show Annual, one could easily surmise that advertising creativity was better than ever. But most people won't see a lot of the work in this book. Much of it was done for small clients with even smaller budgets.

This seems to be a bone of contention with some ad folk. "After all," they say, "it's a lot tougher to sell an ad to a large multi-layered corporation with 47 brand managers than it is to Joe the Barber."

The statement is valid, but does it mean we should reward big clients for doing mediocre commercials and penalize small clients for doing clever ones?

Absolutely not. It does mean that somehow we as an industry have to enlighten a greater number of big clients to the virtues of intelligent advertising.

Not just so they could win awards, but so they could sell more products.

One way to start may be as simple as exposing them to it. Abbie Hoffman once said, "Steal This Book." I say, "Pass It Around."

ONE SHOW JUDGES

BRUCE BILDSTEN
Fallon McElligott/Minneapolis

NEIL LEINWOHL
Korey Kay & Partners/New York

LARRY CADMAN
Bozell/New York

JACK MARIUCCI
DDB Needham Worldwide/New York

KERRY CASEY
Carmichael Lynch/Minneapolis

BILL MILLER
Fallon McElligott/Minneapolis

JAC COVERDALE
Clarity Coverdale Rueff/Minneapolis

CHARLOTTE MOORE
Wieden & Kennedy/Portland

AMIL GARGANO
Amil Gargano & Partners/New York

RICH PELS
Scali McCabe Sloves/New York

GEORGE GIER
DDB Needham Worldwide/Chicago

JEAN ROBAIRE
Stein Robaire Helm/Los Angeles

ROZ GREENE
Altschiller Reitzfeld/New York

TOD SEISSER
Ammirati & Puris/New York

DEAN HACOHEN
Goldsmith/Jeffrey, New York

RICH SILVERSTEIN
Goodby Berlin & Silverstein/San Francisco

CABELL HARRIS
Livingston + Keye/ Venice, CA

MIKE VITIELLO
BBDO/New York

PETER HOLMES
Franklin Dallas/Toronto

BILL WESTBROOK
The Martin Agency/Richmond

DION HUGHES
Angotti Thomas Hedge/New York

NAT WHITTEN
Weiss Whitten Carroll Stagliano/New York

MIKE HUGHES
The Martin Agency/Richmond

TRACY WONG
Livingston & Company/Seattle

WOODY KAY
Pagano Schenck & Kay/Providence

ONE CLUB MEMBERS

Mike Abadi
Jeffrey Abbott
Fraser Adamson
Michael J. Aimette
Andrea Albrecht
Joe Alexander
Jordan Allen
Carl Ally
Allison Aloni
David Altschiller
Kaylene Alvarez
Patricia Alvey
Dina Amarito
Dori Amarito
Caroline Ambrosio
Ralph Ammirati
Kevin Amter
Ron Anderson
Daniel Andreuzzi
Anthony Angotti
Leslie Antommarchi
Jill Applebaum
Sharon Appleman
Joanne Archetti
Arnold Arlow
Stephanie Arnold
Abigail Aron
Eric Aronin
Lorraine Arroll
Michael Asphar
Craig Astler
John Athorn
Ellen Azorin
Robert Baiocco
Elizabeth Baker
Dan Balser
Jeanine Barone
Josephine Barreiro
Jamie Barrett
Bob Barrie
Jim Basirico
Scott Bassen
John Bateman
Nancy Bayerlain
Tim Bayless
Cheryl Beach

Clifford Beach
Judy Bean
Allan Beaver
Wendy Beck
Kris Becker
Wendy Becker
Robert Belkin
Gregg Benedikt
Jacqueline Benitez
Gordon Bennett
John Benson
Kristine Benvenuto
Danielle Berger
Sandy Berger
Joe Berkeley
David Bernstein
Bruce Bildsten
Doug Bixby
Max Black
Dawn Blaine
Brendan Blake
Lillian Blanco
Kristen Bloom
Richard Bloom
Larry Bodkin
Bradley Bonewell
Karen Booney
Simon Bowden
Christine Boyer
John Boyle
Evelyn M. Brady
Lisa J. Brandriff
Yvonne Brandt
Harvey Briggs
Jamie Bright
Timothy Broadus
Jim Brodie
Eden Brody
Bill Brokaw
David Bromberg
Charles Bromley
Stephen Brophy
Theresa Brophy
George Brown
Mark Brown
Nancy Brown Vecilla
John Burke
Ron Burkhardt
Ed Butler
Orville Bynoe

Noel R. Caban
Larry Cadman
John Caliendo
Rita Caliendo
Roger Camp
Cathie Campbell
Ileana Canal
Jaymie Canavero
James Caporimo
Paul Cappell
Kimberly Cardinal
David Carlin
Barbara Carmack
Zammarchi
Susan Carroll
Carlos Castro
Gregory Cerny
Ronald Cesark
Alan Chalfin
Larry Chase
Adam Chasnow
Rani M. Chaudhuri
Cheryl Chapman
Nelson Cheung
Vincent Chieco
Marcia Christ
Andrew Christou
Joseph Cianciotti
Lisa Ciocci
Bob Ciosek
Perry Cirigliano
Ben Citron
John Clapps
Carolyn Clare
Craig Clark
Gary Cohen
Robert Cohen
John Colquhoun
Howard Conyack
Tanya Conyack
Cleveland M. Cook III
Callen Cooper
Kevin Corfield
Andi Cormier
Paul Cornacchini
David L. Corr
Scott Corrigan
Colin Costello
Sharon Cote
Emile Council

Ed Cousineau
Jac Coverdale
Robert Cox
Josephine Craig
Rob Cramer
Court Crandall
Lourdes Crespo
David Crittenden
Joseph Crowley
Kevin Cullen
Roz Cundell
Greg Curran
Dina D'Angelo
Joanna D'Avanzo
James Dale
Patricia Darcey
David Dauterive
Jeannine Marie Davis
Scott Decelles
Jay Deegan
Beth DeFuria
Richard Degni
Tony DeGregorio
Wendy Dehne
Craig Deitch
Restie Delfin
Marcia Deliberto
Denise Dell'Olio
Maria Demartino
Andrea Demurjian
Cynthia Derosier
Sharon Dershin
Kimberly Descetto
Sal DeVito
Rael Didomenico
Steve Dildarian
Greg DiNoto
Angela Dominguez
Douglas Donelan
Roger Donnellan
Winifred R. Donoghue
Penny Dorrance
Kim Douglas
Mike Duckworth
Ann P. Duddy
Joe Duffy
Lorraine Duffy
Laurence Dunst
Jim Durfee
Charles Eaton

Erica Eden
Mark Edwards
Shannon Edwards
Tamara Edwards
Arthur Einstein
Allison Eisen
Melvin Elbaum
Stuart Elliot
Elaine Ellman
Margaret Elman
Lee Epstein
Patricia Lynn Epstein
Laura Ertel
Brian Evans
Julie Evans
Timothy Fahey
Peter Farago
Kristi Faulkner
Neil Fein
Doug Feinstein
Neil Feinstein
Jeremy Feldman
Rachel Feldman
Roger Feldman
Sarah Feldman
Ilse Fernandez
Bernadette Ferrara
Michael D. Field
Peggy Fields
Scott Finkelstein
Ann Fisher
Daron Fisher
Mike Flegle
Frank C. Fleizach
James Floersch
John Follis
Suzanne E. Forcart
Gina Fortunato
Paul W. Foulkes
Richard Fowler
Susan Olivia Fowler
Cliff Freeman
John A. Furr, Jr.
Jerry Fury
Frank Fusco
Jason Gaboriau
Tom Gabriel
Todd P. Gaffney
Bob Gage
Gary Gale

Andrea Gall
Jean Galton
Mark Ganton
Bertrand Garbassi
Lee Garfinkel
Amil Gargano
Lisa Garrone
Dave Gassman
Darren Gee
Daniel Geller
Dean Gemmell
Frixos Georgallides
Robyn Gershberg
Dona Gibbs
Stephen P. Gill
Uma Ginde
Frank Ginsberg
Marc Giragossian
Nicole Gladner
Robert Gloddy
Michael Goldberg
Charles Goldman
Mark Goldstein
Susan Golkin
Andrew D. Goodman
Milt Gossett
Bob Gouveia
Stella Grafakos
Kerry Graham
Alison Grant
John Greenberg
Debra Greene
Rosalind Greene
Brian Greenhalgh
Alexander Gregory
Jeff Griffith
Paul B. Groman
Brett Grossman
Meg Learson Grosso
Philip Growick
Roland Grybauskas
Eric Gutierrez
Amy Haddad
Stephen Haggarty
David T. Halberstadt
Dianne Hall
Matthew Hallock
Trace Hallowell
Phil Hanft
Dean Hanson

Jon Harcharek
Sally Harley
Cabell Harris
Gilmore Harris
Jim Hayman
Barry Hedge
Peter Heid
Kathleen Hennicke
Roy Herbert
Steven Michael Herman
Jennifer Hertslet
Peter Herzog
Dawn Hibbard
James Hillis, Jr.
Julie Hirsch
Peter Hirsch
Debra Hirschorn
Gretchen A. Hoag
Geoffrey D. Hoffman
Keith Hollander
Jenine Holmes
Julia Hopkins
Masayuki Toko Hori
David Horridge
Laurence Horvitz
Hugh Hough
Dion Hughes
Mike Hughes
Neal Hughlett
Lisa Hurwitz
Jon Iafeliece
Peter Iannerelli
Peter Iemma
Patrick Ireland
Ara Ishanyan
George Jaccoma
Dick Jackson
Harry M. Jacobs, Jr.
Corrin Jacobsen
Mark Jacobson
Suzanne Jaffe
Paul Jamieson
John Jarvis
Joan Jedell
Mark Jensen
Mark Jespersen
Anthony Johnson
Raymond Johnson
Heather Jones
Timothy Joyce

Charles Kane
Christina Kane
Barbara Ann Kaplan
Barbara Kaufman
Woody Kay
Nancy Keating
Phillip L. Kellogg
Jack Kemp
Pisut Khwanphulsri
Kyu Kim
Eric King
Jon King
Richard Kirshenbaum
Richard Klauber
Joe Knezic
Andrew Knipe
T.K. Knowles
Robin S. Konieczny
Ronni Korn
Renee Korus
Jennifer Kosarin
Jean Kostelich
Elias Kotsias
Aphichart Kovanit
Helmut Krone
Neal Krouse
Paul Krumenacker
Cristy Kruse
Peter Kulevich
Mike La Monica
Galina Lachman
Larry Laiken
Robin G. Landis
Barton Landsman
Andy Langer
Jennifer Lapatine
Anthony LaPetri
Shannon Lavin
Mary Wells Lawrence
Diane Lazarus
Ruth Lee
Joyce Lempel
Mitchell Lemus
Dany Lee Lennon
Robert Lenois
David Lentini
Margaret M. Leonard
Nanette Lerner
Mike Lescarbeau
Sharon Lesser

Diane Letulle
Robert Levenson
Peter Leviten
Alexander Lezhen
Susan Liben
Tom Lichtenheld
Susan Lieber
Mike Liebowitz
Ann-Marie Light
Lisa Lipkin
Katherine H. Lipsitz
Michele Lisi
Wallace Littman
Roger Livingston
D. Michele Lockhart
David Loew
George Lois
Eric J. Lontok
Sean Looney
Tracey Lovelace
David Lowe
Jessamyn C. Lowy
Margaret Lubalin
Peter Lubalin
David Lubars
Scott Lukas
Yu Zhou Luo
Ernest Lupinacci
Lisa Lurie
Tony Macchia
Roz Makarechi
John Malinowski
Jamie Mambro
Sara B. Mandel
Bradley Manier
Howard Margulies
Mara Marich
Louis Marino
Richard Marino
John Mariucci
Kenneth J. Markey
Gayle Marshall
Rodd Martin
Terry Massey
Ann Mathis
Elizabeth Mauldin
Gary Mauro
Ted Mauseth
Scott McAfee
Ed McCabe

Clem McCarthy
Lisa McCarthy
Ruth McCarthy
Kevin McCaul
Leslie McCutchin
Matthew P. McCutchin
Tom McDonnell
Laura McFarland-Taylor
Robin McIver
William B. McKenna
Kevin McKeon
Jason McKesson
Raymond McKinney
Paul McKittrick
Rob McPherson
Leslie S. Mechanic
Lynne Meena
Mark Mendelis
Mario G. Messina
Lyle Metzdorf
Terri Meyer
Greg Meyers
Scott Michelson
Dennis Mickaelian
Michael Migliozzi II
Mark Millar
Don Miller
Josh Miller
Lawrence Miller
John Lane Mims
Jonathan L. Mindell
Daniel Miner
Marise Mizrahi
Ronald Modica
Thomas J. Monahan
Kipp Monroe
Deborah Morrison
Regina Morrone
John Frank Morton
Gregory Motylenski
Jim Mountjoy
William Munch, Jr.
Thomas Muratore, Jr.
Scott J. Murphy
Michael Myers
Eve Nadel
Jennifer Nash
Thomas Nathan
Nelson Nazario
Robert S. Needleman

Ted Nelson	Robert Reitzfeld	Adam Seifer	Pamela Sullivan	Laura Walls
Thomas Nelson	Mark Renusch	Tod Seisser	Patrick Sullivan	Harley Waltman
Arun K. Nemali	Rebecca Restrepo	Joe Shands	James Robert Sullivan, Jr.	Allison M. Warren
Charles Neri	Lisa Rettig-Falcone	David Shane	Patrick Sutherland	Paul D. Warren
Elizabeth Nice	Nancy Rice	Ari Z. Shapiro	Dale Sutphen	Alan Washa
Steve Nicholas	Hope Rich	Cory Shaw	Robert Swartz	Lyle Wedemeyer
Jennifer Noble	Allen Richardson	Gary A. Shaw	Joe Sweet	Les Weiner
Kevin Noschese	Tim Roan	Cally Shea	Leslie Sweet	Eric Weisberg
Dick O'Brien	Chris Robb	Laura Shepard	Noriko Takabishi	William E. Welsh, Jr.
Vincent O'Dowd	Phyllis Robinson	Brett Shevack	Norman Tanen	Mark Wenneker
Joe O'Neill	Manny Rodriguez	Edward Shieh	Craig Tanimoto	Bill Westbrook
David Oakley	Meg Rogers	Bob Shiffrar	Laura Tannenbaum	Tobin Wheeler
Sharon L. Occhipinti	Courtney Rohan	Dean Shoukas	Vincent Taschetti	Tom White
Rip Odell	Gretchen Rollins	Virgil Shutze	Jay Taub	Joanna Wiecek
David Ogilvy	Gad Romann	Fred Siegel	Abby Terkuhle	Richard Wilde
Vicky Oliver	Deb Rosenberg	Mark Silveira	Mike Tesch	Troy Elizabeth Wilderson
Seymon Ostilly	Scott Rosenblit	Kate Silverberg	Alfred Tessier	Claire Willms
Jim Othmer	Ron Rosenfeld	Kenny Sink	Linh Thai	Emil Wilson
Cele Otnes	Elizabeth Rosenthal	Leonard Sirowitz	Liz Thiem	Wayne Winfield
Maxine Paetro	Robert G. Rosenthal	Melissa Sison	Tom Thomas	Jennifer Winn
Azita Panahpour	Steven Rosenthal	Noelle Sisti	Elsebeth Thomsen	David Wojdyla
Tina Panchal	Stuart Rosenwasser	Ira Sitomer	Sean Tierney	Stefen Wojnarowski
George Papantoniou	Bernie Rosner	Carolyn Slapikas	Todd Tilford	Alan L. Wolk
Jeff Pappalardo	Tom Rost	Mike Slosberg	Garrett Tom	David Wong
Elaine Paque	Mark Rothenberg	Robert Slosberg	Guy Tom	Laura B. Woods
Joon Ho Park	Steve Rotterdam	Anne Smith	Dante Tomaselli	Adrienne T. Wright
Priya Patel	Mark Rumptz	Matt Smith	Adam Torio	Liani Wunderlich
Sean Patrick	Justin Edward Russell	Andy Sohn	Wendy W. Tripp	Cayellen C. Wyatt
William D. Paul	John Russo	Richard Solomon	William Troncone	H. Scott Wyatt
Michael Pavone	Nat Russo	Lee Solon	Anastasios Tsiavos	Elizabeth Wynn
Michael Paxton	Mel Rustom	Midori Sonoda	Michael Tubis	Richard Yelland
Richard Pels	Susan Ryan	Dennis Soohoo	Michael D. Tuggle	Gerard Young, Jr.
Steven Penchina	Mike Rylander	John A. Sowinski	Vinny Tully	Michelle Zadlock
Ellen Perless	Steve Sage	Larry Spector	Anne Tum Suden	Joe Zagorski
Christopher Perone	Nelson Salis	Mark Spector	Karl Turkel	Elizabeth Zamos
Donna Perzel	Kenneth Sandbank	Paul Spencer	Carol Turturro	Lynette Zator
Linda Leigh Phillips	Bret Sanford-Chung	Helayne Spivak	Ben Urman	Rainer Zierer
David Piatkowski	Kerstin Santa	Paige Elizabeth St. John	Victor Valadez	Mat Zucker
Gina Picone	Jon Saunders	Joseph Staluppi	Paul Venables	Mark Zukor
Darlene Pike	Joanne Scannello	Pamela A. Stansel	Matthew Vescovo	
Donna Pilch	Michael Scheiner	Todd Stanton	Larry Vine	
Jonathan Plazonja	Kimberly Scheremeta	Scott Stefan	Michael Vitiello	
Chris Pollock	Glenn Scheuer	Dean Stefanides	Thomas Vogel	
Shirley Polykoff	Christopher Schifando	Karl H. Steinbrenner	Nina Wachsman	
Cynthia Prado	Sy Schreckinger	Dan Stern	Elaine Wagner	
Tony Pucca	Mark Schruntek	William Stolpe	Judy Wald	
Elissa Querze	Ruth Schubert	Khari Streeter	Marvin Waldman	
Lisa Quitoni	Michael Schwabenland	Tom Stvan	Roger W. Walker	
Krista Raut	Robert B. Schwartz	Bob Sullivan	Stacey B. Wall	
G. Ashley Reese	Paul Scolaro	E. Ski Sullivan	Andrew Wallace	

GOLD, SILVER & BRONZE AWARDS

"I know bourbon gets better with age, because the older I get, the more I like it."

~ Booker Noe

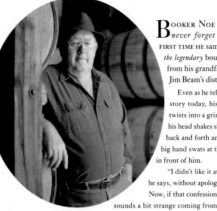

B OOKER NOE *will never forget* THE FIRST TIME HE sampled *the legendary* bourbon from his grandfather Jim Beam's distillery.

Even as he tells the story today, his face twists into a grimace, his head shakes slowly back and forth and his big hand swats at the air in front of him.

"I didn't like it at all," he says, without apologies. Now, if that confession sounds a bit strange coming from a man who's devoted his life to making fine whiskey, there is a perfectly reasonable explanation.

Booker Noe, perhaps better than anyone else, understands that an appreciation for bourbon isn't something people are born with.

You see, in his time as Master Distiller at the Clermont, Kentucky home of Jim Beam Bourbon, Booker has come to cherish the subtle flavors found in the world's finest whiskey.

And he's discovered he's especially fond of bourbon in its

> " LIKE MOST PEOPLE, *learning to love fine bourbon took me a certain amount of time. But as the years have gone by, I've decided there is just nothing better than the taste of whiskey aged in charred white oak to the peak of its flavor. It's uncut, unfiltered and straight from the barrel. This is the bourbon I've chosen to put my name on.*"

purest form, taken straight from the barrel, at its natural proof.

It is this bourbon, Booker Noe believes, with all of its rich, oaky body intact, that is the very best of the best.

Until recently, uncut, unfiltered bourbon like this was the domain of the Master Distiller alone. And while he's no doubt appreciated having the privilege, Booker has always wished that other people, people who truly love fine spirits, could taste this whiskey for themselves.

Which is why Booker Noe recently began bottling his unique bourbon and making it available to the few connoisseurs who can appreciate it.

Considering the special pride he takes in his favorite whiskey, it's not surprising that Booker has put his own name on the label. Nor should it come as any shock that he personally approves

BOOKER NOE grew to love BOURBON in his home state of Kentucky.

every batch of Booker's Bourbon before he allows it to be sent along to you. Fact is, only someone of Booker's experience can determine whether a straight-from-the-barrel bourbon is at the very peak of its flavor.

Depending on the temperament of the seasons in the Bluegrass State, Booker's Bourbon reaches that peak anywhere from six to eight years into the aging process. And since every barrel of whiskey ages differently, each batch of Booker's has a different proof, which can measure anywhere between 121 and 127.

Once selected, the bourbon is painstakingly hand-sealed in a hand-labeled bottle and marked with a tag showing its unique proof and age.

With any luck, you'll find Booker's Bourbon at your local liquor retailer. But since, by its nature, this is not a mass produced bourbon, you may have to look further.

If you should find Booker's impossible to locate,

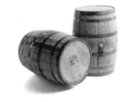

BOOKER'S BOURBON comes straight from the barrel, UNCUT and UNFILTERED.

we suggest you call the toll-free number listed at the bottom of the page, and see about obtaining your Booker's Bourbon that way.

Regardless how you obtain it, Booker Noe believes you'll find his bourbon well worth the time and effort you spend searching.

Especially if, like Booker himself, the years have done for your taste what they do for a bourbon's.

Booker's™ Kentucky Straight Bourbon Whiskey, 60.5%-63.5% Alc./Vol. Bottled by James B. Beam Distilling Co., Clermont KY. ©1992 James B. Beam Distilling Co.
To send the rare gift of Booker's Bourbon to a friend, call 1-800-BE-THERE. Void where prohibited. 1-800-BE-THERE is an independent telephone gift service not affiliated with James B. Beam Distilling Co. Drink Responsibly. It's one of the Basics.

1 Gold

A Mercedes-Benz diesel has been driven over one million miles. Pick a color you can live with.

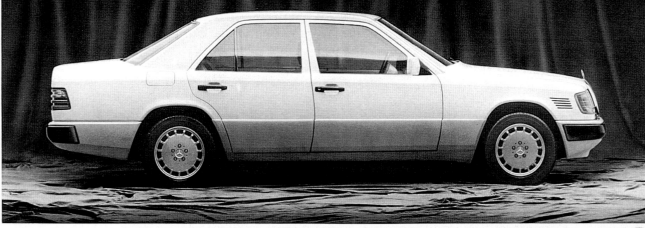

Unfortunately, the term "long-lasting car" is an oxymoron to most car companies. But at Mercedes-Benz, it's part of the mission statement. And the 300D Turbodiesel is the latest in a long line of Mercedes diesels whose durability has become legendary. In fact, a 1968 220D has gone over one million miles. Just stop by your local authorized Mercedes-Benz dealer today for a complete test drive. And be sure you look over the color choices very carefully. After all, what appeals to you today, might not appeal to you a couple decades down the road.

2 Silver

"What evaporates we call the angel's share. Now doesn't that make you want to go to heaven?"

~ Booker Noe

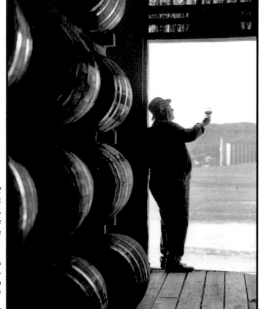

On FIRST *stepping* INSIDE *a* WAREHOUSE FILLED *with* AGING WHISKEY, you can't help feeling like you've walked into a place of worship.

The scale is inspired. Gothic.

Through narrow vertical cracks in the outer walls, slivers of golden light angle down onto a worn wooden floor that aches under the weight of bourbon and time.

The unmistakable aroma of aging whiskey charges the still, moist Kentucky air with a sense of expectation.

Standing there in the silence, amid white oak barrels stacked floor to ceiling, a lifetime bourbon lover experiences a kind of revelation. At last, he truly understands why what escapes these barrels during aging is referred to as "the angel's share."

This is as close as he's ever been to heaven.

The oak barrels in this particular warehouse contain what many people have called the best bourbon there is.

Angel's portion

Your portion

And that opinion gets little argument from Booker Noe, the man whose name goes on the bottle.

Booker is the grandson of Jim Beam. He has lived in this part of Kentucky his entire life, and he's developed some strong notions about how to make whiskey.

One is that the best bourbon is aged from six to eight years (but no longer), depending on how the fickle Kentucky weather decides to behave. Another of Booker's beliefs is that the very finest taste in the world is bourbon straight from the barrel, uncut and unfiltered.

Unfortunately, most people never experience the singular flavor of an uncut whiskey. After all, to create a product that appeals to the masses, distillers combine their bourbon with water.

But that's where another of Booker Noe's strong opinions comes in.

You see, Booker believes that everybody ought to have an opportunity to try bourbon in its purest form. So he did what any self-respecting member of his legendary family would do.

"AS A MASTER DISTILLER, *I've had the opportunity to taste bourbon straight from the barrel at every stage of the aging process. I believe the best tasting bourbon is uncut, unfiltered, and aged anywhere from six to eight years in charred white oak.*

This is the whiskey I choose to put my name on. It's not mass produced. It can't be. I check each barrel myself and only when the bourbon has matured to the ideal age do I clear it to be hand-labeled, hand-sealed and hand-wrapped for you.

I hope you'll get as much pleasure from this rare, natural proof whiskey as I have. And that in the end you'll agree Booker's is the very best bourbon on earth. Or, considering that the angels always get a share, the best bourbon anywhere."

He started bottling it.

Booker's Bourbon goes into its distinctive bottle exactly as it is taken from the barrels. It is in its natural state, which, since each batch ages differently, can be anywhere from 121 to 127 proof.

Despite the inefficiencies built into the process, Booker manages to personally select enough of his Booker's Bourbon to keep a growing number of connoisseurs in small supply.

Each bottle of Booker's is corked and sealed in hot wax by hand. It's then marked with Booker's own handwritten label, and a tag is placed around its neck, which indicates the batch number, the proof and the age of the bourbon inside.

Booker is adamant about the requirements a bourbon has to meet in order to bear his name. Each bottling has to have what he knowingly refers to as "that certain something." Which means it isn't a production schedule that decides when Booker's is ready to come out of the barrels. It's Booker.

BOOKER samples the AGING BOURBON using a tool called a THIEF.

"Harvesting an uncut bourbon at just the right time is the key," says Booker. "Bottle it too early, and the whiskey's character isn't as good as it could be. Wait too long, and the taste gets too heavy and overbearing."

Just as the proof of Booker's Bourbon varies with the whims of the weather, the price appears to fluctuate according to supply and demand. There have been reports of Booker's Bourbon, which had an original suggested price of $40, going for half again as much.

All Booker Noe can do is promise to keep checking his barrels often to see when any new bourbon is ready for bottling. In the meantime, we suggest you contact your local retailer and ask about their current stock of Booker's.

If, in the end, you still can't find a bottle of Booker's, you might call the 800 number at the bottom of the page.

Or you can simply give up, and go without tasting the best whiskey there is for the rest of your life.

After which, of course, some of us think we'll all get to try some.

Booker's™ Kentucky Straight Bourbon Whiskey, 60.5%-63.5% Alc./Vol. Bottled by James B. Beam Distilling Co., Clermont, KY. ©1992 James B. Beam Distilling Co.
To send the rare gift of Booker's Bourbon to a friend, call 1-800-BE-THERE. Void where prohibited. 1-800-BE-THERE is an independent telephone gift service not affiliated with James B. Beam Distilling Co.

3 Bronze

It's the early 19th century. Watt, Ohm, and Volta make great discoveries in the field of electrochemistry and become household names. Michael Faraday develops the first dynamo. And Edgar Allan Poe pens the equation E=MC².

Well, not exactly. But he did come up with some theories years. The scientific community is convinced that space is filled with a luminiferous aether that allowed the transmission of electric and magnetic forces. Albert Einstein, who was working on what was to become his theory of relativity, cried "poppycock" (not literally) and did away with this aether

He came up with a version of the theory of relativity a century before Einstein. He also beat him to the hairdo.

about matter that were remarkably similar to Albert Einstein's.

Skeptical? Well, let's take a look. In 1841, Poe published *Eureka*, his most ambitious work. It was a prose poem of considerable length in which Poe set forth quite a few interesting theories. One curious hypothesis found Poe claiming that matter was made of *"one* particle–a particle of *one* kind–of *one* character–of *one* nature–of *one* size–of *one* form."

Now let's skip ahead 100

nonsense once and for all. In other words, Einstein concluded that matter was made of *"one* particle– a particle of *one* kind–of *one* character–of *one* nature–of *one* size–of *one* form."

Impressed? Stop by the Poe Museum at 1914 East Main. You can read some of Poe's letters and admire portraits of his family and friends. It's a **The Poe** good way to find out more **Museum** about one of the greatest men who ever lived (relatively speaking.)

The Edgar Allan Poe Museum, 1914 East Main Street, Richmond, Virginia 23223. Open 7 Days A Week. Admission $5.00. Call (804)648-5523.

Early Americans called Poe a hack.
The French loved him.
(Does this mean we'll be opening a
Jerry Lewis museum one day?)

After reading Poe's poem "Al Aaraaf", a Baltimore critic wrote "all of our brain-cudgelling could not *compel* us to understand it."

A review in Boston's *The Morning Post* of his *Tales of the Grotesque and Arabesque* cried, "A greater amount of trash within the same compass it would be difficult to find."

The Boston Post called *The Raven and Other Poems* "a parcel of current trash."

And perhaps the most acidic attack came from the *New York Tribune* on the day of Poe's funeral. "Edgar Allan Poe is dead...This announcement will startle many, but few will be grieved by it." Tough crowd.

Meanwhile, over in France, Poe's reputation was hitting Michael Jackson proportions. One reviewer wrote "this Poe is a fellow of great acuteness and spirituality."

In fact, the whole country adored him. He inspired a whole generation of artists.

So why did we scoff at him back here at home?

Perhaps because Poe didn't have a whole lot in common with other American writers of his day.

Just contrast the rugged American feel of James Fenimore Cooper's *The Last of the Mohicans* with any of Poe's tales of madness, decay and death.

Or consider Longfellow, Emerson and Thoreau. They wrote of great, wide-open spaces. Poe wrote of tombs.

Poe was different, and different can be hard to accept.

Now throw in an unscrupulous literary executor who took advantage of his position to slander Poe's life and work. What you end up with is a genius who got a pretty raw deal while he was living.

Today, of course, Poe is a national figure. His fiction has drawn a larger international audience than that of any other American writer. Poe is probably chuckling in his grave (that's a metaphor he would have liked).

Why don't you stop by The Poe Museum at 1914 East Main Street? You can enjoy our slide show about Poe's life and take a tour through a model of what Richmond was like in Poe's day. And we **The Poe Museum** promise, no Jerry Lewis exhibitions yet.

The Edgar Allan Poe Museum, 1914 East Main Street, Richmond, Virginia 23223. Open 7 Days A Week. Admission $5.00. Call (804)648-5523.

Sadomasochist, drug addict, manic depressive, pervert, egomaniac, alcoholic? When did Poe find time to write?

All of Poe's stories were inspired by bizarre opium hallucinations. Once Poe got drunk in New York and was found several days later running like a wild man through the New Jersey woods. He was hopelessly insane.

Whoa! Listen to all the sordid rumors and stories circulating around Edgar Allan Poe and you'd think that he was quite a scoundrel. The fact of the matter is, most frank and trustworthy accounts of the day paint the picture of a basically gentle comrade, a conscientious editor and an attentive husband.

So where did this *National Enquirer* version of his life come from? The primary culprit is one Rufus Griswold. In the early 1830's, Griswold and Poe engaged in a series of brutal literary battles. Among other things that we don't want to print in a family newspaper, Poe claimed that Griswold had "a miserable want of talent."

Poe went on in later years, thinking the feud had been put to rest, to appoint Griswold as executor of his estate.

Griswold took advantage of this trust, after Poe had passed away, to slander the poor man, forging some letters, manipulating others and creating a body of myths and untruths that live with us today. For example, Poe was not a drug addict. We have his doctor's word on that. He was not an alcoholic. True, he had a problem when he did drink. He simply couldn't hold his liquor. From what we know today, his trouble looks suspiciously like diabetes or an enzyme defect.

Of course, we're not trying to say Poe was perfect. He did behave erratically at times. But can you name a genius who didn't? We're just saying, maybe he wasn't that bad of a guy. Why don't you come down to the Poe Museum and make up your own mind? We're at 1914 East Main Street here in Richmond. With one of the largest Poe collections in the world, you'll find out something really **The Poe Museum** startling about Poe's life. The truth.

The Edgar Allan Poe Museum, 1914 East Main Street, Richmond, Virginia 23223. Open 7 Days A Week. Admission $5.00. Call (804)648-5523.

"If you think fishing takes patience, you never waited eight years for bourbon."

~ Booker Noe

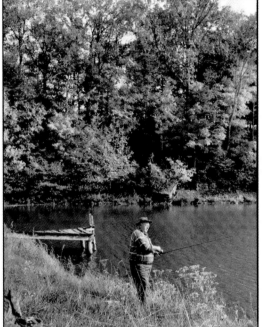

In the *year* 1900, *it took* TWO WEEKS *to travel from* NEW YORK *to* LOS ANGELES. People still spent hours sewing their own clothes by hand. And just making dinner could be a full day's work.

Clearly, during our twentieth century, we've learned how to save a vast amount of time.

But, while today's schedules require things like jet travel and microwave ovens, wouldn't it be nice if we weren't in such a hurry?

Wouldn't it be a pleasant change of pace to have the time to visit the places we fly over, or to smell fresh baked bread in our own kitchens?

In a quiet place called Clermont, Kentucky there is a man who still knows the value of things done the slower way. His name is Booker

> *In all the years I've been a Master Distiller, I've never tasted better than bourbon straight from the charred-oak barrel. That's why I finally decided to bottle a limited amount of uncut, unfiltered bourbon and let some other people try it.*
> *This is bourbon in its purest form, which can be anywhere from 121 to 127 proof. I suggest you enjoy it the same way I made it. Very slowly."*

Noe. And a lot of people think he makes the very finest bourbon in the world: Booker's.

In Clermont, there's a different pace to life than in other places. People stop and talk. Dogs like to sleep a lot. Cars can go years without having their horns honked.

Down by the pond, near the distillery founded by his grandfather Jim Beam, Booker Noe casts out a fishing plug and reels it back through the limestone water.

"My bourbon is always aged between six and eight years," he says, "but if you know how good it tastes, the wait seems even longer."

You see, it isn't a production schedule that decides when the time is right to harvest Booker's. It's Booker.

Using his Master Distiller's experience, he determines the precise moment when weather conditions and the passing of time have brought the whiskey to its ideal maturity.

Much like its age, the proof of Booker's Bourbon changes from batch

BOOKER uses THIS TOOL to knock the bung from a barrel of his BOURBON.

to batch. That's because Booker's is uncut and unfiltered. Which means that unlike any other bourbon you can buy, it is never mixed at any point with water. Only Booker's reaches the shelf with every bit of its natural flavor left intact.

Fortunately, Booker Noe manages to hand-select enough of his Booker's Bourbon to keep a growing number of connoisseurs in short supply.

But regardless of how popular his whiskey becomes, he has no plans to harvest it more often.

"We only do it when the time is right," says Booker with a shrug of his big shoulders. "Besides," he says with a laugh, "it's damn hard work."

Every bottle of Booker's Bourbon is hand-dipped and sealed with hot wax. It is marked with a label written in Booker's own hand and a tag is hung around its neck identifying its age, proof and batch number.

This is not a fast way to bottle whiskey. But if he can wait up to eight years for his bourbon to mature, Booker can certainly spare a few extra minutes for a nice package.

Unfortunately getting your hands on that package can be something of a problem.

The best advice is to phone the better liquor stores in your area and ask about their current inventory. (Don't be surprised if, due to the law of supply and demand, you are asked to pay a little more than Booker's original suggested price of $40 a bottle.)

If you find it impossible to locate Booker's at a retailer, an alternative source is the 800 number at the bottom of the page.

Whichever way you manage to get your hands on Booker's Bourbon, we hope you'll be able to do so soon. In the meantime, please follow Mr. Noe's example and have a little patience.

Without it, a bourbon like Booker's wouldn't be available at all.

"I know bourbon gets better with age, because the older I get, the more I like it."

~ Booker Noe

BOOKER NOE *will never forget* THE FIRST TIME HE sampled *the legendary* bourbon from his grandfather Jim Beam's distillery.

Even as he tells the story today, his face twists into a grimace, his head shakes slowly back and forth and his big hand swats at the air in front of him.

"I didn't like it at all" he says, without apologies.

Now, if that confession sounds a bit strange coming from a man who's devoted his life to making fine whiskey, there is a perfectly reasonable explanation.

Booker Noe, perhaps better than anyone else, understands that an appreciation for bourbon isn't something people are born with.

You see, in his time as Master Distiller at the Clermont, Kentucky home of Jim Beam Bourbon, Booker has come to cherish the subtle flavors found in the world's finest whiskey.

And he's discovered he's especially fond of bourbon in its

" *LIKE MOST PEOPLE, learning to love a fine bourbon took me a certain amount of time. But as the years have gone by, I've decided there is just nothing better than the taste of whiskey aged in charred white oak to the peak of its flavor. It's uncut, unfiltered and straight from the barrel. This is the bourbon I've chosen to put my name on.*"

purest form, taken straight from the barrel, at its natural proof.

It is this bourbon, Booker Noe believes, with all of its rich, oaky body intact, that is the very best of the best.

Until recently, uncut, unfiltered bourbon like this was the domain of the Master Distiller alone. And while he's no doubt appreciated having the privilege, Booker has always wished that other people, people who truly love fine spirits, could taste this whiskey for themselves.

Which is why Booker Noe recently began bottling his unique bourbon and making it available to the few connoisseurs who can appreciate it.

Considering the special pride he takes in his favorite whiskey, it's not surprising that Booker has put his own name on the label. Nor should it come as any shock that he personally approves

BOOKER NOE grew to love BOURBON in his home state of Kentucky.

every batch of Booker's Bourbon before he allows it to be sent along to you. Fact is, only someone of Booker's experience can determine whether a straight-from-the-barrel bourbon is at the very peak of its flavor.

Depending on the temperament of the seasons in the Bluegrass State, Booker's Bourbon reaches that peak anywhere from six to eight years into the aging process. And since every barrel of whiskey ages differently, each batch of Booker's has a different proof, which can measure anywhere between 121 and 127.

Once selected, the bourbon is painstakingly hand-sealed in a hand-labeled bottle and marked with a tag showing its unique proof and age.

With any luck, you'll find Booker's Bourbon at your local liquor retailer. But since, by its nature, this is not a mass produced bourbon, you may have to look further.

If you should find Booker's impossible to locate,

BOOKER'S BOURBON comes straight from the barrel, UNCUT and UNFILTERED.

we suggest you call the toll-free number listed at the bottom of the page, and see about obtaining your Booker's Bourbon that way.

Regardless how you obtain it, Booker Noe believes you'll find his bourbon well worth the time and effort you spend searching.

Especially if, like Booker himself, the years have done for your taste what they do for a bourbon's.

Booker's™ Kentucky Straight Bourbon Whiskey, 60.5%-63.5% Alc./Vol. Bottled by James B. Beam Distilling Co., Clermont KY. ©1992 James B. Beam Distilling Co.
To send the rare gift of Booker's Bourbon to a friend, call 1-800-BE-THERE. Void where prohibited. 1-800-BE-THERE is an independent telephone gift service not affiliated with James B. Beam Distilling Co. Drink Responsibly. It's one of the Basics.

"What evaporates we call the angel's share. Now doesn't that make you want to go to heaven?"

~ Booker Noe

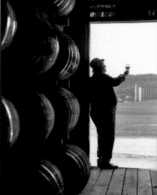

On FIRST *stepping* INSIDE *a* WAREHOUSE FILLED *with* AGING WHISKEY, you can't help feeling like you've walked into a place of worship.

The scale is inspired. Gothic. Through narrow vertical cracks in the outer walls, slivers of golden light angle down onto a worn wooden floor that aches under the weight of bourbon and time.

The unmistakable aroma of aging whiskey charges the still; moist Kentucky air with a sense of expectation.

Standing there in the silence, amid white oak barrels stacked floor to ceiling, a lifetime bourbon lover experiences a kind of revelation. At last, he truly understands why what escapes these barrels during aging is referred to as "the angel's share."

This is as close as he's ever been to heaven.

The oak barrels in this particular warehouse contain what many people have called the best bourbon there is.

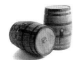

Angel's portion

Your portion

And that opinion gets little argument from Booker Noe, the man whose name goes on the bottle.

Booker is the grandson of Jim Beam. He has lived in this part of Kentucky his entire life, and he's developed some strong notions about how to make whiskey.

One is that the best bourbon is aged from six to eight years (but no longer), depending on how the fickle Kentucky weather decides to behave. Another of Booker's beliefs is that the very finest taste in the world is bourbon straight from the barrel, uncut and unfiltered.

Unfortunately, most people never experience the singular flavor of an uncut whiskey. After all, to create a product that appeals to the masses, distillers combine their bourbon with water.

But that's where another of Booker Noe's strong opinions comes in.

You see, Booker believes that everybody ought to have an opportunity to try bourbon in its purest form. So he did what any self-respecting member of his legendary family would do.

" *AS A MASTER DISTILLER, I've had the opportunity to taste bourbon straight from the barrel at every stage of the aging process. I believe the best tasting bourbon is uncut, unfiltered, and aged anywhere from six to eight years in charred white oak.*

This is the whiskey I choose to put my name on.

It's not mass produced. It can't be. I check each barrel myself and only when the bourbon has matured to the ideal age do I clear it to be hand-labeled, hand-sealed and hand-wrapped for you.

I hope you'll get as much pleasure from this rare, natural proof whiskey as I have. And that in the end you'll agree Booker's is the very best bourbon on earth. Or, considering that the angels always get a share, the best bourbon anywhere."

He started bottling it.

Booker's Bourbon goes into its distinctive bottle exactly as it is taken from the barrels. It is in its natural state, which, since each batch ages differently, can be anywhere from 121 to 127 proof.

Despite the inefficiencies built into the process, Booker manages to personally select enough of his Booker's Bourbon to keep a growing number of connoisseurs in small supply.

Each bottle of Booker's is corked and sealed in hot wax by hand. It's then marked with Booker's own handwritten label, and a tag is placed around its neck, which indicates the batch number, the proof and the age of the bourbon inside.

Booker is adamant about the requirements a bourbon has to meet in order to bear his name. Each bottling has to have what he knowingly refers to as "that certain something." Which means it isn't a production schedule that decides when Booker's is ready to come out of the barrels. It's Booker.

BOOKER samples the AGING BOURBON using a tool called a THIEF.

"Harvesting an uncut bourbon at just the right time is the key," says Booker. "Bottle it too early, and the whiskey's character isn't as good as it could be. Wait too long, and the taste gets too heavy and overbearing."

Just as the proof of Booker's Bourbon varies with the whims of the weather, the price appears to fluctuate according to supply and demand. There have been reports of Booker's Bourbon, which had an original suggested price of $40, going for half again as much.

All Booker Noe can do is promise to keep checking his barrels often to see when any new bourbon is ready for bottling. In the meantime, we suggest you contact your local retailer and ask about their current stock of Booker's.

If, in the end, you still can't find a bottle of Booker's, you might call the 800 number at the bottom of the page.

Or you can simply give up, and go without tasting the best whiskey there is for the rest of your life.

After which, of course, some of us think we'll all get to try some.

Booker's™ Kentucky Straight Bourbon Whiskey, 60.5%-63.5% Alc./Vol. Bottled by James B. Beam Distilling Co., Clermont, KY. ©1992 James B. Beam Distilling Co.
To send the rare gift of Booker's Bourbon to a friend, call 1-800-BE-THERE. Void where prohibited. 1-800-BE-THERE is an independent telephone gift service not affiliated with James B. Beam Distilling Co.

"TRUE!–nervous–very, very dreadfully nervous I had been and am; but why *will* you say I am mad?"

With this opening line of "The Tale-Tell Heart", Edgar Allan Poe took the world into a startling new place. Into the mind of a madman.

We see the entire story through the eyes or rather the words of a killer.

Everything. The murder. The dismemberment. The confession.

The effect is uncomfortable and terrifying. Go ahead. Read it late one night when you're all by yourself and it's raining outside.

How about this description of a ship's passenger caught in a whirlpool from "Manuscript Found In A Bottle"? "Oh horror upon horror! the ice opens suddenly to the right, and to the left, and we are whirling dizzily...round and round..."

Intense huh? But what do these "interior monologues" prove? That Poe was simply a lunatic transcribing his own crazed thoughts?

Of course not. It was an experimental technique that allowed Poe to convey his meanings and themes through patterns,

He was an early pioneer of the stream of consciousness technique what's that noise in the distance that reminds me of brushing my teeth as a child and my mother's sweet embrace.

symbols, images and ideas.

This wasn't the literary fashion of the day. Most writers were concerned with spelling everything out for the reader in detail after exhausting detail. Poe found this tradition constraining (if not outright boring) and decided to throw objective reality out the window and turn inward.

True, Poe was no master of stream of consciousness writing. His work was merely the rough beginnings of a new art form. To enjoy the technique in all its glory we refer you to William Faulkner's *The Sound and the Fury*. Virginia Woolf's *To the Lighthouse*. And, of course, James Joyce's masterpiece, *Ulysses*.

Want to find out more about the mind of Edgar Allan Poe? Visit the Poe Museum. It's located at 1914 East Main Street here in Richmond. You can see some of Poe's possessions, including a chair he used as editor of the *Southern Literary Messenger* that's a lot like the chair that I used as a young student where I once became destracted by the birds singing tweet, tweet, tweet outside my window.

The Poe Museum

The Edgar Allan Poe Museum, 1914 East Main Street, Richmond, Virginia 23223. Open 7 days a week. Admission $5.00. Call (804)648-5523.

Poe created the detective story back in 1841. (Just think how many butlers would be roaming the streets today if he hadn't.)

It was a dark and stormy night in April 1841. The latest issue of Graham's magazine had just hit the streets. And there, nestled between a verse entitled "An April's Day" and music to "Oh! Gentle Love", appeared a quirky little story called "The Murders in the Rue Morgue".

The publication called it a "tale of ratiocination" (the word "detective" had not been coined yet). Poe understatedly called it "something in a new key."

Something in a new key, indeed. In a few short pages, he created one of the most popular literary (and later film) genres of all time.

The story introduced a scholarly recluse by the name of C. Auguste Dupin who had a "peculiar analytic ability." And he put it to good use by solving a particularly brutal murder that had the local police baffled. (The culprit, incidentally, turned out to be a trained orangutan).

Poe went on to pen three more tales of ratiocination. Not only were they highly entertaining, they also introduced many future clichés to the detective business.

For example, the old crime being committed in a locked room scenario. The frame-up. Postmortem examination and ballistic evidence. The "least likely murderer" ploy. Poe even outfitted Dupin with a pipe.

(The murderous orangutan of "The Murders in the Rue Morgue", while a groundbreaking first, has yet to resurface in any later works.)

Obviously, if you've ever cracked an Agatha Christie novel, flipped on a Columbo movie, or ever played a game of Clue, these plot devices are quite familiar.

In fact, Sir Arthur Conan Doyle, creator of Sherlock Holmes and perhaps Poe's most famous disciple, said that "if every man who owed his inspiration to Poe were to contribute a tithe of his profits therefrom, he would have a monument greater than the Pyramids..."

Alas, not everyone has done so, so we'll have to do with our quaint little Poe Museum. Why don't you come check it out? You can wander through the Old Stone House, Richmond's oldest surviving dwelling, study "The Raven" illustrations and see plenty of other mysterious things.

We could give you the address, but why don't you figure it out for yourself. (Here's a clue- it's right here in Richmond, near Church Hill.) **The Poe Museum**

Impressive huh? And that's just the tip of the iceberg. Look at everybody Poe's had an influence on and it reads like a Who's Who of artists from the past 150 years.

First, and most obviously, you have the writers from the field of horror. Everyone from H.P. Lovecraft to Stephen King. Admittedly, Poe wasn't the first to pen a tale of terror, but let's face it, he was the king of goose bumps.

of French writers and artists in the nineteenth century.

Eventually, this movement would ripple out of France and catch the imagination of the rest of the world, including such giants as James Joyce, T.S. Eliot and W.B. Yeats.

Let's see, have we left out any other writers whose work Poe has touched? There's Nathaniel Hawthorne, Joseph Conrad, Thomas Mann...

EDGAR, AGE 27. VIRGINIA, AGE 14.

His technique inspired William Faulkner. His stories inspired Alfred Hitchcock. His marriage inspired Jerry Lee Lewis.

Of course, Poe was the first to pen a detective story. With "The Murders In The Rue Morgue," he gave birth to an entire genre. And gave people like Sir Arthur Conan Doyle (creator of Sherlock Holmes) and Agatha Christie a means to earn a living.

Science fiction? Poe was a true pioneer in the field who had a huge effect on Jules Verne. And Jules Verne, of course, has had a huge effect on everybody.

Poe was also one of the precursors of the Symbolist movement. His belief in the power of a concise, precise image to convey a world of meaning, inspired a whole generation

Well, you get the idea. But don't think the spirit of Poe stops at the boundaries of the literary world.

You can catch a glimpse of Poe in the work of countless film directors, conductors, rock stars, actors, actresses, cartoonists, painters, etc., etc., etc., etc., etc., ad infinitum.

We're running out of room here. Want to find out more? Visit the Poe Museum at 1914 East Main Street. You can browse through our collection of paintings based on Poe's works and explore the Enchanted Garden. **The Poe Museum** (Those are a couple more things he inspired.)

7 Bronze

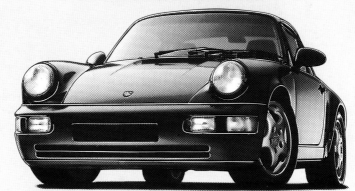

Honestly now, did you spend your youth dreaming about someday owning a Nissan or a Mitsubishi?

There is still only one car that looks, feels, and performs like a Porsche 911: a Porsche 911. It is the one sportscar that manages to be both timeless and ahead of its time. And we're now making it very affordable for you to drive one. After all, we know how many decades you've waited.

PORSCHE®

8 Silver

WE COULD GIVE YOU A LIST OF OUR CLIENTS. BUT THEN WE'D HAVE TO KILL YOU.

THE SPY FACTORY 3701 WEST NORTHWEST HIGHWAY #164.

9 Bronze

THE YET CON. CLOSE TO A FIVE STAR RESTAURANT.

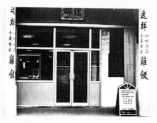

Tantalisingly close.

Just 500 metres, in fact.

(That's about the distance from the Yet Con to the Raffles Grill Room.)

And frankly, that's about as close as we'll ever get to being a 5-star restaurant.

Because there's no fresh, crisp linen on our tables, no newly starched napkins awaiting you, no luxurious carpet underfoot or fine expensive china underfood and certainly no silverware.

Neither will you find us serving whatever the latest fashion in haute cuisine is.

You see, our meals have hardly changed since we opened our doors over 50 years ago.

(Our decor too, remains reassuringly untouched by fads and fashions and certainly by us.)

And some things have been around for even longer than 50 years.

Our waitresses, for instance.

And many of our recipes. Some culled from original ancient Hainanese dishes.

Our famous chicken rice being a case in point.

Steamed chicken served on a bed of snap fresh cucumber accompanied by rice, shredded ginger and red chilli. Washed down with copious quantities of refreshing lime juice. (Or beer, if we can find the opener.)

Simple, but was there ever such a fresh, clean union of culinary taste?

Our pork chop comes close, perhaps, lean breaded pork cooked to perfection in a gravy sauce thick with taste and studded with peas.

They're the sort of meals you can't get in a 5-star restaurant.

Which probably accounts for all the BMWs' outside Yet Con.

25 PURVIS STREET, S'PORE 0718.

SEE, WE DO EVERYTHING IN OUR POWER TO ENSURE YOU HAVE A GOOD MEAL.

Alas, we spend so much money procuring the best chicken and pork that there's precious little left over to spend on other things.

Like furniture.

Or the rest of our decor, for that matter.

Which is actually a blessing in disguise.

It means there is absolutely nothing to distract you from our superbly steamed, contentedly plump chicken.

Or our pork, which we roast, religiously, according to a time-honoured recipe. (It's still pinned behind the dresser.)

So why worry if your table slants a little?

It only means you'll get more than your fair share of our nutritious chicken rice.

And, if your chair should rock occasionally, there is absolutely no cause for alarm.

None whatsoever, may we hasten to add.

In fact, we haven't lost a customer in over forty years.

Besides, there's probably some nice Hainanese music coming from the Kitchen which you can rock your chair to.

Fortunately, with their usual foresight, our founding fathers selected tables and chairs of uncommon durability.

Consider, for a moment, the tables around the walls.

Their tops are solid marble.

Their legs are teak, built like battleships.

(The kind of tables you wouldn't find at the Dorchester.)

In the centre of our dining room are highly functional, neo-Ordinaire tables.

No cheap veneers, you'll notice. All made, respectably, from wood.

We have to admit, generations of diners have probably taken their toll.

And our cleaners have perhaps been less-than-gentle.

But we do value tradition.

Even down to an odd wobble or two on Table 8.

Or a wonky leg on the third chair of Table 9. (Blame the man who stands on it to read the electricity meter.)

But, please, dear reader, bear with us.

Certainly, we'll get round to fixing them one day.

Just as soon as we find the original manufacturer's guarantee card.

"A RESTAURANT." WILL THE FLATTERY EVER CEASE?

Someone actually said it.

We were taken aback, of course.

Call us a chop-shop, by all means, one of the best in town.

But a restaurant?

You see, for over 50 years we've seen ourselves more as a no nonsense, no fuss, no hullabaloo place to eat.

Yet, maybe our generously spirited patron has a point.

We serve food, after all. (A great asset for any restaurant.)

Good food, at that. (Our chicken rice is renowned, if not the world over, certainly Singapore over.)

Of course, some of the best restaurants can afford to fly in chefs from Paris, London and Rome.

Well, we can afford a chef who flies in too.

From Bukit Timah admittedly; and on a Honda '125' rather than a jumbo 747, but still.

The best restaurants also cover their tables in fresh linen and newly starched napkins, while the floors are luxuriously carpeted underfoot and expensive china resides underfood.

We'll own up. We have none of this.

And guess what? It hasn't affected the taste of our food one bit.

But like all the finer establishments in town, we charge ridiculous prices too.

Not ridiculously high, mind, but ridiculously low. (It's a wonder we make a living at all sometimes.)

So you see, perhaps our new accolade isn't so fanciful, after all.

But don't worry, it won't go to our heads.

Because at Yet Con things are going to stay the same as always.

Always.

IF YOU'RE A VEGETARIAN

WE RECOMMEND THE CRISP

ONIONS AND PARSLEY.

YOU'LL FIND THEM

ON TOP OF OUR BIG,

FAT, JUICY STEAKS.

You won't find lawn clippings and tofu here. Just the best diamond-branded, hickory charred prime beef, steaks, and chops in the Cities. We're just a couple blocks from the game, so we're perfect for a stop before or after. For reservations, call 338-1560.

J.D. Hoyt's

DIAMOND BRANDED HICKORY CHARRED PRIME BEEF
301 WASHINGTON AVENUE NORTH, MINNEAPOLIS

11 Bronze

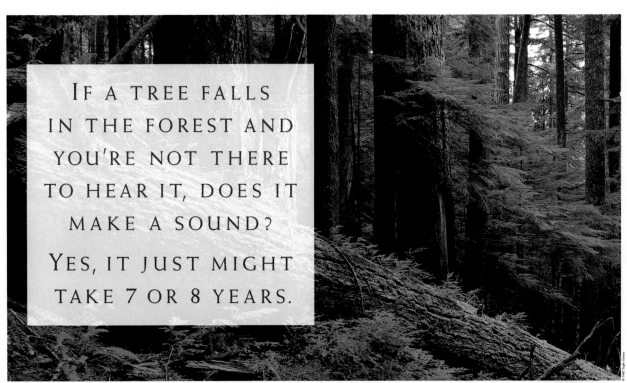

IF A TREE FALLS
IN THE FOREST AND
YOU'RE NOT THERE
TO HEAR IT, DOES IT
MAKE A SOUND?

YES, IT JUST MIGHT
TAKE 7 OR 8 YEARS.

To make a good guitar, you've got to devote a lot of time and attention to it. But then, we haven't been doing much of anything else for the last few years. Write us at 1940 Gillespie Way, El Cajon, CA 92020 to find a dealer.

12 Gold

**CONSUMER MAGAZINE
COLOR 1 PAGE OR
SPREAD: SINGLE**

13 SILVER
ART DIRECTOR
David Page
WRITER
Dave O'Hare
PHOTOGRAPHER
Paul Franz-Moore
CLIENT
Specialized Bicycle
Components
AGENCY
Goodby Berlin &
Silverstein/San Francisco

14 BRONZE
ART DIRECTOR
John Vitro
WRITER
John Robertson
PHOTOGRAPHERS
Art Wolfe
Marshall Harrington
CLIENT
Taylor Guitar
AGENCY
Franklin Stoorza/San Diego

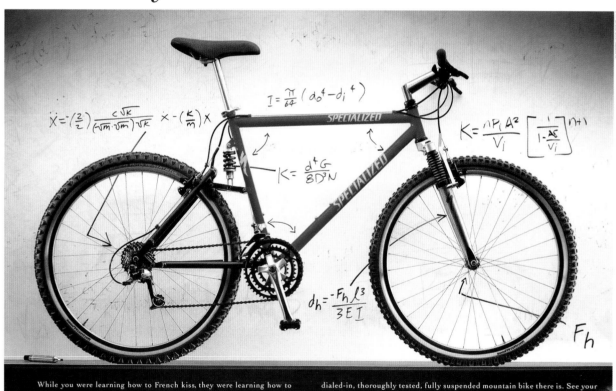

13 Silver

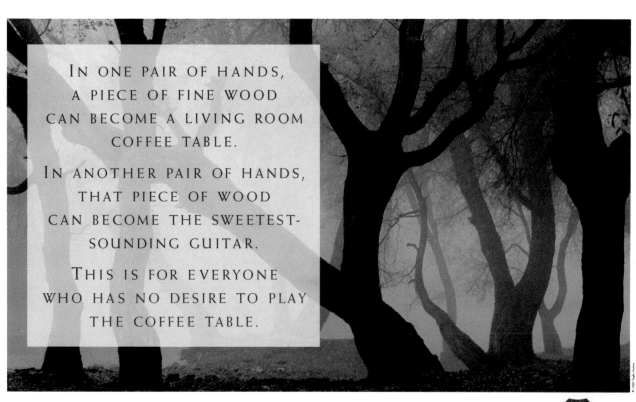

IN ONE PAIR OF HANDS,
A PIECE OF FINE WOOD
CAN BECOME A LIVING ROOM
COFFEE TABLE.

IN ANOTHER PAIR OF HANDS,
THAT PIECE OF WOOD
CAN BECOME THE SWEETEST-
SOUNDING GUITAR.

THIS IS FOR EVERYONE
WHO HAS NO DESIRE TO PLAY
THE COFFEE TABLE.

Some trees become pencils. Some trees become paper that becomes guitar magazines. Some trees become shoe trees. Some trees become Taylor guitars. Some trees have all the luck. Write us: 1940 Gillespie Way, El Cajon, CA 92020.

14 Bronze

CONSUMER MAGAZINE COLOR 1 PAGE OR SPREAD: SINGLE

CONSUMER MAGAZINE B/W 1 PAGE OR SPREAD: CAMPAIGN

15 BRONZE

ART DIRECTOR
David Page

WRITER
Dave O'Hare

ILLUSTRATOR
Alan Daniels

PHOTOGRAPHER
Duncan Sim

CLIENT
American Isuzu Motors

AGENCY
Goodby Berlin & Silverstein/San Francisco

16 SILVER

ART DIRECTOR
Adam Regan

WRITER
Simon Hayward

PHOTOGRAPHER
Jonathan Brade

CLIENT
Gallery 13

AGENCY
The Ball Partnership Euro RSCG/Hong Kong

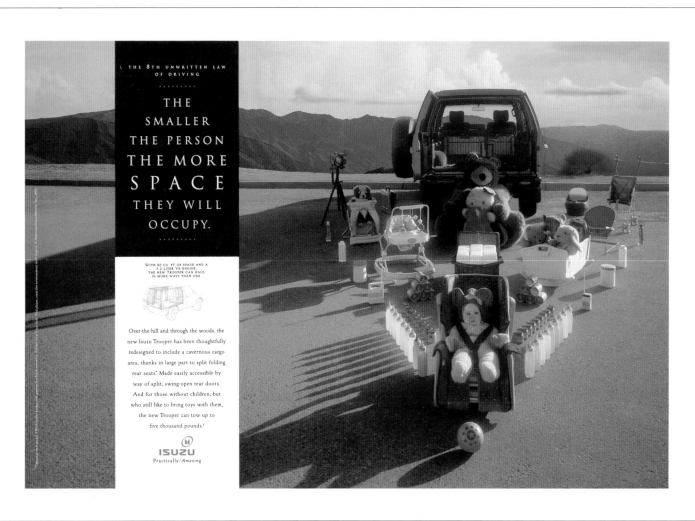

15 Bronze

IN NEW YORK THERE'S A MAN WHO HANGS HEAVY WEIGHTS FROM PINS STUCK THROUGH HIS NIPPLES AND

SCROTUM. IT'S NOT A PLEASANT SIGHT AND PEOPLE, USUALLY MEN, REGULARLY FAINT. HE CALLS IT MODERN ART. SO FAR IT HASN'T SOLD VERY WELL, BUT THEN ARTISTS ARE SUPPOSED TO STRUGGLE.

NO WONDER MODERN CHINESE ART IS SO POPULAR. **Gallery 13** AT THE HILTON HOTEL

THERE'S A WOMAN IN LONDON WHO CHOOSES THREE PEOPLE OFF THE STREET.

SHE TAKES THEM BACK TO HER STUDIO WHERE SHE PROCEEDS TO STRIP HERSELF NAKED. SHE THEN ASKS HER APPRENTICES TO COVER HER IN A RANDOM SELECTION OF OIL PAINTS, PAYING SPECIAL ATTENTION TO HER VARIOUS NOOKS AND CRANNIES. WHEN THEY'VE FINISHED, SHE ROLLS HERSELF UP IN AN ENORMOUS PIECE OF CANVAS, WHICH SHE THEN CALLS MODERN ART. IT HAS YET TO REACH THE AUCTION HOUSES.

NO WONDER MODERN CHINESE ART IS SO POPULAR. **Gallery 13** AT THE HILTON HOTEL

THERE'S AN AMERICAN IN PARIS WHO EVACUATES HIS BOWELS INTO A CAN.

AFTER HAVING IT VACUUM PACKED, HE LOVINGLY LABELS IT, AND CALLS IT MODERN ART. SO FAR IT HASN'T INCREASED IN VALUE.

NO WONDER MODERN CHINESE ART IS SO POPULAR. **Gallery 13** AT THE HILTON HOTEL

GOLD, SILVER & BRONZE AWARDS

CONSUMER MAGAZINE COLOR 1 PAGE OR SPREAD: CAMPAIGN

17 GOLD
ART DIRECTOR
Charlotte Moore
WRITER
Janet Champ
PHOTOGRAPHER
Guzman
CLIENT
Nike
AGENCY
Wieden & Kennedy/ Portland

Why are we so hard on ourselves

and so much easier on others? Did somebody say something once that stuck in our brains and won't go away? Did we mispronounce something in French, did we trip in front of some guy, did we make some huge mistake that we've never gotten over?

What haunts our fine bodies and our fine hearts and makes our heads spin with an image of ourselves we can't accept? We tell our friends not to be so hard on themselves and we tell our loved ones not to be so hard on themselves and we tell ourselves

we're just not being hard enough.

We are such funny women sometimes. We blame ourselves when blame does not apply (terrible word, that *blame).* We feel guilty about what we should have done better (terrible word, that *should).* We are harder on ourselves, harder than we would be on anybody else, anybody. Complete strangers! Big dogs! *People we don't even like!*

And the things we expect are so darn *(continued)*

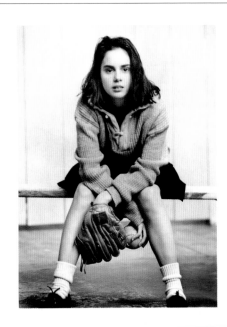

Did you ever wish you were a boy?

Did you? Did you for one moment or one breath or one heartbeat beating over all the years of your life, wish, even a little, that you could spend it as a boy? Honest. Really. Even if you got over it.

Did you ever wish that you could be a boy just so you could do *boy things* and not hear them called *boy things,* did you want to climb trees and skin knees and be third base and not hear the boys say, Sure, play, but that means you have to *be* third base.

Oh *ha ha ha.*

But did you ever wish you were a boy

just because there were *boys,* and there were *girls* and they were *them,* and we were, well,

we weren't them, and we knew there must be a difference because everybody kept telling us there was. But what was it?

You never knew. Like you *knew* that you were a girl *(you run like a girl you throw like a girl you girl you)* and that was great, that was swell, but you *(continued)*

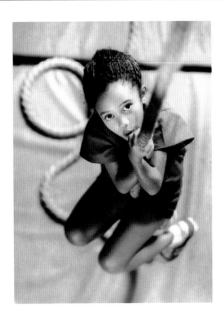

Remember P.E. class?

Remember prison ball and jumping jacks and how your P.E. teacher made you try to climb that rope that hung from the ceiling and you never could, *never?*

Or how you had to do chin-ups and see how long you could hang and you could only hang something like 2.5 seconds but that wasn't good enough, *oh no,*

you had to hang something like 65 seconds and you could never do that and thank God it was only pass/no pass and you got a pass just for showing up and trying. Which was good.

But then you got older.

And P.E. teachers got smarter. Because now you got graded. You got graded and at least once you got the dreaded C or the equally dreaded C+ and there went your whole grade-point average and speaking of average that's what you were now: *plain-old-just-mediocre-better-luck-next-time-see-ya-later average* and you thought *(continued)*

weird, things our mothers once said we should be able to do or our fathers wanted us to achieve or our great Aunt Charlotte wanted us to try and they didn't know that their words would stick

like glue to our hearts with a list of expectations wrapped around it. Look: all these requests and all these demands and all these great expectations get old, *real old,* and only you know when to yell uncle.

Uncle. Uncle. Uncle.

Because for one moment of your life you feel like feeling...perfect. You feel like dashing into those hills or those open roads or right into the air itself

and that's just what you might do

so *Ha.*

You feel like that rusty old image you carry is slipping away, right over the edge of a mirror and out of view. You feel like moving and if you trip, you trip, if you fall, you will get up. And the air feels like it will carry you and push you and it's like nothing you feared it would be. And of course everything you expected it would.

Just do it.

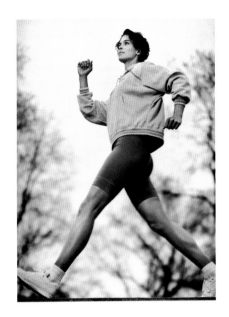

couldn't help wondering what it would be like if you... had been...a *boy.*

And if you could have been a boy, what difference would it have made? Would it have made you faster, cuter, cleaner? And if you *were* a boy, this incredibly bouncing boy, what boy would you have been? All the time knowing no two boys are alike any more than all girls are.

So you wake up. And you learn we all have differences (Yes!) You learn we all have similarities (Right!) You learn to stop lumping everybody in the world into two separate categories, or three, or four, or any at all (Finally!) And you learn to stop beating yourself over the head for things that weren't

wrong in the first place.

And one day when you're out in the world running, feet flying dogs barking smiles grinning, you'll hear those immortal words calling, calling inside your head *Oh you run like a girl*

and you will say shout scream whisper call back *Yes. What exactly did you think I was?*

Just do it.

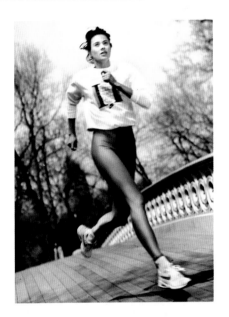

Now wait just a gosh darn minute who, exactly, is average? And the answer came back ringing loud and clear over the top of that chin-up bar: Nobody.

You're not average because average is a lie. You're not average because average means stuck and you're not stuck, you're moving and becoming and trying and you're climbing over every bit of fear or opinion or "no you can't do that" you've ever heard.

So you scoff at average. You laugh. You guffaw. And you run and you play and you move and the more you tell your body that it is a well-oiled machine the more it starts to believe you.

And then one night you have the craziest dream.

You're in the middle of your old gym. Your P.E. teacher is standing there. She is grinning. There is a rope before you. So you climb it. You climb the living heck out of it. You reach the top. And there is absolutely no place to go but up.

Just do it.

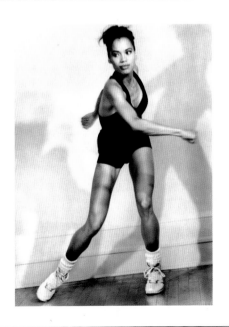

**GOLD, SILVER & BRONZE
AWARDS**

**CONSUMER MAGAZINE
COLOR 1 PAGE OR
SPREAD: CAMPAIGN**

18 **SILVER**
ART DIRECTORS
David Page
Erich Joiner
WRITERS
Dave O'Hare
Scott Burns
ILLUSTRATOR
Alan Daniels
PHOTOGRAPHER
Duncan Sim
CLIENT
American Isuzu Motors
AGENCY
Goodby Berlin &
Silverstein/San Francisco

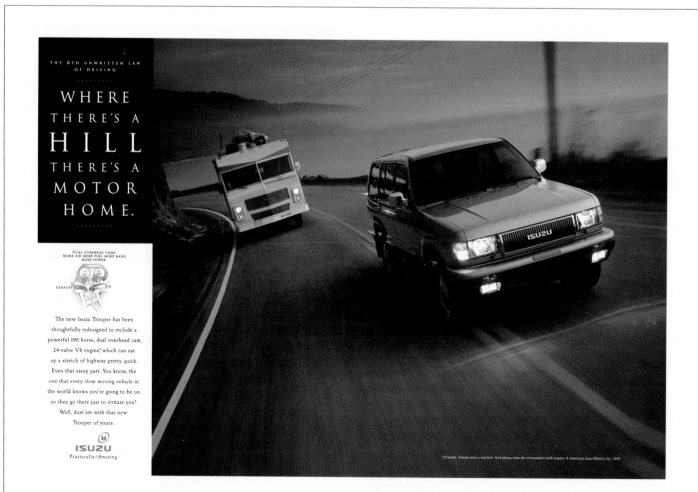

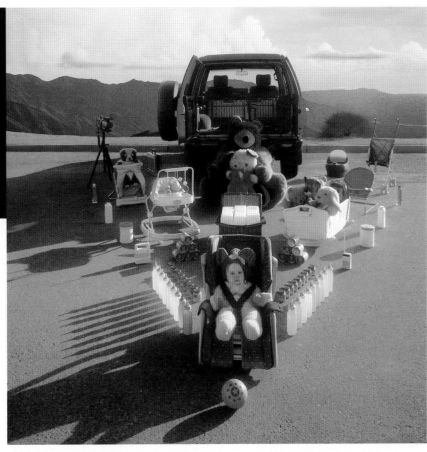

THE SMALLER THE PERSON THE MORE S P A C E THEY WILL OCCUPY.

WITH 90 CU. FT. OF SPACE AND A
3.2 LITER V6 ENGINE,
THE NEW TROOPER CAN HAUL
IN MORE WAYS THAN ONE.

Over-the-hill and through the woods, the
new Isuzu Trooper has been thoughtfully
redesigned to include a cavernous cargo
area, thanks in large part to split folding
rear seats.' Made easily accessible by
way of split, swing-open rear doors.
And for those without children, but
who still like to bring toys with them,
the new Trooper can tow up to
five thousand pounds.'

ISUZU
Practically/*Amazing*

THE ATTRACTION OF SHOPPING CARTS TO AUTOMOBILES

IS AMONG THE STRONGEST FORCES IN THE UNIVERSE.

This being the way of things,
we give every new Trooper five
coats of tough shopping
cart-resistant, space-aged stuff.
Then we paint the parts
only the road sees four times.
Nine coats in all. Then we bake it.
Because even with a 190
horse dual overhead cam engine*

and rear multi-link/coil
suspension, a parked Trooper
must be able to survive
shopping carts, artistic birds
and the car doors of those who
long to be close to you.

ISUZU
Practically/*Amazing*

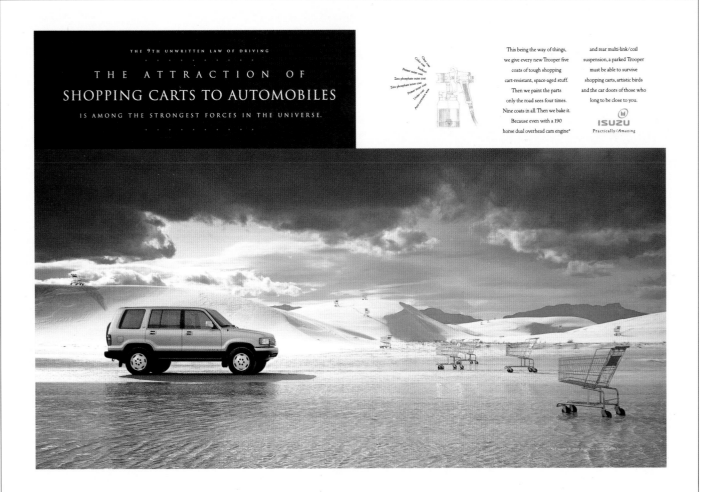

CONSUMER MAGAZINE COLOR 1 PAGE OR SPREAD: CAMPAIGN

19 BRONZE

ART DIRECTOR
Charlotte Moore

WRITER
Janet Champ

PHOTOGRAPHER
Guzman

CLIENT
Nike

AGENCY
Wieden & Kennedy/ Portland

Remember P.E. class?

Remember prison ball and jumping jacks and how your P.E. teacher made you try to climb that rope that hung from the ceiling and you never could, *never?*

Or how you had to do chin-ups and see how long you could hang and you could only hang something like 2.5 seconds but that wasn't good enough, *oh no,*

you had to hang something like 65 seconds and you could never do that and thank God it was only pass/no pass and you got a pass just for showing up and trying. Which was good.

But then you got older.

And P.E. teachers got smarter. Because now you got graded. You got graded and at least once you got the dreaded C or the equally dreaded C+ and there went your whole grade-point average and speaking of average that's what you were now: *plain-old-just-mediocre-better-luck-next-time-see-ya-later average* and you thought *(continued)*

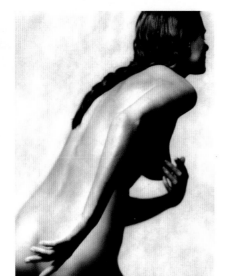

Yes, this is a goddess

but you are not a goddess and you aren't ever going to be a goddess so maybe you should just get used to it. You'll never be perfect *(sorry)* and you're not worshipped *(usually)* and does this matter? No.

Goddesses are worshipped because they aren't real and they aren't us and they aren't allowed to complain. Goddesses are worshipped even though *(and this is important)* they are really stone and really plaster and, more often than not, really dead.

And yes they will never grow old and they will never grow up and they will stay that way *(stay that way stay that way)*. This, however, is not the way you will stay.

Because someday, since you are human, you will notice that time has passed and you are not who you were twenty years ago or ten years ago or even last week. Someday, since you are human, you will notice your body has changed and your face has changed and your kneecaps look more like *(continued)*

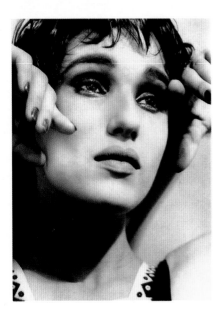

Oh you are so emotional.

There you are all caught up in your emotions, wearing your heart on your sleeve, wearing your heart on every piece of clothing you own. You cry at the drop of a hat. You cry absolute buckets. You cry me a river.

You're a woman (you can't help it) you're a girl (now don't get me wrong) you're a woman and you're *so emotional* about everything and

even at those times when you're *perfectly* rational and *perfectly* capable somebody somewhere will look at you and shake their head and say (like it's the worst thing in the world)

Oh you are so emotional

and of course that really makes you want to scream.

And then just as soon as you don't weep, which is most of the time anyway, and you're cool and calm and absolutely brilliant under pressure somebody somewhere will say you're too cool and too calm and then, of course, you're suddenly and forever called *insensitive.*

Ah, to be a woman. *(continued)*

Now wait just a gosh darn minute who, exactly, is average? And the answer came back ringing loud and clear over the top of that chin-up bar: Nobody.

You're not average because average is a lie. You're not average because average means stuck and you're not stuck, you're moving and becoming and trying and you're climbing over every bit of fear or opinion or "no you can't do that" you've ever heard.

So you scoff at average. You laugh. You guffaw. And you run and you play and you move and the more you tell your body that it is a well-oiled machine the more it starts to believe you.

And then one night you have the craziest dream.

You're in the middle of your old gym. Your P.E. teacher is standing there. She is grinning. There is a rope before you. So you climb it. You climb the living heck out of it. You reach the top. And there is absolutely no place to go but up.

Just do it.

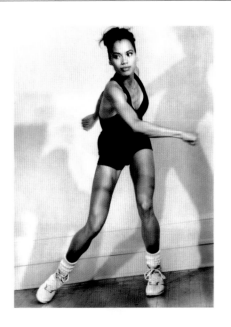

Winston Churchill than ever before.

Do not be alarmed.

Because someday, since you are human, you will decide it is time to take those long walks and run down those streets and push and bend and move your body in ways you'd never thought possible. And it may be harder than you think. And you will get tired and kind of cranky and you may want to stop.

But you won't.

And as you move you will learn to rejoice in your body because it is yours and no one else's. You will learn to rejoice in being imperfect because perfect is such a *complete and utter* bore. You will learn to rejoice in your kneecaps because they are your kneecaps and they have seen the world.

And the goddesses, from some high and chilly mountaintop, will be jealous of you. Let them.

They are stone. You are flesh. They have pedestals. You just kicked the hell out of yours. They can't move. But you can.

Just do it.

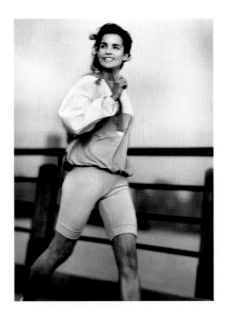

For more information about Nike Women's Products, call 1-800-234-2434.

Somewhere in the middle of all these assumptions and all these labels is the way you really are. You are kind (that's why we have hearts). You are strong (or you wouldn't have made it this far). You are fearless (or you would have hidden your heart long ago). And because you wear your heart so easily sometimes

you know how easily it is broken.

So, through time, you have learned to protect it. You learn to take it out for long walks. You learn to let it breathe deeply. You learn to treat it with respect.

And, through time, you have learned to move it and bend it and shake it and make it accountable, because the best way to keep a heart alive is to be unafraid to use it. And you are so very good at using it.

Listen.

Your heart is beating. This means you are alive. Your body is moving. This means you cannot be stopped. The world and all its labels are calling to you. You'd love to answer. But you're moving so fast you can't hear a thing.

Just do it.

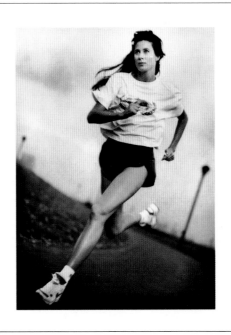

For more information about Nike Women's Products, call 1-800-234-2434.

19 Bronze

GOLD, SILVER & BRONZE AWARDS

CONSUMER MAGAZINE LESS THAN A PAGE B/W OR COLOR: SINGLE

20 SILVER

ART DIRECTOR
Hal Curtis

WRITER
Hal Curtis

CLIENT
JBL

AGENCY
Livingston + Keye/
Venice, CA

21 BRONZE

ART DIRECTOR
Frank Haggerty

WRITER
Kerry Casey

PHOTOGRAPHERS
Shawn Michienzi
Marvy! Advertising
Photography

CLIENT
Normark

AGENCY
Carmichael Lynch/
Minneapolis

IF YOUR SPEAKERS ARE JBL ADD A ★ TO ANYTHING OVER THERE →

20 Silver

It wiggles like Elvis.
It wobbles like Elvis.
Elvis, is that you?

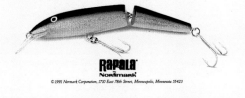

21 Bronze

GOLD, SILVER & BRONZE AWARDS

OUTDOOR: SINGLE

22 GOLD
ART DIRECTOR
Jeff Hopfer
WRITERS
Todd Tilford
Vinnie Chieco
PHOTOGRAPHER
Holly Stewart
CLIENT
Tabu Lingerie
AGENCY
The Richards Group/Dallas

23 SILVER
ART DIRECTOR
Jeff Hopfer
WRITERS
Todd Tilford
Vinnie Chieco
PHOTOGRAPHER
Holly Stewart
CLIENT
Tabu Lingerie
AGENCY
The Richards Group/Dallas

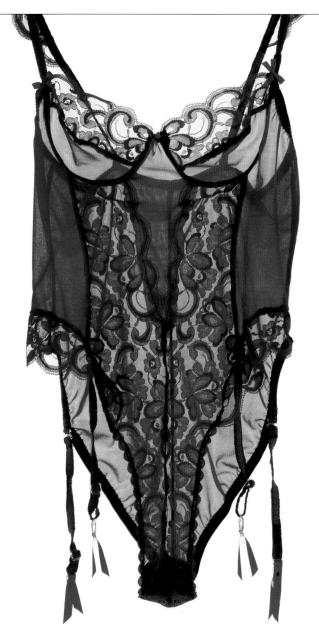

22 Gold

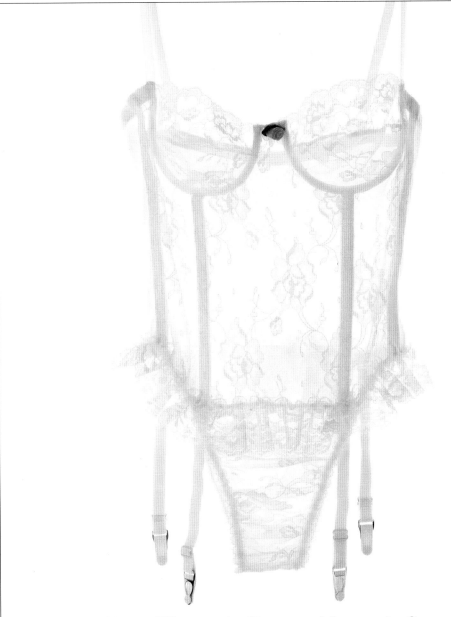

IF YOU WANT A GOOD NIGHT'S SLEEP
WEAR A FLANNEL NIGHTGOWN.

23 Silver

OUTDOOR: SINGLE

24 BRONZE

ART DIRECTOR
Dave Cook

WRITER
Dion Hughes

PHOTOGRAPHER
Rick Dublin

TYPOGRAPHER
Graham Clifford

CLIENT
NYNEX Information Resources

AGENCY
Chiat/Day, New York

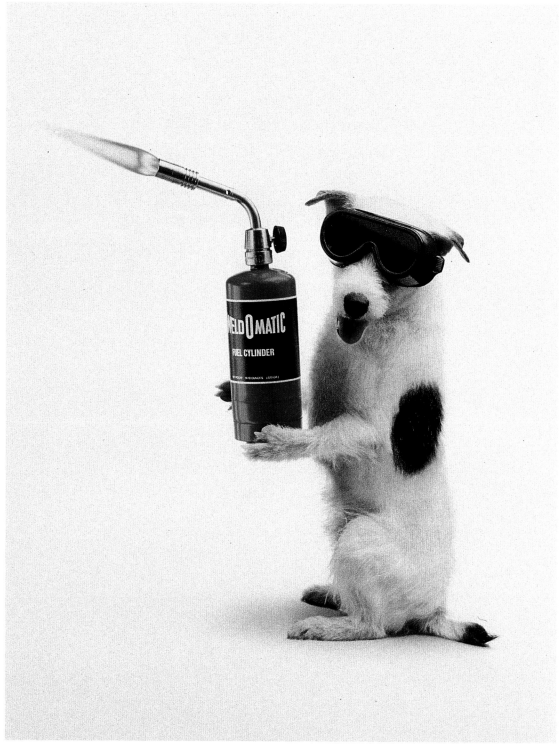

▸ Spot Welding

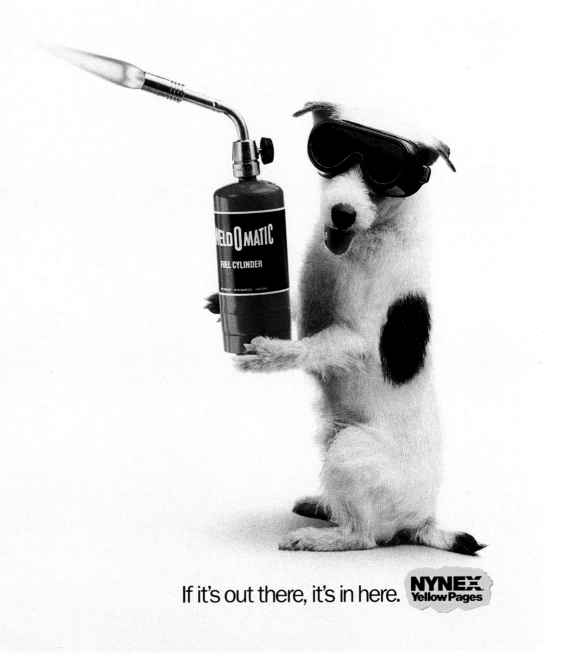

If it's out there, it's in here. **NYNEX Yellow Pages**

24 Bronze

**OUTDOOR: CAMPAIGN
25 GOLD**

**COLLATERAL DIRECT
MAIL: CAMPAIGN
45 GOLD**

ART DIRECTOR
Jeff Hopfer
WRITERS
**Todd Tilford
Vinnie Chieco**
PHOTOGRAPHER
Holly Stewart
CLIENT
Tabu Lingerie
AGENCY
The Richards Group/Dallas

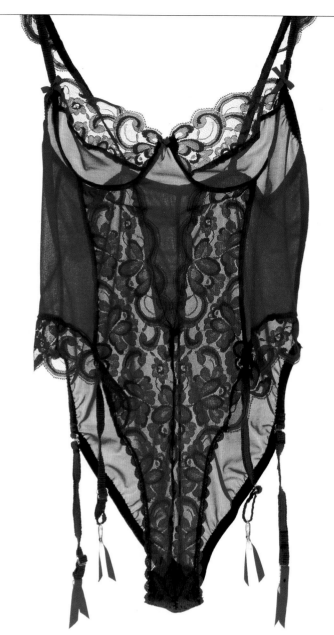

PITY YOU'LL ONLY BE WEARING IT
FOR A FEW MINUTES.

TABU
LINGERIE

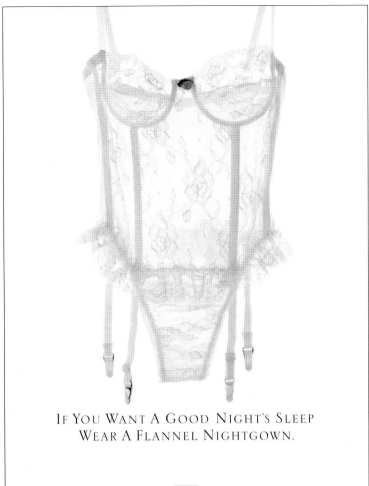

IF YOU WANT A GOOD NIGHT'S SLEEP
WEAR A FLANNEL NIGHTGOWN.

TABU
LINGERIE

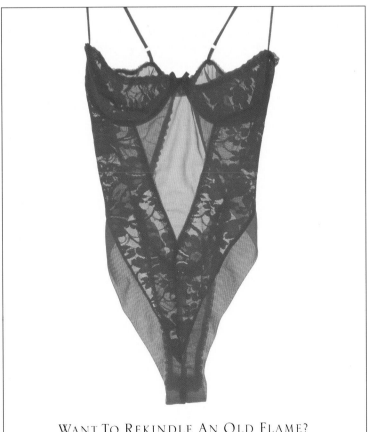

WANT TO REKINDLE AN OLD FLAME?
TRY A BLOWTORCH.

TABU
LINGERIE

OUTDOOR: CAMPAIGN

26 SILVER
ART DIRECTORS
Patrick O'Neill
Al Kelly
Mikal Reich
WRITERS
Patrick O'Neill
Al Kelly
Mikal Reich
PHOTOGRAPHER
Pam Brown
CLIENT
Dead Comics Society
AGENCY
The United States of
America Advertising Agency/
New York

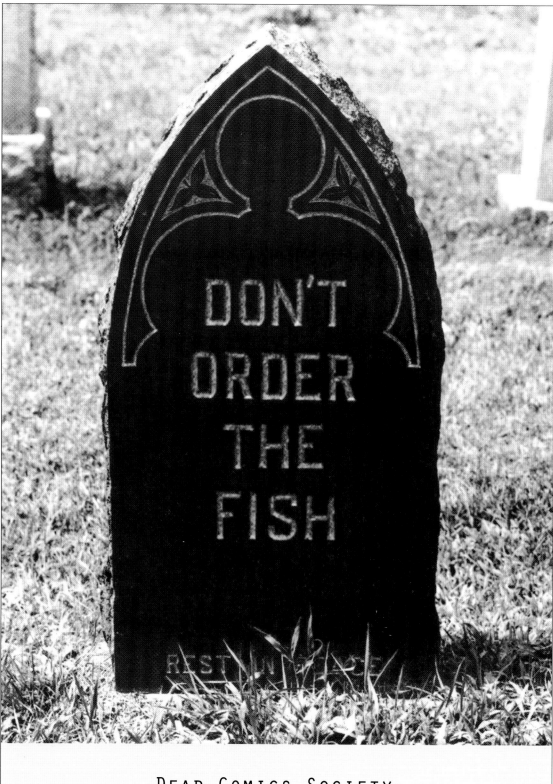

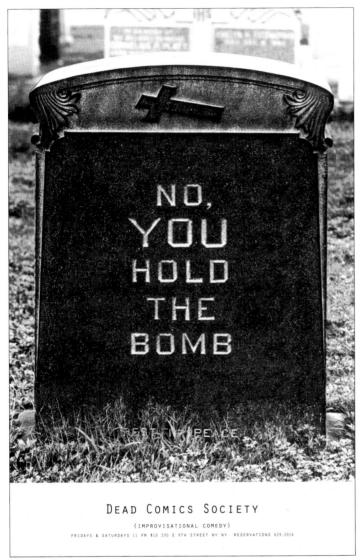

DEAD COMICS SOCIETY

(IMPROVISATIONAL COMEDY)

FRIDAYS & SATURDAYS 11 PM $10 250 E 9TH STREET NY NY RESERVATIONS 629-2016

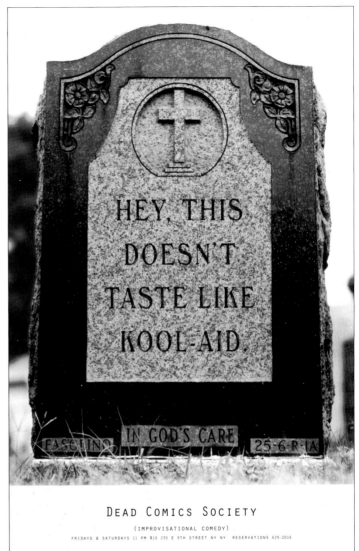

DEAD COMICS SOCIETY

(IMPROVISATIONAL COMEDY)

FRIDAYS & SATURDAYS 11 PM $10 250 E 9TH STREET NY NY RESERVATIONS 629-2016

26 Silver

GOLD, SILVER & BRONZE AWARDS

OUTDOOR: CAMPAIGN

27 BRONZE
ART DIRECTOR
Dave Cook
WRITER
Dion Hughes
PHOTOGRAPHER
Rick Dublin
TYPOGRAPHER
Graham Clifford
CLIENT
NYNEX Information Resources
AGENCY
Chiat/Day, New York

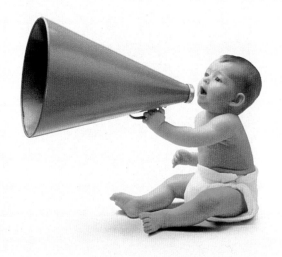

▶ **Baby Announcements**

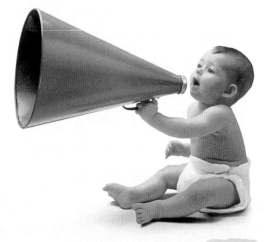

If it's out there, it's in here.

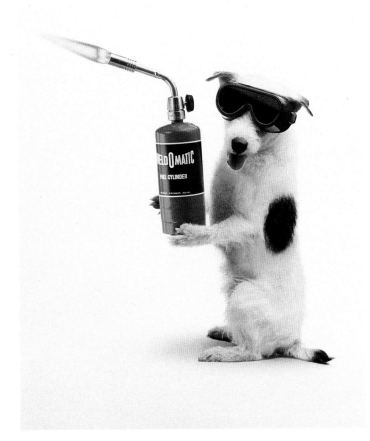

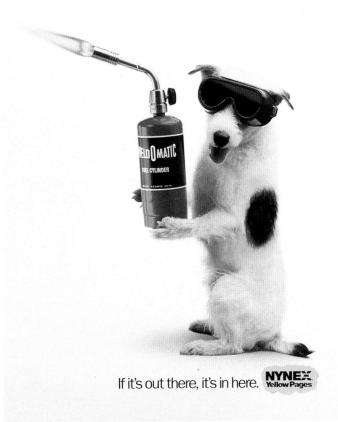

If it's out there, it's in here. **NYNEX Yellow Pages**

▸ **Cheese**

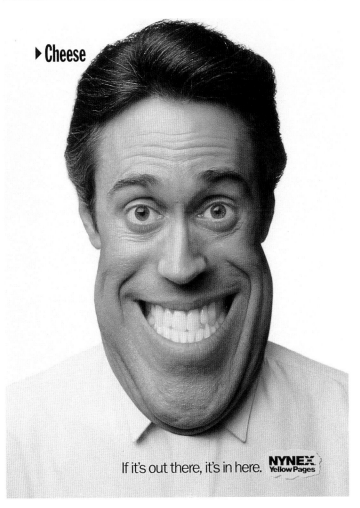

If it's out there, it's in here. **NYNEX Yellow Pages**

TRADE B/W 1 PAGE OR SPREAD: SINGLE

28 SILVER

ART DIRECTOR
Kenny Sink

WRITER
Kerry Feuerman

PHOTOGRAPHER
Mark Segal

CLIENT
Mark Segal Photography

AGENCY
RM&K Advertising/
Richmond

29 BRONZE

ART DIRECTOR
Heward Jue

WRITER
Troy Torrison

CLIENT
Salon/Areti Wines

AGENCY
Citron Haligman &
Bedecarre/San Francisco

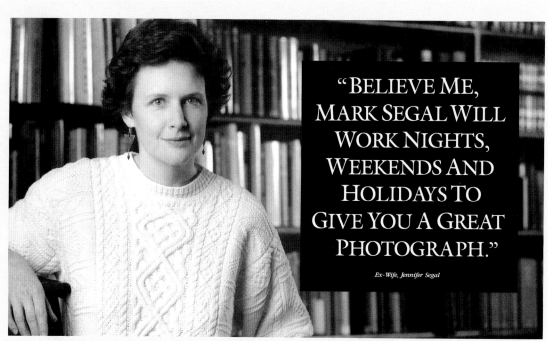

"BELIEVE ME, MARK SEGAL WILL WORK NIGHTS, WEEKENDS AND HOLIDAYS TO GIVE YOU A GREAT PHOTOGRAPH."

Ex-Wife, Jennifer Segal

AMONG ART DIRECTORS, MARK SEGAL IS WIDELY REGARDED AS ONE OF THE BEST PANORAMIC PHOTOGRAPHERS IN THE COUNTRY. AND FOR VERY GOOD REASON. BUT, AS YOU CAN SEE, HE ALSO HAS A WAY WITH PEOPLE.

WHATEVER YOU USE MARK FOR, THERE'S ONE THING YOU CAN BE SURE OF. WHEN YOU LEAVE HIM, YOU'LL HAVE AN INCREDIBLE PHOTOGRAPH IN YOUR HAND. MARK, OF COURSE, GETS TO KEEP THE STUDIO, THE CAMERAS, THE LIGHTS AND HIS HOUSE.

FOR A LOOK AT HIS BOOK, CALL 312-236-8545 OR FAX 312-704-4077.

MARK SEGAL PHOTOGRAPHY

— S —

THE EIGHTIES ARE OVER; AN ERA OF AVARICE, EXCESS, AND RECKLESS SPENDING IS FINISHED.

[TO CELEBRATE, MAY WE SUGGEST A $150 BOTTLE OF CHAMPAGNE?]

THE DAYS OF VULGAR, SHOWY MILLIONAIRES ARE LARGELY— *and some would say thankfully—* OVER. YET EVEN IN THESE TIMES OF AUSTERITY, THERE ARE STILL THOSE WHO SEEK OUT THE VERY BEST. FOR THEM, WE WOULD LIKE TO SUGGEST CHAMPAGNE SALON LE MESNIL. AS ITS PRICE MAY SUGGEST, SALON IS UNIQUE. IN FACT, IT WAS NOT ORIGINALLY INTENDED FOR SALE.

"This is perfection in Champagne."
—THE UNDERGROUND WINE JOURNAL

It was made exclusively for the friends and customers of a wealthy furrier. A legendary perfectionist named Eugène-Aimé Salon. Around the turn of the century, Monsieur Salon set out to make the world's finest Champagne. To accomplish this, he selected the aristocratic Chardonnay grapes from the most expensive district of the Champagne region: Le Mesnil-sur-Oger.

After finding success in Paris as a furrier, Eugène-Aimé Salon returned to his childhood home and pursued his dream—to produce the finest Champagne in the world.

"THE ULTIMATE CHAMPAGNE."
—Connoisseur

He used only the *cuveé*, or first pressing of the grapes—an unbelievable extravagance at the time. He also eschewed conventional practice by avoiding a second, or malolactic fermentation; this decision gave Salon its refreshing crispness, and its uncommon ability to grow more complex with age. Finally, he made his Champagne in only the finest vintage years. Even today, just three or four vintages are released in a given decade.

It will now perhaps be easier to understand why Salon is so rare. And why it is considered by many connoisseurs to be the greatest Champagne available at any price. Harvey Steiman of THE WINE SPECTATOR described Champagne Salon Le Mesnil as *"the most prized Champagne in the world."*

UNCOMMONLY RARE.

The bouquet of Salon is unmistakably toasty and delicate. The color is a pale lemon-gold. The first sip reveals layers of fruit, a fine mousse, and the alluring hint of walnuts. Salon is unlike any Champagne you've ever tasted, because it is unlike any other in the world.

Like every vintage of Salon, the 1982 is indeed cause for celebration. We invite you to discover this for yourself. Look for it on the wine lists of fine restaurants or at your favorite wine store. But if they should be out of stock, please write the exclusive importer of Salon: *Areti Wines, Ltd., P.O. Box 4290, Napa, California 94558; Telephone: (707) 255-2711.*

EACH GLASS OF SALON is perfect. As a final quality control, the cellar master opens each bottle by hand just before shipping to personally examine the bouquet.

{ *Salon Le Mesnil* }

To send Salon almost anywhere in the world, please call 1-800-621-5150. Void where prohibited.

TRADE COLOR 1 PAGE OR SPREAD: SINGLE

30 GOLD

ART DIRECTOR
Jeremy Postaer

WRITER
Steve Simpson

PHOTOGRAPHER
Bruce Davidson

CLIENT
The New Yorker

AGENCY
Goodby Berlin & Silverstein/San Francisco

31 GOLD

ART DIRECTORS
Mikal Reich
Shalom Auslander

WRITER
Nick Cohen

CLIENT
The Economist Magazine

AGENCY
Mad Dogs & Englishmen/ New York

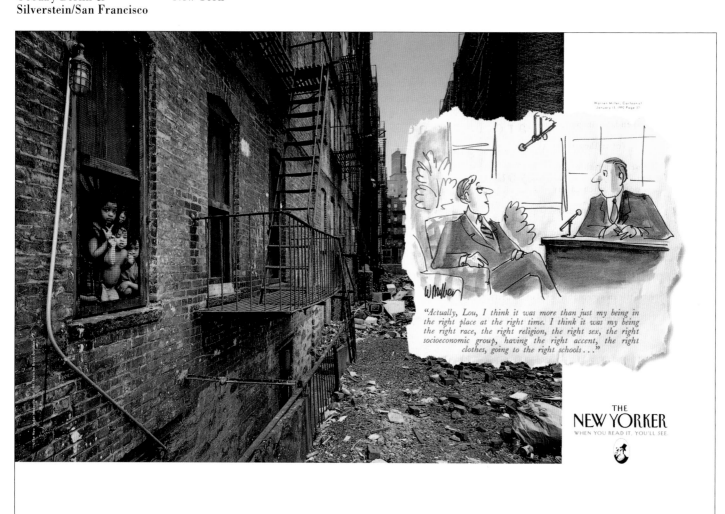

30 Gold

24

Average age when a typical businessman buys his first home.

24

Average age when a typical Economist reader sells it to him.

The Economist

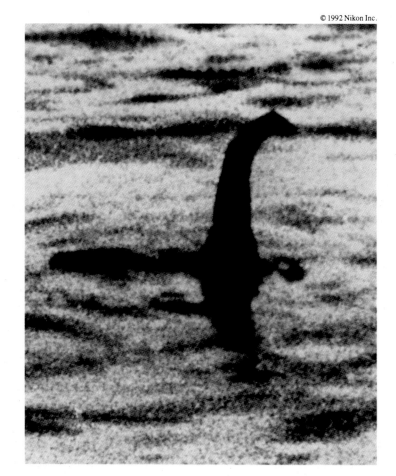

© 1992 Nikon Inc.

SOME PEOPLE SEE A MONSTER. WE SEE IMPROPER METERING, POOR LENS SELECTION, AND A TOTAL LACK OF COMPOSITION.

Spend a day with us and you'll never see a photo the same way again.
In 8 hours, you'll learn everything from composition to the latest multiple
exposure techniques. We'll even throw in lunch — all for 75 dollars.
Call (516) 547-8666 for more information and to find out when we'll be in the
following places: Atlanta, Boston, Chicago, Cleveland, Dallas, Denver,
Detroit, Houston, Los Angeles, Meriden, CT, Miami, Minneapolis,
New York, Orlando, Philadelphia, Phoenix, Pittsburgh, Portland, Sacramento,
San Diego, San Francisco, Seattle, Washington D.C.

Nikon.
We take the world's greatest pictures.

..

A young woman in a string bikini is running along the surf line, straight towards the camera, her long shimmering legs flashing in the water, her hair spread against the sky as she draws nearer and nearer and she looks great ~~and then one of her boobs pops out~~

..

S T R A I G H T **CUT**

Film & Video Editing 213 933.7900 Fax 213 937.6426

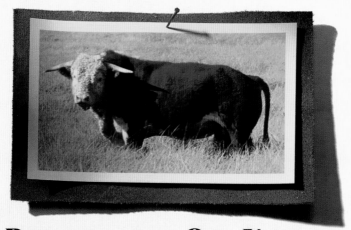

DEPENDING ON YOUR POINT OF VIEW, THIS IS EITHER AN INCREDIBLE STEAK OR AN INCREDIBLE BOOT.

It's sort of like a Rohrschach test. Only thing is, the ink blot is a cow.

What do you see? A fine chateau briand? An exquisite filet mignon? Or, like us, do you see something quite different?

Namely, the rather extraordinary leather in our Dunham Brothers Collection of shoes and boots.

To say that we have gone to extremes to find leather of such comfort and rugged good looks is putting it mildly.

Suffice it to say, there is none finer. Which means that it is, we are proud to report, authentically American. Deeply waxed for a distinctive look in some styles. And repeatedly tumbled for suppleness in others.

And yet, despite the pains we take to find the cream of the leather crop, little good it would do were it to come at the expense of all else.

Our polyurethane cushioned insoles, for instance. Thinsulate®, Apar®, Gore-Tex® and Cambrelle® linings. Or our dual density polyurethane outsoles.

Tough on the outside for durability, yet resilient on the inside for shock absorbing comfort.

In fact, The Dunham Brothers Collection, for all its good looks and comfort, is every bit as long-wearing as any Dunhams we have ever made.

Which is why we urge you to contact your Dunham sales representative today.

Perhaps we can't promise you medium rare steaks. But we can certainly promise you shoes and boots that are very well done.

Offshore? Let's put it this way. Our idea of the Far East is Lewiston, Maine.

Dunham Brothers
Founded 1885

In 1885, George and Charles Dunham got some money together and bought a small retail store in Brattleboro, Vermont. Though it may not seem so to some, it was an event of some significance. Because the shoes and boots that George and Charles made all those years ago set a standard for performance, durability and value that is difficult to maintain to this day. Yet for over 106 years, we've dedicated ourselves to keeping the tradition alive. Cutting no corners. Taking no shortcuts. Overlooking no detail.

34 Bronze

With a casual flick of its tail, the man-eating shark suddenly

came straight at me. Without any hesitation, I pushed my wife forward.

Calmly, she reached into her bag and shot the shark right between the eyes. "That's going to look great in the photo album alongside the picture of us being swallowed by a dragon, my daughter being gently caressed by a python, and my son sizzling his own satay," I thought. Suddenly, with fear in his eyes, the shark turned sharply away. He'd obviously seen my wife.

SINGAPORE CONVENTION BUREAU

35 Bronze

**TRADE ANY SIZE B/W
OR COLOR: CAMPAIGN**

36 GOLD
ART DIRECTOR
Jeremy Postaer
WRITER
Steve Simpson
ILLUSTRATOR
Ann Rhoney
PHOTOGRAPHERS
**Dan Escobar
Bruce Davidson
Stock**
CLIENT
The New Yorker
AGENCY
**Goodby Berlin &
Silverstein/San Francisco**

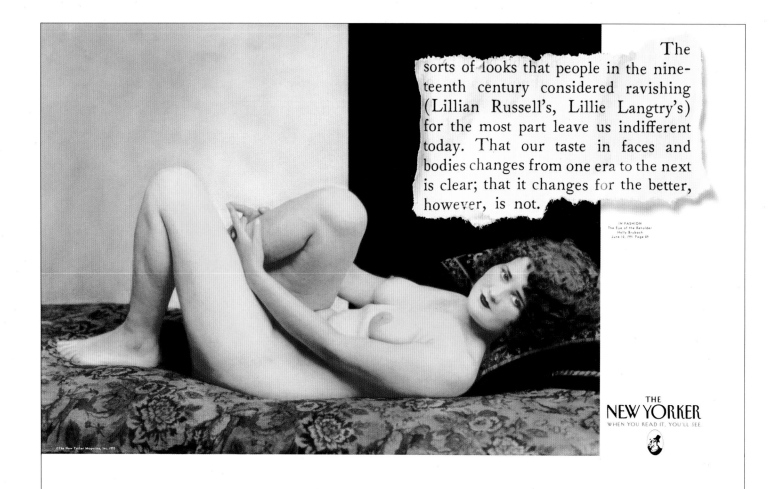

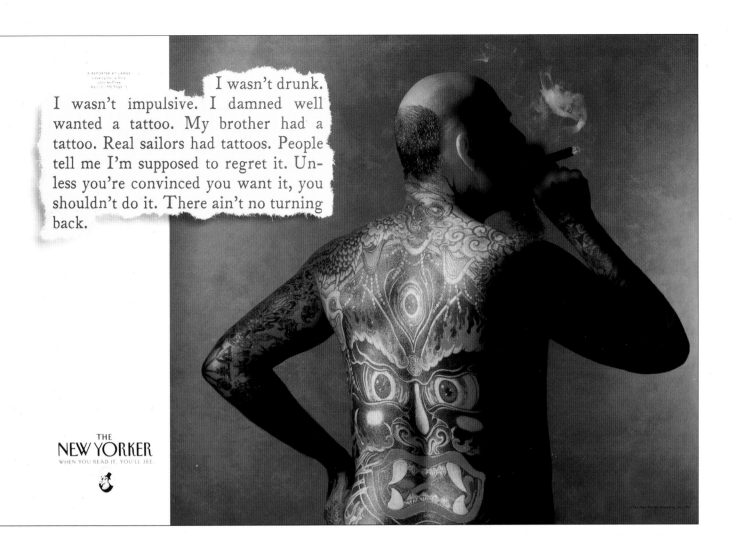

I wasn't drunk. I wasn't impulsive. I damned well wanted a tattoo. My brother had a tattoo. Real sailors had tattoos. People tell me I'm supposed to regret it. Unless you're convinced you want it, you shouldn't do it. There ain't no turning back.

THE
NEW YORKER
WHEN YOU READ IT, YOU'LL SEE.

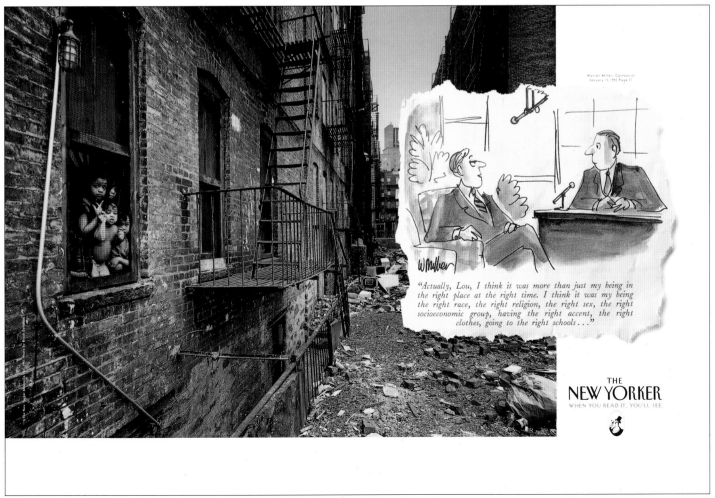

"Actually, Lou, I think it was more than just my being in the right place at the right time. I think it was my being the right race, the right religion, the right sex, the right socioeconomic group, having the right accent, the right clothes, going to the right schools..."

THE
NEW YORKER
WHEN YOU READ IT, YOU'LL SEE.

GOLD, SILVER & BRONZE AWARDS

TRADE ANY SIZE B/W OR COLOR: CAMPAIGN

37 SILVER
ART DIRECTOR
Mike Mazza
WRITER
Steve Silver
CLIENT
Straight Cut
AGENCY
Mazza/Silver, El Segundo, CA

The car looks like crap, still looks like crap, looks even worse than crap and suddenly the car hits a shaft of sunlight and just for an instant the whole front begins to glow and the leaves kicked up by the tires hang in the air like amber pendants and then it's back in the shade and the car looks like crap.

Film & Video Editing 213 933.7900 Fax 213 937.6426

A young woman in a string bikini
is running along the surf line,
straight towards the camera, her
long shimmering legs flashing in
the water, her hair spread against
the sky as she draws nearer and
nearer and she looks great ~~and then one of her boobs pops out~~

CUT

Film & Video Editing 213 933.7900 Fax 213 937.6426

A gorgeous guy in tight jeans
takes a humongous bite out of
the product and his jaws flex
majestically and his eyes light up
as if this is the greatest food in
the world ~~and then a thin line of spittle oozes out of his mouth and down his chin~~

CUT

Film & Video Editing 213 933.7900 Fax 213 937.6426

GOLD, SILVER & BRONZE AWARDS

TRADE ANY SIZE B/W OR COLOR: CAMPAIGN

38 BRONZE
ART DIRECTOR
Jac Coverdale
WRITER
Jerry Fury
PHOTOGRAPHERS
Steve Umland
Rick Dublin
Shawn Michienzi
CLIENT
Northwestern National Life
Insurance
AGENCY
Clarity Coverdale Rueff/
Minneapolis

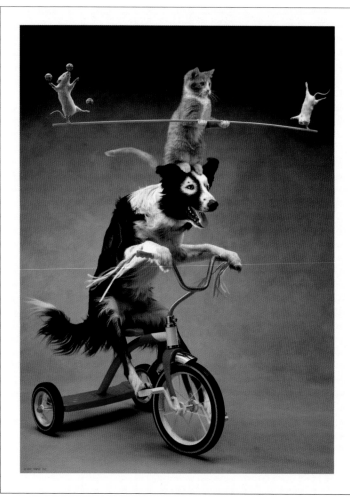

THAT'S NOTHING. NOW TRY TRAINING EMPLOYEES TO MAKE WISE HEALTH CARE DECISIONS.

These days, benefit managers have to deal with a real balancing act.

Because on one hand, you're trying to give your employees health benefits they can put to good use. And on the other hand, you're trying to teach them how to use their benefits wisely.

It's a tough act to perform well.

Let's do something about it.

At Northwestern National Life, we're doing something to help employees be more active in managing their health care decisions.

For example, we help design health plans that encourage employees to be better consumers of health care.

And then we support you with employee education such as our new booklet—*Helping Employees Use Health Care Wisely.*

For your free copy call or write Rick Naymark, Northwestern National Life, Box 20, Minneapolis, MN 55440, (612) 342-7137.

When it comes to helping employees use health care wisely, we've really got our act together.

 Northwestern National Life

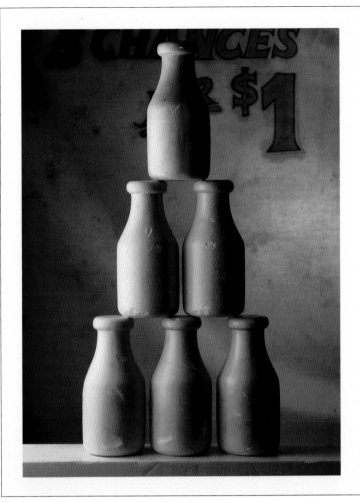

JUST HOW ACCURATE IS YOUR HEALTH CLAIM SERVICE?

According to many benefit managers, the trouble with claim-paying services is they're missing something.

It seems they're either accurate and slow, or they're fast but sometimes miss the mark.

Let's do something about it.

At Northwestern National Life, we're doing something about the inconsistencies in claim service. For example, we guarantee 98% financial and 95% payment accuracy on claims. And we guarantee 80% of your claims will be paid in 14 calendar days. All of which are standards you asked for.

The back of our guarantee is our claim data reports that detail how we're doing. Plus a report card which you fill out to grade our performance on your total satisfaction.

On top of that, we also guarantee your complete satisfaction on all we do. Or we credit your account up to 5% in each of these areas.

To help you better review your current claim service, we'd like to send you our special booklet—*Getting the Most Out of Your Claim Service.*

For your free copy, call or write Rick Naymark, Northwestern National Life, Box 20, Minneapolis, MN 55440, (612) 342-7137. And remember, with our service guarantees you know you won't get thrown a curve.

Northwestern National Life

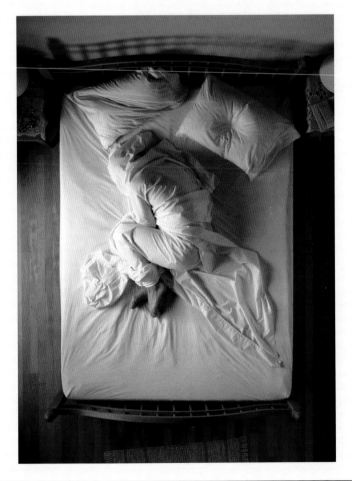

MANY TIMES THE EFFECTS OF STRESS DON'T SHOW UP ON THE JOB.

The fact is, stress keeps close to one million people from going to work every day.

For many businesses, it's leading to expensive, long-term disabilities now costing an average of $73,000 each claim.

Even when employees make it to work, stress has become the number-one hazard in the workplace. Three of four employees say they have frequent illness caused by stress.

Let's do something about it.

At Northwestern National Life, our disability programs specialize in the rehabilitation of stress-disabled workers. In fact, we have saved employers $38 for every $1 invested in stress rehabilitation.

To help you better measure the extent of your employees' stress, let us send you our new 1992 research—*Burnout: Causes and Cures.*

For your free copy, call or write Rick Naymark, Northwestern National Life, Box 20, Minneapolis, MN 55440, (612) 342-7137.

We want to help uncover the problems you and your employees may be having with stress.

Northwestern National Life

COLLATERAL
BROCHURES
OTHER THAN BY MAIL

39 GOLD
ART DIRECTORS
Mike Sheen
Joe Shands
WRITERS
Joe Shands
Mike Sheen
PHOTOGRAPHERS
Lars Topelmann
Doug Petty
CLIENT
Klein Bikes
AGENCY
Cole & Weber/Portland

40 SILVER
ART DIRECTORS
Ian McIlroy
Alan Ainsley
Graham Scott
WRITERS
Simon Scott
Andrew Lindsay
ILLUSTRATORS
Aird McKinstrie
Andrew Baillie
CLIENT
Faulds Advertising
AGENCY
McIlroy Coates/Edinburgh

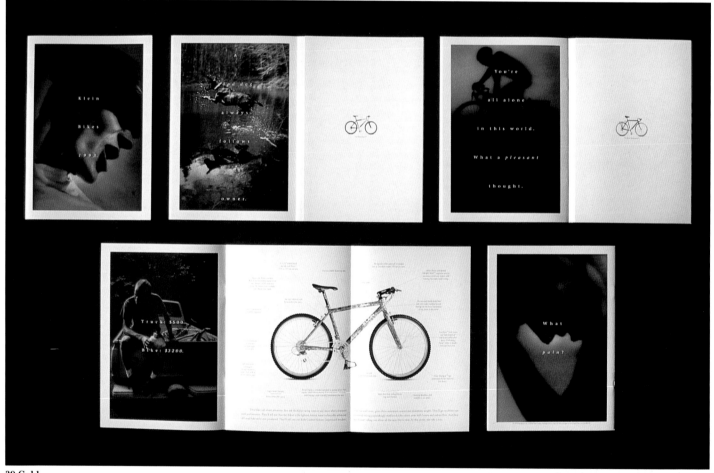

39 Gold

FAULDS

ADVERTISING

AN

INTRODUCTION

GROWTH

We started business in 1985 with 7 staff and no clients. Today we are one of Scotland's largest advertising agencies. Our growth has been measured and carefully planned. We have increased sales and profits every year. And by building a consistently successful business we believe we're better placed to offer sound business advice to our clients.

PLANNING

Faulds is the only Scottish advertising agency to have started out in business with a planning department. Our unique commitment to understanding our clients' markets has given us a distinctive position within our market and a reputation for producing work that is both relevant and effective. Advertising based on intelligence. Advertising that works.

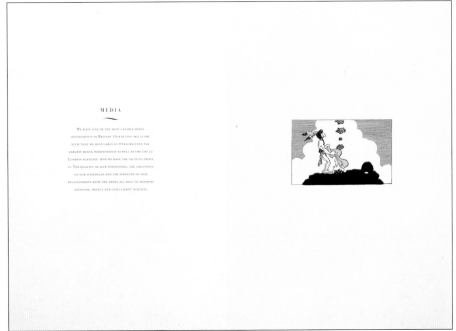

MEDIA

We have one of the most capable media departments in Britain. Our buying skills are such that we regularly outperform even the largest media independents as well as the top 12 London agencies. And we have the facts to prove it. The quality of our positioning, the creativity of our schedules and the strength of our relationships with the media all help to maximise exposure, impact and our clients' budgets.

**COLLATERAL
BROCHURES
OTHER THAN BY MAIL**

41 BRONZE
ART DIRECTOR
Dean Hanson
WRITER
Phil Hanft
CLIENT
Weyerhaeuser Paper
Company
AGENCY
Fallon McElligott/
Minneapolis

**COLLATERAL DIRECT
MAIL: SINGLE**

42 GOLD
ART DIRECTORS
Joe Cupani
Peter White
Rob Cohen
WRITERS
Nancy Vecilla
Jim Herbert
Steve Diamond
PHOTOGRAPHER
Dennis Blachut
CLIENT
Jaguar Cars
AGENCY
Ogilvy & Mather Direct/
New York

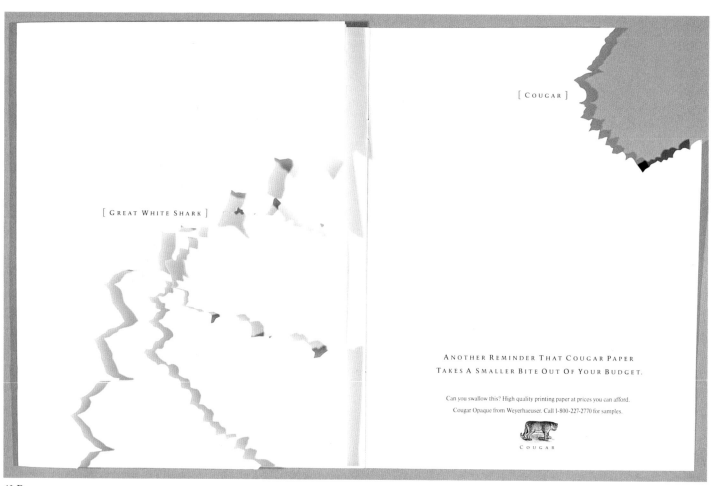

[GREAT WHITE SHARK]

[COUGAR]

ANOTHER REMINDER THAT COUGAR PAPER
TAKES A SMALLER BITE OUT OF YOUR BUDGET.

Can you swallow this? High quality printing paper at prices you can afford.
Cougar Opaque from Weyerhaeuser. Call 1-800-227-2770 for samples.

COUGAR

41 Bronze

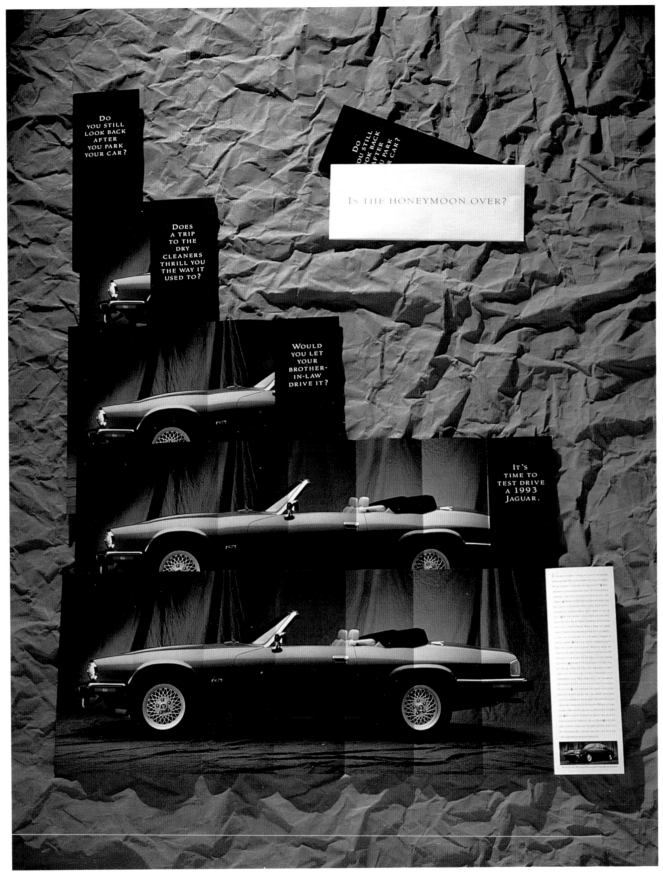

COLLATERAL DIRECT MAIL: SINGLE

43 SILVER
ART DIRECTOR
Dante Pauwels
WRITER
Marcus Woolcott
ILLUSTRATOR
Fiona King
CLIENT
The Timberland Company
AGENCY
Mullen/Wenham, MA

44 BRONZE
ART DIRECTOR
Jamie Mahoney
WRITER
Steve Dolbinski
PHOTOGRAPHER
Dean Hawthorne
CLIENT
The Martin Agency
AGENCY
The Martin Agency/Richmond

IDITAROD MUSHERS HAVE BEEN KNOWN TO URINATE ON THEIR HANDS TO PREVENT FROSTBITE.

SOMETHING TO KEEP IN MIND WHEN YOU MEET RICK SWENSON.

Timberland invites you to meet the Iditarod champion at this year's Winter Market.

43 Silver

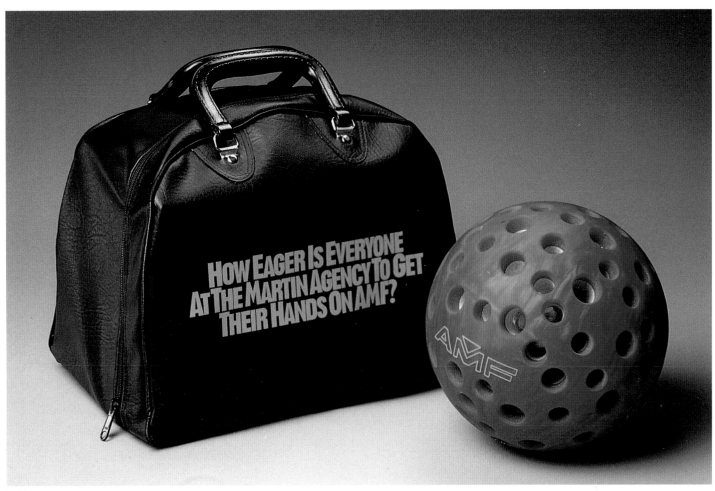

44 Bronze

COLLATERAL DIRECT MAIL: CAMPAIGN

46 SILVER

ART DIRECTOR
Bryan Burlison

WRITER
Todd Tilford

PHOTOGRAPHER
Richard Reens

CLIENT
Harley-Davidson of Texas

AGENCY
The Richards Group/Dallas

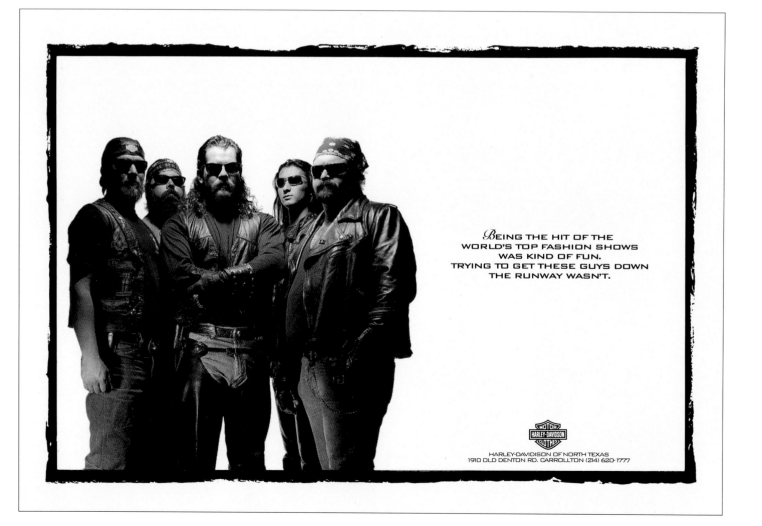

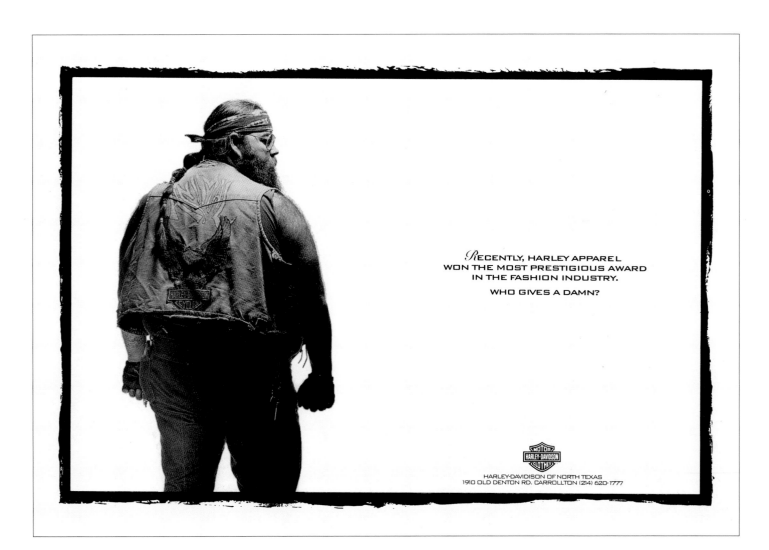

*R*ECENTLY, HARLEY APPAREL
WON THE MOST PRESTIGIOUS AWARD
IN THE FASHION INDUSTRY.

WHO GIVES A DAMN?

HARLEY-DAVIDISON OF NORTH TEXAS
1910 OLD DENTON RD. CARROLLTON (214) 620-1777

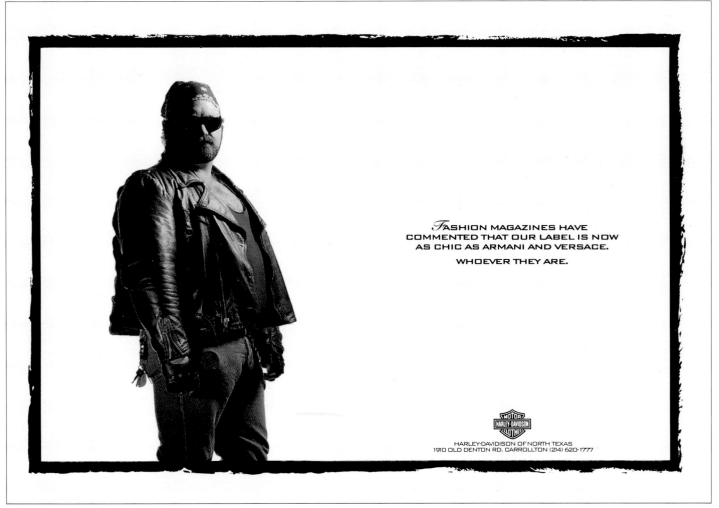

*F*ASHION MAGAZINES HAVE
COMMENTED THAT OUR LABEL IS NOW
AS CHIC AS ARMANI AND VERSACE.

WHOEVER THEY ARE.

HARLEY-DAVIDISON OF NORTH TEXAS
1910 OLD DENTON RD. CARROLLTON (214) 620-1777

COLLATERAL P.O.P

47 GOLD

ART DIRECTOR
Michael Sundell

WRITER
Michael Sundell

CLIENT
The Bell Pub

AGENCY
Think Tank/Nanaimo,
British Columbia

48 SILVER

ART DIRECTOR
Pat Harris

WRITER
Pieter Blikslager

PHOTOGRAPHER
Karl Steinbrenner

CLIENT
Ace Window Cleaners

AGENCY
Hawley Martin Partners/
Richmond

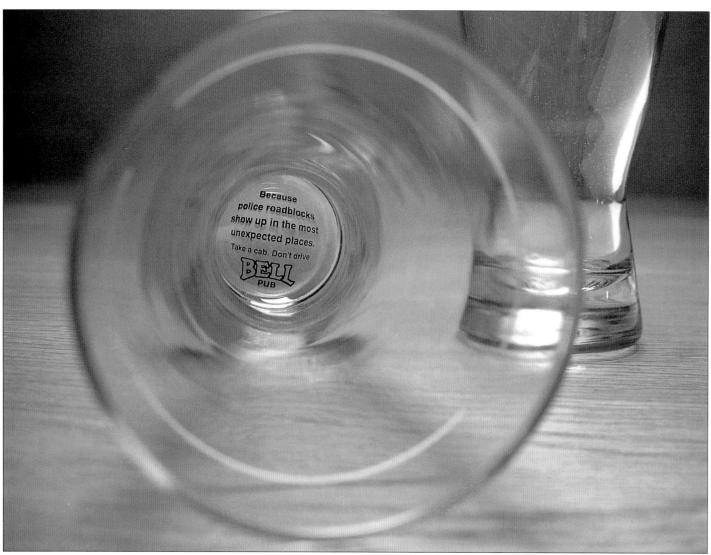

Because police roadblocks show up in the most unexpected places.

Take a cab. Don't drive

BELL PUB

47 Gold

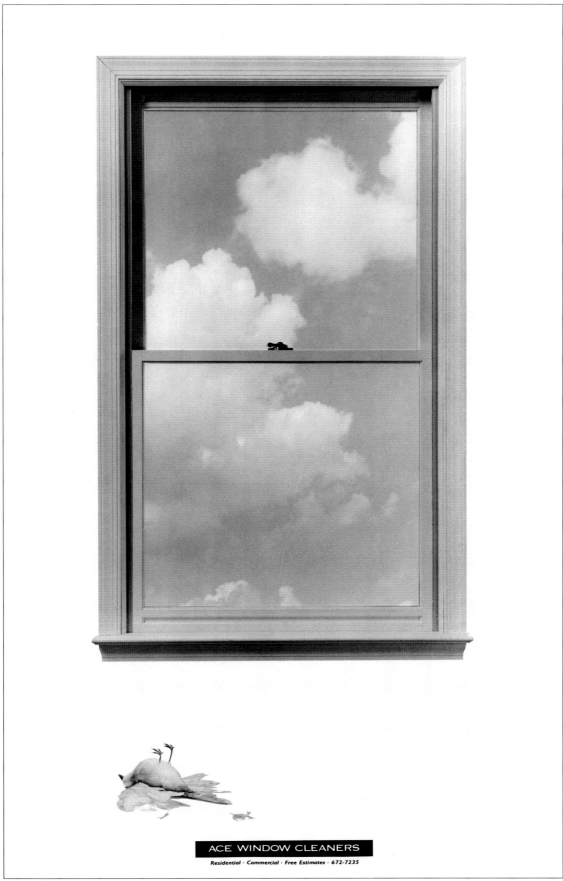

ACE WINDOW CLEANERS

Residential · Commercial · Free Estimates · 672-7235

48 Silver

COLLATERAL P.O.P

49 BRONZE
ART DIRECTOR
Jeff Hopfer
WRITERS
Todd Tilford
Vinnie Chieco
PHOTOGRAPHER
Holly Stewart
CLIENT
Tabu Lingerie
AGENCY
The Richards Group/Dallas

PUBLIC SERVICE/ POLITICAL NEWSPAPER OR MAGAZINE: SINGLE

50 GOLD
ART DIRECTOR
Mitch Gordon
WRITER
George Gier
PHOTOGRAPHER
Werner Straube Studio
CLIENT
The Lake Michigan Federation
AGENCY
DDB Needham Worldwide/ Chicago

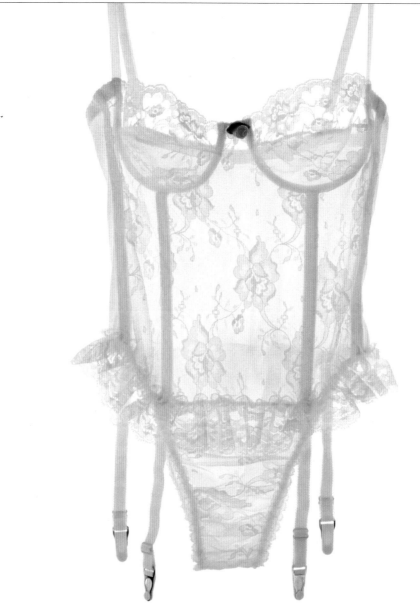

IF YOU WANT A GOOD NIGHT'S SLEEP
WEAR A FLANNEL NIGHTGOWN.

TABU LINGERIE

49 Bronze

EITHER THERE IS AN EXTRAORDINARY AMOUNT OF TOXINS IN THE LAKE, OR FISH HAVE FOUND A WAY TO SMOKE CIGARETTES UNDER WATER.

For years, the Surgeon General has put labels on cigarettes to warn us of the dangers of smoking. Now it may not be too long before the Surgeon General must issue a warning about our water as well. With all the industry around the Great Lakes dumping heavy metals, chemicals and grease in the water, our lakes have become cesspools filled with toxic waste.

Fish have already felt the effects of the pollution. Some have tumors, others can't reproduce and others show deformities.

Birds, mammals and other animals are suffering too. Toxins in the water cause cormorants that nest near Green Bay to be born with crossed bills. These mutated beaks make it impossible for the birds to eat and they slowly starve to death.

More visible deformities are crossed bills as with this young cormorant.

Are we next? There are already signs that what is destroying the wildlife will not stop at the shores of the Great Lakes. Investigating the effects of pollution along the Niagara River, a heavily polluted waterway running into Lake Erie, Dr. Beverly Paigen found that children born to parents living in the area suffered birth defects at a rate three times higher than normal. These defects included: webbed feet, extra toes and kidney abnormalities.

In one of the most disturbing studies, Wayne State University researchers found that children of mothers who ate PCB-contaminated fish from Lake Michigan did not learn as well as other people not exposed to PCBs.

How has this happened? For over a hundred years industry has been allowed to dump hazardous wastes in the Great Lakes with little or no control. The lakes, rivers, and ground water of the Great Lakes basin have become a landfill for hundreds of millions of tons of waste.

Common tern eggs, like this, develop shells so thin the bird never has a chance to hatch.

In addition, pesticide runoff from farms, municipal waste and landfills has contributed to the contamination. In his 1986 book *The Late Great Lakes: An Environmental History*, William Ashworth notes: "At

LAKE TROUT
Toxins in the water collect in the fatty tissue, making fish like this as lethal as cigarettes.

the southern end of Lake Michigan, near Chicago, there is a harbor with a floor that is half PCBs and another in which the bottom sludge is forty percent mud and sixty percent a sort of twentieth-century witch's brew involving PCBs, chromium, zinc, lead, oil and grease, iron and various compounds..."

Volvox: An algae that is part of the delicate balance in the food chain that is altered by toxins.

But what can we do? You don't have to be a senator to make a difference in the Great Lakes. In 1971 the Lake Michigan Federation got the Chicago City Council to ban phosphates in detergents. Then we worked with other environmental organizations to get detergent phosphates banned in Wisconsin, Michigan and Indiana.

The fight to ban phosphates in detergents went on to become one of the big environmental battles of the '70s and this victory is

Night Heron

one of the reasons Lake Michigan is looking cleaner today. However, now we have to save the lake from toxic chemicals.

The toxin poisoning can't continue. We have to eliminate them completely from our environment. Reducing the limit industry can legally dump, diluting them or relocating them won't alleviate the problem — no matter what,

they'll always find their way back to our water supply. We must stop dumping them altogether. This is what we call zero discharge, and it is really our only hope.

If we act now it is not too late to save Lake Michigan, the other Great Lakes and their waterways. We can make them safe and clean for our children and grandchildren.

It seems an enormous task, but consider the alternatives. We go about living our lives the way we do now. The deformities in wildlife multiply. Our risk of cancer and deformities in children continue to rise.

PERHAPS THE SURGEON GENERAL SHOULD PUT WARNING LABELS ON FISH.

A recent study conducted at the University of Michigan found levels of pesticides in women with breast cancer fifty to sixty times greater than levels in women without breast cancer.

"The findings weren't subtle. They were very dramatic," said Dr. Frank Falk.

Among these pesticides are DDT, BCH and HCB. A veritable alphabet soup of toxins. Also found were high levels of PCBs and PBBs.

Where did these chemicals come from? Manufacturing and agriculture have been using them for generations.

And to this day they are still being dumped into the Great Lakes, or are running off into the lakes in alarming quantities. As they make their way up the food chain they become concentrated in the fatty tissue of fish and other animals, including people.

But there is hope. If we begin cleaning up our waterways now, we can help reduce the risk of our daughters and granddaughters suffering from these poisons.

The toxic sediment at the bottoms of our lakes, rivers and streams grows. It won't be long before we're living very near five of the largest hazardous waste dumps in the world.

If you want to know what you can do to help, call the Lake Michigan Federation at 1-312-939-0839. We're not only looking for donations, we're looking for help, ideas and commitment.

The LAKE MICHIGAN FEDERATION

59 E. Van Buren St., Suite 2215, Chicago, IL 60605 312·939·0838

The Lake Michigan Federation is a not-for-profit, grassroots environmental organization founded in 1970 to promote citizen action to protect a Great Lake. For the past twenty-two years the Federation has been working to: improve water quality in the Lake; promote sound plans for shoreline management; and increase Lake appreciation through education.

HAVE YOU EVER WONDERED WHY 3.2 MILLION GALLONS OF WATER FROM FRANCE ARE BOUGHT IN CHICAGO EACH YEAR?

The largest freshwater reservoir in the world, The Great Lakes, puts one-fifth of the earth's drinkable water at our doorstep.

They are everywhere, hundreds of thousands of little trendy bottles imported all the way from France. Today people will pay an outrageous price for something we once considered an almost unlimited commodity — water.

There's a reason people are buying a lot of bottled water: they're afraid of the toxins and impurities in their ordinary tap water. Though our tap water is filtered to make drinkable, we can't be sure how pure it really is. So their fears are not unfounded. Toxic discharge into the Great Lakes has become so widespread and so concentrated you no longer need sophisticated water testing equipment to see the damage.

Common tern eggs, like this, develop shells so thin the bird never has a chance to hatch.

Fish, birds and wildlife near the lakes and rivers that run into them are suffering from deformities, tumors, and are having trouble reproducing.

Bittern

And there's evidence that these toxic manifestations are showing up in people. For example, people who eat just one lake trout in the course of their lifetime increase their risk of cancer by ten times. And children born to parents living in highly polluted areas were found to have birth defects at three times the normal rate.

Puccoon

How has this happened? For over a hundred years industry has been allowed to dump hazardous wastes in the Great Lakes with little or no legislation governing them. The lakes, rivers, and ground water of the Great Lakes basin became a veritable landfill for hundreds of thousands of tons of waste. In addition pesticide runoff from farms, municipal waste and landfills have all contributed to the contamination. In his 1986 book, *The Late Great Lakes: An Environmental History,* William Ashworth notes: "At the southern end of Lake Michigan, near Chicago, there is a harbor with a floor that is half PCBs and another in which the bottom sludge is 40 percent mud and 60 percent a sort of twentieth-century witch's brew involving PCBs, chromium, zinc, lead, oil and grease, iron and various compounds…"

Not all the toxic waste in the Great Lakes comes from industry, agriculture or landfill leaching. Another big source of toxins is the everyday products we use to clean our homes and cars. *No, this is not an ad for bottled water importers.* Cleansers, rug shampoos, degreasers, foaming agents are just a handful of the products that go down the drain and into our water. Additionally, lawn care products and fertilizers add a lot to the pollution. That doesn't mean we can't turn back the tide of destruction. To do this we have to stop using our lakes as liquid landfills. Industry has to find ways of manufacturing that won't pollute. We have to convince people to stop using hazardous household products that get flushed into our water. Farmers need help in finding alternative ways of farming that don't require mass dumpings of chemical pesticides and fertilizers.

How can one person make a difference? Well, you don't have to be a senator to help clean up the Great Lakes. In 1970 a group of women in Buffalo banded together and formed "Housewives to End Pollution." They mounted a campaign to force grocery stores to list the phosphate content of detergent right on store shelves. Determined to use whatever tactics necessary, their word spread. More and more groups like theirs formed. The fight to ban phosphates in detergents became one of the big environmental battles of the '70s. Their victory is one of the reasons we still have the Great Lakes to try and save 20 years later.

Perhaps the first thing we can all do to make a difference in the lakes starts right at home. Use safe alternatives, like baking soda, to cleansers, recycle used motor oil, and use soap and water whenever possible instead of harsh chemicals.

If we don't begin the clean-up now, we must consider the alternatives: We go about living our lives the way we do now. The deformities in wildlife multiply. Our risks of cancer and deformities in children continue to rise. The toxic sediment at the bottom of our lakes, rivers and streams grows. It won't be long before we're living very near five of the largest hazardous dumps in the world.

Legally, millions of tons of toxins are poured into the lakes each year from outlets like this.

Water is elemental to life and fourteen million people depend on Lake Michigan for drinking water.

If you want to help, now's the time. We not only need donations, we need your ideas and your commitment. Call us at 312-939-0838 and help reverse the tide.

LAKE MICHIGAN FEDERATION
59 E. Van Buren St., Suite 2215, Chicago, IL 60605 312·939·0838

The Lake Michigan Federation is a not-for-profit, grassroots environmental organization founded in 1970 to promote citizen action to protect a Great Lake. For the past twenty-two years the Federation has been working to: improve water quality in the Lake; promote sound plans for shoreline management; and increase Lake appreciation through education.

51 Silver

THIS ISN'T SOMETHING OUT OF JULES VERNE, IT'S A FISH OUT OF LAKE MICHIGAN.

The signs of toxic poisoning are showing up in fish in the form of lesions, tumors, and cancer.

When a Canadian newspaper announced it was sponsoring a fishing contest on Lake Ontario, sportfishermen turned out in droves. After a full day out on the lake the contestants brought in their catch of the day and a winner was determined. But that day the biggest fish didn't win. Shortly after the winner was announced, the judge determined that it could not possibly have been caught in Lake Ontario — it wasn't contaminated enough.

Although you can't see it, the toxics that contaminated Lake Ontario are contaminating Lake Michigan and the other Great Lakes. They have become liquid landfills for toxic wastes the likes the world has never seen. PCBs, chromium, lead, mercury, DDT, dioxin; you name it, the lakes have it. And every day the pollution continues. Industry continues to dump in tons of toxics, runoff from farms and municipalities add more, and airborne toxics contribute up to half the amount in Lake Michigan alone.

Where does it all go? Most of it settles on the bottom creating a hazardous muck that would make drinking motor oil seem safe. But it doesn't just sit there. Along comes a small organism like a snail that absorbs it in its system. Then a fish swims along and eats a few snails. The concentration of toxics grows. Then a bigger fish eats a few dozen smaller fish and so on. By the time we work up the food chain the concentration of hazardous wastes in their bodies increases anywhere from ten thousand to a million times greater than levels found in the water.

This process is called biomagnification, and it is taking its toll at the top of the food chain — us. The effects of toxic wastes have begun to show up in people living in the Great Lakes region. Birth defects, low birth weights, stress sensitivity and slow growth were found in babies whose mothers ate at least one fish weekly with a high accumulation of PCBs. Sadly, once some of these toxics get into the DNA of humans, they may be passed on for generations to come. A genealogical nightmare for families of the region.

For over a hundred years industry has been dumping hazardous wastes in the Great Lakes with little or no legislation governing them, making the Great Lakes basin a landfill for tons of waste. Pesticide runoff from farms, municipal waste and landfills have all contributed to the contamination.

A big source of toxins is the everyday products we use to clean up our homes and our cars. Cleansers, rug shampoos, degreasers and foaming agents are just a few of the products that go down the drain and into our water.

In his 1986 book, *The Late Great Lakes: An Environmental History*, William Ashworth notes: "At the southern end of Lake Michigan, near Chicago, there is a harbor with a floor that is half PCBs and another in which the bottom sludge is forty percent mud and sixty percent a sort of twentieth-century witch's brew

Many stages of the food chain, like this tadpole, are affected by toxins.

A Caspian Tern embryo with a crossed bill preserved for further research.

Eggs from shore birds often develop shells so thin they never get a chance to hatch.

involving PCBs, chromium, zinc, lead, oil and grease, iron and various compounds..."

To clean up the Great Lakes will cost billions. But cleanup can't begin until we stop the poisoning. That means zero discharge of all hazardous chemicals that concentrate in the food chains.

Bufflehead

How can we possibly hope for zero discharge? It starts with you. The movement toward cleaning up our environment has just begun. Pressure from the public has been instrumental in getting rid of foam packaging in fast food restaurants and creating an entire new line of environmentally safe consumer products.

IF WATER CATCHES ON FIRE WHAT DO YOU PUT IT OUT WITH?

In 1971, the residents near the Niagara River were asking themselves that very question. Pollutants such as grease, oil and sludge being dumped into the river became a soupy quagmire of highly flammable scum.

One day, when a spark from a worker's acetylene torch hit the river, it ignited, and flames raged twenty feet high. The fire quickly spread down the river and incinerated bridges and scorched the banks.

It prompted city officials to put up signs near the river warning people of the potential fire hazard.

Twenty years later the pollution that plugged up the river and created a fire hazard has been drastically reduced. But therein lies the problem we are faced with today: toxins. You see, since the Great Lakes and their rivers look much better than they have in the past, people seem to think pollution is no longer a threat.

However, what they can't see, the poisonous toxic waste that's dumped into them each day, threatens to affect all of us in a much more severe way. That's what the Lake Michigan Federation aims to clean up. And it all starts with you.

Perhaps the first thing we can all do to make a real difference in the lakes starts right in our homes. For instance, use safe alternatives, like baking soda, to harsh cleansers, recycle used motor oil, and use soap and water whenever possible instead of harsh chemicals. Help us start the cleanup. Call us at 312-939-0838. Donations are needed, but so are your ideas and commitment.

The LAKE MICHIGAN FEDERATION

59 E. Van Buren St., Suite 2215, Chicago, IL 60605 312·939·0838

The Lake Michigan Federation is a not-for-profit, grassroots environmental organization founded in 1970 to promote citizen action to protect a Great Lake. For the past twenty-two years the Federation has been working to: improve water quality in the Lake; promote sound plans for shoreline management; and increase Lake appreciation through education.

THIS ISN'T SOMETHING OUT OF JULES VERNE, IT'S A FISH OUT OF LAKE MICHIGAN.

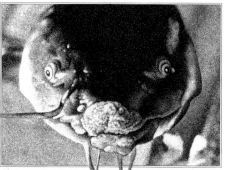

The signs of toxic poisoning are showing up in fish in the form of lesions, tumors, and cancer.

When a Canadian newspaper announced it was sponsoring a fishing contest on Lake Ontario, sportfishermen turned out in droves. After a full day out on the lake the contestants brought in their catch of the day and a winner was determined. But that day the biggest fish didn't win. Shortly after the winner was announced, the judge determined that it could not possibly have been caught in Lake Ontario — it wasn't contaminated enough.

Many stages of the food chain, like this tadpole, are affected by toxins.

Although you can't see it, the toxics that contaminated Lake Ontario are contaminating Lake Michigan and the other Great Lakes. They have become liquid landfills for toxic wastes the likes the world has never seen. PCBs, chromium, lead, mercury, DDT, dioxin; you name it, the lakes have it. And every day the pollution continues. Industry continues to dump in tons of toxics, runoff from farms and municipalities add more, and airborne toxics contribute up to half the amount in Lake Michigan alone.

Where does it all go? Most of it settles on the bottom creating a hazardous muck that would make drinking motor oil seem safe. But it doesn't just sit there. Along comes a small organism like a snail that absorbs it in its system. Then a fish swims along and eats a few snails. The concentration of toxics grows. Then a bigger fish eats a few dozen smaller fish and so on. By the time we work up the food chain the concentration of hazardous wastes in their bodies increases anywhere from ten thousand to a million times greater than levels found in the water.

A Caspian Tern embryo with a crossed bill preserved for further research.

This process is called biomagnification, and it is taking its toll at the top of the food chain — us. The effects of toxic wastes have begun to show up in people living in the Great Lakes region. Birth defects, low birth weights,

stress sensitivity and slow growth were found in babies whose mothers ate at least one fish weekly with a high accumulation of PCBs. Sadly, once some of these toxics get into the DNA of humans, they may be passed on for generations to come. A genealogical nightmare for families of the region.

For over a hundred years industry has been dumping hazardous wastes in the Great Lakes with little or no legislation governing them, making the Great Lakes basin a landfill for tons of waste. Pesticide runoff from farms, municipal waste and landfills have all contributed to the contamination.

A big source of toxins is the everyday products we use to clean up our homes and our cars. Cleansers, rug shampoos, degreasers and foaming agents are just a few of the products that go down the drain and into our water.

Eggs from shore birds often develop shells so thin they never get a chance to hatch.

In his 1986 book, *The Late Great Lakes: An Environmental History*, William Ashworth notes: "At the southern end of Lake Michigan, near Chicago, there is a harbor with a floor that is half PCBs and another in which the bottom sludge is forty percent mud and sixty percent a sort of twentieth-century witch's brew

involving PCBs, chromium, zinc, lead, oil and grease, iron and various compounds…"

To clean up the Great Lakes will cost billions. But cleanup can't begin until we stop the poisoning. That means zero discharge of all hazardous chemicals that concentrate in the food chains.

Bufflehead

How can we possibly hope for zero discharge? It starts with you. The movement toward cleaning up our environment has just begun. Pressure from the public has been instrumental in getting rid of foam packaging in fast food restaurants and creating an entire new line of environmentally safe consumer products.

IF WATER CATCHES ON FIRE WHAT DO YOU PUT IT OUT WITH?

In 1971, the residents near the Niagara River were asking themselves that very question. Pollutants such as grease, oil and sludge being dumped into the river became a soupy quagmire of highly flammable scum.

One day, when a spark from a worker's acetylene torch hit the river, it ignited, and flames raged twenty feet high. The fire quickly spread down the river and incinerated bridges and scorched the banks.

It prompted city officials to put up signs near the river warning people of the potential fire hazard.

Twenty years later the pollution that plugged up the river and created a fire hazard has been drastically reduced. But therein lies the problem we are faced with today: toxins. You see, since the Great Lakes and their rivers look much better than they have in the past, people seem to think pollution is no longer a threat.

However, what they can't see, the poisonous toxic waste that's dumped into them each day, threatens to affect all of us in a much more severe way. That's what the Lake Michigan Federation aims to clean up. And it all starts with you.

Perhaps the first thing we can all do to make a real difference in the lakes starts right in our homes. For instance, use safe alternatives, like baking soda, to harsh cleansers, recycle used motor oil, and use soap and water whenever possible instead of harsh chemicals. Help us start the cleanup. Call us at 312-939-0838. Donations are needed, but so are your ideas and commitment.

The
LAKE MICHIGAN FEDERATION

59 E. Van Buren St., Suite 2215, Chicago, IL 60605 312·939·0838

The Lake Michigan Federation is a not-for-profit, grassroots environmental organization founded in 1970 to promote citizen action to protect a Great Lake. For the past twenty-two years the Federation has been working to: improve water quality in the Lake; promote sound plans for shoreline management; and increase Lake appreciation through education.

INEXPERIENCED. POLITICALLY NAIVE. AND HE DOESN'T REALLY WANT THE JOB. THE PERFECT CANDIDATE.

Representative democracy is really an agreement: citizens give up their power with the understanding that the officials they've elected will represent their concerns, ideas and values.

Easy, right? Wrong. These days, it seems most career politicians are more concerned with their own interests than the interests of their constituents.

"WE'VE GOT TO COMPLETELY RESTRUCTURE THE SYSTEM. COULD I SOUND BITE IT? NO, COULD SOLOMON SOUND BITE IT?"

Ross Perot isn't a career politician. In fact, he's never run for public office. He's a businessman who understands the problems facing the country. It's that simple. And that's why he's running for the

presidency. Like many, he believes that the current political system is broken and can't address the problems of unemployment, violence, discrimination, taxes, the recession, or the deficit.

To change course, he believes people have to be lead once again in Washington. Not with a thousand points of light. Not with 17 point programs. Not with invisible promises. Ross Perot believes the only way we can address the issues is to confront them head-on with fresh solutions.

"IF YOU CAN'T STAND A LITTLE PAIN, WE'RE NEVER GOING TO STRAIGHTEN THIS COUNTRY OUT."

The budget deficit is Ross Perot's number one priority. For starters, he'd cut over $180 billion alone just by eliminating fraud, abuse and waste. Waste like taking Air Force 1 to golf outings. He believes another $100 billion could be cut simply by asking Germany and Japan to pay for U.S. troops in their countries.

Ross Perot also believes, for most politicians, raising taxes is like taking dope. After the initial euphoria, the same old problems still exist. That's why he proposes no new taxes, except in the case of a national emergency.

To get the economy moving, Ross Perot would take the shackles off American business. He'd like to see elected officials working side by side with businesspeople in an intelligent, supportive relationship.

Of course, these are just a few of Ross Perot's ideas. He has many more. About health care, abortion, and ethnic violence. Just call 1-800-685-7777 and talk to a Ross Perot volunteer to learn more, or to find out how you can help.

And if you get a recording, relax. It will be the only time you'll ever get a stock answer from Ross Perot.

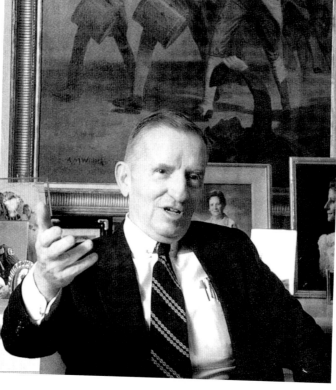

CITIZENS FOR PEROT FOR PRESIDENT

ONCE AGAIN, ROSS PEROT IS SPENDING HIS OWN MONEY TO RESCUE INNOCENT PEOPLE FROM AN OPPRESSIVE GOVERNMENT.

Franklin Roosevelt once said "Take a method and try it. If it fails, admit it and simply try another. But above all, try something."

In recent polls, the majority of Americans feel the current administration is doing little or nothing to end the recession, stop unemployment, and balance the budget.

"IF YOU CAN'T STAND A LITTLE PAIN, WE'RE NEVER GOING TO STRAIGHTEN THIS COUNTRY OUT."

Ross Perot is not a professional politician. In fact, he's never run for public office. He's simply a businessman who realizes the country can't follow it's current course. That's why he's running for president.

Like many, he believes the political system in America is broken, unable to address both economic and social issues because of red tape, lobbyists, and laziness.

To solve these problems, the country needs a strong leader who can identify problems and make tough decisions to solve them. Ross Perot isn't a stranger to this kind of leadership.

In 1969, disregarding White House objections, he sent a relief plane to the POWs in Hanoi.

In 1979, after the United States Government failed, he hired a paramilitary team that freed two of his EDS employees from Teheran's Gasr prison.

"WE'RE GOING TO GET RID OF THE WASTE. IF YOU WANT LAWRENCE WELK MUSIC, THEN I'M NOT YOUR MAN."

Cutting the deficit is not going to easy, but it has to be done. Ross Perot would pass a law to stop deficit spending. Then he'd pass another one to balance the budget. He believes billions

of dollars can be rescued just by cutting the waste. Like the 1,200 planes worth $2 billion that fly politicans around like royalty. Or the $100 billion used each year to defend Asia and Europe that the U.S. isn't reimbursed for.

"ACTION, ACTION, ACTION."

Economic issues aren't the only issues. Ross Perot wants to toughen the standards of our educational system. He proposes longer school years, merit pay raises for teachers, and equal funding for rich and poor school districts.

Ross Perot will fight "night and day" to get the guns out of the hands of violent people. He wants much harsher punishment for crimes involving guns and supports the death penalty.

And when it comes to affirmative action, he believes the country should be "color-blind" and "sex-blind." It's that simple. He opposes, however, the hiring of less-qualified over more-qualified.

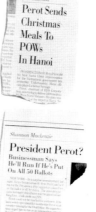

Of course, Ross Perot has taken a tough look at many more issues. To learn about them, just call 1-800-685-7777 and talk to a Perot volunteer. But do it soon. Because like all rescue efforts, time is of the essence.

CITIZENS FOR PEROT FOR PRESIDENT

STUBBORN. COMPETITIVE. UNCOMPROMISING. HONEST. JUST LIKE PRESIDENTS USED TO BE.

The single constant in American politics has been the desire for change. Today, that yearning has never been stronger. According to recent polls more than 80% of Americans believe that the country is on the wrong track. 1 out of 3 are dissatisfied with the current leadership. 75% say the government is run for the benefit of a few big businesses.

"ACTION, ACTION, ACTION."

Ross Perot isn't a professional politician. In fact, he's never run for public

office. Simply put, he's a businessman who happens to understand many of the problems facing the country.

Like a handful of past presidents, he sees the role of leadership as identifying the problem and then making the tough decisions to solve it.

He has no 17-point programs. No claims that he has the best answers. Ross Perot simply has the willingness to tackle the deficit, unemployment, taxes, health care and many more issues by rolling up his sleeves and doing something about them. That's why he's running for president.

Harry Truman once said the buck stops here, at his desk. Unfortunately today, the buck isn't stopping anywhere. The deficit is growing by the second. Taxes are being raised by the quarter. And the trade imbalance simply grows wider and wider by the year.

"RAISING TAXES IS LIKE TAKING DOPE FOR MOST POLITICIANS. THE MORE MONEY YOU GIVE THEM, THE MORE THEY'LL SPEND."

Ross Perot believes taxes should only be raised in the event of a national emergency. And the power to raise them should lie not with Congress, but with the people who have to pay them. Us. But if we don't raise taxes, we have to cut spending. Ross Perot truly believes the deficit can be eliminated. At least $100 billion could be cut just by taking out the waste in Washington. Waste like flying Air Force 1 to a golf outing at tax payers' expense.

Of course, Ross Perot's concerns aren't just economic. His stance on abortion is simple. It's a woman's right. But he opposses its use for birth control.

He's always been a leader in educational reform. In Texas, he helped bring about the "no pass, no play" rule for student athletes.

When it comes to affirmative action, the country should be "color blind and sex blind." But Ross Perot opposes the promotion of the less qualified over the more qualified.

These are just a few of Ross Perot's many views. If you'd like to learn more, just call 1-800-685-7777 and talk to a Ross Perot volunteer. He or she will give you honest, no-bull answers to your questions. Just like their boss would.

CITIZENS FOR PEROT FOR PRESIDENT

PUBLIC SERVICE/ POLITICAL: OUTDOOR

55 GOLD
ART DIRECTOR
Kent Suter
WRITER
Eric Grunbaum
PHOTOGRAPHER
Michael Jones
CLIENT
Oregon Donor Program
AGENCY
Borders Perrin & Norrander/Portland

56 SILVER
ART DIRECTOR
Dean Hanson
WRITER
Doug de Grood
ILLUSTRATOR
Mary Northrup
CLIENT
Communities Caring for Children
AGENCY
Fallon McElligott/ Minneapolis

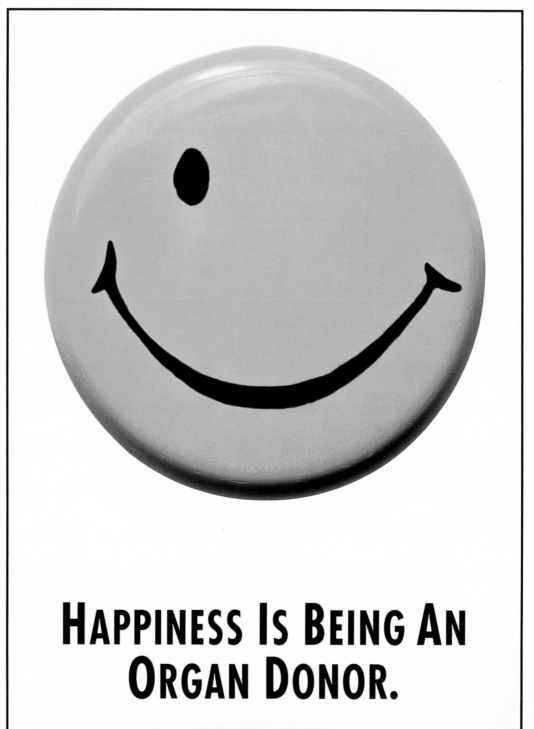

55 Gold

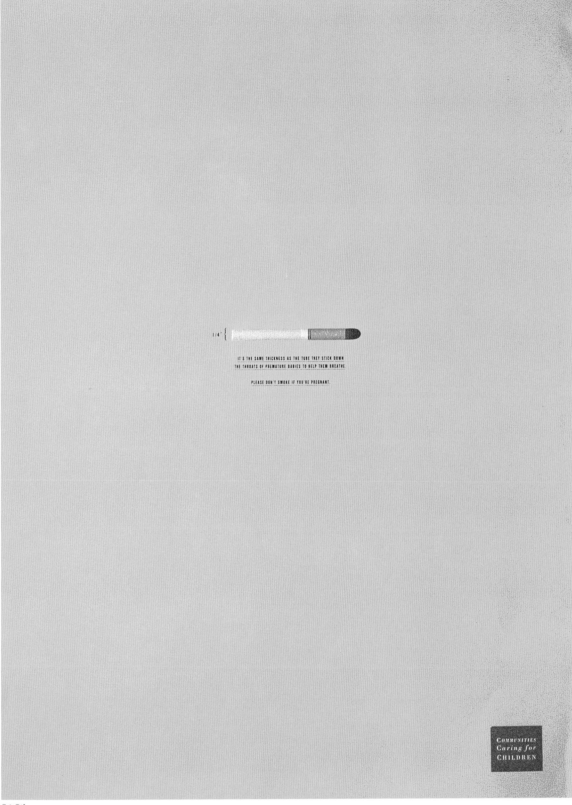

1/4" { IT'S THE SAME THICKNESS AS THE TUBE THEY STICK DOWN
THE THROATS OF PREMATURE BABIES TO HELP THEM BREATHE.

PLEASE DON'T SMOKE IF YOU'RE PREGNANT.

COMMUNITIES
Caring for
CHILDREN

56 Silver

**PUBLIC SERVICE/
POLITICAL: OUTDOOR**

57 BRONZE
ART DIRECTOR
Todd Grant
WRITER
Chuck McBride
PHOTOGRAPHER
Scott Schulman
CLIENT
**New Hope for Animals
Foundation**
AGENCY
**Ads While-U-Wait/
Philadelphia**

58 BRONZE
ART DIRECTOR
Stan Toyama
WRITER
Rob Schwartz
PHOTOGRAPHER
Lonnie Duka
CLIENT
Olive Crest
AGENCY
**Hill Holliday Connors
Cosmopulos/Boston**

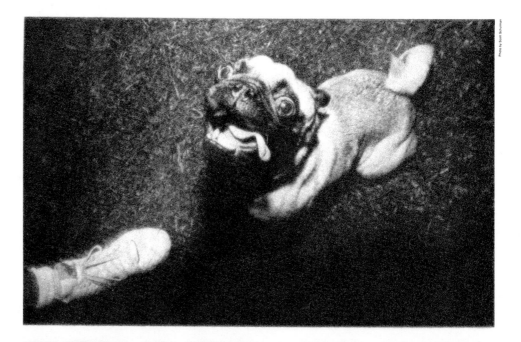

57 Bronze

FOR SOME, SEX BEFORE MARRIAGE IS IMMORAL. WHAT DO YOU CALL SEX BEFORE KINDERGARTEN?

ONE IN EVERY SIX BOYS AND ONE IN EVERY THREE GIRLS ARE SEXUALLY ABUSED BY THE TIME THEY'RE 18. 95% OF ABUSE
VICTIMS HAVE BEEN MOLESTED BY THEIR MOTHERS, FATHERS, AUNTS, UNCLES OR CLOSE FAMILY FRIENDS. NOW THAT YOU KNOW,
NOW YOU SHOULD HELP. OLIVE CREST TREATMENT CENTERS FOR ABUSED CHILDREN. TO DONATE PLEASE CALL (714) 777-4999.
HELP US TURN STATISTICS BACK INTO CHILDREN.

58 Bronze

PUBLIC SERVICE/ POLITICAL RADIO: SINGLE

59 GOLD
WRITERS
Jay Williams
Jamie Mambro
Bill Murphy
AGENCY PRODUCER
Diane Carlin
PRODUCTION COMPANY
Soundtrack
CLIENT
The Pine Street Inn
AGENCY
Hill Holliday Connors Cosmopulos/Boston

60 SILVER
WRITER
Lyle Wedemeyer
AGENCY PRODUCER
Mary Fran Werner
PRODUCTION COMPANY
CityPost
CLIENT
Minnesota Department of Health
AGENCY
Martin/Williams, Minneapolis

PUBLIC SERVICE/ POLITICAL RADIO: CAMPAIGN

61 GOLD
WRITERS
Jay Williams
Jamie Mambro
Bill Murphy
AGENCY PRODUCERS
Kelly Pauling
Diane Carlin
PRODUCTION COMPANY
Soundtrack
CLIENT
The Pine Street Inn
AGENCY
Hill Holliday Connors Cosmopulos/Boston

59 Gold
STEPHEN KING: The rats seemed to pour out of the pipe and run down the alley.
ANNCR: Stephen King, author of *Carrie, The Shining,* and *Pet Sematary.*
STEPHEN KING: His legs were too bad to let him move with any speed. He shifted frantically, trying to get up as he watched them come in a seemingly endless wave, past the dumpsters and the barrels. But he couldn't move. And so he sat, against the bags of trash, his face frozen in horror, as they raced toward him, past him, around him, over him and finally settled on him . . . diving into his pockets, shredding the bags behind him, ripping at the shopping bag he held, nipping at the exposed skin at his ankles and his wrists. The squealing seemed to fill the sky . . .
The most horrifying part of this story, is that I didn't write it. It's the true account of what happened to a homeless man in an alley in Boston's Back Bay. Please. Support The Pine Street Inn. You can't imagine what the homeless go through. Even I can't.
ANNCR: The Pine Street Inn. 444 Harrison Avenue. 482-4944.

60 Silver
ANNCR: A thank you to the cigarette companies of America. From the women of America. Thank you for selecting us as a target for your advertising.
Thank you for spending millions of dollars a year to convince us that smoking makes us more interesting. Thank you for presenting smoking as a nice break from our stressful lives. Thank you for getting us hooked. Thank you for the 52,000 cases of lung cancer you cause in women each year. Thank you. We only hope we can return the favor some day.

61 I Gold

STEPHEN KING: The rats seemed to pour out of the pipe and run down the alley.

ANNCR: Stephen King, author of *Carrie, The Shining,* and *Pet Sematary.*

STEPHEN KING: His legs were too bad to let him move with any speed. He shifted frantically, trying to get up as he watched them come in a seemingly endless wave, past the dumpsters and the barrels. But he couldn't move. And so he sat, against the bags of trash, his face frozen in horror, as they raced toward him, past him, around him, over him and finally settled on him . . . diving into his pockets, shredding the bags behind him, ripping at the shopping bag he held, nipping at the exposed skin at his ankles and his wrists. The squealing seemed to fill the sky . . .
The most horrifying part of this story, is that I didn't write it. It's the true account of what happened to a homeless man in an alley in Boston's Back Bay.
Please. Support The Pine Street Inn. You can't imagine what the homeless go through. Even I can't.

ANNCR: The Pine Street Inn. 444 Harrison Avenue. 482-4944.

61 II

SUSAN BUTCHER: No matter how many times you're out there, you never get used to the cold . . .

ANNCR: Susan Butcher, four-time winner of Alaska's Iditarod Dogsled Race.

SUSAN BUTCHER: You're always thinking of a way to get out of it. It's what keeps you going, out there all alone. You think about what it would be like to be warm for even just a few minutes. You daydream about what it would be like to feel the chill start to melt out of your hands and feet . . . to feel your face start to soften out of its cold, stiff expression. You keep telling yourself that you're going to make it. Sometimes even out loud. It's like you're in another world . . .
Unfortunately, this is not a description of what it's like to race the Iditarod. It's a homeless woman's description of what it's like to walk the streets of Boston. Please. Support The Pine Street Inn. You can't imagine what the homeless go through. Even I can't.

ANNCR: The Pine Street Inn. 444 Harrison Avenue. 482-4944.

61 III

TERRY ANDERSON: The physical part is bad, but it's the loneliness that's the hardest thing . . .

ANNCR: Terry Anderson. Journalist and eight-year Lebanon hostage.

TERRY ANDERSON: You're completely cut off. There isn't even the slightest bit of human warmth in your day. You may hear the news in staticky snippets from a passing radio. You might see a newspaper from time to time, but only a piece . . . you don't know what it all means. A phone call is something you remember vaguely, from your previous life. And a letter, well, you don't expect you'll ever hold a letter in your hands again for as long as you live . . .
Unfortunately, this isn't my account of my captivity in Lebanon. This is a homeless man's account of life on the street in Boston. Please. Support The Pine Street Inn. You can't imagine what it's like to be homeless. Even I can't.

ANNCR: The Pine Street Inn. 444 Harrison Avenue. 482-4944.

PUBLIC SERVICE/ POLITICAL TELEVISION: SINGLE

62 GOLD

ART DIRECTORS
Leslie Sweet
Peter Cohen
WRITERS
Peter Cohen
Leslie Sweet
AGENCY PRODUCERS
Leslie Sweet
Peter Cohen
PRODUCTION COMPANY
First Light
DIRECTOR
Laura Belsey
CLIENT
Coalition for the Homeless
AGENCY
Streetsmart Advertising/ New York

63 SILVER

ART DIRECTOR
Sally Wagner
WRITER
Christopher Wilson
AGENCY PRODUCER
Mary Fran Werner
DIRECTOR
Chuck Statler
PRODUCTION COMPANY
Jigsaw Pictures
CLIENT
American Humane Association
AGENCY
Martin/Williams, Minneapolis

64 BRONZE

ART DIRECTOR
Jeremy Postaer
WRITER
Jeremy Postaer
AGENCY PRODUCER
Cindy Fluitt
PRODUCTION COMPANY
In-House
DIRECTOR
Jeffrey Goodby
CLIENT
Partnership for a Drug Free America
AGENCY
Goodby Berlin & Silverstein/San Francisco

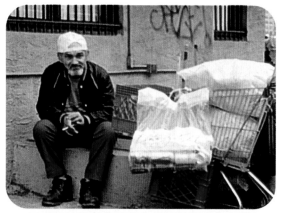

62 Gold
(ALL: SINGING)
CURTIS: *Start spreading the news, I'm leaving today, I want to be a part of it . . .*
JOHN: *New York, New York.*
AMEEN: *I want to wake up in a city that doesn't sleep . . .*
JIM: *And find I'm king of the hill . . .*
JESSE: *Top of the heap.*
JULIUS: *These little town blues, are meltin' away . . .*
TERESA: *I'll make a brand new start of it, in old New York.*
BOB: *If I can make it there, I'll make it anywhere . . .*
SUPER: IT'S UP TO YOU, NEW YORK, NEW YORK.
SUPER: COALITION FOR THE HOMELESS. 695-8700.

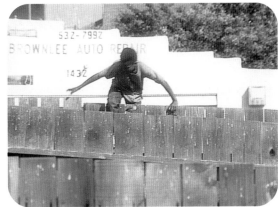

63 Silver

(SFX: DRUMROLL)

SUPER: WHO SAYS YOU CAN'T TEACH AN OLD DOG NEW TRICKS?

SUPER: ADOPT AN OLDER DOG. THEY'RE COOL.

SUPER: AMERICAN HUMANE ASSOCIATION.

64 Bronze

(MUSIC: THROUGHOUT)

KID: My teacher tells us all we gotta do is just say no. And the other day a policeman came to our class talking about say no too.

Well, my teacher doesn't have to walk home through this neighborhood.

And maybe the dealers are scared of the police . . . but they're not scared of me.

And they sure don't take no for an answer.

ANNCR: To Kevin Scott . . . and all the other kids who take the long way home, we hear you. . . don't give up.

**PUBLIC SERVICE/
POLITICAL TELEVISION:
CAMPAIGN**

65 GOLD
ART DIRECTOR
Sally Wagner
WRITER
Christopher Wilson
AGENCY PRODUCER
Mary Fran Werner
DIRECTOR
Chuck Statler
PRODUCTION COMPANY
Jigsaw Pictures
CLIENT
**American Humane
Association**
AGENCY
**Martin/Williams,
Minneapolis**

65 I Gold
(SFX: DRUMROLL)
SUPER: WHO SAYS YOU CAN'T TEACH AN OLD DOG
NEW TRICKS?
SUPER: ADOPT AN OLDER DOG. THEY'RE COOL.
SUPER: AMERICAN HUMANE ASSOCIATION.

WHO SAYS
YOU CAN'T TEACH
AN OLD DOG
NEW TRICKS?

WHO SAYS
YOU CAN'T TEACH
AN OLD DOG
NEW TRICKS?

ADOPT AN OLDER DOG.
THEY'RE COOL.

ADOPT AN OLDER DOG.
THEY'RE COOL.

65 II
(MUSIC: *GONE WITH THE WIND* THEME-TYPE)
SUPER: WHO SAYS YOU CAN'T TEACH AN OLD DOG
 NEW TRICKS?
SUPER: ADOPT AN OLDER DOG. THEY'RE COOL.
SUPER: AMERICAN HUMANE ASSOCIATION.

65 III
(MUSIC: ACCORDIAN)
SUPER: WHO SAYS YOU CAN'T TEACH AN OLD DOG
 NEW TRICKS?
SUPER: ADOPT AN OLDER DOG. THEY'RE COOL.
SUPER: AMERICAN HUMANE ASSOCIATION.

PUBLIC SERVICE/ POLITICAL TELEVISION: CAMPAIGN

66 SILVER

ART DIRECTORS
Steve St. Clair
Judy John
WRITERS
Judy John
Steve St. Clair
AGENCY PRODUCERS
David Medlock
Keen Music
PRODUCTION COMPANY
Videogenics
DIRECTORS
Steve St. Clair
Judy John
CLIENT
Leukemia Research Fund
AGENCY
Two Cities/New York, Toronto

67 BRONZE

ART DIRECTOR
Jamie Mahoney
WRITERS
Ken Hines
Bill Westbrook
Mike Hughes
Raymond McKinney
AGENCY PRODUCER
Jim Vaile
PRODUCTION COMPANY
Makeshift Productions
DIRECTOR
Jamie Mahoney
CLIENT
United Way
AGENCY
The Martin Agency/ Richmond

EVERY YEAR, THOUSANDS OF LIVES ARE CUT SHORT BY LEUKEMIA.

PLEASE GIVE GENEROUSLY TO HELP FIND A CURE.

LEUKEMIA
RESEARCH FUND OF CANADA

1-800-268-2144

66 Silver
(SFX: FILM PROJECTOR)
(MUSIC: LIGHT PIANO THROUGHOUT)
SUSAN: . . . and, hopefully, it will all end up someday I'll be off traveling, seeing Europe, Spain, Italy—I want to see the Sistene Chapel. All the great things of the world. There are things here, too. Uhh, and while I'm young . . .
(SFX: CLICK OF FILM BREAKING, SILENCE)
SUPER: EVERY YEAR, THOUSANDS OF LIVES ARE CUT SHORT BY LEUKEMIA.
SUPER: PLEASE GIVE GENEROUSLY TO HELP FIND A CURE.
SUPER: LEUKEMIA RESEARCH FUND OF CANADA.

The hookers show up outside our building every night.

Why does The Martin Agency give to The United Way?

67 Bronze
(MUSIC: BASS AND SYNTH)
SUPER: THE HOOKERS SHOW UP OUTSIDE OUR
 BUILDING EVERY NIGHT.
(SFX: BOTTLES CRASHING, BANGING METAL)
SUPER: AN ELDERLY WOMAN BEGS FOR MONEY IN
 OUR PARKING LOT.
(SFX: FOOTSTEPS)
SUPER: A HOMELESS MAN SEARCHES OUR DUMPSTER
 FOR CANS.
(SFX: SIRENS)
SUPER: AN AMBULANCE SCREAMS PAST OUR WINDOWS.
(SFX: PEOPLE SHOUTING ANGRILY)
SUPER: THE SIDEWALKS GLITTER WITH BROWN
 BROKEN WINE BOTTLES.
(SFX: LOUD CAR MUSIC AND HONKING)
SUPER: AND WE'RE IN A NICE PART OF TOWN.
SUPER: WHY DOES THE MARTIN AGENCY GIVE TO THE
 UNITED WAY?
SUPER: JUST LOOK AROUND.

CONSUMER RADIO: SINGLE

68 SILVER
WRITER
Joe Alexander
AGENCY PRODUCER
Morty Baron
CLIENT
The Richmond Symphony
AGENCY
The Martin Agency/
Richmond

69 BRONZE
WRITER
Mike Lescarbeau
AGENCY PRODUCER
Kathy Jydstrup
CLIENT
Star Tribune
AGENCY
Fallon McElligott/
Minneapolis

70 BRONZE
WRITER
Dean Hacohen
AGENCY PRODUCER
Dean Hacohen
CLIENT
Crain's New York Business
AGENCY
Goldsmith/Jeffrey,
New York

CONSUMER RADIO: CAMPAIGN

71 SILVER
WRITER
Dean Hacohen
AGENCY PRODUCER
Dean Hacohen
CLIENT
Crain's New York Business
AGENCY
Goldsmith/Jeffrey,
New York

68 Silver

JIM (SINGING): *Strangers in the night . . .*
SGT. CARTER: I can't hear you!
JIM (SINGING LOUDER): *Strangers in the night . . .*
SGT. CARTER: I can't hear you!
ANNCR: Find out how four years as Marine Private Gomer Pyle gave a man the discipline to become one of the top vocalists in the world . . .
JIM (SINGING EVEN LOUDER): *Strangers in the night . . .*
SGT. CARTER: I can't hear you.
ANNCR: Hear Jim Nabors sing with The Richmond Symphony, January 25, at The Mosque. For tickets, call 1-800-736-2000.

69 Bronze

GUY: Honey, would you mind if I turn the channel from this football game to something more . . . meaningful?
ANNCR: Somewhere out there, there's a man you've only dreamed about.
GUY: The guys wanted me to go out tonight, but I told them I was having dinner with my best friend. My wife.
ANNCR: He's one in a million.
GUY: Sure, I'll paint her house. She's *your* mother, isn't she?
ANNCR: How are you going to find him?
(SFX: VACUUM CLEANER)
GUY: Sorry, I'll be done with this noisy vacuuming in a minute.
ANNCR: Maybe you should try the Get Acquainted column in the *Star Tribune*.
GUY: I want to open up to you and talk about my feelings.
ANNCR: Call 673-9015 for more information about Get Acquainted.
GUY: I think you *needed* to gain weight.
ANNCR: We might just have the perfect guy for you.
ANNCR 2: Check out Get Acquainted every Tuesday, Friday and Sunday, in the *Star Tribune* classified section.

70 Bronze

ANNCR: Nah, nah, nah, nah, nah. You can't catch me. I'm the king of the castle. You're the dirty rascal. Missed me, missed me. Now you gotta kiss me. There's no end to the torturous remarks children will make when beating the pants off each other. Of course at *Crain's New York Business*, we've outscooped *The New York Times* and *The Wall Street Journal* time and time again in the past year. And while we would never pour salt in a wound, we would like to mention one thing in reference to the next business story to break in this city . . . Last one there's a rotten egg.

71 Silver

ANNCR: The New York Metropolitan Museum of Art houses the single most extensive collection of arms and armor in the Western world. There on the main floor, are the very swords, shields and suits of armor that safeguarded those who battled to protect their turf and expand their territory in the belligerent climate of their day. The editors of *Crain's New York Business* wish to applaud this important armory. And when the museum updates the collection to include 20th century artifacts, we would be happy to donate a copy of *Crain's New York Business.*

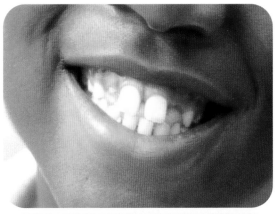

CONSUMER TELEVISION OVER :30 (:45/:60/:90) SINGLE

72 GOLD
ART DIRECTOR
Michael Prieve
WRITER
Jim Riswold
AGENCY PRODUCERS
Renee Raab
Bill Davenport
PRODUCTION COMPANY
Propaganda Films
DIRECTOR
David Fincher
CLIENT
Nike
AGENCY
Wieden & Kennedy/ Portland

73 SILVER
ART DIRECTOR
Peter Gatley
WRITER
Jon Matthews
AGENCY PRODUCER
Sarah Pollitt
PRODUCTION COMPANY
Limelight Productions
DIRECTOR
John Lloyd
CLIENT
Barclaycard
AGENCY
BMP DDB Needham Worldwide/London

74 BRONZE
ART DIRECTOR
Tom Notman
WRITER
Alastair Wood
AGENCY PRODUCER
Barry Stephenson
PRODUCTION COMPANY
Spots Films International
DIRECTOR
Kevin Molony
CLIENT
Bass Brewers
AGENCY
BSB Dorland/London

72 Gold
SUPER: THREE, FOUR.
(MUSIC: "INSTANT KARMA" BY JOHN LENNON)
LENNON (SINGING): *Instant Karma's gonna get you.*
 Gonna look you right in the face.
 You better get yourself together darlin',
 join the human race.
 How in the world you gonna see . . .
 Laughin' at fools like me?
 Who on earth d'you think you are?
 A superstar?
 Well right you are.
 Well we all shine on . . .
 Like the moon and the stars and the sun.
 Yeah we all shine on.
 Well we all shine on,
 like the moon and the stars and the sun.
 Well we all shine . . .
SUPER: JUST DO IT.
SUPER: NIKE.

73 Silver

LATHAM: That's the place, Bough, cover me. Wendy?

WENDY: Urrgh!

BOUGH: Wendy!

LATHAM: Don't just stand there, get a cold compress and loosen his clothing. We need the local doctor.
(INTO PHONE) Mujarra nibbib akhnool? Shiwabbi. Nooo! Lakha.

BOUGH: What did they say?

LATHAM: I'd forgotten, Wendy is the local doctor. Don't frisk him, Bough, he's one of ours.

BOUGH: We need his 4-9-2-9.

LATHAM: His Barclaycard? The man's in no state to go shopping!

BOUGH: No, we phone up.

LATHAM: Yes, ring the cinema, good idea, book tickets, that'll cheer him up.
(READING FROM BOOK) "Heavy Breathing" . . .

BOUGH: No, Barclaycard International Rescue . . . they give medical advice . . .

LATHAM: "Palpitations"—medical advice from a credit card company! Why not! And then we can phone the gas board for a second opinion . . . Tch! "Dilated pupils" . . .

BOUGH: Sir, they can even send a doctor.

LATHAM: "Foul Body Odor" . . . "Snakebite"! Look, there's only one thing going to save this man and it isn't his Barclaycard. I'll have to suck out the poison. You know, Bough, I can't fail to be touched by your faith in Barclaycard, but the world of finance is no place for budding Florence Nightingales . . . Now, where's he been bitten?
Yes, actually, on reflection perhaps you had better phone Barclaycard, I've suddenly remembered I have a lunch appointment. Good idea, carry on.

74 Bronze

ANNCR: You are taking part in a commercial for T.A.G. the lager brewed by Jacob Stauder. You are paired with ice-dance champion Olga Sukova. Learn your lines and repeat them after the bleeps.

SUPER: OOOPS!

SUPER: OUCH!

SUPER: CAN'T WE DISCUSS THIS OVER A BOTTLE OF T.A.G.?

ANNCR: Good Luck.

(SFX: BLEEP)

(SFX: BLEEP)

(SFX: BLEEP)

ANNCR: Treffliches Altenessen Gold. Ask for it by name.

CONSUMER TELEVISION OVER :30 (:45/:60/:90) CAMPAIGN

75 GOLD

ART DIRECTOR
Larry Frey

WRITER
Stacy Wall

AGENCY PRODUCER
Donna Portaro

PRODUCTION COMPANY
Limelight Productions

DIRECTOR
Alex Proyas

CLIENT
McKenzie River Corporation/ Black Star Beer

AGENCY
Wieden & Kennedy/ Portland

TIMES SQUARE, 1935

75 I Gold

(MUSIC: WW II PARADE TYPE)
BRIT G.I. 1: Give me some of that Yankee brew.
BRIT G.I. 2: Yah, Black Star!
BRIT G.I. 3: Send us a case!
BRIT G.I. 4: Send us two!
BRIT G.I. 5: Send us two!
(MUSIC: BIG BAND)
JOHN CORBETT: Minott's Black Star was once the most popular beer in the world. Everyone was drinking it.
(MUSIC: 1950s)
(MUSIC: BIG BAND WITH HORNS)
CORBETT: And since it was America's most interesting beer, everyone was talking about it too!
BUZZY (PAST): . . . borrow the car? What do you think I am son, a case of refreshing premium Black Star Beer?! Wheeeeee, oooooooh, wheeeeeee, oooooh!
BUZZY'S WIFE: Oh Buzzy!
BUZZY (PRESENT): Black Star wasn't a sponsor, but I loved the stuff.
(SFX: AUDIENCE APPLAUSE, LAUGHTRACK)
BUZZY (PRESENT): So I improvised. That was the beauty of my show.
CORBETT: And that's the beauty of Black Star, because what was once America's most interesting beer is now America's only interesting beer.
HOST: What do you consider the greatest invention of the 20th century?
MS. GALAXY: Black Star Beer.
(MUSIC: BIG BAND WITH HORNS)

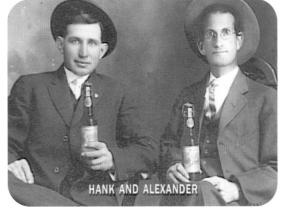

PORTLAND SPEEDWAY. NOV. 30, 1972.

HANK AND ALEXANDER

75 II

(MUSIC: LOW TRACK WITH GUITARS)

SKIER: Nothing is more interesting than Black Star Beer.

JOHN CORBETT: Through the years there's been a lot of different advertising campaigns for Black Star Beer.

BARTENDER: Minott's?

CUSTOMER: Minott's.

BARTENDER 1: Black Star?

BARTENDER 1: Black Star.

BARTENDER 2: Frosty Mug?

BARTENDER 1: Huuuuuuh.

JOHN CORBETT: Black Star pioneered the use of animation in commercials with *Zippy the Cap* films in the early 1930s.

ZIPPY: I'm Zippy the Cap, the only thing that can top the taste of Black Star Beer.

(MUSIC: EARLY ORGAN, XYLOPHONE JAZZ RIFF)

JOHN CORBETT: Along came those loveable scamps, The Black Star Bullies. Black Star commercials really changed the way people thought about film.

(MUSIC: BLACK STAR HOLIDAY JINGLE)

COUPLE (SINGING): *For people who play . . . it's a Black Star holiday! Yeah!*

GUS VAN SANT: The one commercial, the Brewvy commercial, was ah, certainly ahead of its time.

(MUSIC: 1960s HARD ROCK N' ROLL)

GO-GO DANCER 1: Black Star Beer is brewvy!

JOHN CORBETT: Black Star, once America's most interesting beer . . .

(MUSIC: JAZZ WITH HORNS)

JOHN CORBETT: . . . is now America's only interesting beer.

75 III

RACE ANNCR: He's coming out of the third turn. The Black Star car is out of control . . . the bottle is . . . Oh, the humanity!

JOHN CORBETT: No other beer has a history as interesting as Black Star Beer. Founded by Alexander Minott, eccentric brewing mogul, adventurer, Black Star was once the most popular beer in the world.

BREWMASTER: We couldn't make enough of the stuff. Alexander Minott was a genius. We made and still make a darn fine beer.

CORBETT: And since it was America's most interesting beer, everyone was talking about it too.

DAPHNE MINOTT: Joey, I was hoping that he would name his beer after me, Daphne Beer. But he said he would never name a beer after a loved one so . . .

ALEXANDER MINOTT: We will now be known as Black Star Beer.

JOHN CORBETT: Black Star, what was once America's most interesting beer is now America's only interesting beer.

BRITS (SINGING): *Oh, Black Star we love you, oi!*

CONSUMER TELEVISION OVER :30 (:45/:60/:90) CAMPAIGN

76 SILVER
ART DIRECTORS
Rick Boyko
Debby Lucke
WRITER
Michael Ward
AGENCY PRODUCER
Ed Kleban
PRODUCTION COMPANY
**Lovinger/
Cohn & Associates**
DIRECTOR
Jeff Lovinger
CLIENT
American Express
AGENCY
**Ogilvy & Mather/
New York**

77 BRONZE
ART DIRECTORS
Darryl McDonald
Michael Prieve
WRITER
Jim Riswold
AGENCY PRODUCERS
Donna Portaro
Bill Davenport
John Adams
PRODUCTION COMPANIES
Pytka Productions
Propaganda Films
DIRECTORS
Joe Pytka
David Fincher
CLIENT
Nike
AGENCY
**Wieden & Kennedy/
Portland**

CONSUMER TELEVISION :30/:25 SINGLE

78 GOLD
ART DIRECTOR
David Angelo
WRITER
Paul Spencer
AGENCY PRODUCER
Eric Herrmann
PRODUCTION COMPANY
Limelight Productions
DIRECTOR
John Lloyd
CLIENT
New York State Lottery
AGENCY
**DDB Needham
Worldwide/New York**

76 Silver

CHARLES LAZARUS: The true test of whether something is really a good idea is whether it sounds simple. You can walk into a store in Hong Kong, Kuala Lumpur, or here in New York and find the same items in the same area. If you get confused just ask some child, they'll tell you where it is. Too many companies, in my opinion, look quarter-to-quarter. Twenty-five years ago we started with the earliest computers and today we probably are among the most sophisticated in retailing. Children come along and say, "I gotta have ...," "If I don't get I will die . . . " Those are our salespeople. Parents who use the card are probably gonna buy more. And grandparents certainly are gonna buy more. I buy the majority of my purchases, frankly, with the American Express Card. It's simpler for me. Period.

ANNCR: American Express is welcomed at Toys-R-Us and other fun spots.

77 Bronze

(MUSIC: THROUGHOUT)

(ALL: RAPPING)

CHARLES BARKLEY: *Throwin' blows to the jaw to the nose . . . fat paychecks and the refs give me techs. I bump and I bruise in the black Nike shoes. No cause for alarm when I thump an arm . . .*

BARKLEYETTES: *No cause for alarm when Charles thumps an arm. Sir Charles don't mean no harm. (Bet the farm).*

BARKLEY: *'84's when Charles started poppin' . . . forwards like flies they begin droppin'. Fans they boo me I spit and they sue me. I don't understand why they do this to me. The leagues they fine . . . I get irate. Takin' eggs and steak maybe turkey off my plate.*

ALL: *Charles, Charles, Charles!!*

BARKLEY: *Come on!*

BARKLEYETTES: *Sellin' books and punchin' crooks.*

BARKLEY: *And singing Vegas-style musical hooks.*

BARKLEYETTES: *But bustin' heads . . . for a championship ring . . .*

BARKLEY: *Is what I love more than anything . . . sing.*

ALL: *Bumpin' thumpin' A-bomb dunkin' . . . donut dunkin' and charm school flunkin'. The pocket says it pays to be mean.*

(MUSIC: STOPS)

BARKLEY: Excuse me, but don't I have the cutest smile you've ever seen?

(MUSIC: UP AND FADE)

NEW YORK
LOTTO

Hey, you never know.

YOU MUST BE 18 YEARS OLD TO PLAY LOTTERY GAMES.
SEE YOUR LOTTERY AGENT FOR GAME DETAILS.

78 Gold

(MUSIC: THROUGHOUT)

J.P.: In short gentlemen, our capitalization plan has paid handsome dividends. Johnson here will fill you in on the details.

JOHNSON: Thank you J.P. Let me begin by saying . .

(SFX: DOOR SLAMS)

MAN: We've been acquired.

J.P.: By whom? The Omega Corporation?

MAN: No, Chuck . . . from the mailroom.

CHUCK: Howdy boys, Ms. Whittiker.

ANNCR: New York Lotto. Hey, you never know.

CHUCK: Coffee, Johnson.

CONSUMER TELEVISION :30/:25 SINGLE

79 SILVER
ART DIRECTOR
Rick McQuiston
WRITER
Bob Moore
AGENCY PRODUCER
Donna Portaro
PRODUCTION COMPANY
Propaganda Films
DIRECTOR
Dominic Sena
CLIENT
Nike
AGENCY
Wieden & Kennedy/ Portland

80 BRONZE
ART DIRECTOR
Ann Rhodes
WRITER
Larry Asher
AGENCY PRODUCER
Josh Reynolds
PRODUCTION COMPANY
Square One Productions
DIRECTOR
Kelley Baker
CLIENT
King County Medical
AGENCY
Borders Perrin & Norrander/Seattle

81 BRONZE
ART DIRECTOR
Bruce Hurwit
WRITER
Don Austen
AGENCY PRODUCER
Melanie Klein
PRODUCTION COMPANY
Steifel & Co.
DIRECTOR
Jon Francis
CLIENT
Little Caesar Enterprises
AGENCY
Cliff Freeman & Partners/ New York

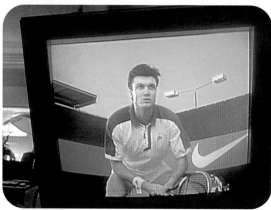

79 Silver
(SFX: STATIC)
ANNCR: . . . here at center court with Andre Agassi and David Wheaton.
WILLARD: Nice shoes!
(SFX: LOUD THUMP)
(SFX: GLASS BREAKING)
(SFX: STORE BURGLAR ALARM)
ANNCR: Apparently having some technical difficulty. Please stand by.

80 Bronze

(MUSIC: (HAYDN'S "SERENADE"))

ANNCR: Here's a word of advice for all you weekend warriors: If at first you don't succeed . . . at least get a good health plan.

81 Bronze

(SFX: SQUEAK OF THE GURNEY)

NURSE 1: Now, let's get those tonsils out.

NURSE 2: Is it too brassy?

NURSE 3: I like that color.

(SFX: STRETCHING SOUND)

MAN: Wo-ooo-oooo!

NURSE 4: Here's your baby.

MAN: Woo-ooo!

ANNCR: Little Caesar's Cheeser! Cheeser! Two pizzas with extra cheese, up to three toppings and free Crazy Bread for $8.98.

LITTLE CAESAR: Cheeser! Cheeser!

GOLD, SILVER & BRONZE AWARDS

CONSUMER TELEVISION :30/:25 CAMPAIGN

82 GOLD

ART DIRECTORS
Donna Weinheim
Bruce Hurwit
WRITERS
Cliff Freeman
Arthur Bijur
Don Austen
Jeff Alphin
AGENCY PRODUCERS
Melanie Klein
Anne Kurtzman
PRODUCTION COMPANIES
Steifel & Co.
Harmony Pictures
Crossroads Films
DIRECTORS
Jon Francis
Charles Wittenmeier
Mark Story
CLIENT
Little Caesar Enterprises
AGENCY
Cliff Freeman & Partners/ New York

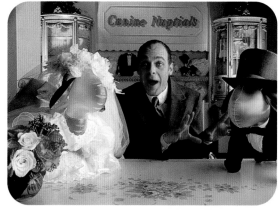

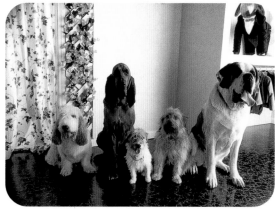

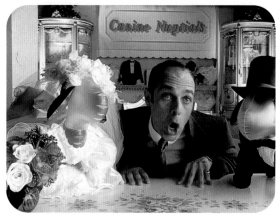

82 I Gold
ANNCR: This is crazy!
PROPRIETOR: Dog weddings, most people call them. But we prefer canine nuptials! Now the bride will be wearing antique ivory, the bridesmaids . . . are they here?
(SFX: DOGS PANTING)
PROPRIETOR: Ah, lavender tulle.
(SFX: POOF OF CAMERA)
(MUSIC: "WEDDING MARCH")
PROPRIETOR: Say cheese now. Beautiful . . . stay, no! Bad dog, bad dog, oh you're all bad dogs . . . good dog.
ANNCR: This is Crazy! Crazy! Two pizzas with any topping, two free crazy breads, two free soft drinks all for $7.98 at Little Caesar's.
LITTLE CAESAR: Pizza! Pizza!

82 II

(SFX: SQUEAK OF THE GURNEY)

NURSE 1: Now, let's get those tonsils out.

NURSE 2: Is it too brassy?

NURSE 3: I like that color.

(SFX: STRETCHING SOUND)

MAN: Wo-ooo-oooo!

NURSE 4: Here's your baby.

MAN: Woo-ooo!

ANNCR: Little Caesar's Cheeser! Cheeser! Two pizzas with extra cheese, up to three toppings and free Crazy Bread for $8.98.

LITTLE CAESAR: Cheeser! Cheeser!

82 III

ANNCR: Wouldn't it be great to have X-ray vision?

(SFX: WHISTLE)

COACH: Men, you've come here today dressed for battle.

TEENAGER: Boy!! You've got a lot of pepperoni in your bread!

ANNCR: Get Little Caesar's new Pepperoni Bread and two pizzas with extra pepperoni for $7.98

LITTLE CAESAR: Pizza! Pizza!

ANNCR: And get free Chocolate! Chocolate!

GOLD, SILVER & BRONZE AWARDS

CONSUMER TELEVISION :30/:25 CAMPAIGN

83 SILVER
ART DIRECTOR
Michael Fazende
WRITER
Mike Lescarbeau
AGENCY PRODUCER
Judy Brink
PRODUCTION COMPANY
Park Village Productions
DIRECTOR
Roger Woodburn
CLIENT
The Lee Company
AGENCY
Fallon McElligott/
Minneapolis

84 BRONZE
ART DIRECTOR
Bob Brihn
WRITER
Phil Hanft
AGENCY PRODUCER
Char Loving
PRODUCTION COMPANY
Young & Company
DIRECTOR
Eric Young
CLIENT
Time Magazine
AGENCY
Fallon McElligott/
Minneapolis

85 BRONZE
ART DIRECTOR
Kirk Souder
WRITER
Court Crandall
AGENCY PRODUCER
John Stein
PRODUCTION COMPANY
Pytka Productions
DIRECTOR
Joe Pytka
CLIENT
Museum of Contemporary
Art
AGENCY
Stein Robaire Helm/
Los Angeles

83 Silver
(MAN SINGS ITALIAN ARIA IN TENOR)
(SFX: ZZZZIP)
(MAN SINGS ITALIAN ARIA IN SOPRANO)
ANNCR: Need a little more room in your jeans? Try
 Relaxed Fit Jeans from Lee.

84 Bronze

(SFX: ELECTRIC DRILL)

ANNCR: They already know how much you make and what you spend it on.

(SFX: KEYHOLE SAW)

ANNCR: They know your court appearances and your business dealings. They know your health history, your marital history, your credit history.

(SFX: FINGER PUNCHING OUT HOLE)

ANNCR: Next, they'll invite themselves into your bedroom. Then again, maybe they already have. Somebody's watching. If it's important to you, you'll find it in Time.

SUPER: TIME.

85 Bronze

(SFX: DRONE OF TV GAME SHOW)

SUPER: THIS
SUPER: IS
SUPER: LIFE.
SUPER: THAT'S
SUPER: WHY
SUPER: THERE'S
SUPER: ART.
SUPER: THE MUSEUM OF CONTEMPORARY ART.

GOLD, SILVER & BRONZE AWARDS

CONSUMER TELEVISION :20 AND UNDER SINGLE

86 GOLD
ART DIRECTOR
Mat Gooden
WRITER
Ben Walker
AGENCY PRODUCER
Trish Thompsett
PRODUCTION COMPANY
Stark Films
DIRECTOR
Jeff Stark
CLIENT
Guinness Publishing
AGENCY
Leo Burnett/London

87 SILVER
ART DIRECTOR
Dave Ayriss
WRITER
Ron Saltmarsh
AGENCY PRODUCER
Sue Mowrer
DIRECTOR
Peter O'Fallon
CLIENT
Washington State Lottery
AGENCY
Borders Perrin & Norrander/Seattle

88 BRONZE
ART DIRECTOR
Walter Campbell
WRITER
Tom Carty
AGENCY PRODUCER
Kate Taylor
PRODUCTION COMPANY
Lewin & Watson
DIRECTORS
Vaughan & Anthea
CLIENT
IKEA
AGENCY
Abbott Mead Vickers. BBDO/London

86 Gold
PRESENTER: This is Britain's quickest ever TV ad.

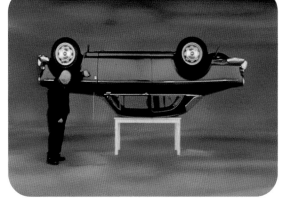

87 Silver

ANNCR: So if you were a millionaire, what would you do with the money?
MAN: I'd surprise my wife with a world cruise.
(SFX: SHIP HORN BLASTS)
MAN: Bon Voyage!
SUPER: LOTTO. $11 MILLION.
ANNCR: What you do with the money is up to you.

88 Bronze

ANNCR: This IKEA table comes flat-packed, so you don't have to put the table on top of the car. However, because it's been made so strong, you could always put the car on top of the table. IKEA. The furnishings store from Sweden.

**CONSUMER TELEVISION
:20 AND UNDER
CAMPAIGN**

89 **GOLD**

ART DIRECTORS
**Darren Elwood
David Hughes**

WRITERS
**Darren Elwood
David Hughes**

AGENCY PRODUCERS
**Darren Elwood
David Hughes**

DIRECTORS
**Darren Elwood
David Hughes**

CLIENT
**The Utah Short Film &
Video Center**

AGENCY
**Williams & Rockwood/
Salt Lake City**

89 I Gold
(SFX: BLEEP)
(MUSIC: DRAMATIC THROUGHOUT)
FRIGHTENED MAN: Don't!
(SFX: GUN SHOT)
SUPER: THE END.
SUPER: THE UTAH SHORT FILM & VIDEO FESTIVAL.
SUPER: JUNE 15 - 20. AT THE UTAH FILM &
 VIDEO CENTER.
SUPER: DON'T MISS IT.

89 II
(SFX: BLEEP)
(MUSIC: OMINOUS THROUGHOUT)
SUPER: THE END.
SUPER: THE UTAH SHORT FILM & VIDEO FESTIVAL.
SUPER: JUNE 15 - 20. AT THE UTAH FILM &
VIDEO CENTER.
SUPER: DON'T MISS IT.

89 III
(SFX: BLEEP)
(MUSIC: DRAMATIC THROUGHOUT)
(SFX: EXPLOSION)
SUPER: THE END.
SUPER: THE UTAH SHORT FILM & VIDEO FESTIVAL.
SUPER: JUNE 15 - 20. AT THE UTAH FILM &
VIDEO CENTER.
SUPER: DON'T MISS IT.

CONSUMER TELEVISION :20 AND UNDER CAMPAIGN

90 BRONZE
ART DIRECTOR
David Angelo
WRITER
Paul Spencer
AGENCY PRODUCER
Eric Herrmann
PRODUCTION COMPANY
Limelight Productions
DIRECTOR
John Lloyd
CLIENT
New York State Lottery
AGENCY
DDB Needham Worldwide/ New York

CONSUMER TELEVISION VARYING LENGTHS CAMPAIGN

91 GOLD
ART DIRECTOR
Dave Godfree
WRITER
Nick Hastings
AGENCY PRODUCER
Mark Andrews
PRODUCTION COMPANY
Spots Films International
DIRECTOR
Tarsem
CLIENT
Scottish & Newcastle Breweries
AGENCY
Collett Dickenson Pearce & Partners/London

90 Bronze
(SFX: BIRDS, OUTSIDE NOISES)
MAN: Does it come with cable?
AGENT: Ah, well . . .
ANNCR: New York Lotto. Hey, you never know.

91 I Gold ·
(MUSIC: INSTRUMENTAL THROUGHOUT)
ANDREW: I like seeing the countdown to films. What else do I like? Eating the kind of food they eat in cartoons. But I hate ticking.
(SFX: LOUD TICKING)
(SFX: MORE LOUD TICKING)
(SFX: CACOPHONY OF LOUD TICKING)
COWBOY IN FILM: Hymns, he likes hymns, but he hates cowboys.
ANDREW: I hate walking into cobwebs.
SPIDER: Hey, everybody's got to live somewhere right?
ANDREW: I like skimming stones. But I hate some of the things people call sport. I like kaleidoscopes. Draughts I really hate. Except McEwan's Export . . . *that* I like. Yes . . . yes . . . yes . . . yes.

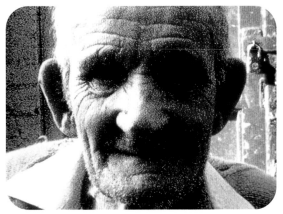

91 II
(MUSIC: INSTRUMENTAL THROUGHOUT)
PETER: I like . . . the way you can kid dogs. But I hate
supermarket trolleys with one dodgy wheel. Something
else I like . . . people whose life story is written all
over their face. And I like tacky holiday souvenirs.
(SFX: GARBLED STATION ANNOUNCEMENTS)
PETER: I hate garbled station announcements. Here's
a sound I like.
(SFX: CAN OPENING)
PETER: Only when McEwan's Export is inside mind.
Oh yes, and I like disaster movies . . . very funny.

91 III
(MUSIC: INSTRUMENTAL THROUGHOUT)
GORDON: I like watching people who can waggle their
ears. Tell you what I hate . . . breaking in new shoes.
And I hate using pencils other people have chewed.
But I like hiding behind trees.
And I like . . . McEwan's Export.
(SFX: SOUND OF SWALLOWING)
GORDON: Always have done.

GOLD, SILVER & BRONZE AWARDS

CONSUMER TELEVISION VARYING LENGTHS CAMPAIGN

92 SILVER

ART DIRECTOR
Carl Warner

WRITER
Harold Einstein

AGENCY PRODUCER
Jackie Kincaid

PRODUCTION COMPANY
Weiss Productions

DIRECTOR
Marty Weiss

CLIENT
Missouri Auction School

AGENCY
Warner Einstein/Chicago

CONSUMER TELEVISION UNDER $50,000 BUDGET

93 GOLD

ART DIRECTORS
Darren Elwood
David Hughes

WRITERS
Darren Elwood
David Hughes

AGENCY PRODUCERS
Darren Elwood
David Hughes

DIRECTORS
Darren Elwood
David Hughes

CLIENT
Utah Short Film & Video Center

AGENCY
Williams & Rockwood/ Salt Lake City

92 Silver
SUPER: DAY ONE
(A STUDENT IS STRUGGLING WITH AN AUCTIONEER'S CHANT)
SUPER: DAY FIVE
(STUDENT IMPROVES SLIGHTLY)
SUPER: DAY NINE
(HE IS NOW GETTING THE HANG OF IT)
SUPER: DAY TWELVE
(WEARING A GRADUATION CAP AND GOWN, HE PERFORMS HIS CHANT LIKE A PRO)
ANNCR: The Missouri Auction School. Call to find out when our next two-week session begins.
SUPER: MISSOURI AUCTION SCHOOL. 816-421-7117.

93 Gold
(SFX: BLEEP)
(MUSIC: OMINOUS THROUGHOUT)
SUPER: THE END.
SUPER: THE UTAH SHORT FILM & VIDEO FESTIVAL.
SUPER: JUNE 15 - 20. AT THE UTAH FILM &
 VIDEO CENTER.
SUPER: DON'T MISS IT.

GOLD, SILVER & BRONZE AWARDS

CONSUMER TELEVISION UNDER $50,000 BUDGET

94 SILVER

ART DIRECTOR
Steve Whittier
WRITER
Ted Nelson
AGENCY PRODUCER
Win Peniston
PRODUCTION COMPANIES
Edit Works
Catspaw
CLIENT
Rocky Mountain College of Art & Design
AGENCY
The Joey Reiman Agency/ Atlanta

95 BRONZE

ART DIRECTOR
Jeremy Postaer
WRITER
Steve Simpson
AGENCY PRODUCER
Ben Latimer
PRODUCTION COMPANY
In-House
DIRECTORS
Steve Simpson
Jeremy Postaer
CLIENT
Chevys Mexican Restaurants
AGENCY
Goodby Berlin & Silverstein/San Francisco

NON-BROADCAST: CINEMA/VIDEO

96 GOLD

ART DIRECTOR
Steve Miller
WRITER
Rob Slosberg
TYPOGRAPHER
Graham Clifford
AGENCY PRODUCER
Penny Cohen
CLIENT
Reebok
AGENCY
Chiat/Day, New York

94 Silver
(MUSIC: DRIVING ROCK AND ROLL GUITAR)
SUPER: PARENTS
SUPER: 60% OF ALL COLLEGE STUDENTS MOVE BACK HOME AFTER GRADUATION.
(SFX: CREEKING ROCKING CHAIR)
SUPER: 60% OF ALL ART SCHOOL STUDENTS MOVE TO NEW YORK AFTER GRADUATION.
SUPER: ROCKY MOUNTAIN COLLEGE OF ART AND DESIGN. 1-800-123-4567.
SUPER: OUR ADMISSIONS DEPARTMENT IS STANDING BY.

95 Bronze
(MUSIC: THROUGHOUT)
(SFX: DOGS BARKING)
ANNCR: It's incredible, but true. Some restaurants use pre-packaged tortillas.
SUPER: UGH!
ANNCR: And while you wouldn't wanna eat them, they are good for some things. At Chevys we make all of our food fresh every day. In fact, we make our tortillas fresh every 53 seconds. So Chevys tortillas never become hard or aerodynamic. Hey, you can't please everybody.
SUPER: CHEVYS FRESH MEX.

96 Gold

(MUSIC: "ZAAR" BY PETER GABRIEL)

SUPER: YOU CAN SAY A STORY WAS FABRICATED. YOU CAN SAY THE JURY WAS CORRUPT. YOU CAN SAY A DOCUMENT IS FALSE. YOU CAN SAY A PERSON IS LYING. YOU CAN EVEN SAY YOU DON'T TRUST NEWSPAPERS. BUT YOU CAN'T SAY WHAT YOU JUST SAW NEVER HAPPENED. TAKE PICTURES. SHOOT A FILM. MAKE A VIDEO. HELP US GIVE CAMERAS TO THE WORLD. EXPOSE INJUSTICE. SHOW US WHAT'S WRONG WITH THE WORLD. AND MAYBE WE CAN MAKE IT RIGHT.

SUPER: WITNESS.

GOLD, SILVER & BRONZE AWARDS

NON-BROADCAST: CINEMA/VIDEO

97 SILVER
ART DIRECTOR
John Merriman
WRITER
Chris Herring
AGENCY PRODUCER
Charles Crisp
PRODUCTION COMPANY
Spots Films International
DIRECTOR
Tarsem
CLIENT
Smirnoff
AGENCY
Lowe Howard Spink/London

98 BRONZE
ART DIRECTOR
John Wagner
WRITER
Greg Ketchum
AGENCY PRODUCER
Laura Kelley
CLIENT
Earth Communications Office
AGENCY
BBDO/Los Angeles

97 Silver
(SFX: DISTANT PARTY MUSIC)
(SFX: BUZZ AND SNAP)
(SFX: LOUD PARTY MUSIC)
(SFX: FOX SNARLS)
(SFX: FLAMETHROWER)
(SFX: SNAKE HISS)
(SFX: RISING CHORD)
(SFX: DEEP GROWL OF PANTHER)

98 Bronze
(MUSIC: THROUGHOUT)
ANNCR: It's the third planet from the sun. A tiny blue
sphere spinning for a moment in time. A remarkable
place that was kind enough to yield just the right
elements to sustain a phenomenon called life.
Where each creature is as unique as the world we call
home. And a day begins in much the same way for
all. Maybe that's when it crosses your mind. In the
warmth from a ray of sun . . . or the kindness of a
stranger. It occurs to you how one life touches so
many others. And you begin to see how all things are
connected. Like the blood that unites one family.
And you come to realize that mankind did not weave
the web of life. We're merely a strand in it. And
whatever we do to the web . . . we do to ourselves.
On the third planet from the sun.
SUPER: IT'S NOT JUST A PLANET.
SUPER: IT'S HOME.
SUPER: EARTH COMMUNICATIONS OFFICE.
SUPER: IN LOVING MEMORY OF U.S. SENATOR
JOHN HEINZ.

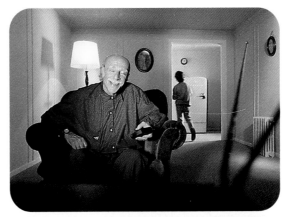

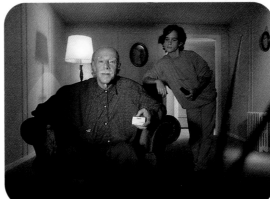

INTERNATIONAL FOREIGN LANGUAGE COMMERCIAL: TELEVISION

99 SILVER
ART DIRECTORS
Johan Gulbranson
Morten Varhaug
WRITER
Oistein Borge
PHOTOGRAPHER
Erik Poppe
AGENCY PRODUCER
Knut E. Jensen
PRODUCTION COMPANY
Leo Film
DIRECTOR
Johan Gulbranson
CLIENT
Braathens S.A.F.E.
AGENCY
N&T Leo Burnett/Oslo

100 SILVER
ART DIRECTOR
German White
WRITER
Hernan Ponce
AGENCY PRODUCER
Luis Pompeo
PRODUCTION COMPANY
Contemporaneos
DIRECTOR
Enrique Meziat
CLIENT
Mastellone HNOS
AGENCY
Young & Rubicam/ Buenos Aires

99 Silver
(A boy dressed in cowboy gear is waiting in the ticket check-in line with his mother. The man behind them diverts their attention by exploding the boy's balloon with his burning cigar, then unnoticeably jumps in front of the line. The boy gets revengeful thoughts. The next thing we know the rude man is apprehended at the security check-point for carrying a gun—it is in fact the boy's toy gun which he snuck into the man's coat pocket at the check-in line.)
SUPER: RELAX. WE'VE GOT LOTS OF FLIGHTS GOING YOUR WAY.
SUPER: BRAATHENS S.A.F.E. THE NORWEGIAN AIRLINE.

100 Silver
(SFX: TELEVISION)
ANNCR: Cindor Shake: chocolate, strawberry and now also caramel. Shake it.

COLLEGE COMPETITION
Assignment: Tourism in
student's home state.

101 **GOLD**
ART DIRECTORS
Mark Cooke
Bryan Hutson
WRITERS
Bryan Hutson
Mark Cooke
PHOTOGRAPHER
Harry DeZitter
COLLEGE
East Texas State
University/Dallas

102 **SILVER**
ART DIRECTOR
Ashby Parsons
WRITERS
Ginnie Read
Gary Pascoe
COLLEGE
Portfolio Center/Atlanta

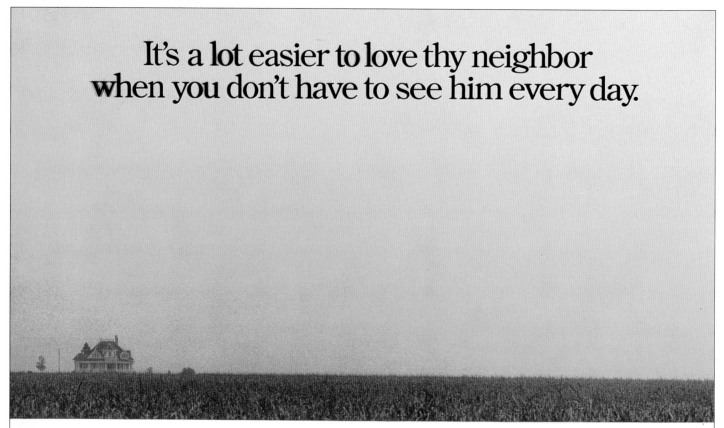

It's a lot easier to love thy neighbor when you don't have to see him every day.

We're a haven for those who value privacy. From the piney woods of the east to the desert prairies in the west, visitors are surrounded by beauty, not people. Texas is a great place to visit, and who knows, you might even want to live here. TEXAS

101 Gold

MICHIGAN IS HOME TO FOUR GREAT LAKES. AND 11,037 PRETTY GOOD ONES.

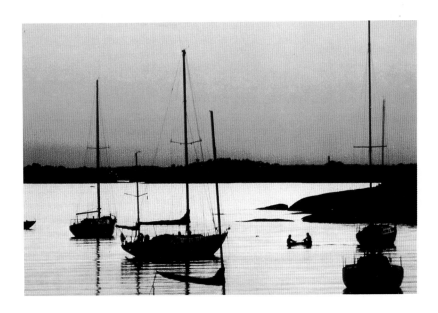

It's tempting to ramble on about the beauty of our state and its endless supply of lakes. But this is one time the movie would be better than the book.

Words can't describe a sunrise along our endless miles of shoreline. The sight of hundreds of spinnaker sails cutting across the horizon. Or the utter silence booming through our forests.

We're called the Great Lake State, but there's more to Michigan than just lakes.

Give us a call at 1-800-543-2937 and we'll send you information filled with more words that don't do Michigan justice. You'll just have to see it for yourself.

M I C H I G A N

GOLD, SILVER & BRONZE AWARDS

COLLEGE COMPETITION
Assignment: Tourism in student's home state.

103 SILVER
ART DIRECTORS
Burnley Vest
Adam Wadsworth
WRITERS
Burnley Vest
Adam Wadsworth
COLLEGE
Portfolio Center/Atlanta

104 BRONZE
ART DIRECTOR
Carol Holsinger
WRITERS
Sally Hogshead
David Huntington
COLLEGE
Portfolio Center/Atlanta

A big ol' igloo farm.
Land of three million lakes.
Home of fertile rain forests and impotent sand dunes.
Mason jar to the wooly mammoth fossil.
Call 1-800-ACRONYM.
Alaska-It's out there.

103 Silver

WITH 25,000 SQUARE MILES OF UNTOUCHED WILDERNESS, IT'S NO WONDER WE WERE NAMED AFTER A VIRGIN.

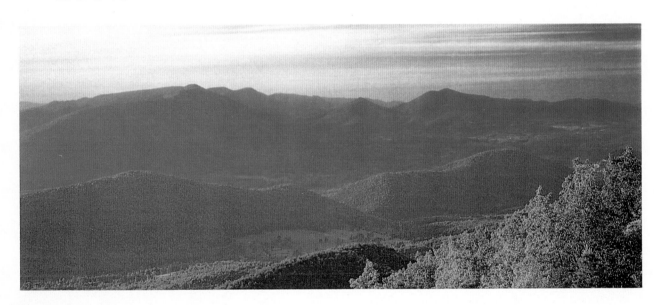

Upon seeing the majestic landscape, English settlers christened their new home Virginia, for Elizabeth I, the Virgin Queen. Much of the land they discovered remains the same today. Unspoiled by traffic and uninhabited by crowds. In short, a land quite innocent of human interference, preserved in the Shenandoah Valley and the Blue Ridge Mountains. Visit the natural splendor of Virginia. A state that lives up to its name. VIRGINIA

104 Bronze

(ALL: SINGING)

CURTIS: *Start spreading the news, I'm leaving today, I want to be a part of it . . .*

JOHN: *New York, New York.*

AMEEN: *I want to wake up in a city that doesn't sleep . . .*

JIM: *And find I'm king of the hill . . .*

JESSE: *Top of the heap.*

JULIUS: *These little town blues, are meltin' away . . .*

TERESA: *I'll make a brand new start of it, in old New York.*

BOB: *If I can make it there, I'll make it anywhere . . .*

SUPER: IT'S UP TO YOU, NEW YORK, NEW YORK.

SUPER: COALITION FOR THE HOMELESS. 695-8700.

IT'S UP TO YOU NEW YORK, NEW YORK.

Best of Show

ART DIRECTORS
Leslie Sweet
Peter Cohen
WRITERS
Peter Cohen
Leslie Sweet
AGENCY PRODUCERS
Leslie Sweet
Peter Cohen
PRODUCTION COMPANY
First Light
DIRECTOR
Laura Belsey
CLIENT
Coalition for the Homeless
AGENCY
**Streetsmart Advertising/
New York**

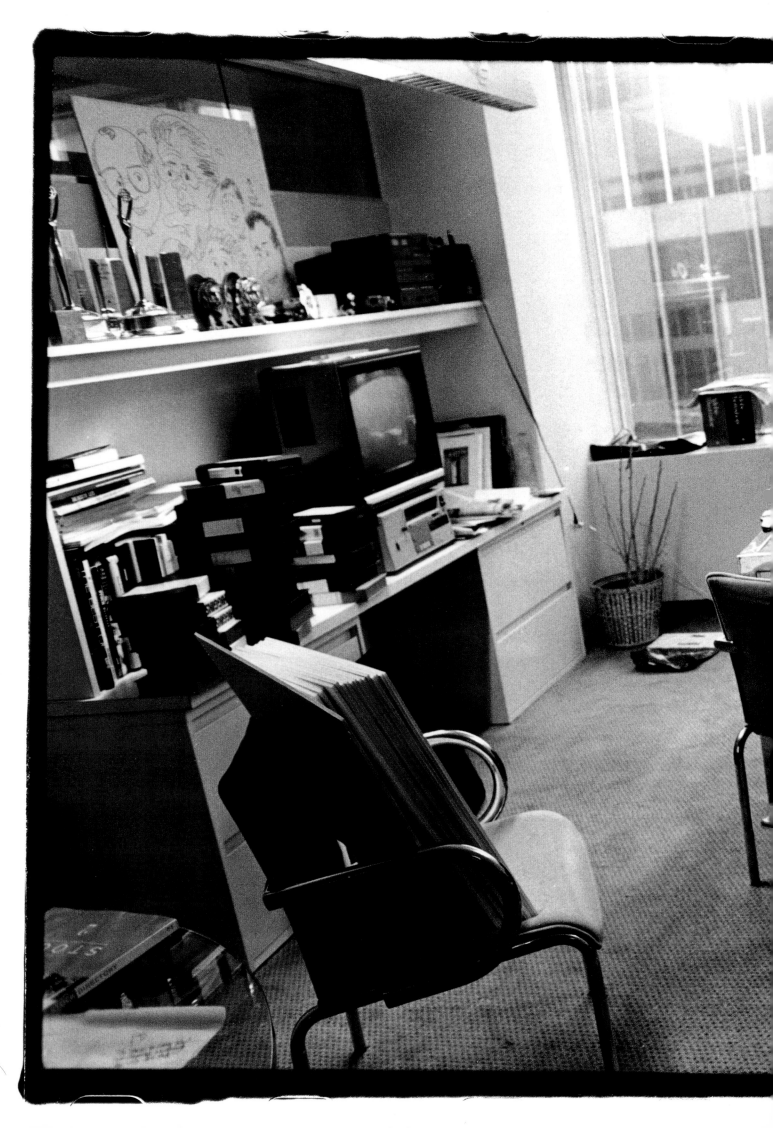

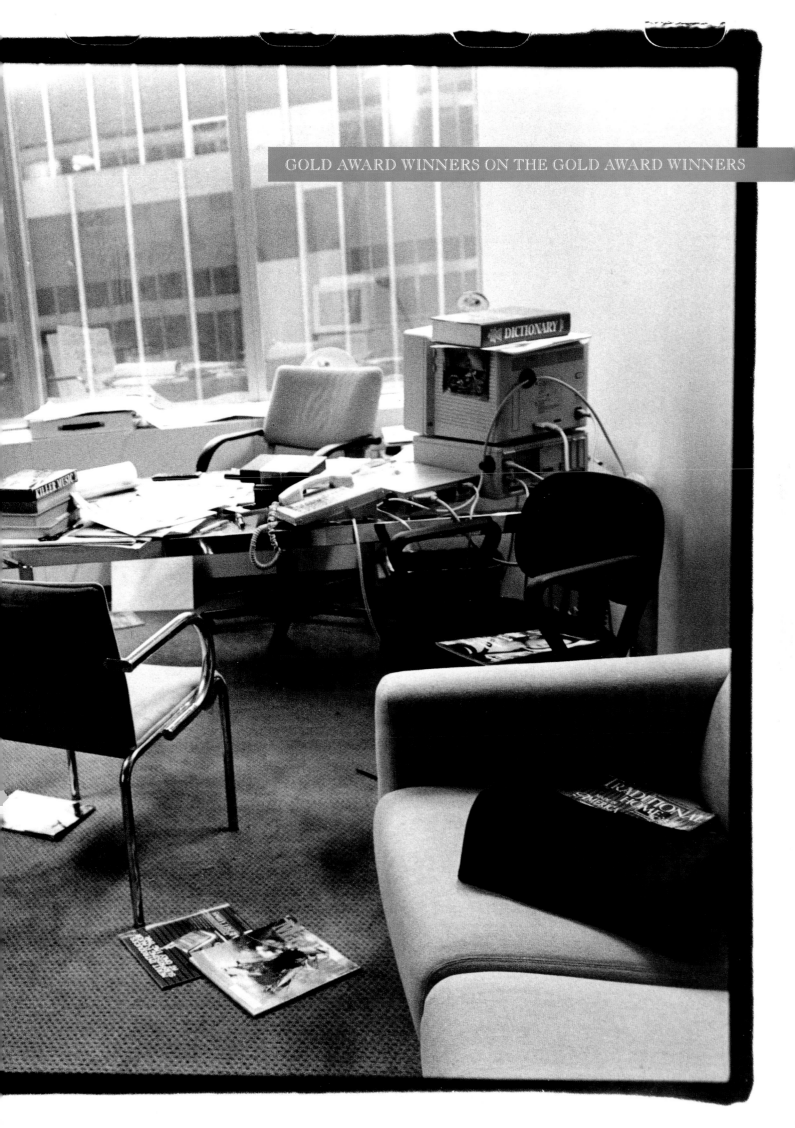

CONSUMER MAGAZINE
COLOR 1 PAGE OR SPREAD: CAMPAIGN

AGENCY
Wieden & Kennedy/Portland
CLIENT
Nike

It's great to be rewarded for work that grew out of a friendship and an endless conversation. It doesn't get much better than that.

*CHARLOTTE MOORE
JANET CHAMP*

17

OUTDOOR: SINGLE and CAMPAIGN

COLLATERAL DIRECT MAIL: CAMPAIGN

AGENCY
The Richards Group/Dallas
CLIENT
Tabu Lingerie

A lot of people like this campaign because we didn't depict women in a sexist manner. (Thank goodness we decided to crop out the naked models holding up the lingerie.)

*TODD TILFORD
VINNIE CHIECO*

I'd like to dedicate this year's awards to Suzanne, the eternal love of my life. These gold pencils are nothing compared to the streets of gold you're walking on now. I'll never forget you.

JEFF HOPFER

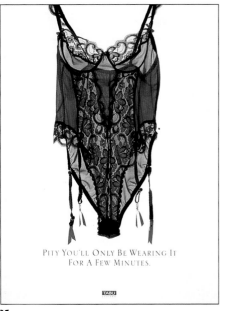

PITY YOU'LL ONLY BE WEARING IT
FOR A FEW MINUTES.

25

CONSUMER NEWSPAPER
OVER 600 LINES: SINGLE

AGENCY
Fallon McElligott/Minneapolis
CLIENT
Jim Beam Brands

We wanted to say it was our writing and art direction that helped this piece garner a gold medal in the One Show. Being that he's our client, however, we have to concur with Booker Noe's explanation. It was the sexy male model.

*SUSAN GRIAK
MIKE LESCARBEAU*

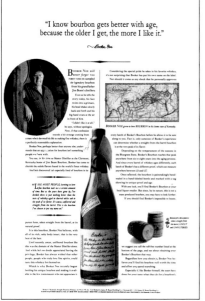

1

CONSUMER NEWSPAPER
OVER 600 LINES: CAMPAIGN

AGENCY
The Martin Agency/Richmond
CLIENT
The Poe Museum

Our meetings with the board of directors of The Poe Museum were filled with talk of dismemberments, insanity and premature details.

Like most client meetings, actually.

*RAYMOND McKINNEY
CLIFF SORAH*

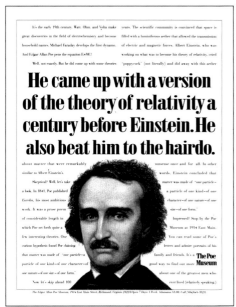

5

TRADE
COLOR 1 PAGE OR SPREAD: SINGLE

TRADE ANY SIZE
B/W OR COLOR: CAMPAIGN

AGENCY
Goodby Berlin & Silverstein/San Francisco
CLIENT
The New Yorker

We read pieces on baseball, Singapore, Vietnam, Greek gods transformed into dogs, buffalo, plant sex, Palio horses defecating on church floors, Billie Holiday, clowns, dead jazz players, live jazz players, Pi, sexual fantasies about dental hygienists, clowns, geology, hemlines, whales, militaristic toys, the Cowboy Junkies, Christopher Columbus, Jesse Jackson, sleep labs, homeless villages in Manhattan, copulating verbs, an English trawlerman arrested for eating live worms ("It's just like spaghetti . . . a quick chomp soon stops them wriggling too much."), the "unadvisability" of L.A., golden monkeys, vertigo, Tom Mix Festivals, Alexander the Great, "life coffins."

Too bad we could pick only three.

STEVE SIMPSON
JEREMY POSTAER

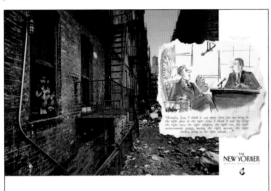

30

CONSUMER MAGAZINE
COLOR 1 PAGE OR SPREAD: SINGLE

AGENCY
Franklin Stoorza/San Diego
CLIENT
Taylor Guitar

Some trees get made into guitars.
And some trees get made into paper which gets made into a magazine which runs an ad which sells guitars.

Our job was to make sure none of the trees died in vain.

JOHN VITRO
JOHN ROBERTSON

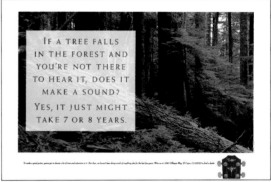

12

**COLLATERAL
DIRECT MAIL: SINGLE**

AGENCY
Ogilvy & Mather Direct/New York
CLIENT
Jaguar Cars

Mention direct mail and everybody runs. But we know it's just another form of advertising. The piece we did for Jaguar could just as well have been an ad or a TV spot—with one exception. It had to produce immediate results.

Well, it sold cars and won a pencil. Now when people start running we have something to throw at them.

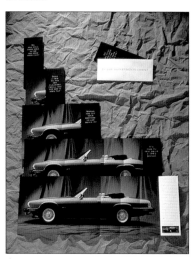

42

**COLLATERAL
P.O.P**

AGENCY
Think Tank/Nanaimo, British Columbia
CLIENT
The Bell Pub

Local police drunk driving roadblocks are a successful means of getting drunks off the street, so I wanted to tie this assignment into the program. But what local ads fail to address is the question, "Well, what about the cops?"

It seems to me you turn a corner, and there they are, quite unexpectedly. From there, the ad wrote itself. I just put it in an unexpected place before the pub's patrons got into their cars.

MICHAEL SUNDELL

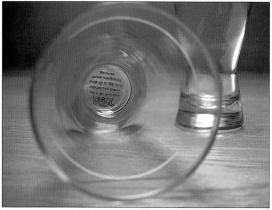

47

COLLATERAL
BROCHURES OTHER THAN BY MAIL

AGENCY
Cole & Weber/Portland
CLIENT
Klein Bikes

Here's how it went.
Klein needed to sell bikes.
Very expensive bikes.
Klein needed advertising.
Klein had no money for advertising.
So how do you sell expensive bikes when you have
no money for advertising?
Spread ads.
Expensive spread ads.
Image ads that make hard-core cyclists feel like you
understand them.
Get ads printed.
Staple ads together.
Call it a catalog.
Simple, huh?

JOE SHANDS
MIKE SHEEN

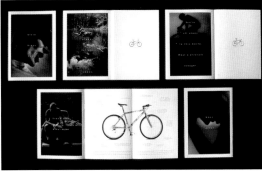

39

PUBLIC SERVICE/POLITICAL
NEWSPAPER OR MAGAZINE: SINGLE and
CAMPAIGN

AGENCY
DDB Needham Worldwide/Chicago
CLIENT
The Lake Michigan Federation

There are serious problems in the Great Lakes.
Like canaries in coal mines, hundreds of plant and
animal species are being profoundly affected, and,
like canaries in coal mines, they serve to indicate
the potential effect on us top-of-the- food-chainers.

The Lake Michigan Federation is an established
water conservation group that has been quietly
helping to preserve the Great Lakes since 1970, and
they felt it was time for them to voice these
concerns more loudly.

We felt by now, readers have grown insensitive to,
if not annoyed by, a lot of the dramatic, harsh or
incomplete public service advertising done over the
last decade, and we wanted to make sure the
impression we made was a credible one. We used
photos of deformity and contamination to educate
rather than shock. The type treatments and
editorial style represented the responsible
personality of The Lake Michigan Federation, while
making a lot of information available and
believable. Basically we wanted to look
trustworthy and we wanted to sound smart. It
seemed a mixture of fact, sense of humor and
insight was the best way to go. From that point,
the facts speak for themselves. We wanted readers
to learn as much as was practical and for them to
form their own opinions.

The visuals were the result of an extensive search
enlisting the charitable cooperation of national
parks, other environmental organizations,
aquariums, scientists, photographers, artists,
fisherman, the EPA, and a sweet old librarian at the
Harold Washington Library.

The Great Lakes make up 20 percent of all the fresh
water in the world. We truly hope this work will
get people interested in how they can help initiate
some changes.

MITCH GORDON
GEORGE GIER

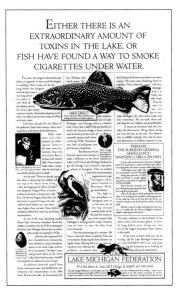

50

**PUBLIC SERVICE/POLITICAL
RADIO: SINGLE and CAMPAIGN**

AGENCY
Hill Holliday Connors Cosmopulos/Boston
CLIENT
The Pine Street Inn

Some people think that sitting down, all alone, with
a blank sheet of paper to write a radio commercial
is the scariest thing in the world.
They're wrong.
The scariest thing in the world is being locked in a
room alone with Stephen King.

The campaign was originally presented to another
client, who threw it out.
But we dug it out of the trash and made use of it.
Somehow that seems particularly appropriate.

*JAY WILLIAMS
JAMIE MAMBRO
BILL MURPHY*
59

**PUBLIC SERVICE/POLITICAL
TELEVISION: SINGLE**

AGENCY
Streetsmart Advertising/New York
CLIENT
Coalition for the Homeless

The most important part of this 60 second
commercial is only four seconds long; so we're
repeating it.

IT'S UP TO YOU NEW YORK, NEW YORK.
COALITION FOR THE HOMELESS. 212-695-8700.

*PETER COHEN
LESLIE SWEET*

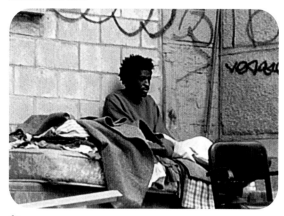

62

PUBLIC SERVICE/POLITICAL TELEVISION: CAMPAIGN

AGENCY
Martin/Williams, Minneapolis
CLIENT
American Humane Association

Who cares how we did these spots. The important thing is, if you're looking for a mature relationship, get an old dog from your local shelter. You'll be getting a veteran of dog life. A connoisseur of fire hydrants. A gourmand of mailmen. A dog-about-town who's outgrown puppy love, your mother's leg and the cute little poodle next door. An old hand (or should we say *old paw*) who'll treat you like the god you really are. And all they'll want in return is a little love and a chance to sniff out the competition now and then. Okay? They're cool. And if people don't adopt them, they're dead.

CHRISTOPHER WILSON
SALLY WAGNER

The more I see of people, the more I like my dog.
— FREDERICK THE GREAT

65

NON-BROADCAST: CINEMA/VIDEO

AGENCY
Chiat/Day, New York
CLIENT
Reebok

Witness is a human rights program, financially backed by Reebok, that helps distribute cameras throughout the world.
It's founded on the principle that pictures of atrocities are far more convincing then telling people about atrocities.
The client wanted a video to introduce this program to the public.
Once we started looking through the footage, we realized how very little we had to add to make it a powerful piece.

ROB SLOSBERG
STEVE MILLER

96

**THE GOLD AWARD WINNERS
ON
THE GOLD AWARD WINNERS**

COLLEGE COMPETITION

SCHOOL
East Texas State University/Dallas

ASSIGNMENT
Print ad promoting student's own state

Bryan and I worked night and day banging our heads against the wall trying to come up with an ad that would somehow do justice to our great, big, proud state. We took the challenge with a sense of duty. After all, we had never seen a decent ad written for Texas (that's not to say that Austin wouldn't be a simply wonderful place to work). Searching for inspiration, we turned to the Bible. Literally. There it was. In black and white. The greatest ad ever written.
We showed our beautiful ad to Bryan's father. He said, "God, that's funny. What does it mean?"
Then we showed it to our professional advertising friends in Dallas. They all seemed to have the same opinion, "I wouldn't put that in my book."
That's when we knew it was perfect.
Thanks for the pencil.
We also want to thank our professor, Rob Lawton, who retires this year (again). This is the fourth time over the past nine years that Rob's students have won the coveted gold pencil. And thanks go to Henry and Gina Popp. Professors like these make ETSU what it is, a great school for advertising/design in an otherwise really backward town.

*MARK COOKE
BRYAN HUTSON*

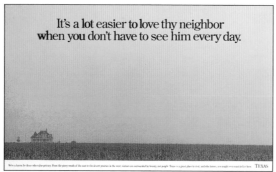

It's a lot easier to love thy neighbor
when you don't have to see him every day.

101

AGENCY
Wieden & Kennedy/Portland

CLIENT
Nike

All the creative work was done 23 years ago.

*MICHAEL PRIEVE
JIM RISWOLD*

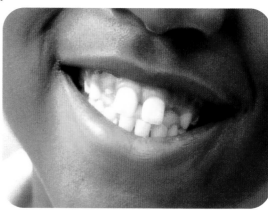

72

**CONSUMER TELEVISION
:30/:25 SINGLE**

AGENCY
DDB Needham Worldwide/New York
CLIENT
New York State Lottery

I wrote and art directed this spot all by myself.
I art directed and wrote this spot all by myself.
Did not.
Did too.
Without me, you're going to be a miserable failure at Chiat.
Without me, you're going to disappear completely at DDB.
Am not.
Are too.

*PAUL SPENCER
DAVID ANGELO*

78

**CONSUMER TELEVISION
:30/:25 CAMPAIGN**

AGENCY
Cliff Freeman & Partners/New York
CLIENT
Little Caesar Enterprises

Last minute production changes were a big factor in the success of these spots. For instance, in the original client-approved board for "Canine Nuptials," the spot was called "Blind Date" and was actually two gerbils meeting in a trendy cafe. The old man on the hospital gurney was originally shot with Harlequin Romance coverboy Fabio. But after focus groups seemed distracted by this, the decision was made to paintbox in an 85-year old man. And in the third spot, instead of a boy wearing X-ray glasses, it was originally supposed to be a rabbi wearing a red hat.

*CLIFF FREEMAN
DONNA WEINHEIM
ARTHUR BIJUR
BRUCE HURWIT
DON AUSTEN
JEFF ALPHIN*

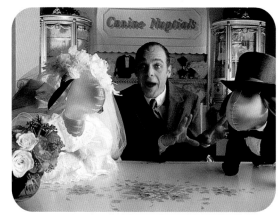

82

**THE GOLD AWARD WINNERS
ON
THE GOLD AWARD WINNERS**

**CONSUMER TELEVISION
:20 AND UNDER SINGLE**

AGENCY
Leo Burnett/London
CLIENT
Guinness Publishing

5 months thinking,
4 hour shoot,
3 second ad,
2 happy creatives,
1 show award.

*BEN WALKER
MAT GOODEN*

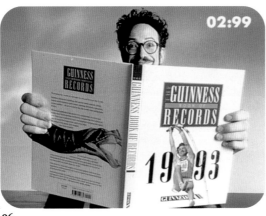

86

**CONSUMER TELEVISION
:20 AND UNDER CAMPAIGN**

**CONSUMER TELEVISION
UNDER $50,000 BUDGET**

AGENCY
Williams & Rockwood/Salt Lake City
CLIENT
The Utah Short Film & Video Center

This is proof that creative advertising works: After
running these spots attendance tripled from the
previous year.
Over forty people showed up.

*DARREN ELWOOD
DAVID HUGHES*

93

**CONSUMER TELEVISION
VARYING LENGTHS CAMPAIGN**

AGENCY
Collett Dickenson Pearce & Partners/London
CLIENT
Scottish & Newcastle Breweries

The list of things people like or hate is infinite.
The hard part of the campaign was squeezing
infinity into 120 seconds.
Thank you for confirming that it can be done.

*NICK HASTINGS
DAVID GODFREE*

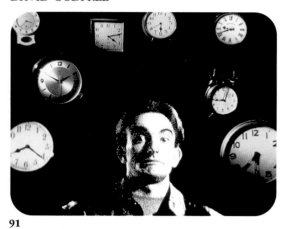

91

**CONSUMER TELEVISION
OVER :30 (:45/:60/:90) CAMPAIGN**

AGENCY
Wieden & Kennedy/Portland
CLIENT
McKenzie River Corporation/Black Star Beer

Honesty isn't always the best policy.

*LARRY FREY
STACY WALL*

75

105
ART DIRECTOR
John Horton
WRITER
Richard Foster
TYPOGRAPHER
Joe Hoza
CLIENT
The Economist
AGENCY
Abbott Mead Vickers.
BBDO/London

106
ART DIRECTOR
Paul Briginshaw
WRITER
Malcolm Duffy
TYPOGRAPHER
Joe Hoza
CLIENT
The Economist
AGENCY
Abbott Mead Vickers.
BBDO/London

107
ART DIRECTOR
Michael Tan
WRITER
Eugene Cheong
CLIENT
Shangri-La Hotel,
Singapore
AGENCY
Batey Ads/Singapore

108
ART DIRECTOR
Michael Tan
WRITER
Eugene Cheong
CLIENT
Shangri-La Hotel,
Singapore
AGENCY
Batey Ads/Singapore

Two thirds of the globe is covered by water.

The rest is covered by The Economist.

105

Not all mind expanding substances are illegal.

The Economist

106

A few real life incidents that are unreal, to say the least.

ON MAY 29, 1986, 12 [school] children in western China were sucked up by a *tornado*. It put them down some 20 km away – completely *unharmed*.

BELIEVE IT OR NOT! Angel Santana, of New York City, escaped unharmed when a robber's *bullet* bounced off his pant's *zipper!*

THE TOMBSTONE PORTRAIT of Springplace, Georgia. A few years after the death of Smith Treadwell an exact likeness of him appeared on his *gravestone.*

PHINEAS P. GAGE of Cavenish, Vermont, survived an explosion that drove a 13-pound *iron rod* right through his brain – he lived another 12 years with a 3½-inch-wide *hole* in his skull!

BEER DRINKERS' DREAM COME TRUE. Yesterday at Xanadu in [the Shangri-La], guests were served as much *beer* as they could consume, *free* of charge! Those who missed last night's *excesses* needn't despair, there'll be another session tonight between 8.30pm and 3am.

[They may sound incredible but every word on this page is genuine.]

In 1942, Lieutenant I.M. Chisov, a [*Russian*] pilot fell **21,980** feet from his fighter plane without a parachute — and *survived*.

A fishy tale. — A mid-air collision between a *fish* and a *jetliner* in Juneau, Alaska, delayed the plane's flight for an hour. The fish was dropped by an *eagle* flying above the jet.

April 2, 1868. A'a Holaua was washed out to *sea* when a *tidal wave* struck his home at Niole, Hawaii, grabbing a plank he *surfed* a 50-foot wave safely to shore.

In 1978, Doug Pritchard, aged **13,** of Lenoir, North Carolina, went to his doctor with a *sore* foot. — He found a *tooth* at the bottom of his instep!

The Pub that serves FREE Beer! This week on Thursday and Friday, **X**anadu (at the *Shangri-La*) will treat *anyone* who steps up to the bar to as much **beer** as they can consume — *free* of charge — until closing time at **3** am.

Features include auto reverse, digital tuning and removable Volkswagen Polo.

Music lovers everywhere. Have we got a stereo radio/cassette for you.
Built to last, it comes with a rigid steel safety cell, crumple zones and side impact bars.
Servo-assisted brakes mean that you shouldn't have any trouble stopping in your tracks. (No pun intended.)
Standard features include a catalytic converter to filter out undesirables.
And a battery that's a little different. It recharges itself.
Fine tuning isn't a problem either. It only needs a major service every 20,000 miles.
It will take you from Mendelssohn to Motorhead or Middlesbrough to Mayfair.
And all at a cost of less than £8,000. If you do want to carry it around though, we suggest leaving the heavy-duty casing parked out in the street. **Polo**

109

RELATIVE TO THE REST OF EUROPE, IT'S EASY TO LOCATE SCOTLAND. WE'RE A FEW DEGREES ABOVE EVERYONE ELSE.

Scotland is easy to find on a map. It's conveniently located in western Europe, in the northern part of Britain.

Geography aside, there is another sure-fire way to distinguish Scotland from other European nations. By examining the people of Scotland and appreciating their penchant for learning.

With more university graduates per capita than any other European nation, you'll find Scotland a land of well-educated people. After all, a quarter of our universities were founded before Columbus discovered America.

With such a heritage, you might expect to find most students engaged in the liberal arts. On the contrary, you'll find every one of our universities awarding degrees in high technology subjects.

Most Scottish universities have their own science park. Glasgow University, for example, is linked to the West of Scotland Science Park. And the University of Edinburgh is currently developing a 2,300-acre site for the Edinburgh Technopole.

There are so many great reasons to locate in Scotland. A few thousand of them will be graduating soon. To learn how they can be of help to your company, call 1-800-THE-SCOT.

LOCATE IN SCOTLAND
INNOVATION RUNS IN OUR BLOOD

Scottish Enterprise

JUST A FEW OF THE INNOVATIVE U.S. COMPANIES WHO'VE LOCATED IN SCOTLAND:

ALDUS
BURR BROWN
CAMPBELL FOODS
COMPAQ
CONNER PERIPHERALS
DIGITAL
W.L. GORE
HEWLETT-PACKARD
HONEYWELL
HOOVER
HUGHES
HYSTER
INMAC
IBM
JOHNSON & JOHNSON
LEVI-STRAUSS
MOTOROLA
NATIONAL SEMICONDUCTOR
NCR
PENNWALT
PLAYTEX
POLAROID
ROHM AND HAAS
SCI
SEAGATE
SUN MICROSYSTEMS
TANDY
TEREX EQUIPMENT
WRANGLER
WYNNS PRECISION

LOCATE IN SCOTLAND, 4 LANDMARK SQUARE, SUITE 500, STAMFORD, CT 06901. US OFFICES ALSO IN HOUSTON, CHICAGO AND SAN MATEO. LOCATE IN SCOTLAND IS THE JOINT INWARD INVESTMENT ORGANIZATION OF SCOTTISH ENTERPRISE (FORMERLY THE SCOTTISH DEVELOPMENT AGENCY) AND THE U.K. GOVERNMENT.

IN A COUNTRY WHERE KNOWLEDGE IS KING, IT'S NO COINCIDENCE THAT OUR UNIVERSITIES RESEMBLE CASTLES.

In the words of Plato, a nation "cultivates whom it honors." These words have particular relevance in Scotland. Here we reserve our highest honors not for athletes and rock stars, but rather for students and professors.

This dedication to education shouldn't be entirely surprising. After all, the world's first compulsory education system was founded here in 1492. What may surprise you is the high number of students pursuing degrees in technical areas. In fact, there are currently 90,000 students studying scientific, engineering, or computer-related subjects in Scotland. In a nation of only 5.1 million people, there are eight world-class universities

and some 70 technical schools from which to choose.

To a company which locates here, this emphasis on education is most valuable. For Scotland consistently has the highest number of university graduates per capita among the nations of western Europe. They, in turn, turn out products of very high quality. For example, a team of scientists at Edinburgh University recently developed an integrated circuit which incorporates all the functions of a video camera on a single silicon chip.

There are so many practical reasons for locating in Scotland. Several thousand of them are graduating soon. To put them to work for you, call 1-800-THE SCOT.

LOCATE IN SCOTLAND
INNOVATION RUNS IN OUR BLOOD

LOCATE IN SCOTLAND, 4 LANDMARK SQUARE, SUITE 500, STAMFORD, CT. 06901. US OFFICES ALSO IN HOUSTON, CHICAGO AND SAN MATEO. LOCATE IN SCOTLAND IS THE JOINT INWARD INVESTMENT ORGANIZATION OF SCOTTISH ENTERPRISE (FORMERLY THE SCOTTISH DEVELOPMENT AGENCY) AND THE U.K. GOVERNMENT.
This material is prepared by Clarke Goward Fitts Matteson, 535 Boylston Street, Boston, MA 02116 which is registered with the Department of Justice, Washington, D.C. under the Foreign Agents Registration Act as an agent of Locate in Scotland, Glasgow, Scotland. This material is filed with the Department of Justice where the required registration statement is available for public inspection. Registration does not indicate approval of the contents of the material by the United States Government.

Scottish Enterprise

JUST A FEW
OF THE INNOVATIVE
U.S. COMPANIES
WHO'VE LOCATED
IN SCOTLAND:
ALDUS
BURR BROWN
CAMPBELL FOODS
COMPAQ
CONNER PERIPHERALS
DIGITAL
W.L. GORE
HEWLETT PACKARD
HONEYWELL
HOOVER
HUGHES
HYSTER
INMAC
IBM
JOHNSON & JOHNSON
LEVI-STRAUSS
MOTOROLA
NATIONAL
SEMICONDUCTOR
NCR
PENNWALT
PLAYTEX
POLAROID
ROHM AND HAAS
SCI
SEAGATE
SUN MICROSYSTEMS
TANDY
TEREX EQUIPMENT
WRANGLER
WYNNS PRECISION

There are two happy days in a boat owner's life. The day they buy a boat. And the day they sell it.

Remember that first day. Friends flocked to you. Everyone packed into your boat and cruised off into the sunset; a blur of motorized machinery and bronzed bodies. You lived the life of a beer commercial. Times change. These days your once-cherished boat lives in the yard while you dream of something a bit more "yachting" in size. Our advice? Perhaps it's time to sell. Call us at 221-8000 and put an ad in the Economy Class Classifieds. We've made it easier than ever. Ads now cost less than $4 a day. And thousands of people see them. So chances are you'll find someone looking for a boat just like yours. They'll drive up, write you a hefty check, and drive away smiling. It'll be the happiest day of their life. And, quite possibly, yours too.

The Oregonian

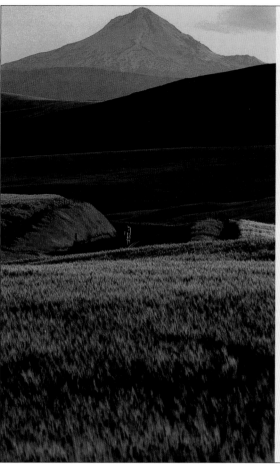

Mountains **can't move.**

Forests can't move.

Lakes, valleys and deserts can't move.

Looks like it's up to **you.**

Your couch will never take you to the rim of Crater Lake. Your stair machine will never climb the Oregon Cascades. Your company will never move you to a grove of Douglas firs. But from Sept. 13 to 19, Cycle Oregon will. $337 covers meals and support staff. 450 scenic miles cover the route. And your handwriting on the line below covers your request for registration. Cycle Oregon Five.

Name _____ Address _____ City _____ State _____ Zip _____

To enter, clip and mail to: Cycle Oregon V, Box 40268, Portland, OR 97240. © 1992 Cycle Oregon V.

113

Something tells us golfers crave attention.

Why the two-tone shoes, argyle-tufted caps and tangerine slacks? Psychologists suspect a deep-seated need to be noticed. Accordingly, we at The Oregonian are now offering golfers their moment of fame. Every Wednesday, we'll be printing winners of local tournaments in our golf pages. Just have your pro call with the results. With a circulation of 340,000, we promise you more attention than even the brightest plaid knickers.

Public and Private Club Tournament Results. Wednesdays in Sports. The Oregonian

114

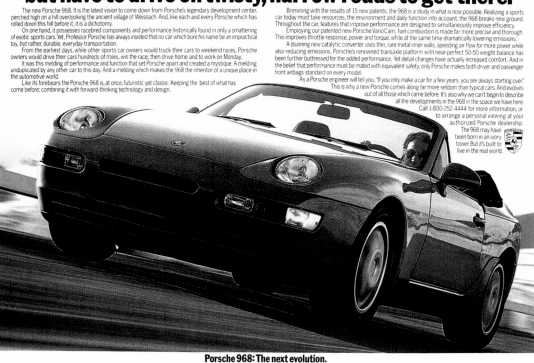

It's what happens when engineers work in an ivory tower but have to drive on twisty, narrow roads to get there.

The new Porsche 968. It is the latest vision to come down from Porsche's legendary development center, perched high on a hill overlooking the ancient village of Weissach. And, like each and every Porsche which has rolled down this hill before it, it is a dichotomy.

On one hand, it possesses racebred components and performance historically found in only a smattering of exotic sports cars. Yet, Professor Porsche has always insisted that no car which bore his name be an impractical toy, but rather, durable, everyday transportation.

From the earliest days, while other sports car owners would truck their cars to weekend races, Porsche owners would drive their cars hundreds of miles, win the race, then drive home and to work on Monday.

It was this melding of performance and function that set Porsche apart and created a mystique. A melding unduplicated by any other car to this day. And a melding which makes the 968 the inheritor of a unique place in the automotive world.

Like its forebears the Porsche 968 is, at once, futuristic yet classic. Keeping the best of what has come before; combining it with forward-thinking technology and design.

Brimming with the results of 15 new patents, the 968 is a study in what is now possible. Realizing a sports car today must take resources, the environment and daily function into account, the 968 breaks new ground. Throughout the car, features that improve performance are designed to simultaneously improve efficiency.

Employing our patented new Porsche VarioCam, fuel combustion is made far more precise and thorough. This improves throttle response, power and torque, while at the same time dramatically lowering emissions.

A stunning new catalytic converter uses thin, rare metal inner walls, speeding air flow for more power while also reducing emissions. Porsche's renowned transaxle platform with near-perfect 50-50 weight balance has been further buttressed for the added performance. Yet detail changes have actually increased comfort. And in the belief that performance must be mated with equivalent safety, only Porsche makes both driver and passenger front airbags standard on every model.

As a Porsche engineer will tell you, "If you only make a car for a few years, you are always starting over." This is why a new Porsche comes along far more seldom than typical cars. And evolves out of all those which came before. It's also why we can't begin to describe all the developments in the 968 in the space we have here.

Call 1-800-252-4444 for more information, or to arrange a personal viewing at your authorized Porsche dealership.

The 968 may have been born in an ivory tower. But it's built to live in the real world.

Porsche 968: The next evolution.

117

There are rational arguments for buying a new Porsche, but we won't bore you with them.

118

Four other car companies have already bought one. Whatever do you suppose they want them for?

The hand-finished paint was hardly dry on our first Porsche 968s before we started hearing the stories. Stories about them going "under the knife."

Granted, it's not unusual for car companies to check out each other's new creations. But it seems that when it's a new Porsche, it gets an inordinate amount of attention. Perhaps that's because a new Porsche doesn't come along every day. Which leaves everyone waiting to see what the automotive world can expect next.

So, what do you suppose they want to know?

They're no doubt interested in how we created the highest torque 3 litre atmospheric engine in the world, with a top speed of 156 mph, but still lowered emissions a dramatic 22%. (Hint: Check out the patented new Porsche VarioCam system that burns fuel more efficiently and thoroughly, and the breakthrough catalytic converter with rare metal inner walls.)

Maybe they covet the secrets of our Tiptronic transmission, the world's first dual function gearbox that allows either full automatic or clutchless manual shifting. (Another hint: Try and get your hands on one of our legendary 962 race cars with PDK transmission in which we developed the concept.)

In total, the Porsche 968 bears the fruit of 15 new patents. Right down to new headlamps that use the principle

of a bee's eyes, as more than 1,000 reflective facets provide variable point focus to cut reflected glare.

Then there are the myriad other racebred concepts and meticulous tuning details. Such as the application of racing style "internal aerodynamics" to speed the flow of air through the body and suspension of the car, reducing drag and providing exceptional cooling for components such as the massive disc brakes with ABS.

The fact is, combining new developments with painstaking refinement we have made the 968 one of the highest performance yet most comfortable Porsches ever. And then fused all of this stunning capability with classic Porsche design and our fabled handcrafting.

So it's little wonder everyone is anxious to see how we accomplished all this. No doubt you'll start seeing simpler versions of 968 ideas crop up sometime in the future in other cars.

Then again, you needn't go to extremes to learn all about the new Porsche 968. Just call 1-800-252-4444 for more information or to arrange a private viewing at your authorized Porsche dealer. We'd love to tell you about it in great detail.

Or, if you're one of our friends who already has a 968 in a few hundred pieces and you have questions, send it to us. We'll put it back together for you.

Porsche 968: The next evolution.

Any car can say they're as good as a Porsche in an ad. On a racetrack it's a bit more difficult.

For the second consecutive year, the Porsche 911 Turbo not only won the IMSA Bridgestone Supercar Championship, it completely dominated it.

Just two years old, the Supercar Series is a return to racing in its purest form: a head to head battle between sportscars that are virtually the same as the ones you can actually buy at your local dealer. In short, it is the race of truth. And the truth is, nothing comes close to a 911 Turbo.

With 332 pounds of torque and 315 horsepower the Turbo not only

has brute force, it has incredible agility and tremendous stopping power. Its legendary 3.6 litre boxer six powerplant, sophisticated new chassis, and gargantuan ABS-fortified disc brakes result in an automobile that goes from 0 to 60 in (don't blink) 4.25 seconds, and stops faster than any production car in the world.

To see the 911 Turbo, or any of its equally impressive siblings at a dealer near you, call 1-800-252-4444. After all, before you look at any of those sportscars that compare themselves to a Porsche you really should see what they're comparing themselves to.

1991 & 1992 IMSA Supercar Champion

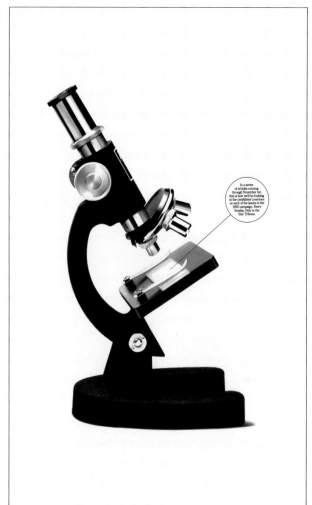

In a series
of articles running
through November 1st,
this is how we'll be looking
at the candidates' positions
on each of the issues in the
1992 campaign. Every
Sunday. Only in the
Star Tribune.

121

Congratulations. You pass. Because that's how little it can
cost to have cellular phone service each month with PacTel.
We call it the Personal Plan. It's only $19.95 a month.
(Which is about what your basic cable TV service will run you these days.)
And the "airtime" — the time you spend on the phone — is priced right, too. For
calls you make during "off-peak" hours (in other words, nights and weekends)
your airtime is only 19 cents a minute.

Take this simple test to see if you can afford a cellular phone. Question #1: Do you have $20?

So, there goes the theory that cellular phones only make sense if you're
some hot-shot Big Cheese type. We came up with the Personal Plan for people
who don't need to use the phone for long periods during the day, but still want
the convenience of a phone sitting right there beside them in the car.

Of course, if you really *are* a hot-shot Big Cheese who's always on the
phone, we've got other pricing plans designed just for you.

In fact, no matter what size Cheese you are, you should talk to us.
PacTel's working hard to make cellular more affordable to everybody.

Give us a call. (619) 535-6400.

A PACIFIC TELESIS COMPANY / ▐ █ █ █ ▌ ━━━━━━━━ **PAC◼TEL.
CELLULAR**

EVEN INSIGNIFICANT
CARTOON FIGURES LIKE US
CAN AFFORD ONE!

122

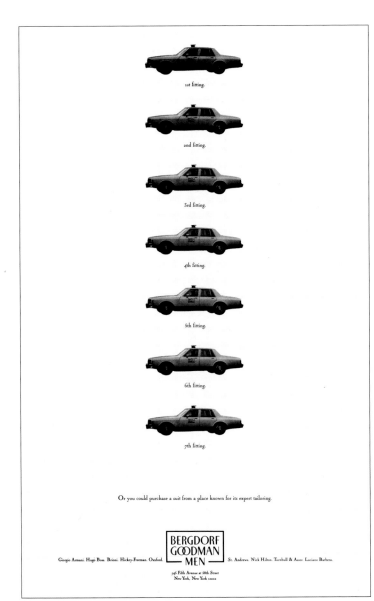

1st fitting.

2nd fitting.

3rd fitting.

4th fitting.

5th fitting.

6th fitting.

7th fitting.

Or you could purchase a suit from a place known for its expert tailoring.

BERGDORF GOODMAN MEN

Giorgio Armani. Hugo Boss. Brioni. Hickey-Freeman. Oxxford. St. Andrews. Nick Hilton. Turnbull & Asser. Luciano Barbera.

745 Fifth Avenue at 58th Street
New York, New York 10022

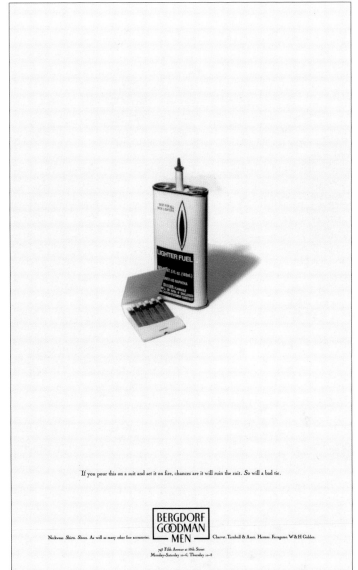

If you pour this on a suit and set it on fire, chances are it will ruin the suit. So will a bad tie.

BERGDORF GOODMAN MEN

Neckwear. Shirts. Shoes. As well as many other fine accessories. Charvet. Turnbull & Asser. Hermes. Ferragamo. W & H Gidden.

745 Fifth Avenue at 58th Street
Monday-Saturday 10-6; Thursday 10-8

123 124

125
ART DIRECTOR
Gary Goldsmith
WRITER
Dean Hacohen
PHOTOGRAPHER
Ilan Rubin
CLIENT
Bergdorf Goodman
AGENCY
Goldsmith/Jeffrey,
New York

127
ART DIRECTOR
Dennis Soohoo
WRITER
Roy Davimes
PHOTOGRAPHER
Karl Steinbrenner
CLIENT
Carolinas Medical Center
AGENCY
Hawley Martin Partners/
Richmond

126
ART DIRECTOR
Woody Lowe
WRITER
Rocky Botts
PHOTOGRAPHER
Jeff Nadler
CLIENT
Saturn Corporation
AGENCY
Hal Riney & Partners/
San Francisco

128
ART DIRECTOR
Rich Wakefield
WRITERS
Peter Sheldon
Lee Sloan
PHOTOGRAPHER
Karl Steinbrenner
CLIENT
Virginia Power
AGENCY
Hawley Martin Partners/
Richmond

It's not how many closets you have. It's what you have in them.

BERGDORF
GOODMAN
MEN

Giorgio Armani. Brioni. Hickey-Freeman. Oxxford. Ferragamo. Turnbull & Asser. Charvet. Joseph Abboud. Ralph Lauren.

546 Fifth Avenue at 56th Street
New York, New York 10011

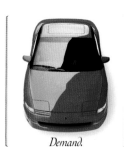

Supply. *Demand.*

Economically speaking, we call this stump the experts.

"It's just another small car in an incredibly crowded market, heading into what could be a really nasty recession," warned a leading auto analyst in an October 25, 1990, *USA Today* article.

What most pundits failed to recognize at the time, however, was our resolve to make a good car. Not the next "most amazing automobile on four wheels," mind you. But a good, well-designed, high-value car. One you might consider, not simply because it was made in America, but because it was clearly a car worthy of your consideration.

Roughly two years later, everything seems to indicate that we are, indeed, making cars that people like. So if you find yourself waiting for one, please bear in mind it's only because we're not willing to rush production and risk building anything other than the best cars we possibly can.

After all, the last thing we want to do is start proving the experts right.

A DIFFERENT KIND OF COMPANY. A DIFFERENT KIND OF CAR.

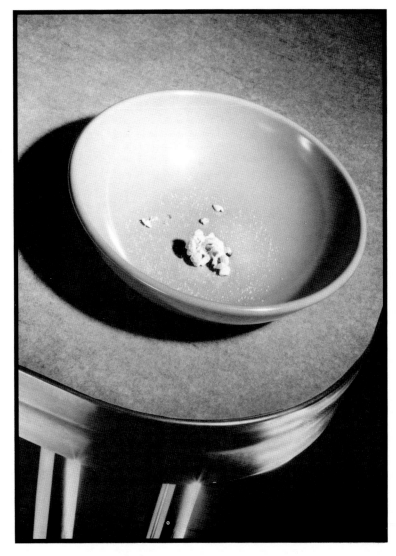

IN A TWO YEAR-OLD'S THROAT, IT BECOMES A CORK.

GRAPES, POPCORN, EVEN A GOOD OLD HOT DOG. A SMALL CHILD CAN CHOKE ON VIRTUALLY ANYTHING. IN AMERICA, CHOKING

IS THE FOURTH LEADING CAUSE OF ACCIDENTAL DEATH IN CHILDREN UNDER THREE YEARS OF AGE. PLEASE BE CAREFUL WHAT

YOU FEED THEM AND IF YOU HAVE TO LEAVE THE ROOM, PUT THE FOOD OUT OF THEIR REACH. IT ONLY TAKES A SECOND.

THE CHILDREN'S HOSPITAL
AT CAROLINAS MEDICAL CENTER

Some Families Are Still Cold At Night Even With The Thermostat Set At 400°.

An open oven door with the thermostat knob turned up full tilt constitutes central heat for too many families in need in the Hampton Roads area. Because, all too often, people who live in housing with inadequate heat and little or no insulation must resort to high-risk methods to keep warm during the winter. Such as ovens. Old space heaters. Even open fires. And sometimes, these unsafe alternatives can lead to tragic results.

But you can make a difference. Every old sweater you donate to the Virginia Power Sweater Recycling Project will make someone's winter a bit warmer and safer.

And while there's a need for sweaters of all sizes, there will be a particularly high demand for infant and toddler sizes in the cold months ahead.

Farm Fresh and WTKR-TV3 have agreed to

help by setting aside a day in September when we can all do our part. Just bring any of your old, but useable sweaters to your local participating Farm Fresh store on Saturday, September 12 between 9 a.m. and 4 p.m. Virginia Power volunteers will be stationed at all collection areas to accept your donations and deliver them to the Salvation Army.

From there, the sweaters will be given to health and human service organizations, churches and schools. These organizations will then distribute them to those with limited resources, families in crisis situations, the elderly, children—anyone in the area facing difficult times.

So please make a small, medium, large or extra large donation to the Virginia Power Sweater Recycling Project. And help share the warmth this winter.

Please Support The Virginia Power Sweater Recycling Project.

VIRGINIA POWER
SWEATER RECYCLING PROJECT

CONSUMER NEWSPAPER
OVER 600 LINES:
SINGLE

129
ART DIRECTOR
Gary Marshall
WRITER
Paul Marshall
PHOTOGRAPHER
Darren Rees
CLIENT
O.M. Scott & Sons
AGENCY
Leagas Delaney/London

130
ART DIRECTOR
Gary Marshall
WRITER
Paul Marshall
PHOTOGRAPHER
Darren Rees
CLIENT
O.M. Scott & Sons
AGENCY
Leagas Delaney/London

131
ART DIRECTOR
Gary Marshall
WRITER
Paul Marshall
PHOTOGRAPHER
Darren Rees
CLIENT
O.M. Scott & Sons
AGENCY
Leagas Delaney/London

132
ART DIRECTOR
Christine Jones
WRITER
Giles Montgomery
PHOTOGRAPHER
John Claridge
CLIENT
Timberland
AGENCY
Leagas Delaney/London

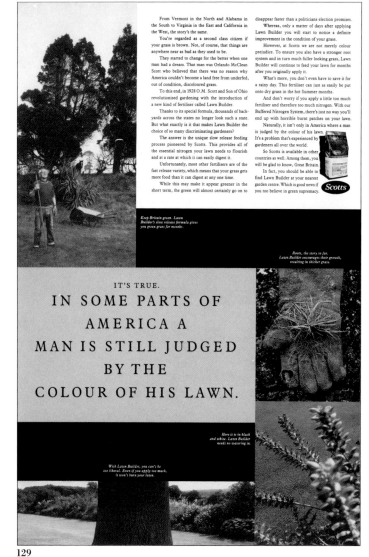

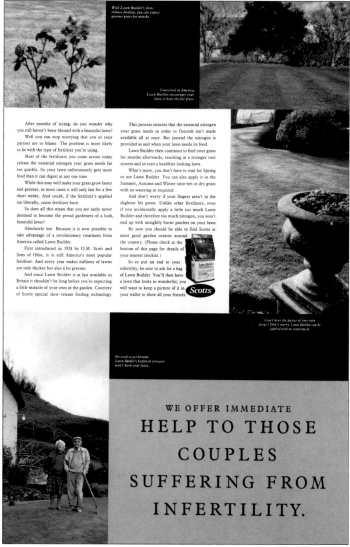

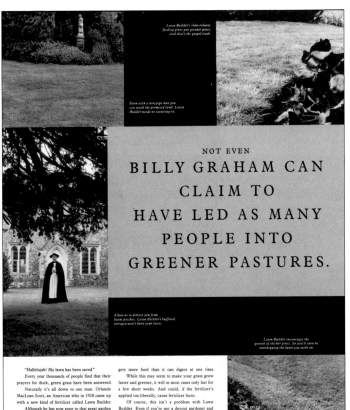

Lawn Builder's slow-release feeding gives you greener grass. And that's the gospel truth.

Even with a hosepipe ban you can reach the promised land. Lawn Builder needs no watering-in.

NOT EVEN
BILLY GRAHAM CAN
CLAIM TO
HAVE LED AS MANY
PEOPLE INTO
GREENER PASTURES.

Allow us to deliver you from burnt patches. Lawn Builder's buffered nitrogen won't burn your lawn.

Lawn Builder encourages the growth of thicker grass. So you'll soon be worshipping the lawn you walk on.

"Hallelujah! My lawn has been saved."

Every year thousands of people find that their prayers for thick, green grass have been answered.

Naturally it's all down to one man. Orlando MacLean Scott, an American who in 1928 came up with a new kind of fertilizer called Lawn Builder.

Although he has now gone to that great garden in the sky, the good work he started back then has been continued by his descendants at O.M. Scott and Sons of Ohio.

Sixty four years after it was first introduced, Lawn Builder is without doubt one of the world's most popular fertilizers. Indeed, it is now helping more gardeners than ever before to convert their lawns into earthly paradises. But what, you may ask, is the reason for this miraculous success? The answer lies in the special slow-release feeding.

This process ensures that the essential nitrogen your grass needs in order to flourish isn't made available all at once. But instead the nitrogen is provided only when your grass needs food.

Lawn Builder then continues feeding your grass, resulting in a stronger root system and in turn a beautiful green lawn you'll still be giving thanks for in the months to come.

Unfortunately, most other fertilizers aren't quite so effective. The trouble is that they are normally of the fast-release variety. Which means that your grass

gets more food than it can digest at one time.

While this may seem to make your grass grow faster and greener, it will in most cases only last for a few short weeks. And could, if the fertilizer's applied too liberally, cause fertilizer burn.

Of course, this isn't a problem with Lawn Builder. Even if you're not a devout gardener and accidentally apply a little too much fertilizer and therefore too much nitrogen, you won't end up with unsightly burnt patches on your lawn.

What's more, you don't even have to pray for the heavens to open to apply Lawn Builder. In fact, you can spread it straight onto wet or dry grass with absolutely no watering-in required.

There's also no need to wait for the arrival of Spring to use Lawn Builder. It can just as easily be applied in Summer, Autumn and Winter.

Hopefully, if you have been using another fertilizer up until now, reading this will have helped you to see the error of your ways.

So that the next time you visit a garden centre you will ask for Scotts Lawn Builder. (Check at the bottom of this page for details of your nearest stockist.)

And if you don't? Then may the Lord have mercy on your grass.

Scotts

131

AT MINUS 80°F YOUR BOOTS CAN DO SOMETHING YOUR BODY CAN'T. KEEP YOUR FEET ALIVE.

There's nothing like a bit of cold weather to demonstrate the merciless nature of Nature. Frostbite doesn't politely wait for you to dress up nice and warm before it attacks. Likewise hypothermia.

Even the human body becomes a little ruthless in order to defend itself.

Below a critical body temperature, the brain orders the blood supply to be diverted from your outer shell to your vital internal organs.

This leaves supposedly non-vital items (you know, odd bits like toes) to fend for themselves.

But while your brain thinks feet are expendable, the brains at Timberland think quite the opposite.

We make boots, shoes and clothing for people who enjoy being in the great outdoors, even at its most unforgiving.

And to ensure that our products can be relied upon under any conditions we have a foolproof test. It's called Alaska.

Every March, this State hosts the Iditarod Trail Sled Dog Race, a 1,049 mile slog through icy tundra, blizzards and life-threatening cold.

And because the competitors, or mushers, have to push themselves and their huskies to the limit, we naturally feel honour-bound to

do exactly the same with our boot-making skills.

The result? A boot which, for the sake of any Alaskan readers, has been tested at -80°F. For everyone else, let's just say that they'll keep your feet well protected in all weathers.

The leathers we use are treated with oils and silicone to make them waterproof.

On the inside of the boot we lavish layers of 3M's renowned Thinsulate insulation.

Then into the outer boot we drop an inner 'boot' consisting of two man-made materials: a layer of Cambrelle to 'wick' away perspiration from the foot and a layer of Gore-Tex to stop moisture entering the boot and robbing the foot of heat.

Can our concern for your well being and the protection of your feet go any further? Is it cold in Alaska?

We add cup stiffeners to the heel and toe sections to guard against knocks.

Insulated double-padded collars are fitted to stop freezing air and ice sneaking in.

And on seams where two rows of stitching might do we use four. Then we seal them with latex, blocking even needle holes to water.

(Why, we'd do anything to avoid incurring the wrath of an Iditarod competitor.

During the 1985 event, one of the female competitors had to single-handedly despatch an angry moose. Think what she'd do to us.)

Fact is, the time we spend in Alaska has helped us solve all kinds of design problems.

It's also helped us deal with a big sore point: boots that don't fit.

The solution? Two roller cinch hooks that allow you to adjust the tension of the laces, and 'mould' the boot to your foot.

With credentials like these, the Iditarod Boot will no doubt be popular wherever ice, snow and the threat of frostbite can be found.

Perhaps you should invest in a pair.

Unless, of course, you have the kind of brain that thinks you don't even need a pair of feet.

Timberland

132

THERE ARE A LOT OF HOT, SWEATY JOINTS IN NEW HAMPSHIRE. THE ANKLE ISN'T ONE OF THEM.

There are some very popular joints in the state of New Hampshire.

Not as many as in New York maybe. Or down in the South, where it gets hotter and sweatier than hades. But that's not surprising.

See, living in a state like New Hampshire with all those mountains, forests, rivers and lakes on your doorstep, folk have plenty to keep themselves busy.

Back-packing, rafting, climbing, trekking, cycling, skiing. Why, people in this part of America practically live in the outdoors.

Which could explain why it's also home to Timberland, the small but legendary boot, shoe and clothing manufacturer.

A company that has people who spend all their waking hours thinking about one joint and one joint only.

No, we don't mean the one on the corner opposite the workshop. We are, of course, talking about the ankle.

Or to give it its technical description: the syndesmosis or fibrous joint comprising the tibia, fibula and talus.

Obviously, Timberland's obsessive interest in this part of your anatomy is utterly selfish.

We do, after all, make a good chunk of our living selling footwear. If we don't know what gives or rather what doesn't give, ankle-wise, our customers could well decide to give us the proverbial boot.

Naturally, we do everything in our power to ensure that while your feet are in our boots they get to enjoy first class hospitality.

Take the Tan Buck, for example, sitting down there in the corner.

To the untutored eye it resembles a good number of boots you see around these days.

But underneath, it's practically a scientific laboratory with a sole attached.

To start with, that innocent looking leather is impregnated with silicone and injected with natural oils and hot waxes. It's one of the reasons we can guarantee the boot 100% waterproof.

Keeping your joints dry is our way of making them feel right at home.

But that doesn't mean that keeping them warm doesn't get our undivided attention. As far as we're concerned this job can't be done using the thick cotton padding that's found in a lot of the other boots currently on the market.

Which is why we use B-400 Thinsulate in the tongue, shaft and quarter. And Ensolite, for extra insulation around the toes.

Sometimes we use even heavier insulation, for example in our high performance Iditarod boot. Then, to stop your feet 'cooking' we utilise another of Man's ingenious inventions.

Gore-Tex is a miracle fabric which has 9 billion pores per square inch, each one 20,000 times smaller than a rain drop but 700 times larger than a molecule of perspiration, thus allowing your foot to breathe.

As a result, your whole foot, will never suffer from overheating. Or get clammy from trapped perspiration.

Of course there's one thing worse than a hot ankle and that's one that is twisted, or, heaven forbid, broken. (According to that incessantly pessimistic tome, 'Sports Injuries' by Doctors Lars Peterson and Per Renström, the ankle is the joint which most often suffers fractures. Don't say we didn't warn you.)

For our part, we've inserted a steel shank along the length of the Tan Buck boot to help keep it rigid, on the basis that if your boot can't twist then neither can your ankle.

The sole is made of a special dual density polyurethane which, apart from being light-weight and hard wearing, has shock absorbing qualities known only to people who've studied our price tags and still bought our boots.

Despite the predictions made by those two doctors we mentioned, the life of an ankle isn't all bad.

For instance, the inside of the Tan Buck is lined with soft glove leather.

And the collar is actually covered in the stuff.

What's more, it's contoured to fit snugly round the top of the ankle to keep out wind, rain and snow.

All in all, we reckon Timberland shows the ankle a pretty good time while it's in our hands. Come to that, our range of Weathergear clothing can probably protect and cosset every other joint in your body too.

Unless, of course, you happen on one of those hot, sweaty places in New Hampshire where people practise involuntary falling over. And then it will take more than a pair of Tan Buck boots to keep you upright.

Timberland ⧫

ONLY THE QUEEN'S BETTER AT ABSORBING SHOCKS.

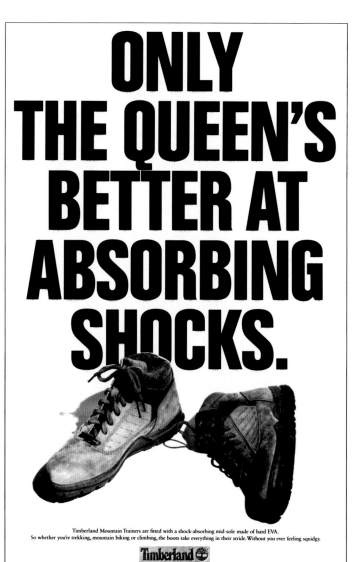

Timberland Mountain Trainers are fitted with a shock-absorbing mid-sole made of hard EVA.
So whether you're trekking, mountain biking or climbing, the boots take everything in their stride. Without you ever feeling squidgy.

Timberland ⧫

IRAN CONTRA, THE PENTAGON PAPERS, WATERGATE. WHO BETTER THAN THE AMERICANS TO KNOW ABOUT LEAKS.

We line our Iditarod boots with waterproof Gore-Tex, seal every seam with latex and inject the leather
with silicone oils and hot waxes. We have to be 100% certain they're 100% waterproof. One leak and we could be finished.

Timberland

We didn't build the best car in the world to let a lousy economy keep you from driving it.

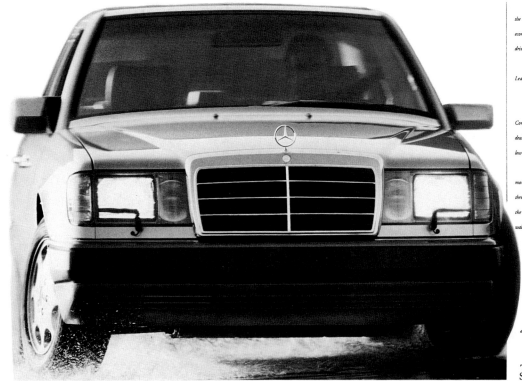

We at Mercedes-Benz simply can't bear the thought of allowing these less than perfect economic times to spoil your opportunity to drive one of our extraordinary cars.

That said, we introduce the Win/Win Lease, provided by Mercedes-Benz Credit

$26,052

Corporation through our local authorized dealers. It doesn't force you to choose between low cost or a shorter term. It offers both.

Take our superb 400 E, for example. Now more of you can experience the exuberant thrust of a light-alloy 4.2 liter multivalve V-8, the luxury of leather upholstery and burl walnut trim, the convenience of an electrically adjustable steering column and cruise control, and, perhaps best of all, the security of both driver- and passenger-side air bags. For more information about the Win/Win Lease and the 400 E, call 1-800-272-7001. Or visit your local authorized Mercedes-Benz dealer.

The Win/Win Lease.
Short term. Less cost.

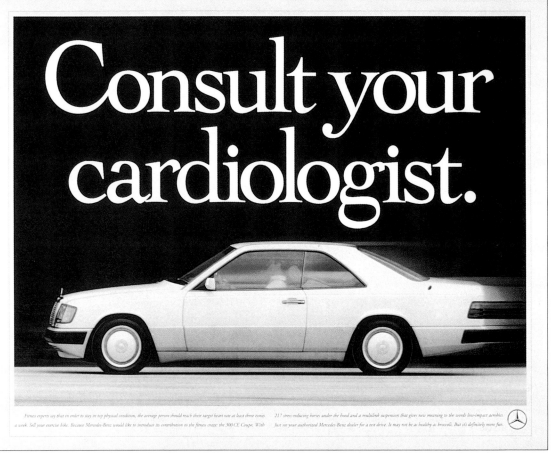

Consult your cardiologist.

Fitness experts say that in order to stay in top physical condition, the average person should reach their target heart rate at least three times a week. Sell your exercise bike. Because Mercedes-Benz would like to introduce its contribution to the fitness craze: the 300 CE Coupe. With 217 stress-reducing horses under the hood and a multilink suspension that gives new meaning to the words low-impact aerobics. Just see your authorized Mercedes-Benz dealer for a test drive. It may not be as healthy as broccoli. But it's definitely more fun.

137

Poe created the detective story back in 1841. (Just think how many butlers would be roaming the streets today if he hadn't.)

It was a dark and stormy night in April 1841. The latest issue of Graham's magazine had just hit the streets. And there, nestled between a verse entitled "An April's Day" and music to "Oh! Gentle Love", appeared a quirky little story called "The Murders in the Rue Morgue".

The publication called it a "tale of ratiocination" (the word "detective" had not been coined yet). Poe understatedly called it "something in a new key."

Something in a new key, indeed. In a few short pages, he created one of the most popular literary (and later film) genres of all time.

The story introduced a scholarly recluse by the name of C. Auguste Dupin who had a "peculiar analytic ability." And he put it to good use by solving a particularly brutal murder that had the local police baffled. (The culprit, incidentally, turned out to be a trained orangutan).

Poe went on to pen three more tales of ratiocination. Not only were they highly entertaining, they also introduced many future clichés to the detective business.

For example, the old crime being committed in a locked room scenario. The frame-up. Postmortem examination and ballistic evidence. The "least likely murderer" ploy. Poe even outfitted Dupin with a pipe.

(The murderous orangutan of "The Murders in the Rue Morgue", while a groundbreaking first, has yet to resurface in any later works.)

Obviously, if you've ever cracked an Agatha Christie novel, flipped on a Columbo movie, or ever played a game of Clue, these plot devices are quite familiar.

In fact, Sir Arthur Conan Doyle, creator of Sherlock Holmes and perhaps Poe's most famous disciple, said that "if every man who owed his inspiration to Poe were to contribute a tithe of his profits therefrom, he would have a monument greater than the Pyramids..."

Alas, not everyone has done so, so we'll have to do with our quaint little Poe Museum. Why don't you come check it out? You can wander through the Old Stone House, Richmond's oldest surviving dwelling, study "The Raven" illustrations and see plenty of other mysterious things.

We could give you the address, but why don't you figure it out for yourself. (Here's a clue-it's right **The Poe** here in Richmond, near Church Hill.) **Museum**

The Edgar Allan Poe Museum, 1914 East Main Street, Richmond, Virginia 23223. Open 7 Days A Week. Admission $5.00. Call (804)648-5523.

138

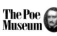

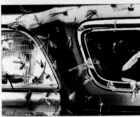

145
ART DIRECTOR
John Boone
WRITER
Ron Huey
PHOTOGRAPHER
Rick Rusing
CLIENT
Beechcraft
AGENCY
**Team One Advertising/
El Segundo, CA**

146
ART DIRECTOR
John Boone
WRITER
Ron Huey
PHOTOGRAPHER
Rick Rusing
CLIENT
Beechcraft
AGENCY
**Team One Advertising/
El Segundo, CA**

147
ART DIRECTOR
Mike Mazza
WRITER
Steve Silver
PHOTOGRAPHERS
**Michael Rausch
Joe Dominic
Richard Leech**
CLIENT
Lexus
AGENCY
**Team One Advertising/
El Segundo, CA**

148
ART DIRECTOR
Miles Turpin
WRITER
Melissa Huffman
PHOTOGRAPHER
Michael Ruppert
CLIENT
Lexus
AGENCY
**Team One Advertising/
El Segundo, CA**

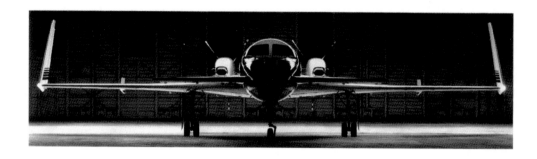

On the thoroughfares of corporate America, an executive's image can fade as quickly as week-old shoe polish. Which may explain why the decision makers of more and more

YOU CAN TELL A LOT ABOUT A C.E.O. BY HIS WINGTIPS. leading companies are con-

sidering the Beechcraft Starship.™ What do they gain? For starters, they have an aircraft that epitomizes the forefront of aerospace technology. Its avionics were inherited from

the newest 747. Its brakes were pioneered on space shuttle flights. And inside, it offers one of the most spacious cabins of any business aircraft going. You'll

Beechcraft
STARSHIP

find these and other distinguishing points detailed in our Starship brochure. To obtain one, simply call 800-835-7767, ext. 682. And let us help you put your best foot forward.

145

146

EXACTLY HOW SMOOTH

IS THE RIDE IN A STARSHIP?

THIS AD WAS WRITTEN IN ONE.

My pen is a Montblanc Meisterstück.™ My paper, a Starwhite Vicksburg Tiara. And my seatbelt is securely fastened. Yet perhaps more pertinent, my writing surface is perfectly still. This is quite amazing considering the world just beyond the window is clipping by at a speed of roughly 335 knots. Now I could easily get

into all the high-tech hoopla that makes this smooth ride possible, but let's face it, you're probably not an aeronautical engineer. (Frankly, neither am I, but as a spokesman for Beechcraft, I've conferred with quite a few of them.) Suffice to say, the Starship's grace is due to several factors. The first being its tandem

wing design, which cushions the severity of wind gusts. Translation: your freshly poured cup of coffee will stay in your cup, not your lap. Here's another reason – the Starship is the only aircraft built almost entirely of carbon fiber composites. The unusual stiffness of composites

gives them the uncanny ability to calm the brunt of say, a malicious and unsuspected air pocket. (Composites are also lightweight and incredibly strong, which does wonders for fuel economy.) The Starship's uncommon level of comfort

also extends to interior points of interest like increased headroom, generous closet space, and plush, handcrafted leather seats. (The latter I can vouch for from current personal experience.) Yet, possibly the most comforting feeling you'll experience in a Starship has little to do with

tandem wings and luxurious leather seats. It's the sensation you get stepping down the staircase to greet a client. If this sounds like something you might enjoy, feel free to call 800-835-7767, ext. 681, for a Starship brochure. The brochure, in case you were wondering, won't be handwritten.

Beechcraft
STARSHIP

Does Your Car Fall Apart This Well?

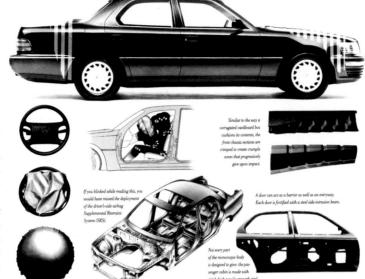

Just before metal meets metal, a car has a host of systems that allow you to take evasive action. The engine, the brakes, the steering—all are at your disposal to help you get out of trouble.

Unfortunately, trouble is not always avoidable. And at the instant of impact and for the next fraction of a second, a number of other systems in your car are there to help defend you.

That is why, in the event of a severe frontal collision (the most common type of accident), the LS 400 is carefully orchestrated to self-destruct. The energy from the crash is

If you blinked while reading this, you would have missed the deployment of the driver's-side airbag Supplemental Restraint System (SRS).

Similar to the way a corrugated cardboard box cushions its contents, the front chassis sections are crimped to create crumple zones that progressively give upon impact.

Not every part of the monocoque body is designed to give: the passenger cabin is made with rigid, high-tensile-strength steel.

A door can act as a barrier as well as an entryway. Each door is fortified with a steel side-intrusion beam.

channelled through what is known as the "crumple zone," which manages much of the impact in order to help protect the driver and passengers.

Indeed, that is the point of all our safety features: to help reduce the risk of injury to you and yours. It is a goal that is impossible for anyone to ever guarantee. But it is a goal to which we are nevertheless committed. So if you are impressed by how well a Lexus is put together, let us assure you of one thing: it falls apart rather impressively, too.

LEXUS
The Relentless Pursuit Of Perfection.

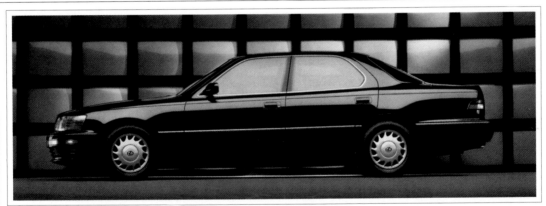

Proof That A Generation Raised On Television Can Still Make Intelligent Decisions.

Despite sociologists' predictions, spending our formative years pasted to the television screen has obviously not stunted our mental growth. In fact, judging by the sales figures of the LS 400, it's actually stimulated it.

After all, what could be a more intelligent, responsible action than purchasing a car that has been rated by the automotive press, time and again, as superior to far more expensive cars? A car that ranked in the Top Ten Models in J.D. Power and Associates' latest Initial Quality Study, receiving the best score in the history of the survey.

All things considered, it's hard to imagine why anyone would want to buy a more expensive luxury car when they could have an LS 400. Maybe they didn't watch enough TV as a child.

Come into your Lexus dealer today for a little more visual stimulation.

Your Lexus Dealer. Pursuing Perfection.

The Mauritius Natural History Handbook lists 174 rare species. Last summer, a visitor spotted Brigitte Bardot.

Many are the delights that await the avid naturalist in Mauritius.

A couple of million years ago, this tiny island parted company with Africa and India.

In retrospect, a wise decision.

For it has remained unscathed by civilisation ever since.

There are still vast tracts of virgin jungle alive with the twittering of rare species of birds.

Lagoons clear as gin, where you can study the seabed if you haven't downed one too many.

Beaches that stretch endlessly without remnants of fast food packaging, where constructing anything taller than a palm tree is considered breach of law.

The waters are abundant with prawns, oysters and lobsters, heavy with the taste of the ocean.

Even the architecture harks back to an unhurried era.

Large Creole houses with wooden verandas, angular roofs and white picket fences.

Many of which could be yours for the season.

Should these material comforts

seem intrusive, you can set sail to any one of our Robinson Crusoe islands that dot the lagoons.

Or visit the Vanille Crocodile Nature Park at Senneville, the southern-most tip of the island.

Or Chamarel, where the earth is displayed in all colours of the rainbow. (Collect it in the morning before the fine powder is dispersed by the wind.)

But perhaps you'd like to lie back on the beach with one of our award winning beers, contemplating other forms of life.

Geena Davis, Princess Caroline of Monaco, and Princess Stephanie.

Call 240047 or write in to the Government of Mauritius Tourism Office, PO Box-1, Bombay 400 001 for a suggested itinerary.

Unless of course you plan to go to Goa.

Where you can spot Uncle Desai, Aunt Agatha and oh my god isn't that Krish from Accounts!

MAURITIUS
99% fun. 1% land.

149

Political assassins. Ruthless mercenaries. Ex Nazis. Frederick Forsyth found them all in Mauritius.

For many years now, we have been monitoring the movements of Mr. Forsyth.

Since 1986, he's been to Mauritius no less than five times.

With each visit, he's turned out a remarkable new bestseller.

Ahem, we said, the plot thickens.

Could there be some connection between the characters he fleshes so well and the palm fringed island near the Tropic of Capricorn?

We did some digging.

Herewith the dossier, gentlemen.

Mauritius is a country with 720 sq. miles and 25 discotheques.

The island is ringed by turquoise lagoons and a spectacular coral reef that keeps the little fish in and the big ones out.

White beaches stretch an average of 2½ miles each. (At the peak tourist season you'll still have a mile to yourself.)

The weather, as always, is a balmy 22°, through most part of the year.

If the inhabitants aren't gambling, they're sailing, windsurfing or fishing.

For respite, they dance the sega on the beach after sunset.

Having whipped up a hearty appetite, they dig into the catch of the day. Fresh lobsters, prawns, clams and oysters are cooked in the native manner.

Which could be French, Indian, Chinese or Creole.

A few things will strike the trained investigator as odd for a tourist paradise.

A distinct absence of highrise hotels. (Regulations forbid anything taller than a palm tree.)

Clear blue waters that are teeming with fish, not fast food debris.

And a complete and utter lack of camera clicking tourists.

But deep as we've delved, the only mystery we've been able to unearth is that of a bird that became extinct 300 years ago.

Material sufficient for 'The Day of the Dodo' perhaps, but not much more.

But then, it's quite possible we have missed out on a few things Mr. Forsyth saw.

Why not check out Mauritius for yourself? There's an Air Mauritius flight that leaves twice a week from Bombay.

For more information, write in to the Government of Mauritius Tourism Office, PO Box—1, Bombay 400 001 or call 240047.

You will hear a click. Wait for the mysterious voice at the other end to say 'Nisha Madan. May I help you?'

MAURITIUS
99% fun. 1% land.

150

Top-left ad

Horrifying Vegetarians Since 1980.

The Post House
New York City

"All that a steakhouse should be..." – *Zagat's*
"The restaurant remains a haunt of dedicated carni-
vores and lobster-grapplers..." – *Gourmet Magazine*
"Steaks and chops seared to juicy perfection."
– *Town & Country*

28 East 63rd Street between Park and Madison Avenues.
For reservations, call (212) 935-2888.

Top-right ad

RARE PORCELAIN, CHINA, BRONZE, SILVER. BUT NO PLASTIC.

It's always satisfying to find that rare, unique old relic; a quaint remnant from the past. Like a shop that doesn't take Visa or MasterCard. But when you do, you could be in for heartache. Because, as much as we as a credit card-offering bank detest admitting it, the fact is that some of the most interesting, fascinating, idiosyncratic old shops – the ones that don't take credit cards – are the ones that sell the most interesting, fascinating, idiosyncratic old things.

Especially, according to Sod's Law, overseas. When you've found the thing you've been looking for for years. Five minutes before the shop closes for the owner to take an extremely well-deserved six month sabbatical. Precisely one thousand three hundred and seventy two miles from anywhere you might just possibly, remotely, perhaps in a million years, stand a chance of getting your hands on some of that stuff of which you are, at this particular point in time, so highly, highly desirous. Specifically: cash.

Shame. Tragedy. Sorrow. Despair. Etc, etc, etc... Unless – (ta-ran-ta-raaa!) – unless you're one of the fortunate, blessed souls who happen to hold a HongkongBank Cheque-Up account.

With Cheque-Up, you get a card called ETC International. (The ETC stands for Electronic Teller Card.) A card that gives you access to more than a hundred thousand ATMs in 50 countries, among them America, Britain, Australia, UAE, Saudi Arabia, China, Bahrain, Macau and even strange, obscure little places like Oman, and Qatar, and Colombia. You can use these ATMs to access your own account at home in Singapore, to withdraw cash and do much more. Everything you can do at an ATM in Orchard Road, in fact, you can do at an ATM in Oman. Everything you can do at an ATM in Shenton Way, you can do at an ATM in Shenzhen. And so on, and so on.

The vast network to which these ATMs belong is called *GlobalAccess*. It means, your astoundingly brilliant mind will have deduced from the name, you have *global access* to your bank account here in Singapore. You'll also have deduced from Cheque-Up's name that you get a cheque book.

And you get interest, calculated daily. The rate, as with any bank's, is subject to change; it's currently at two and three quarter percent. Or, on the off chance that your balance is above ten thousand dollars, you get a slightly more generous three percent. On *all* your money. Which will come in handy.

It will probably mean you can afford the rare silver, porcelain, china or bronze in the first place.

Bottom-left ad

AMERICA, LAND OF THE FREE? FREE WHAT, EXACTLY?

Imagine it. The world has finally come to this. So horrendously expensive are things in the United States these days, even the simple act of spending a penny costs twenty five cents.

Little shocks like this await the unwary traveller on every corner of the streets of the Big Apple. A couple of chilli dogs for you and your good lady wife, for example. Simple, working class food; a New York equivalent of *nasi lemak*. And the change you get from a crisp new ten dollar bill is worryingly less than the change you'd expect to get from a five.

Not that the mean streets of America are at all different from those in the rest of the world. Holidays and business trips anywhere can empty your pockets with astonishing, nay *savage*, ferocity.

So, then, you need cash. Painfully obvious, that.

You've got money stashed in your account in Singapore. Absolute tons of the stuff. Lovely fat wad upon wad of it. But while you're away overseas, it might as well be safely tucked away on Jupiter for all the good it does you. You just can't get to it.

Well. Actually, with one particular account, you can. (You could see this coming a mile off, couldn't you!)

It's called a Cheque-Up account. It's from the good folk at HongkongBank. And it gives you an ATM card, going by the name of ETC International, with which you can access your money all around the world.

Note that: *Your money*. At ATMs in fifty countries, including America, Australia, Hong Kong, Britain, and Thailand; and even places like Oman, and Colombia, and Ecuador, wherever they are. Cheque-Up, as the name implies, gives you a cheque book too. And while you're away seeing places of interest, Cheque-Up is providing another place of interest: your account. Rates are subject to change at the bank's discretion; right now they're two and three quarter percent annually, or three percent for those infuriatingly wealthy souls with balances over $10,000. So the horror of the highly-priced hot dogs is cushioned by a nice surprise when you get back home: your account has been earning you money in your absence. Possibly enough pennies for you to spend for years.

Having a Cheque-Up account means you can feel free in the land of the free. To do as you wish, without running into problems when you run out of cash.

This vast international network, giving you global access to your money, has a name. A rather predictable one, if we're to be honest: it's called *GlobalAccess*. Global access, with one card, to more than a hundred thousand automatic cash machines around the world, all open twenty four hours a day, seven days a week.

It would, of course, be very nice to list every one of them here; but, unfortunately, space restricts.

Unlike a Cheque-Up account.

Bottom-right ad

SOMETIMES YOU'D RATHER THE CARD YOU CARRY DIDN'T MAKE A STATEMENT.

"Dear, oh dear, oh dear, oh dear, oh dear. 'Bad night, that. Of course, the event was securely tucked away in the 'not for public release' section of my personal history. But the wife got her hands on the statement when it arrived, and when she opened it she opened a real can of worms..."

Familiar? Your credit card, which was the key to the great night you had with the boys last month in Hong Kong, also happened to be the key to your undoing: Convenient ammunition for your wife (or, possibly, now ex-wife) to throw a tantrum equivalent to the force of three Hiroshimas.

As you settle down for a comfortable night's sleep on the living room sofa, you may just possibly wish you had a HongkongBank Cheque-Up account.

When you open a Cheque-Up account, you get a lovely little thing; a pocket-sized saviour that goes by the name of ETC International.

ETC International is a card you can use overseas, to access money. Nothing unusual in that. But here's the unusual bit: *The money you access with it is yours*. You can withdraw cash - your own cash - from any of more than a hundred thousand ATMs in 50 countries: USA, Britain, Australia, Saudi Arabia, China, Macau, Qatar, Ecuador, Guam, Oman, Canada, Hong Kong and thirty eight others. You can do it twenty four hours a day, seven days a week; in the process, artfully avoiding cash advance charges and interest fees. And tracing. Because the statements you get (pay attention, now; this is the good bit) feature only how much money you withdraw, and conveniently omit to mention where you spend it.

The money you'll be withdrawing is the money from your own account, here in Singapore, linked magically to that vast, massive, positively *mammoth* global ATM network belonging to HongkongBank.

There are reasons to open a Cheque-Up account other than not wanting to leave a trail, of course.

Through the aforementioned ATM network, you can do much more than get at your money.

In fact, everything you can do at an ATM in Tanglin, you can do at an ATM in Tsimshatsui. Everything you can do at an ATM in Shenton Way, you can do at an ATM in Shenzhen. GlobalAccess, we call it. It means, unsurprisingly, you have *global access* to your account.

Hence the (admittedly predictable) name.

You get a cheque book, too. And you get interest, calculated daily, at a rate (which is, we should tell you, subject to change at the bank's discretion) of two and three quarter percent; or three percent on your entire balance if it's above ten thousand dollars.

What you don't get, though, are charges for cash advances, or interest fees. Or revealing statements.

CONSUMER NEWSPAPER
OVER 600 LINES:
CAMPAIGN

153
ART DIRECTOR
Michael Tan
WRITER
Eugene Cheong
CLIENT
Shangri-La Hotel
Singapore
AGENCY
Batey Ads/Singapore

154
ART DIRECTOR
Robert Rich
WRITER
Michael Sheehan
ILLUSTRATOR
Rob Bolster
PHOTOGRAPHER
Mike Ryan
CLIENT
Locate in Scotland
AGENCY
ClarkeGowardFitts
Matteson/Boston

AMAZING BUT TRUE STORIES
[They may sound incredible but every word on this page is genuine.]

In 1942, Lieutenant I.M. Chisov, a [*Russian*] pilot fell **21,980** feet from his fighter plane without a parachute—and *survived*.

A fishy tale. — A mid-air collision between a *fish* and a *jetliner* in Juneau, Alaska, delayed the plane's flight for an hour. The fish was dropped by an *eagle* flying above the jet.

April 2, 1868. A'a Holaua was washed out to *sea* when a *tidal wave* struck his home at Niole, Hawaii, grabbing a plank he *surfed* a 50-foot wave safely to shore.

In 1978, Doug Pritchard, aged **13,** of Lenoir, North Carolina, went to his doctor with a *sore* foot. — He found a *tooth* at the bottom of his instep!

The Pub that serves FREE Beer! This week on Thursday and Friday, Xanadu (at the *Shangri-La*) will treat *anyone* who steps up to the bar to as much **beer** as they can consume — *free* of charge — until closing time at 3 am.

STRANGE OCCURRENCES
A few real life incidents that are unreal, to say the least.

ON MAY 29, 1986, 12 [school] children in western China were sucked up by a *tornado.* It put them down some 20 km away – completely *unharmed.*

BELIEVE IT OR NOT! Angel Santana, of New York City, escaped unharmed when a robber's *bullet* bounced off his pant's *zipper!*

THE TOMBSTONE PORTRAIT of Springplace, Georgia. A few years after the death of Smith Treadwell an exact likeness of him appeared on his *gravestone.*

PHINEAS P. GAGE of Cavenish, Vermont, survived an explosion that drove a 13-pound *ironrod* right through his brain – he lived another 12 years with a 3½-inch-wide *hole* in his skull!

BEER DRINKERS' DREAM COME TRUE. Yesterday at Xanadu in [the Shangri-La], guests were served as much *beer* as they could consume, *free* of charge! Those who missed last night's *excesses* needn't despair, there'll be another session tonight between 8.30pm and 3am.

BELIEVE IT OR NOT
Printed on this page are facts that'll give both fiction and fantasy a run for their money

Mokele-Mbembe ~ A dinosaur-like beast has been *sighted* several times in the [African] Congo's Lake Telle by many people, including members of a scientific expedition. †† According to scientists it could be the world's *last surviving dinosaur.*

The blood of lobsters is ~ BLUE.

The human brain has the storage capacity of a pile of 5¼-inch floppy disks five thousand, eight hundred miles high.

The White Bone Pagodas of Liangchow. The *bones* of more than A MILLION MEN who fell during the Mohammedan Rebellion were *ground* into the building material to erect these towers. †† Friend and foe are mingled in this huge memorial.

Fachi, a city and fortress in the Sahara Desert is built entirely of SALT.

A paradise for beer-lovers ~ TODAY and TOMORROW, people who visit Xanadu (at the Shangri-La) will be in for a pleasant surprise. †† They can drink *all the beer they want* — and not pay a cent! †† (8.30pm to 3am.)

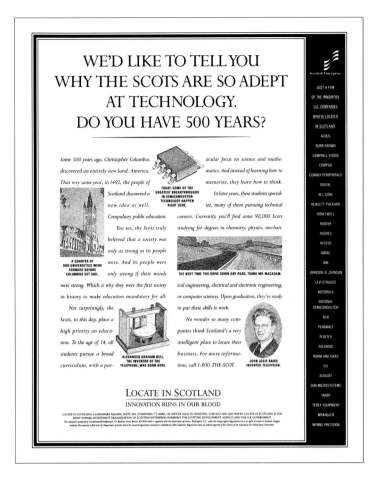

WE'D LIKE TO TELL YOU WHY THE SCOTS ARE SO ADEPT AT TECHNOLOGY. DO YOU HAVE 500 YEARS?

Some 500 years ago, Christopher Columbus discovered an entirely new land. America. That very same year, in 1492, the people of Scotland discovered a new idea as well. Compulsory public education.

You see, the Scots truly believed that a society was only as strong as its people were. And its people were only strong if their minds were strong. Which is why they were the first society in history to make education mandatory for all.

Not surprisingly, the Scots, to this day, place a high priority on education. To the age of 14, all students pursue a broad curriculum, with a par-

TODAY, SOME OF THE GREATEST BREAKTHROUGHS IN SEMICONDUCTOR TECHNOLOGY HAPPEN RIGHT HERE.

A QUARTER OF OUR UNIVERSITIES WERE FOUNDED BEFORE COLUMBUS SET SAIL.

ALEXANDER GRAHAM BELL, THE INVENTOR OF THE TELEPHONE, WAS BORN HERE

THE NEXT TIME YOU DRIVE DOWN ANY ROAD, THANK MR. MACADAM.

JOHN LOGIE BAIRD INVENTED TELEVISION.

ticular focus on science and mathematics. And instead of learning how to memorize, they learn how to think.

In later years, these students specialize, many of them pursuing technical careers. Currently, you'll find some 90,000 Scots studying for degrees in chemistry, physics, mechanical engineering, electrical and electronic engineering, or computer sciences. Upon graduation, they're ready to put these skills to work.

No wonder so many companies think Scotland's a very intelligent place to locate their business. For more information, call 1-800-THE-SCOT.

LOCATE IN SCOTLAND
INNOVATION RUNS IN OUR BLOOD

LOCATE IN SCOTLAND, 4 LANDMARK SQUARE, SUITE 500, STAMFORD, CT 06901. US OFFICES ALSO IN HOUSTON, CHICAGO AND SAN MATEO. LOCATE IN SCOTLAND IS THE JOINT INWARD INVESTMENT ORGANIZATION OF SCOTTISH ENTERPRISE (FORMERLY THE SCOTTISH DEVELOPMENT AGENCY) AND THE U.K. GOVERNMENT.

JUST A FEW OF THE INNOVATIVE U.S. COMPANIES WHO'VE LOCATED IN SCOTLAND: ALDUS, BURR BROWN, CAMPBELL FOODS, COMPAQ, CONNER PERIPHERALS, DIGITAL, W.L. GORE, HEWLETT PACKARD, HONEYWELL, HOOVER, HUGHES, HYSTER, INMAC, IBM, JOHNSON & JOHNSON, LEVI STRAUSS, MOTOROLA, NATIONAL SEMICONDUCTOR, NCR, PENNWALT, PLAYTEX, POLAROID, ROHM AND HAAS, SCI, SEAGATE, SUN MICROSYSTEMS, TANDY, TEREX EQUIPMENT, WRANGLER, WYNNS PRECISION

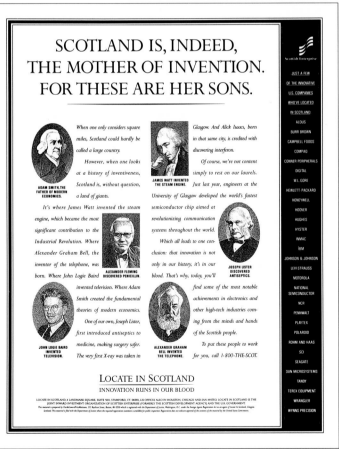

SCOTLAND IS, INDEED, THE MOTHER OF INVENTION. FOR THESE ARE HER SONS.

When one only considers square miles, Scotland could hardly be called a large country.

However, when one looks at a history of inventiveness, Scotland is, without question, a land of giants.

It's where James Watt invented the steam engine, which became the most significant contribution to the Industrial Revolution. Where Alexander Graham Bell, the inventor of the telephone, was born. Where John Logie Baird invented television. Where Adam Smith created the fundamental theories of modern economics. One of our own, Joseph Lister, first introduced antiseptics to medicine, making surgery safer. The very first X-ray was taken in

ADAM SMITH, THE FATHER OF MODERN ECONOMICS.

JAMES WATT INVENTED THE STEAM ENGINE.

ALEXANDER FLEMING DISCOVERED PENICILLIN.

JOHN LOGIE BAIRD INVENTED TELEVISION.

JOSEPH LISTER DISCOVERED ANTISEPTICS.

ALEXANDER GRAHAM BELL INVENTED THE TELEPHONE.

Glasgow. And Alick Isaacs, born in that same city, is credited with discovering interferon.

Of course, we're not content simply to rest on our laurels. Just last year, engineers at the University of Glasgow developed the world's fastest semiconductor chip aimed at revolutionizing communication systems throughout the world.

Which all leads to one conclusion: that innovation is not only in our history, it's in our blood. That's why, today, you'll find some of the most notable achievements in electronics and other high-tech industries coming from the minds and hands of the Scottish people.

To put these people to work for you, call 1-800-THE-SCOT.

LOCATE IN SCOTLAND
INNOVATION RUNS IN OUR BLOOD

LOCATE IN SCOTLAND, 4 LANDMARK SQUARE, SUITE 500, STAMFORD, CT 06901. US OFFICES ALSO IN HOUSTON, CHICAGO AND SAN MATEO. LOCATE IN SCOTLAND IS THE JOINT INWARD INVESTMENT ORGANIZATION OF SCOTTISH ENTERPRISE (FORMERLY THE SCOTTISH DEVELOPMENT AGENCY) AND THE U.K. GOVERNMENT.

JUST A FEW OF THE INNOVATIVE U.S. COMPANIES WHO'VE LOCATED IN SCOTLAND: ALDUS, BURR BROWN, CAMPBELL FOODS, COMPAQ, CONNER PERIPHERALS, DIGITAL, W.L. GORE, HEWLETT PACKARD, HONEYWELL, HOOVER, HUGHES, HYSTER, INMAC, IBM, JOHNSON & JOHNSON, LEVI STRAUSS, MOTOROLA, NATIONAL SEMICONDUCTOR, NCR, PENNWALT, PLAYTEX, POLAROID, ROHM AND HAAS, SCI, SEAGATE, SUN MICROSYSTEMS, TANDY, TEREX EQUIPMENT, WRANGLER, WYNNS PRECISION

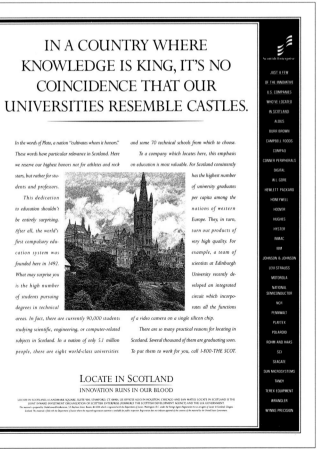

IN A COUNTRY WHERE KNOWLEDGE IS KING, IT'S NO COINCIDENCE THAT OUR UNIVERSITIES RESEMBLE CASTLES.

In the words of Plato, a nation "cultivates whom it honors." These words have particular relevance in Scotland. Here we reserve our highest honors not for athletes and rock stars, but rather for students and professors.

This dedication to education shouldn't be entirely surprising. After all, the world's first compulsory education system was founded here in 1492. What may surprise you is the high number of students pursuing degrees in technical areas. In fact, there are currently 90,000 students studying scientific, engineering, or computer-related subjects in Scotland. In a nation of only 5.1 million people, there are eight world-class universities and some 70 technical schools from which to choose.

To a company which locates here, this emphasis on education is most valuable. For Scotland consistently has the highest number of university graduates per capita among the nations of western Europe. They, in turn, turn out products of very high quality. For example, a team of scientists at Edinburgh University recently developed an integrated circuit which incorporates all the functions of a video camera on a single silicon chip.

There are so many practical reasons for locating in Scotland. Several thousand of them are graduating soon. To put them to work for you, call 1-800-THE-SCOT.

LOCATE IN SCOTLAND
INNOVATION RUNS IN OUR BLOOD

LOCATE IN SCOTLAND, 4 LANDMARK SQUARE, SUITE 500, STAMFORD, CT 06901. US OFFICES ALSO IN HOUSTON, CHICAGO AND SAN MATEO. LOCATE IN SCOTLAND IS THE JOINT INWARD INVESTMENT ORGANIZATION OF SCOTTISH ENTERPRISE (FORMERLY THE SCOTTISH DEVELOPMENT AGENCY) AND THE U.K. GOVERNMENT.

JUST A FEW OF THE INNOVATIVE U.S. COMPANIES WHO'VE LOCATED IN SCOTLAND: ALDUS, BURR BROWN, CAMPBELL FOODS, COMPAQ, CONNER PERIPHERALS, DIGITAL, W.L. GORE, HEWLETT PACKARD, HONEYWELL, HOOVER, HUGHES, HYSTER, INMAC, IBM, JOHNSON & JOHNSON, LEVI STRAUSS, MOTOROLA, NATIONAL SEMICONDUCTOR, NCR, PENNWALT, PLAYTEX, POLAROID, ROHM AND HAAS, SCI, SEAGATE, SUN MICROSYSTEMS, TANDY, TEREX EQUIPMENT, WRANGLER, WYNNS PRECISION

CONSUMER NEWSPAPER
OVER 600 LINES:
CAMPAIGN

155
ART DIRECTOR
Bill Schwab
WRITER
Tom Darbyshire
PHOTOGRAPHER
Michael Maschita
CLIENT
The Savvy Traveler
AGENCY
Earle Palmer Brown/
Bethesda

156
ART DIRECTORS
Nick Scott
Tony Hector
WRITERS
Richard Spencer
Ashley Hempsall
PHOTOGRAPHER
Max Forsythe
CLIENT
Rolls Royce Motor Cars
AGENCY
Edwards Martin Thornton/
London

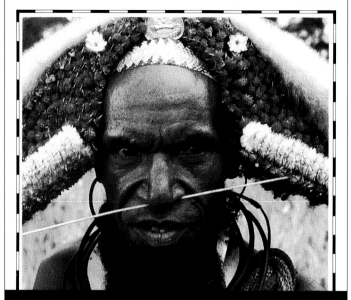

IF COURTESY FAILS, BLUFF HIM. IF BLUFFING FAILS, BRIBE HIM. IF BRIBERY FAILS, SEE PAGE 47.

Our travel books cover every place on earth, from civilized Europe to bizarre destinations like New Guinea and L.A. You'd have to search the globe to find a better selection of maps. And search the map for a better choice of travel gear. Visit soon. Because our travel guides can help you save money. They can help you save face. And sometimes, they can even save your skin. **THE SAVVY TRAVELLER** It's a great big world in here.

50 E. Washington, Chicago, IL, 60602 312-263-2100

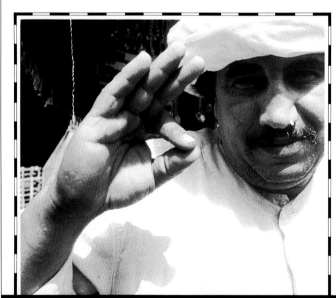

WHEN DOING BUSINESS ABROAD, SMALL GESTURES CAN MEAN A LOT. THIS ONE, FOR INSTANCE, MEANS, "SHOVE IT."

In Indonesia, never pat a child on the head. In Pakistan, never offer your card with your left hand. In Bulgaria, nodding your head means "no." And a gesture that's O.K. at home is definitely not O.K. in Brazil. Fortunately, our travel books, cultural guides, language tapes, maps and globes can help you put your best foot forward. Instead of in your mouth. **THE SAVVY TRAVELLER** It's a great big world in here.

50 E. Washington, Chicago, IL, 60602 312-263-2100

WITH THE PROPER MAP, YOU CAN FIND ANYTHING. PERHAPS EVEN YOURSELF.

If you're looking for some direction in your life, or are simply seeking the road less travelled, then begin your pilgrimage at our store. We offer every imaginable sort of map, plus travel guides for any place on earth you'd desire to go, and even some you wouldn't. So climb every mountain. Ford every stream. Follow every rainbow. But first, get a map. **THE SAVVY TRAVELLER** It's a great big world in here.

50 E. Washington, Chicago, IL, 60602 312-263-2100

155

"I felt a tremendous sensation of power. And then I switched the engine on."

For those used to being in the driving seat, the driving seat of the Bentley Turbo R is the place to be.

It affords a feeling of power that becomes decidedly more tangible when the turbo-charged, inter-cooled V8 engine breathes into life; transporting you from standstill to sixty in something under seven seconds.

And, should you choose to make a takeover bid, you'll find more than enough brake horse power at your disposal. Certainly enough to enjoy life in the fast lane.

Fortunately, stopping is considerably less dramatic, thanks to power braking, while revolutionary suspension and interactive power steering allow you to manoeuvre with astonishing agility.

No wonder so many of the well-heeled put their foot down and insist on the Bentley Turbo R.

BENTLEY MOTORS

There is a Rolls-Royce for those who wish to stay in touch with the real world.

Lower the hood of a Rolls-Royce Corniche IV and you're immediately more at one with the world.

The sights, sounds and smells that now surround you as you cruise along, are those shared by the man in the street, boulevard or Strqße.

Of course, should you not wish to share these ambient delights, simply raise the carefully crafted hood and you'll be in a world of your own. Namely, a rarefied interior so silent you'd hardly believe the engine was running.

You'll know the air-conditioning is on, though. Ceaselessly monitored, the temperature is maintained precisely as you require, whatever the weather.

However, we think you'll prefer the hood down, passing through the madding crowd or getting far from it.

ROLLS-ROYCE MOTOR CARS

Once you own a Rolls-Royce, nothing else will do. But then, nothing else will have to.

Driving your own Rolls-Royce is the experience of a lifetime. Better than that, it's an experience you can enjoy for a whole lifetime, thanks to the enduring quality of our motor cars.

You see, at Rolls-Royce we stint neither on the materials we use nor in the manner in which they are assembled. As a result, two thirds of Rolls-Royce motor cars ever built are still on the road today. Line has to say that of a shame roads aren't made to the same exacting standards.

As the years roll by, you'll really start to appreciate the care and craftsmanship that go into each and every Rolls-Royce. Only then can you begin to understand the beauty of a motor car that makes no claims to be recyclable because it never has to be recycled.

However, the truth is, that although you'll never need anything else once you own a Rolls-Royce, really you'll never want anything else. If you would like to know more about Rolls-Royce motor cars, please telephone 0753 446600.

ROLLS-ROYCE MOTOR CARS

Starting from "a clean sheet of paper" is fine.
If you have nothing worth keeping.

Porsche 968: The next evolution.

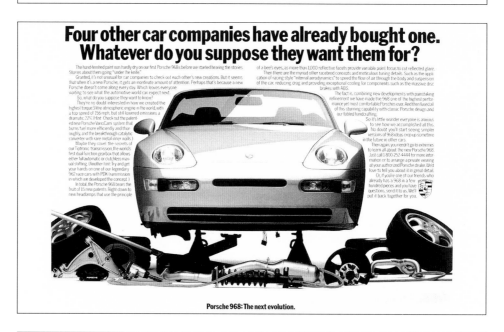

Four other car companies have already bought one.
Whatever do you suppose they want them for?

Porsche 968: The next evolution.

We would have released it sooner,
but we were too busy applying for patents.

Porsche 968: The next evolution.

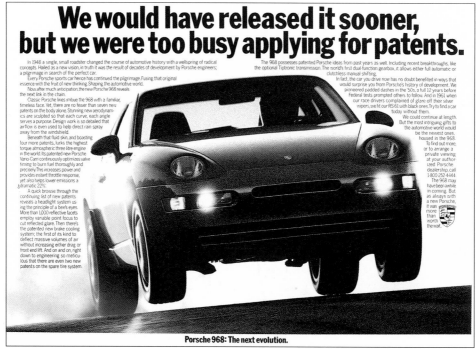

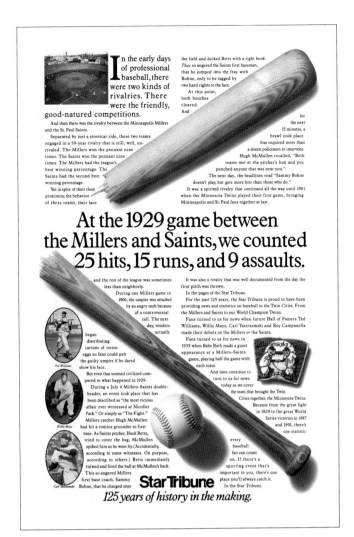

In the early days of professional baseball, there were two kinds of rivalries. There were the friendly, good-natured competitions.

And then there was the rivalry between the Minneapolis Millers and the St. Paul Saints.

Separated by just a streetcar ride, these two teams engaged in a 59-year rivalry that is still, well, unrivaled. The Millers won the pennant nine times. The Saints won the pennant nine times. The Millers had the league's best winning percentage. The Saints had the second best winning percentage.

Yet in spite of their close proximity, the behavior of these teams, their fans

the field and decked Betts with a right hook. *That* so angered the Saints first baseman, that he jumped into the fray with Bohne, only to be tagged by two hard rights to the face.

At this point, both benches cleared. And for the next 15 minutes, a brawl took place that required more than a dozen policemen to intervene.

Hugh McMullen recalled, "Both teams met at the pitcher's box and you punched anyone that was near you."

The next day, the headlines read "Sammy Bohne doesn't play, but gets more hits than those who do."

It was a spirited rivalry that continued all the way until 1961 when the Minnesota Twins played their first game, bringing Minneapolis and St. Paul fans together at last.

At the 1929 game between the Millers and Saints, we counted 25 hits, 15 runs, and 9 assaults.

and the rest of the league was sometimes less than neighborly.

During one Millers game in 1906, the umpire was attacked by an angry mob because of a controversial call. The next day, vendors actually began distributing cartons of rotten eggs so fans could pelt the guilty umpire if he dared show his face.

But even that seemed civilized compared to what happened in 1929. During a July 4 Millers-Saints doubleheader, an event took place that has been described as "the most vicious affair ever witnessed at Nicollet Park." Or simply as "The Fight." Millers catcher Hugh McMullen had hit a routine grounder to first base. As Saints pitcher, Huck Betts, tried to cover the bag, McMullen spiked him as he went by. (Accidentally, according to some witnesses. On purpose, according to others.) Betts immediately turned and fired the ball at McMullen's back. This so angered Millers first base coach, Sammy Bohne, that he charged onto

Ted Williams

Willie Mays

Carl Yastrzemski

It was also a rivalry that was well documented from the day the first pitch was thrown.

In the pages of the Star Tribune.

For the past 125 years, the Star Tribune is proud to have been providing news and statistics on baseball in the Twin Cities. From the Millers and Saints to our World Champion Twins.

Fans turned to us for news when future Hall of Famers Ted Williams, Willie Mays, Carl Yastrzemski and Roy Campanella made their debuts on the Millers or the Saints.

Fans turned to us for news in 1935 when Babe Ruth made a guest appearance at a Millers-Saints game, playing half the game with each team.

And fans continue to turn to us for news today as we cover the team that brought the Twin Cities together, the Minnesota Twins. Because from the great fight in 1929 to the great World Series victories in 1987 and 1991, there's one statistic every baseball fan can count on. If there's a sporting event that's important to you, there's one place you'll always catch it. In the Star Tribune.

Star Tribune
125 years of history in the making.

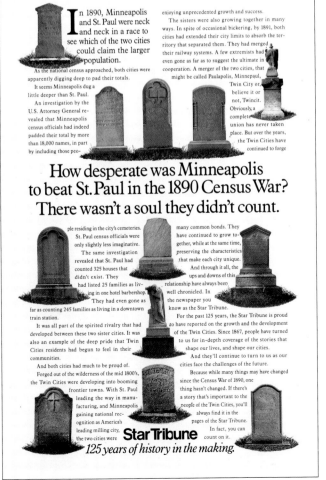

In 1890, Minneapolis and St. Paul were neck and neck in a race to see which of the two cities could claim the larger population.

As the national census approached, both cities were apparently digging deep to pad their totals.

It seems Minneapolis dug a little deeper than St. Paul.

An investigation by the U.S. Attorney General revealed that Minneapolis census officials had indeed padded their total by more than 18,000 names, in part by including those peo-

enjoying unprecedented growth and success.

The sisters were also growing together in many ways. In spite of occasional bickering, by 1891, both cities had extended their city limits to absorb the territory that separated them. They had merged their railway systems. A few extremists had even gone as far as to suggest the ultimate in cooperation. A merger of the two cities, that might be called Paulapolis, Minnepaul, Twin City or, believe it or not, Twincit. Obviously, a complete union has never taken place. But over the years, the Twin Cities have continued to forge

How desperate was Minneapolis to beat St. Paul in the 1890 Census War? There wasn't a soul they didn't count.

ple residing in the city's cemeteries. St. Paul census officials were only slightly less imaginative.

The same investigation revealed that St. Paul had counted 325 houses that didn't exist. They had listed 25 families as living in one hotel barbershop. They had even gone as far as counting 245 families as living in a downtown train station.

It was all part of the spirited rivalry that had developed between these two sister cities. It was also an example of the deep pride that Twin Cities residents had begun to feel in their communities.

And both cities had much to be proud of.

Forged out of the wilderness of the mid 1800's, the Twin Cities were developing into booming frontier towns. With St. Paul leading the way in manufacturing, and Minneapolis gaining national recognition as America's leading milling city, the two cities were

many common bonds. They have continued to grow together, while at the same time, preserving the characteristics that make each city unique.

And through it all, the ups and downs of this relationship have always been well chronicled. In the newspaper you know as the Star Tribune.

For the past 125 years, the Star Tribune is proud to have reported on the growth and the development of the Twin Cities. Since 1867, people have turned to us for in-depth coverage of the stories that shape our lives, and shape our cities.

And they'll continue to turn to us as our cities face the challenges of the future.

Because while many things may have changed since the Census War of 1890, one thing hasn't changed. If there's a story that's important to the people of the Twin Cities, you'll always find it in the pages of the Star Tribune.

In fact, you can count on it.

Star Tribune
125 years of history in the making.

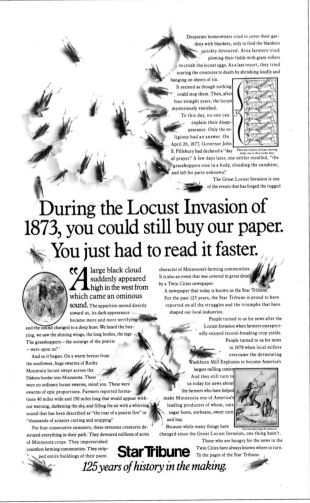

Desperate homeowners tried to cover their gardens with blankets, only to find the blankets quickly devoured. Area farmers tried plowing their fields with giant rollers to crush the locust eggs. As a last resort, they tried scaring the creatures to death by shrieking loudly and banging on sheets of tin.

It seemed as though nothing could stop them. Then, after four straight years, the locust mysteriously vanished.

To this day, no one can explain their disappearance. Only the religious had an answer. On April 26, 1877, Governor John S. Pillsbury had declared a "day of prayer." A few days later, one settler recalled, "the grasshoppers rose in a body, clouding the sunshine, and left for parts unknown."

The Great Locust Invasion is one of the events that has forged the rugged

During the Locust Invasion of 1873, you could still buy our paper. You just had to read it faster.

"A large black cloud suddenly appeared high in the west from which came an ominous sound. The apparition moved directly toward us, its dark appearance became more and more terrifying and the sound changed to a deep hum. We heard the buzzing, we saw the shining wings, the long bodies, the legs. The grasshoppers—the scourge of the prairie — were upon us."

And so it began. On a warm breeze from the southwest, huge swarms of Rocky Mountain locust swept across the Dakota border into Minnesota. These were no ordinary locust swarms, mind you. These were swarms of epic proportions. Farmers reported formations 40 miles wide and 150 miles long that would appear without warning, darkening the sky, and filling the air with a whirring sound that has been described as "the roar of a prairie fire" or "thousands of scissors cutting and snipping."

For four consecutive summers, these ravenous creatures destroyed everything in their path. They devoured millions of acres of Minnesota crops. They impoverished countless farming communities. They stripped entire buildings of their paint.

character of Minnesota's farming communities. It is also an event that was covered in great detail by a Twin Cities newspaper.

A newspaper that today is known as the Star Tribune.

For the past 125 years, the Star Tribune is proud to have reported on all the struggles and the triumphs that have shaped our local industries.

People turned to us for news after the Locust Invasion when farmers unexpectedly enjoyed record-breaking crop yields.

People turned to us for news in 1878 when local millers overcame the devastating Washburn Mill Explosion to become America's largest milling center.

And they still turn to us today for news about the farmers who have helped make Minnesota one of America's leading producers of wheat, oats, sugar beets, soybeans, sweet corn and hay.

Because while many things have changed since the Great Locust Invasion, one thing hasn't.

Those who are hungry for the news in the Twin Cities have always known where to turn. To the pages of the Star Tribune.

Star Tribune
125 years of history in the making.

159

ART DIRECTOR
Paul Norwood
WRITER
Jeff Huggins
ILLUSTRATOR
Greg Dearth
CLIENT
Teledyne Water Pik/
Instapure Water Filter
AGENCY
Foote Cone & Belding/
San Francisco

160

ART DIRECTOR
Gary Goldsmith
WRITER
Dean Hacohen
ILLUSTRATOR
Chris Wormell
CLIENT
J.P. Morgan
AGENCY
Goldsmith/Jeffrey,
New York

You've Just Stumbled Upon A Pristine, Rushing Mountain Stream. Beneath The Falls, You Find A Small, Tranquil Pool. You Reach Down And Scoop Up A Handful Of Cold, Clear Water...

An Oaken Barrel, Left Standing In The Rain, Full To The Top With The Glistening Water Of Countless Spring Showers. You Reach Down Into The Cold, Still Water And With Both Hands, Lift It Toward Your Mouth...

You Run Through The Grass, Barefoot And Laughing, Just As You Did Years Ago. When You Reach The Well, You Hold Out Your Hands And Pump The Cold, Gushing Water Into Your Palms...

Instapure Water Filters TELEDYNE WATER PIK

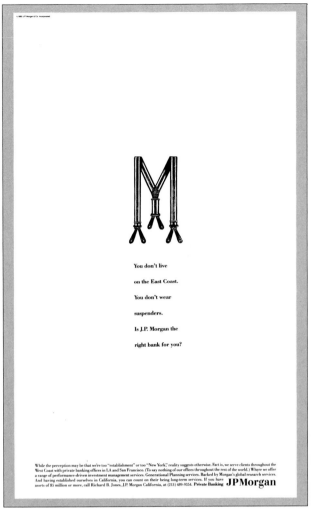

You don't live

on the East Coast.

You don't wear

suspenders.

Is J.P. Morgan the

right bank for you?

While the perception may be that we're too "establishment" or too "New York," reality suggests otherwise. Fact is, we serve clients throughout the West Coast with private banking offices in LA and San Francisco. (To say nothing of our offices throughout the rest of the world.) Where we offer a range of performance-driven investment management services. Generational Planning services. Backed by Morgan's global research services. And having established ourselves in California, you can count on their being long-term services. If you have assets of $5 million or more, call Richard B. Jones, J.P. Morgan California, at (213) 489-9354. **Private Banking** **JPMorgan**

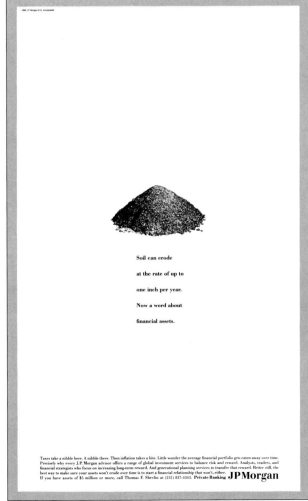

Soil can erode

at the rate of up to

one inch per year.

Now a word about

financial assets.

Taxes take a nibble here. A nibble there. Then inflation takes a bite. Little wonder the average financial portfolio gets eaten away over time. Precisely why every J.P. Morgan advisor offers a range of global investment services to balance risk and reward. Analysts, traders, and financial strategists who focus on increasing long-term reward. And generational planning services to transfer that reward. Better still, the best way to make sure your assets won't erode over time is to start a financial relationship that won't, either. If you have assets of $5 million or more, call Thomas F. Shevlin at (212) 837-4343. **Private Banking** **JPMorgan**

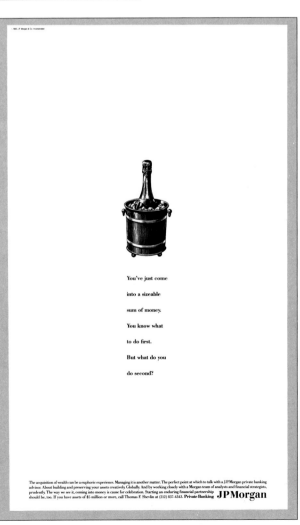

You've just come

into a sizeable

sum of money.

You know what

to do first.

But what do you

do second?

The acquisition of wealth can be a euphoric experience. Managing it is another matter. The perfect point at which to talk with a J.P. Morgan private banking advisor. About building and preserving your assets creatively. Globally. And by working closely with a Morgan team of analysts and financial strategists, prudently. The way we see it, coming into money is cause for celebration. Starting an enduring financial partnership should be, too. If you have assets of $5 million or more, call Thomas F. Shevlin at (212) 837-4343. **Private Banking** **JPMorgan**

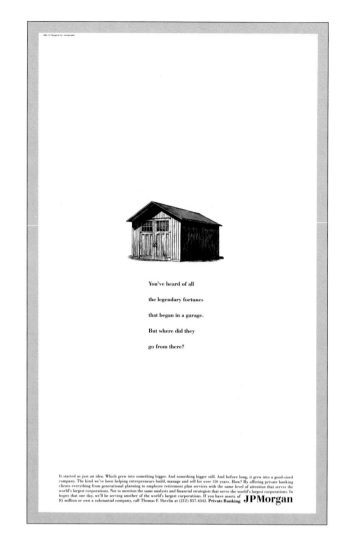

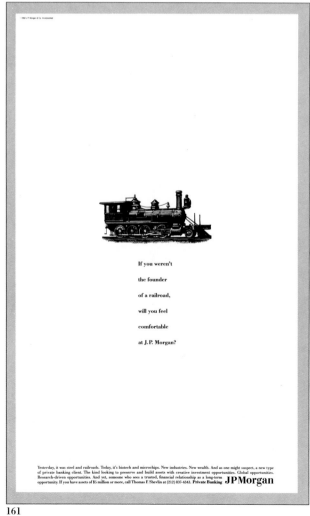

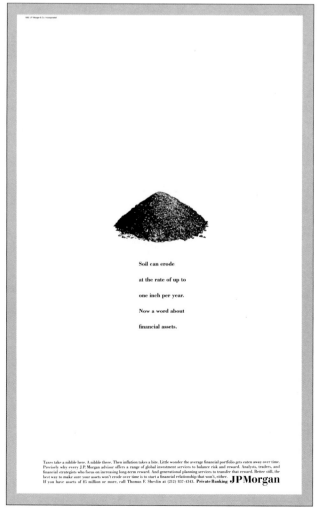

On holiday as you lounge around what was supposed to be an Olympic sized swimming pool set amongst 60 acres of lush tropical foliage what will you be reading? The Guardian has a few suggestions. Because every day until August 21st, we will be publishing extracts from a selection of some of this summers most critically acclaimed new books. None of which we're sure will be left half finished. If only the same could be said of your hotel.

*The***Guardian**

Read the greatest piece of holiday fiction since the description of your hotel.

Ask Paddy Ashdown, Pamella Bordes, or any member of the Royal Family. As the law stands, what you do in your private life is between you and twenty-six million newspaper readers. Would a Privacy bill provide some much needed protection for the individual? Or would it simply be an undemocratic restriction on press freedom? Stephen Cook discusses the issues in this Monday's Guardian. Make sure there's a copy on your doorstep.

*The***Guardian**

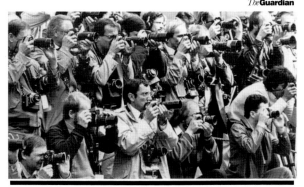

Not everyone likes to wake up and find the newspapers on their doorstep.

After four years of being held captive in Beirut, Brian Keenan finally saw the light of day. Two years later so has his story. You can read the first part in the new Weekend Guardian next Saturday. It reveals the continuous beatings, torture and humiliation he had to endure at the hands of Islamic Jihad. And how a sense of humour and his friendship with cellmate, John McCarthy helped him do the most remarkable thing of all. Live.

*The***Guardian**

You have to die to go to heaven. Unfortunately, Brian Keenan found the same wasn't true of hell.

162

163
ART DIRECTOR
Christine Jones
WRITER
Giles Montgomery
PHOTOGRAPHER
The Douglas Brothers
CLIENT
Marie Stopes
AGENCY
Leagas Delaney/London

164
ART DIRECTOR
Christine Jones
WRITER
Giles Montgomery
PHOTOGRAPHER
Tom Mulvee
CLIENT
Timberland
AGENCY
Leagas Delaney/London

MOOD SWINGS,
IRRITABILITY, SHORT TEMPER.
MENOPAUSAL WOMEN
PUT UP WITH A LOT FROM
THEIR DOCTORS.

MARIE STOPES HEALTH CLINICS

IN 1967 AN ACT
OF PARLIAMENT MADE
ABORTION LEGAL.
WHY IS IT STILL A CRIME?

MARIE STOPES HEALTH CLINICS

THERE'S AN
INTIMATE PART OF A WOMAN
THAT MOST DOCTORS
ARE RELUCTANT TO CHECK.
HER MIND.

MARIE STOPES HEALTH CLINICS

IN HAMPTON, NEW HAMPSHIRE IT'S NOT JUST THE MEN WHO GET WELL OILED.

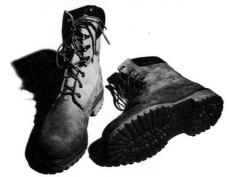

Before we make our Tan Buck boots, we make sure the premium full grain leather gets well and truly soaked in water-resisting silicone oils. This way, at least you know your feet will never be the worse for wear.

FOLLOWING IN THE FOOTSTEPS OF THE G.I.'S, ANOTHER BUNCH OF AMERICANS WHO ARE BRINGING NYLONS TO BRITAIN.

Introducing Nylon Weathergear by Timberland. It comes with mesh ventilation gussets, a Teflon water-repellent finish and a £99 price tag. So you could well find yourself over-indulged, over-protected, over here.

IRAN CONTRA, THE PENTAGON PAPERS, WATERGATE. WHO BETTER THAN THE AMERICANS TO KNOW ABOUT LEAKS.

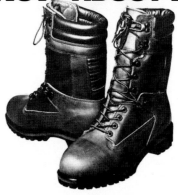

We line our Iditarod boots with waterproof Gore-Tex, seal every seam with latex and inject the leather with silicone oils and hot waxes. We have to be 100% certain they're 100% waterproof. One leak and we could be finished.

164

The nose of the average hotel concierge has been known to turn 3mm north at the sight of any visitor who happens to fall below his rather regal expectations.

Which is quite amusing, really. Except on those few (or not so few) occasions when *you* happen to be the guest.

After half a day in an airline seat which seems to defy every existing airline advertising claim, this is, perhaps, not the best of welcomes.

Nevertheless, tired and weary, you shrug it off and proceed silently to your room.

At dinner, however, the trial continues. The atmosphere in the restaurant is sombre.

Four waiters hover around your table a trifle too attentively.

(As if in an attempt to make up for the concierge.)

And even a soft, gentle cough is interpreted as a cry for help.

All in all, it's a harrowing experience. But you accept it quietly, along with all the other little annoyances, as part and parcel of "London tradition".

Now, thankfully, you have an option. The Regent, London. The first classic London hotel without the stuffy atmosphere.

A hotel designed with the practical needs of today's business traveller in mind.

So does this mean we're some glassy, glitzy modern structure? Far from it.

What really makes us so special, is that we are a young, irreverent spirit, in a grand hundred-year-old Victorian building.

Above the sprawling courtyard at the entrance, where horse-drawn carriages once waited, we've built an atrium eight storeys high.

Creating one of the most spectacular hotel lobbies in the world. And setting the trend for the rest of the hotel.

The rooms, of course, are equally surprising.

The light, understated and contemporary decor is in stark contrast to the old architecture of the building.

We wouldn't have it any other way.

Because while we've tried to keep all the charming aspects of the old days, we've made sure we haven't forgotten the needs of the modern business traveller.

And let's face it, it's a lot easier to get work done sitting at a desk in a neat, elegant, efficiently

The supercilious concierge.
As examined by The Regent, London.

planned room, than while sitting under the most elaborate curtains in Great Britain.

(Sorry, but it had to be said.)

We must admit that there is one thing about our rooms that's dreadfully old fashioned. The size.

With an average floor area of fifty square metres, our rooms show scant regard for the shortage of space in London today.

As far as technology goes, quite obviously, we've kept pace. So if you'd like to toss away the old quill, we can send up a computer to your room.

Even a fax machine, if you like.

But enough of that. It's not all work and no play at The Regent.

For those interested in keeping their bodies as active as their minds, we have a health spa, gymnasium and swimming pool.

As well as access to twelve tennis courts just down the road.

Well, seeing that you've read this far, perhaps it's time we told you where we are located.

Hold your breath, we're in NW1, near Marylebone station.

Before you yell "not on Park Lane" and turn the page, there are a few things to consider.

For a start, what's so great about Park Lane anyway? Do you really care whether or not you're next to five other hotels?

If you have to get to the heart of the financial district, it's quicker from where we are.

There's less traffic, and there are fewer red lights.

We also have Regent's Park just three minutes away, where you can stroll around and take in some of the freshest air in London.

But don't take our word for all this. Just do us a favour.

The next time you're looking for a hotel in London, make sure you examine The Regent.

For reservations please call - Hong Kong 366 3361. Singapore 737 3555. Toll free: Australia (008) 022 800. Japan 0120 001500. USA & Canada (800) 545 4000. Switzerland 01 302 0876. Sweden 02079 5151. Germany 0130 2332.

The Regent, London, a Regent International Hotel, is located at 222 Marylebone Road, London NW1 6JQ, UK. Telephone: (44 71) 631 8000 Facsimile: (44 71) 631 8080.

Opening December, 1992.

Why is it that from the minute you walk into a hotel in London, you're made to feel as if you are on trial?

First the doorman gives you the once over.

Then the staff at the reception (like a particularly strict jury) size you up.

As you're being shown to your room, a rather aloof bellhop decides to inspect your suitcase to see if it's up to scratch.

And from there on, things get worse. The restaurants are more than a trifle cheerless, and laughter at the dinner table is taboo.

In fact, the overall atmosphere in the hotel is so formal that even when you order room service, you feel compelled to wear a dinner jacket.

Still, you accept it, along with all the other annoyances, as part and parcel of "London tradition".

Now, fortunately, you have an option. The Regent, London.

The first classic London hotel without the typically staid and stuffy atmosphere.

So does this mean our concierge will tell you a few jokes and slap you on the back as you enter our hotel? Not at all.

But you will find that our young, friendly staff are a welcome change from their counterparts.

You could well be wondering by now if we're some glassy, glitzy modern structure?

Nothing could be further from the truth.

We're a grand hundred-year-old building with exquisite Victorian architecture.

Above the sprawling courtyard at the entrance, where horse-drawn carriages once waited, we've built a glass atrium eight storeys high.

Creating one of the most spectacular hotel lobbies in the world. And setting the trend for the rest of the hotel.

The rooms, of course, are equally surprising.

The light, understated and contemporary decor is in stark contrast to the traditional architecture of the building.

We wouldn't have it any other way.

Because while we've tried to keep all the charming aspects of the old days, we've made sure we haven't forgotten the practical needs of the modern business traveller.

And let's face it, it's much easier to get work done sitting at a desk in a neat, elegant, efficiently

Visitors to The Regent, London are permitted to laugh.

planned room, than while sitting under the most elaborate curtains in Great Britain. (Sorry, but it had to be said.)

We must admit that there is one thing about our rooms that's dreadfully old fashioned. The size.

With an average floor area of fifty square metres, our rooms show scant regard for the shortage of space in London. As far as technology goes, quite obviously, we've kept pace.

So if you'd like to toss away the old quill, we can send up a computer to your room.

Even a fax machine, if you like.

But enough of that. It's not all work and no play at The Regent, London.

For those interested in keeping their bodies as active as their minds, we also have a health spa, gymnasium and swimming pool.

As well as access to twelve tennis courts just down the road.

Well, seeing that you've read this far, perhaps it's time we told you where we are located.

Hold your breath, we're in NW1, near Marylebone station.

Before you yell "not on Park Lane" and turn the page, there are a few things to consider.

For a start, what's so great about Park Lane anyway? Do you really care whether or not you're next to five other hotels?

If you have to get to the heart of the financial district, it's quicker from where we are.

There's less traffic, and there are fewer red lights.

We also have Regent's Park just a three minute walk away, where you can stroll around and take in some of the freshest air in London.

But don't take our word for all this. Drop by The Regent and decide for yourself.

Rest assured we'll give you something to smile about.

For reservations please call - Hong Kong 366 3361. Singapore 737 3555. Toll free: USA and Canada (800) 545 4000. Australia (008) 022 800. Sweden 02079 5151. Germany 0130 2332. Switzerland 01 302 0876. Japan 0120 001500.

The Regent, London, a Regent International Hotel, is located at 222 Marylebone Road, London NW1 6JQ. Telephone: (44 71) 631 8000 Facsimile: (44 71) 631 8080.

If it's happened once, it's happened a hundred times.

A guest arrives at a restaurant completely unaware of any dress code.

Then, at the entrance, he is enlightened: "Sorry Sir, gentlemen are required to wear ties in our restaurant."

One would think that at this point, the guest would be politely tossed out. But unfortunately, a more severe punishment is in store for him.

Much to his embarrassment, he is handed an atrocious tie which, even by the wildest stretch of the imagination, cannot be seen to match anything else he is wearing.

Of course, by this time, everyone around is watching, and it's far too late to retreat.

So, after a quick concerted effort to regain lost aplomb, he knots his tie and proceeds to the dinner table.

At The Regent, London, we think it's time to change all this.

We believe that guests shouldn't be inspected like the salad and the soufflé.

Which is why we have created some of the most pleasant places in which to dine.

Where guests will feel as comfortable in casual jackets as they will in tuxedos.

Where the maitre d' will not have a stack of ties hidden behind the cash register.

And where the waiters will not be as stiff as the napkins.

The Dining Room, a classic restaurant, offers some of the best Italian and British cuisine in London.

While the Winter Garden, with its soaring glass atrium, makes a perfect meeting place.

Of course, if you'd prefer to sit in a bar, we have The Cellars, with a truly impressive collection of imported beer, wine and champagne.

The rooms at The Regent, London are, naturally, as surprising as the restaurants.

The light, understated and contemporary decor is in stark contrast to the old architecture of the building.

We wouldn't have it any other way.

Because while we've tried to keep all the charming aspects of the old days, we've made sure we haven't forgotten the practical needs of the modern business traveller.

And let's face it, it's much easier to get work done sitting at a desk in a neat, elegant, efficiently planned room, than while sitting under

What happens if the guest is not dressed as well as the lobster?

the most elaborate curtains in Great Britain.

We must admit, however, that there is one thing about our rooms that's dreadfully old fashioned. The size.

With an average floor area of fifty square metres, our rooms show scant regard for the shortage of space in London these days.

As far as technology goes, quite obviously, we have kept pace. So if you'd like to toss away the old quill, we can send up a computer to your room.

Even a fax machine, if you like.

But enough of that. It's not all work and no play at The Regent.

For those interested in keeping their bodies as active as their minds, we also have a health spa, gymnasium and swimming pool.

As well as access to twelve tennis courts just down the road.

Well, seeing that you've read this far, perhaps it's time we told you where we are located.

Hold your breath, we're in NW1, near Marylebone station.

Before you yell "not on Park Lane" and turn the page, there are a few things to consider.

For a start, what's so great about Park Lane anyway? Do you really care whether or not you're next to five other hotels?

If you have to get to the heart of the financial district, it's quicker from where we are.

There's less traffic, and there are fewer red lights.

We also have Regent's Park just a three minute walk away, where you can stroll around and take in some of the freshest air in London.

But don't take our word for all this. Drop by The Regent and decide for yourself.

And make sure you stay for lunch.

You'll find we have the best dressed salads in town.

For reservations please call - Hong Kong 366 3361. Singapore 737 3555. Toll free: UK (0800) 282 245. USA/Canada (800) 545 4000. Germany 0130 2332. Switzerland 01 302 0876. Sweden 02079 5151. Japan 0120 001500.

The Regent, London, a Regent International Hotel, is located at 222 Marylebone Road, London NW1 6JQ. Telephone: (44 71) 631 8000 Facsimile : (44 71) 631 8080.

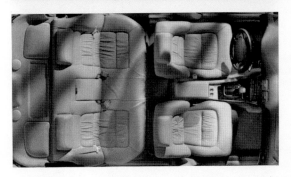
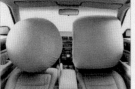 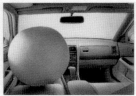

167

168

Luck runs out. Insight doesn't.

Luck is, by definition, a chance commodity. While Barron's is based on something more reliable.

Something called insight, which makes regular appearances in its pages 52 weeks a year. Where the most prescient investors offer their visions of the future, including which emerging companies are poised to become household names.

And because insight is fueled by information, Barron's provides timely data on stocks, bonds, real estate, mutual funds and a multitude of other markets.

As a result, your success depends not on getting lucky, but on getting Barron's. At your newsstand this weekend. Or at 1-800-328-6800, Ext. 322.

BARRON'S
HOW MONEY BECOMES WEALTH.™

YOUR SAAB DEALER'S BRAKE SPECIAL. STOP BY WHILE YOU STILL CAN.

Compromise on the price of your brakes, not on the quality. Get an authentic Saab brake inspection for the price of an imitation.

BRAKE INSPECTION/MODEL
$00.00
(List services included in price.)

SAAB

(Dealer name and address.)

CONSUMER NEWSPAPER
600 LINES OR LESS:
SINGLE

171
ART DIRECTOR
Steve Mitchell
WRITER
Doug Adkins
CLIENT
City Pages
AGENCY
Bozell/Minneapolis

172
ART DIRECTOR
Michael Kadin
WRITER
Eric Springer
PHOTOGRAPHER
Craig Saruwatari
CLIENT
Airporter Inn
AGENCY
DDB Needham
Worldwide/Los Angeles

173
ART DIRECTOR
Bob Barrie
WRITER
Bruce Bildsten
PHOTOGRAPHER
Rick Dublin
CLIENT
Porsche Cars North America
AGENCY
Fallon McElligott/
Minneapolis

174
ART DIRECTOR
Craig Ferguson
WRITER
Craig Ferguson
CLIENT
Ex-Smokers for
Hypnosis
AGENCY
Ferguson/Associates,
Brooklyn

We probe as deeply as the subject matter allows.

Dan Quayle

Some things are easier to discuss intelligently than others. But we manage
to offer insightful, thorough coverage of even the shallowest political issues.
So turn to us for all the latest political cartoons.

CITY PAGES

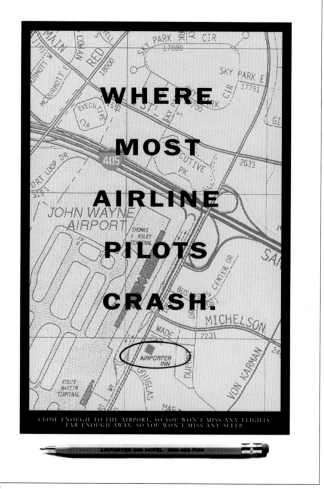

WHERE MOST AIRLINE PILOTS CRASH.

CLOSE ENOUGH TO THE AIRPORT, SO YOU WON'T MISS ANY FLIGHTS.
FAR ENOUGH AWAY, SO YOU WON'T MISS ANY SLEEP.

Now used Porsches are guaranteed for one year or 10 million miles.
(Whichever comes first.)

Our new limited warranty on qualifying pre-owned Porsches covers over 500 components–from engines to headlights. And mileage, as you may have gathered, is unlimited. Ask your Porsche dealer for details.

Porsche Pre-owned Limited Warranty Program.

173

THE INGREDIENT IN NICODERM IS VERY EFFECTIVE.

EXTERMINATORS HAVE BEEN FUMIGATING WITH IT FOR YEARS.

The chemical in Nicoderm is widely used. As an insecticide.
On the other hand, hypnosis is not only 80% effective,
it has no side effects. So try hypnosis.
After all, a cure for smoking shouldn't kill you.

EX-SMOKERS FOR HYPNOSIS
152 West 20th Street, New York, NY 10011

©1992

174

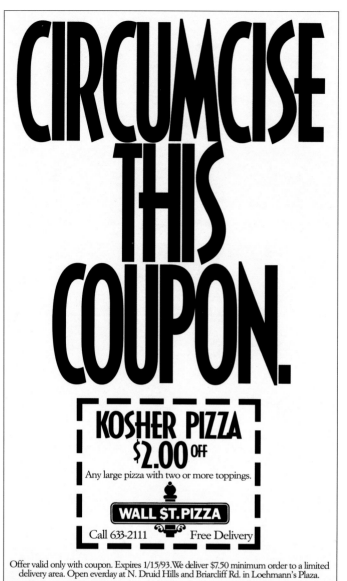

175

176

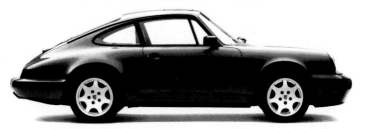

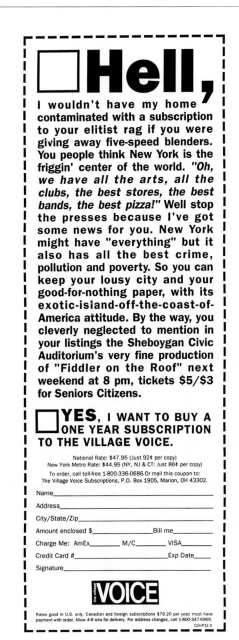

☐ **Hell,**

I wouldn't have my home contaminated with a subscription to your elitist rag if you were giving away five-speed blenders. You people think New York is the friggin' center of the world. *"Oh, we have all the arts, all the clubs, the best stores, the best bands, the best pizza!"* Well stop the presses because I've got some news for you. New York might have "everything" but it also has all the best crime, pollution and poverty. So you can keep your lousy city and your good-for-nothing paper, with its exotic-island-off-the-coast-of-America attitude. By the way, you cleverly neglected to mention in your listings the Sheboygan Civic Auditorium's very fine production of "Fiddler on the Roof" next weekend at 8 pm, tickets $5/$3 for Seniors Citizens.

☐ **YES**, I WANT TO BUY A ONE YEAR SUBSCRIPTION TO THE VILLAGE VOICE.

National Rate: $47.95 (Just 92¢ per copy)
New York Metro Rate: $44.95 (NY, NJ & CT: Just 86¢ per copy)

To order, call toll-free 1-800-336-0686.Or mail this coupon to:
The Village Voice Subscriptions, P.O. Box 1905, Marion, OH 43302.

Name_____

Address_____

City/State/Zip_____

Amount enclosed $_____Bill me_____

Charge Me: AmEx_____ M/C_____ VISA_____

Credit Card #_____Exp Date_____

Signature_____

VOICE

Rates good in U.S. only. Canadian and foreign subscriptions $79.20 per year; must have payment with order. Allow 4-6 wks for delivery. For address changes, call 1-800-347-6969.
D2HP32-0

181

FIRST CLASS SEATS AVAILABLE.

We have liposuction procedures for the front, sides and, of course, the rear. Call 804-481-5151 to set up an appointment for a consultation.

Center for Cosmetic Plastic Surgery

182

IT'S LIKE STANDING ON YOUR HEAD FOR 40 YEARS.

Looking to reverse the effects of gravity? How about a facelift? It sure beats all of that blood rushing to your head. Call 804-481-5151 to set up an appointment for a consultation.

Center for Cosmetic Plastic Surgery

183

We've cleverly disguised this week's guest so you can surprise your kids.

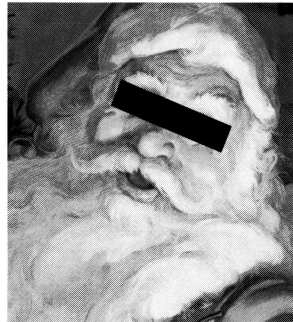

Bring the family to the Symphony as George Manahan and a surprise visitor lead you through Mozart, Handel, popular carols, a sing-a-long, and more. December 4 and 5 at 8 p.m. Call 788-1212 or 782-3900 for ticket information.

The Richmond Symphony

184

Imagine talking to him about your period.

Let's face it, he's never had one. Which means he can't really share your monthly war stories. But we can. We're a group of female physicians specializing in gynecology and family medicine. And while you'll also find women psychologists and nutritionists to help you with PMS, eating less and stress, you won't find anyone discussing jock itch. So call us for an appointment.

Woman To Woman Medical Center 818·346·9600

Not even Hallmark has a card that keeps you healthy.

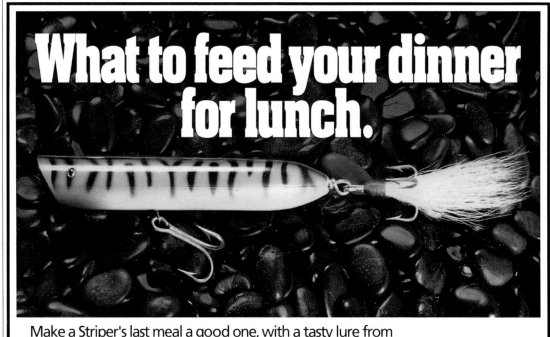

187

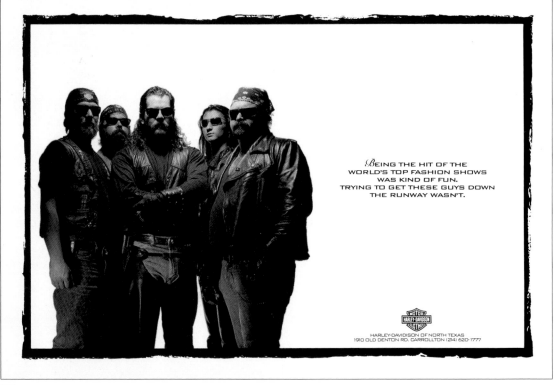

188

189

190

A nice frame can make even a lousy picture look good. To prove it put your driver's license here.

At Gilbert Gallery, we've got big frames. Small frames.
Square frames. Round frames. Ready-made frames. Custom-made
frames. Expensive frames. Not-as-expensive frames.
All kinds of frames that protect, preserve, and accent your prints.

Gilbert Gallery & Framing
191 Lisbon Street, Lewiston, 783-3100.

191

Apparently, Amnesty International hasn't stamped out all forms of torture.

What kind of a mind does it take to think up these forms
anyway? Robert Felsenfeld knows, he used to work for the IRS.
But now he'll work for you. Revenge is sweet, isn't it?

Robert Felsenfeld, CPA

23120 Alicia Pkwy·Suite 212·Mission Viejo, CA 92692 (714)583-0662

192

193

CONSUMER NEWSPAPER
600 LINES OR LESS:
CAMPAIGN

194
ART DIRECTOR
Bob Barrie
WRITER
Bruce Bildsten
PHOTOGRAPHERS
Shawn Michienzi
Vic Huber
CLIENT
Porsche Cars North America
AGENCY
Fallon McElligott/
Minneapolis

195
ART DIRECTOR
Nick Cohen
WRITERS
Shalom Auslander
Mikal Reich
CLIENT
Village Voice
AGENCY
Mad Dogs & Englishmen/
New York

Honestly now, did you spend your youth dreaming about someday owning a Nissan or a Mitsubishi?

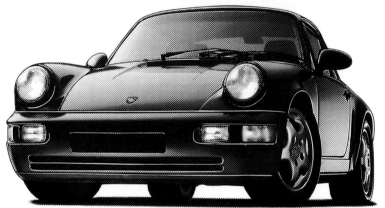

There is still only one car that looks, feels, and performs like a Porsche 911: a Porsche 911. It is the one sportscar that manages to be both timeless and ahead of its time. And we're now making it very affordable for you to drive one. After all, we know how many decades you've waited.

PORSCHE®

Haven't you made enough rational decisions in your life?

PORSCHE

It's not politically correct. (What better reason is there?)

PORSCHE

196
ART DIRECTOR
Sean Riley
WRITER
Joe Alexander
ILLUSTRATION
Stock
PHOTOGRAPHER
Dean Hawthorne
CLIENT
The Richmond Symphony
AGENCY
The Martin Agency/
Richmond

197
ART DIRECTOR
Everett Young Wilder
WRITER
Todd Tilford
PHOTOGRAPHER
Julio Castaner III
CLIENT
Auto Exam
AGENCY
The Richards Group/Dallas

This is the 8-ball in your

dad's basement that's sitting on top of the

pool table that's never been

completely balanced until last

Christmas Eve when you gave your dad

the book "Crab Grass: The Root of all Evil"

and he put it under the left front leg. Try

Richmond Symphony Gift Certificates

this year. Only $7 and up. Call 788-1212.

This is Wilbur, your

next door neighbor's dog who loves to chase

cars, play catch with your red

frisbee, sleep on the porch,

and attach himself to your husband's leg

every time he wears that cheap cologne you

gave him last year for Christmas. Try

Richmond Symphony Gift Certificates

this year. Only $7 and up. Call 788-1212.

This is a moth, order

Lepidoptera, who's been living inside your

wife's dresser inside the top

right hand drawer inside the pair of

dark magenta wool socks with the ducks

flying in tight formation that you gave

her last year for Christmas. Try

Richmond Symphony Gift Certificates

this year. Only $7 and up. Call 788-1212.

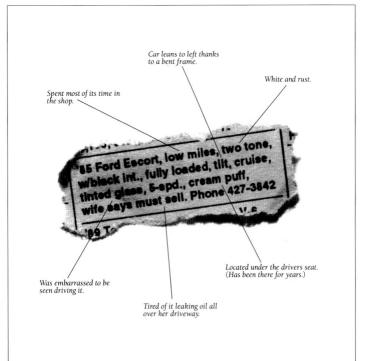

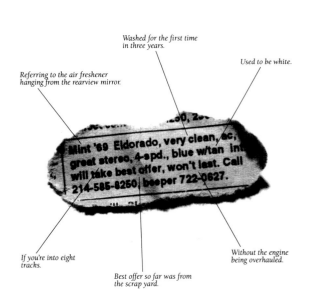
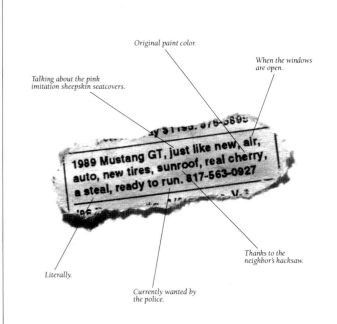

CONSUMER NEWSPAPER
600 LINES OR LESS:
CAMPAIGN

198
ART DIRECTOR
Bryan Burlison
WRITER
Todd Tilford
PHOTOGRAPHER
Richard Reens
CLIENT
Harley-Davidson of Texas
AGENCY
The Richards Group/Dallas

199
ART DIRECTORS
Eric Tilford
Bryan Burlison
WRITER
Todd Tilford
CLIENT
The Spy Factory
AGENCY
The Richards Group/Dallas

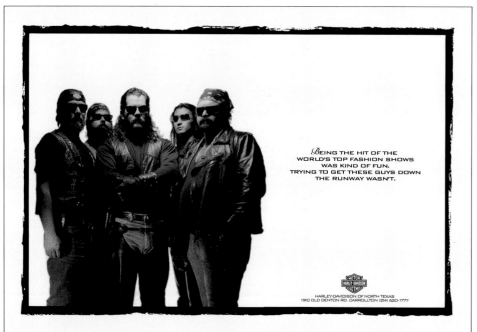

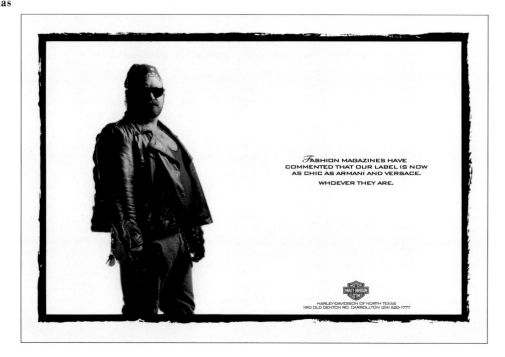

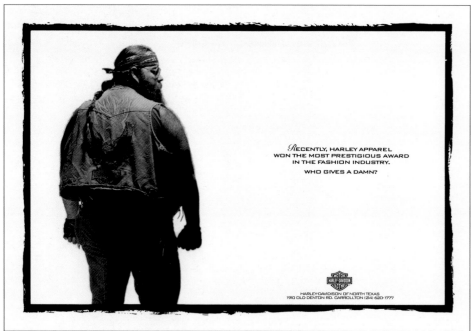

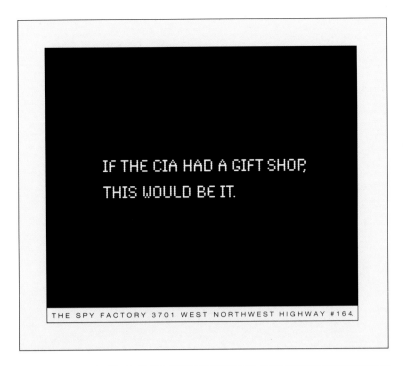

IF THE CIA HAD A GIFT SHOP,
THIS WOULD BE IT.

THE SPY FACTORY 3701 WEST NORTHWEST HIGHWAY #164.

WE COULD GIVE YOU A LIST OF
OUR CLIENTS. BUT THEN WE'D
HAVE TO KILL YOU.

THE SPY FACTORY 3701 WEST NORTHWEST HIGHWAY #164.

BOND DIDN'T GET ALL THOSE
NIFTY GADGETS FROM Q.

THE SPY FACTORY 3701 WEST NORTHWEST HIGHWAY #164.

200
ART DIRECTOR
Steve St. Clair
WRITERS
Stephanie Crippen
Steve St. Clair
CLIENT
Outward Bound
AGENCY
Two Cities/New York,
Toronto

201
ART DIRECTOR
Pat Zimmerman
WRITER
Joe Tradii
CLIENT
Robert Felsenfeld, CPA
AGENCY
Zimmerman/Tradii,
Huntington Beach, CA

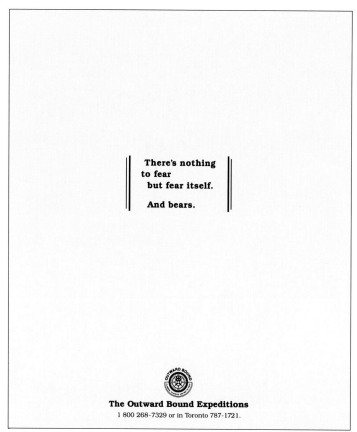

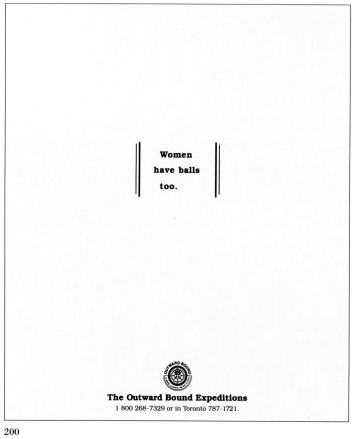

Apparently, Amnesty International hasn't stamped out all forms of torture.

What kind of a mind does it take to think up these forms anyway? Robert Felsenfeld knows, he used to work for the IRS. But now he'll work for you. Revenge is sweet, isn't it?

Robert Felsenfeld, CPA

23120 Alicia Pkwy · Suite 212 · Mission Viejo, CA 92692 (714) 583-0662

Buy one less lunch for a Senator next year.

Tired of feeling like you're expected to pay off the national debt all by yourself? Then call Robert Felsenfeld, CPA. For personal or self-employment taxes, tax planning or any new tax situation. Because in these fiscally frugal times, there's no such thing as a free lunch.

Robert Felsenfeld, CPA

23120 Alicia Pkwy · Suite 212 · Mission Viejo, CA 92692 (714) 583-0662

Suddenly, a cold day in January doesn't seem so bad.

If the mention of an innocent Spring day sends shivers up your spine, it's time you got professional help. With over 20 years experience in the tax field, Robert Felsenfeld has a lot of help to offer. Call today for an appointment. And start enjoying Springtime again.

Robert Felsenfeld, CPA

23120 Alicia Pkwy · Suite 212 · Mission Viejo, CA 92692 (714) 583-0662

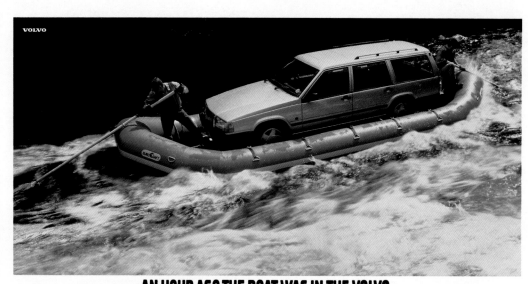

202

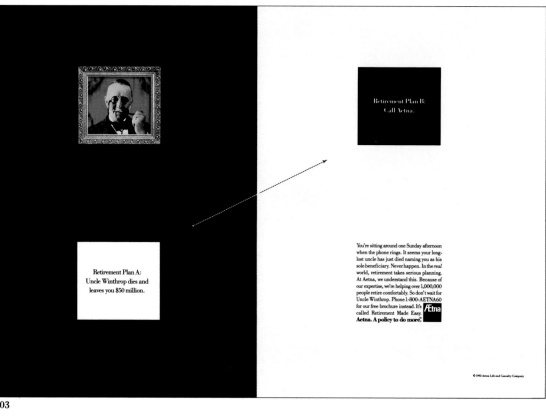

203

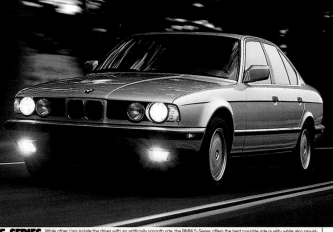
204

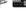
205

206

207

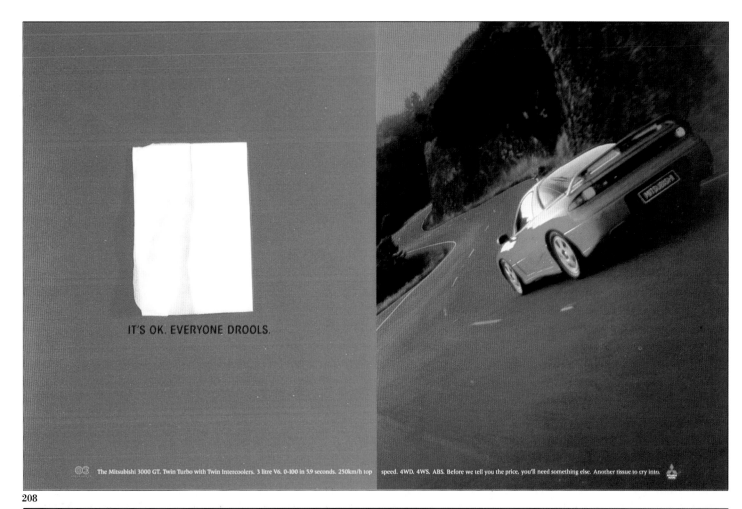

IT'S OK. EVERYONE DROOLS.

The Mitsubishi 3000 GT. Twin Turbo with Twin Intercoolers. 3 litre V6. 0-100 in 5.9 seconds. 250km/h top speed. 4WD. 4WS. ABS. Before we tell you the price, you'll need something else. Another tissue to cry into.

208

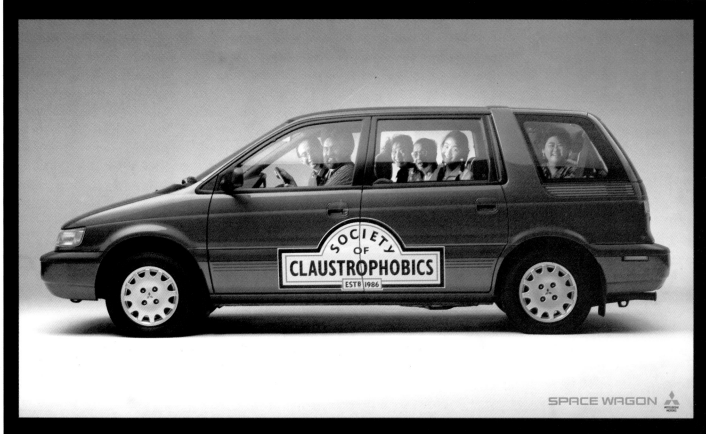

SPACE WAGON

209

MILK REFRESHES THE PARTS OTHER DRINKS CANNOT REACH.

210

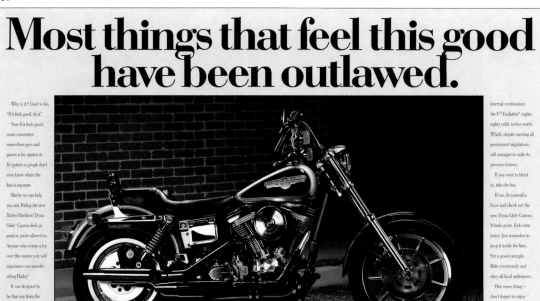

211

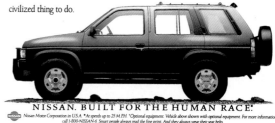

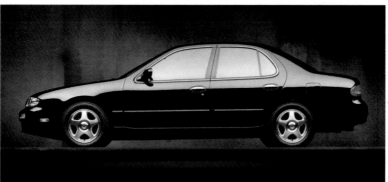

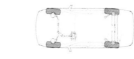

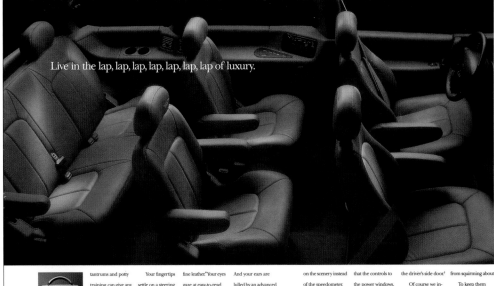

214

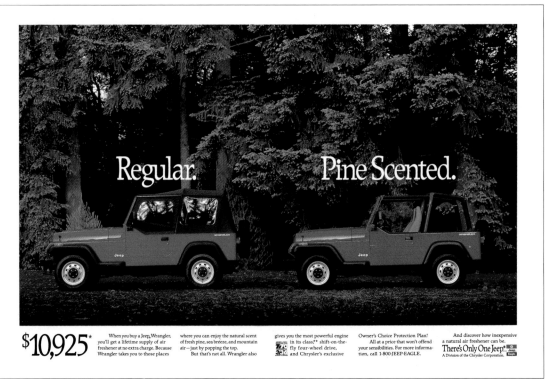

215

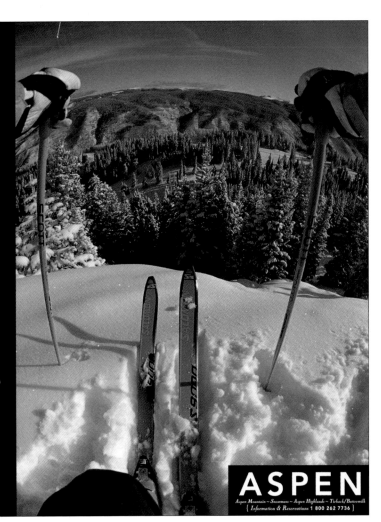
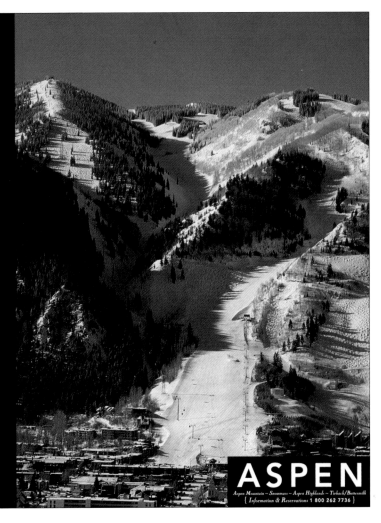

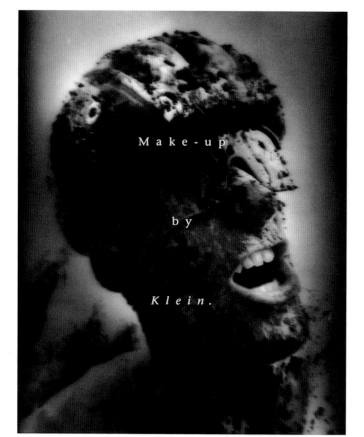

218

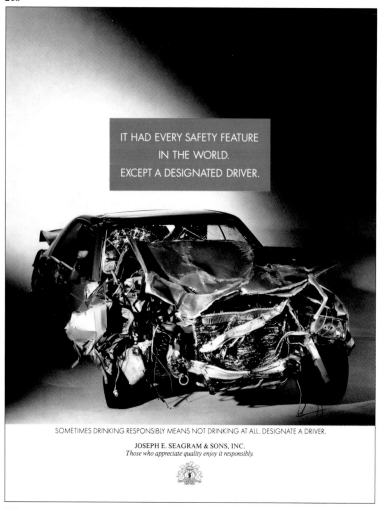

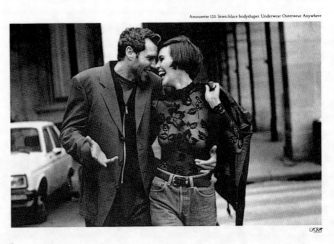

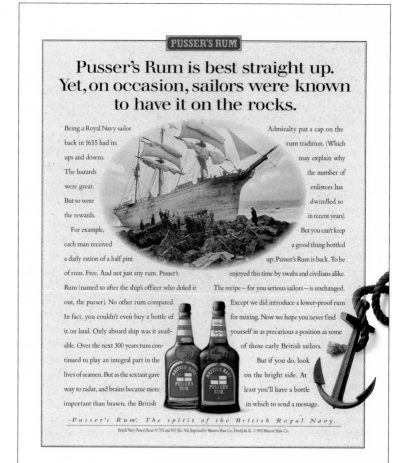

222

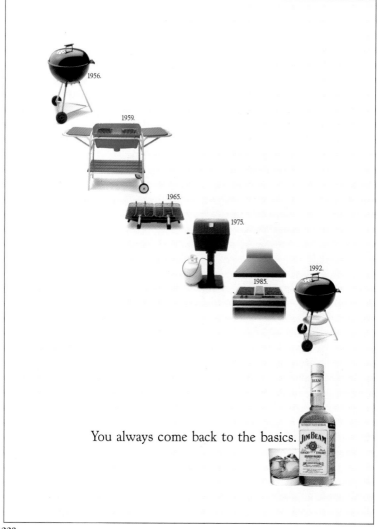

223

"What evaporates we call the angel's share.
Now doesn't that make you want to go to heaven?"

~ Booker Noe

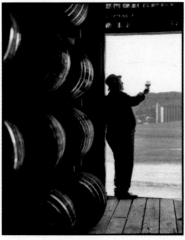

*I*N A WAREHOUSE *on the grounds of Kentucky's legendary Jim Beam distillery, there strolls one very*
contented man. His name is Booker Noe. He is the grandson of Jim Beam "Himself." And he spends his days
making what a lot of people are calling the very best bourbon whiskey there is.

You see, Booker's Bourbon is different from any other whiskey you can buy. It's bourbon bottled straight
from the barrel, uncut and unfiltered, with every new batch selected and approved by Booker Noe personally.
Booker's Bourbon can be anywhere from six to eight years old, and, depending on how the weather behaves
during those years of aging, it can be anywhere from 121 to 127 proof.

It's obviously not a mass-produced whiskey. In fact, each bottle of Booker's is hand-labeled then hand-
sealed with hot wax, after which a tag is hung around its neck indicating its own unique proof and age. The
label is written in Booker's own hand, and, as a final touch each bottle is placed in its own wooden gift box.

Booker clearly takes pride in Booker's Bourbon. "I just hope you'll get half as much pleasure
from my natural proof whiskey as I do," *he says.* "Because I think Booker's is the best bourbon
on earth. Or, considering that the angels always get a share, the best bourbon anywhere."

"I know bourbon gets better with age,
because the older I get, the more I like it."

~ Booker Noe

*B*OOKER NOE *will never forget the first time*
he sampled the legendary bourbon from his grandfather
Jim Beam's distillery.

Even when he tells the story today, his face twists
into a grimace, his head shakes slowly back and forth and
his big hand swats at the air in front of him.
"I didn't like it at all," *he says, without apologies.*

Now, if that confession sounds a bit strange coming
from a man who's devoted his life to making fine whiskey, there is a perfectly reasonable explanation.

Booker Noe, perhaps better than anyone else, understands that an appreciation for bourbon isn't
something people are born with. "Like most people, learning to love fine bourbon took me a
certain amount of time," *he says,* "But as the years have gone by, I've decided there's just
nothing better than whiskey aged in charred white oak, uncut, unfiltered and straight
from the barrel." *Which is why Booker Noe recently began bottling his unique bourbon and*
making it available to the few connoisseurs of fine spirits who can appreciate it.

Depending on the temperament of the seasons in the Bluegrass State, Booker's Bourbon
reaches its peak anywhere from six to eight years into the aging process. And since every barrel
ages differently, each batch of Booker's has its own unique proof, measuring anywhere from 121
to 127. With any luck, you'll find Booker's Bourbon at your local liquor retailer. But since, by its
nature, this is not a mass-produced bourbon, you may have to look further.

Regardless how it comes into your possession, Booker Noe believes you will find his
bourbon well worth the time and effort spent searching for it. Especially if, like Booker himself,
the years have done for your taste what they do for a bourbon's.

Windsor® Canadian Supreme Whisky, 40% Alc./Vol. (80 Proof). Imported and Bottled by The Windsor Distillery Co., Deerfield, IL. © 1992 The Windsor Distillery Co.

Fortunately, every day comes with an evening.

226

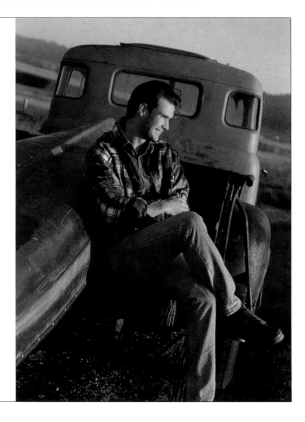

How to cover your rear when
you're out of the office.

When you finally get a chance to kick back and relax, nothing fits your body or your mood
better than the comfort of Lee Riders. Next time you're able to break away from work, try
on a pair for yourself. They'll make you feel so good, the boys wouldn't even recognize you.
L E E · R I D E R S

227

The two most painful experiences
of motherhood. Childbirth. And buying
your kid jeans.

Remember the good old days when kids didn't care what they wore? They're gone. Next time you're laboring to find jeans your kids will wear, get them to try on a pair of Lee's Baggy Rider. Because it shouldn't be as hard to have a kid as it was to have a baby.
B A G G Y · R I D E R

The brand that fits.

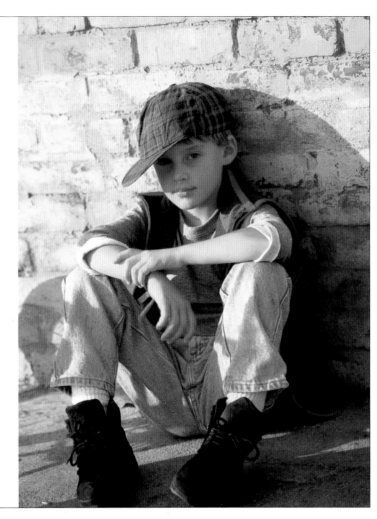

If you really want to relax, maybe it's
your jeans that should loosen up.

Wearing jeans should make it easier to relax. But there's nothing easy about the way most jeans fit. That's why Lee makes Easy Riders, jeans that always fit right, because they're built the way you're built. Easy Riders. Because if you're going to stop and catch your breath, you have to be able to breathe.
E A S Y · R I D E R S

The brand that fits.

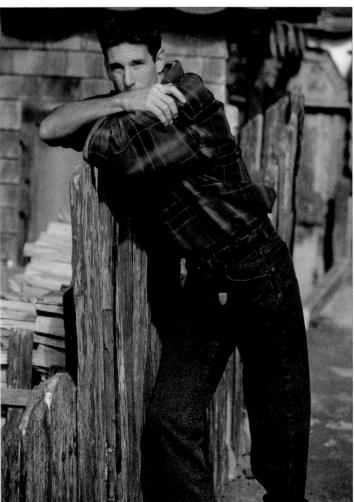

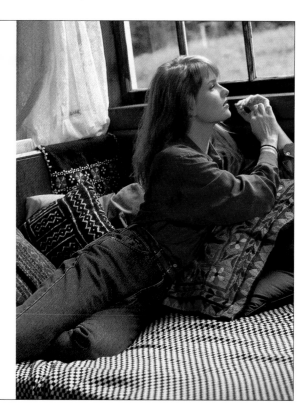

If they were any more relaxing,
we'd need FDA approval.

Lee Relaxed Riders have a fit that can change your whole outlook on life. Just an application of these jeans once a day will calm your nerves, ease your mind and work wonders for your appearance. Try on a pair today. But do be careful. They may prove to be habit forming.

R E L A X E D · R I D E R

The brand that fits.

230

Four other car companies have already bought one.
Whatever do you suppose they want them for?

The hand-finished paint was hardly dry on our first Porsche 968s before we started hearing the stories. Stories about them going "under the knife."

Granted, it's not unusual for car companies to check out each others' new creations. But it seems that when it's a new Porsche, it gets an inordinate amount of attention. Perhaps that's because a new Porsche doesn't come along every day. Which leaves everyone waiting to see what the automotive world can expect next.

So, what do you suppose they want to know?

They're no doubt interested in how we created the highest torque 3 litre atmospheric engine in the world, with a top speed of 156mph, but still lowered emissions a dramatic 22%.(Hint: Check out the patented new Porsche VarioCam system that burns fuel more efficiently and thoroughly, and the breakthrough catalytic converter with rare metal inner walls.)

Maybe they're interested in the secrets of our Tiptronic transmission, the world's first dual function gearbox that allows either full automatic or clutchless manual shifting. (Another hint: Try to get your hands on one of our legendary 962 race cars with PDK transmission where we developed the concept.)

In total, the 968 bears the fruit of 15 new patents. Right down to new headlamps

that use the principle of a bee's eyes, as over 1,000 reflective facets provide variable point focus to cut reflected glare. Then there are the myriad other racebred concepts and meticulous tuning details. Such as the application of racing style "internal aerodynamics" to speed the flow of air through the body and suspension of the car, reducing drag and providing exceptional cooling for components such as the massive disc brakes with ABS.

The fact is, combining new developments with painstaking refinement we have made the 968 one of the highest performance yet most comfortable Porsches ever. And fused all this capability with classic Porsche design and fabled handcrafting.

So it's little wonder everyone is anxious to see how we accomplished all this. No doubt you'll start seeing simpler versions of 968 ideas crop up sometime in the future in other cars.

Then again, you needn't go to extremes to learn all about the new Porsche 968. Just call 1-800-252-4444 for more information or to arrange a private viewing at your authorized Porsche dealership. We'd love to tell you about it in great detail.

Or, if you're one of our friends who already has a 968 in a few hundred pieces and you have questions, send it to us. We'll put it back together for you.

Porsche 968: The next evolution.

231

How to look like a million bucks.

It would seem the path to success for many cars today is to emulate some established, renowned thoroughbred.

However nothing can ever look like a Porsche quite like another Porsche. Because each and every model since our first, handbuilt roadster emerged over 40 years ago has been driven by a unique philosophy, founded in pure function. Still, while that means all Porsches share a certain family resemblance, even within the Porsche stable there are variances in both price and rarity.

The 959 shown on the left possesses a silhouette that would make it seem you have seen it often. Yet, it is one of only 200 such "rolling test beds" in existence. A 200 mph Supercar project that allowed our engineers to explore what would be possible by the turn of the century. Literally a physics lab on wheels.

Which brings us to the new 968, shown on the right. In typical Porsche fashion, it is an amalgam of everything we have learned to this moment. Futuristic thinking, melded with the classic Porsche essence. So it is only natural it would bear a resemblance to the 959, along with other forebears. Is it heresy that a new $39,850* production car look so strikingly like a car that collectors pay close to $1,000,000 to acquire? No, it's simply part of the evolution which provides Porsche drivers with a heritage unduplicated in automotive history.

The 968 not only shares lines with the 959; it shares thinking, as well. You will find evidence of the 959 in the new wheel design, carefully sculpted to reduce rotating mass and improve brake cooling. You will find it in the body aerodynamics, which actually use airflow for purposes such as directing rain spray away from the windshield. The principle of "internal aerodynamics" carries over as well, in which meticulous shaping of underbody components speeds the flow of air through the chassis to reduce drag and lift, while providing more prodigious cooling.

Then again, the 968 brings along new thinking of its own. Like the patented new Porsche VarioCam™ which continuously varies valve timing to burn fuel more thoroughly and efficiently, providing more power and instant throttle response while dramatically reducing emissions." Plus details like a patented new headlamp system that uses the principle of a bee's eyes, employing over 1,000 reflective facets to provide variable point focus and cut reflected glare.

As you can see, even since the 959, with the new 968 we have moved on. Call 1-800-252-4444 for more information, or to arrange a private viewing at your authorized Porsche dealership.

The fact is, based on pure daily practicality, the 968 is probably an even more desirable Porsche to have in your garage. Of course, if someone thinks they see you loading groceries into a $1,000,000 car, why quibble?

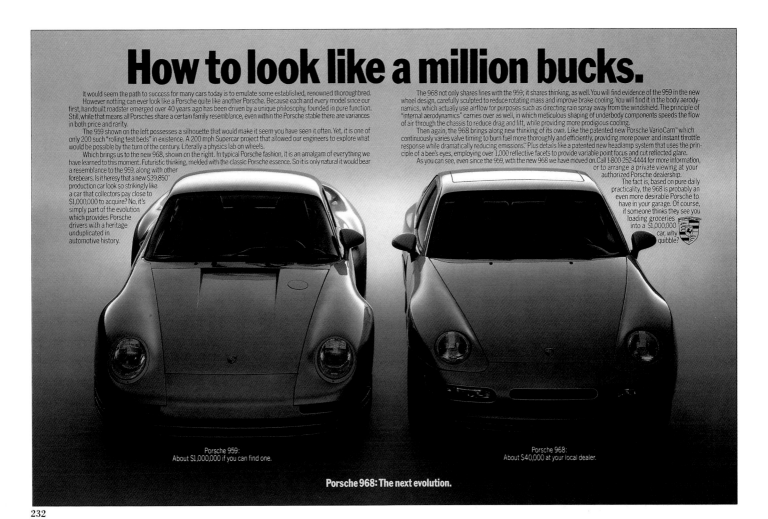

Porsche 959:
About $1,000,000 if you can find one.

Porsche 968:
About $40,000 at your local dealer.

Porsche 968: The next evolution.

It's what happens when engineers work in an ivory tower but have to drive on twisty, narrow roads to get there.

The new Porsche 968. It is the latest vision to come down from Porsche's legendary development center, perched high on a hill overlooking the ancient village of Weissach. And, like each and every Porsche which has rolled down this hill before it, it is a dichotomy.

On one hand, it possesses racebred components and performance historically found in only a smattering of exotic sports cars. Yet, Professor Porsche has always insisted that no car which bore his name be an impractical toy, but rather, durable, everyday transportation.

From the earliest days, while other sports car owners would truck their cars to weekend races, Porsche owners would drive their cars hundreds of miles, win the race, then drive home and to work on Monday. It was this melding of performance and function that set Porsche apart and created a mystique. A melding unduplicated by any other car to this day. And a melding which makes the 968 the inheritor of a unique place in the automotive world.

Like its forebears the 968 is, at once, futuristic yet classic. Keeping the best of what has come before; combining it with forward-thinking technology and design.

Brimming with the results of 15 new patents, the 968 is a study in what is now possible. Realizing a sports car today must take resources, the environment and daily function into account, the 968 breaks new ground. Throughout the car, features that improve performance are designed to simultaneously improve efficiency.

Employing our patented new Porsche VarioCam,™ fuel combustion is made far more precise and thorough. This improves throttle response, power and torque, while at the same time dramatically lowering emissions.'

A stunning new catalytic converter uses thin, rare metal inner walls, speeding air flow for more power while also reducing emissions. Porsche's renowned transaxle platform with near-perfect 50-50 weight balance has been further buttressed for the added performance. Yet detail changes have actually increased comfort. And in the belief that performance must be mated with equivalent safety, only Porsche makes both driver and passenger front airbags standard on every model.

As a Porsche engineer will tell you, "If you only make a car for a few years, you are always starting over." This is why a new Porsche comes along far more seldom than typical cars. And evolves out of all those which came before. It's also why we can't begin to describe all the developments in the 968 in the space we have here.

Call 1-800-252-4444 for more information, or to arrange a personal viewing at your authorized Porsche dealership. The 968 may have been born in an ivory tower. But it's built to live in the real world.

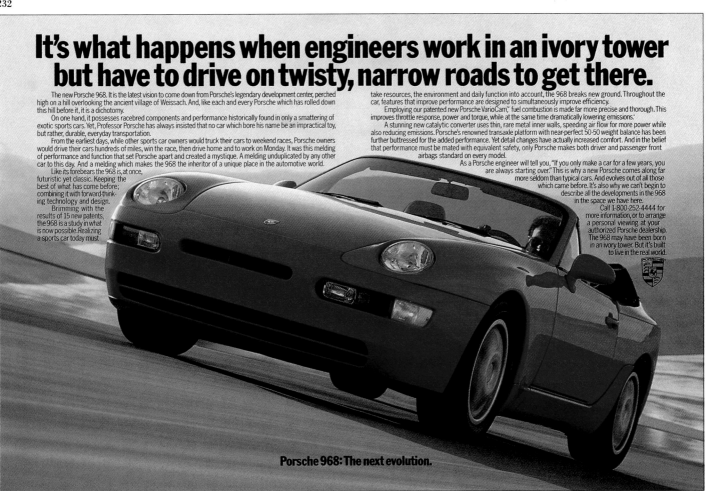

Porsche 968: The next evolution.

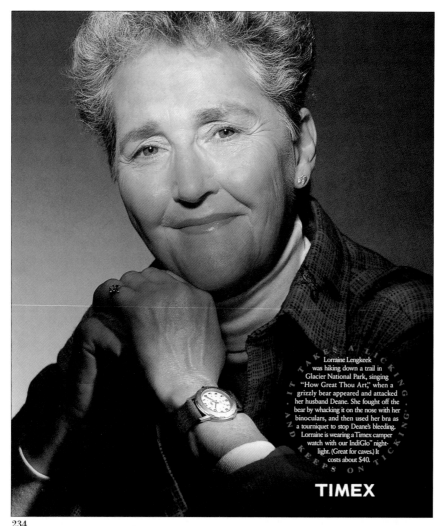

234

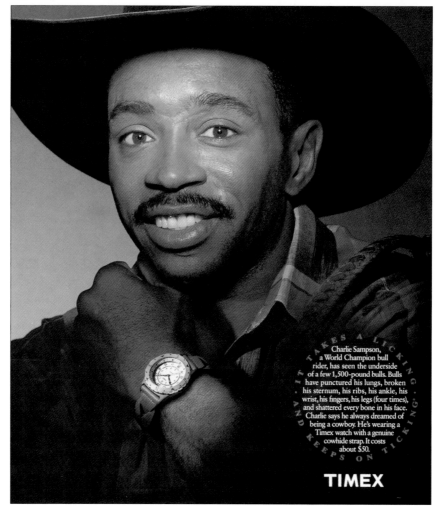

235

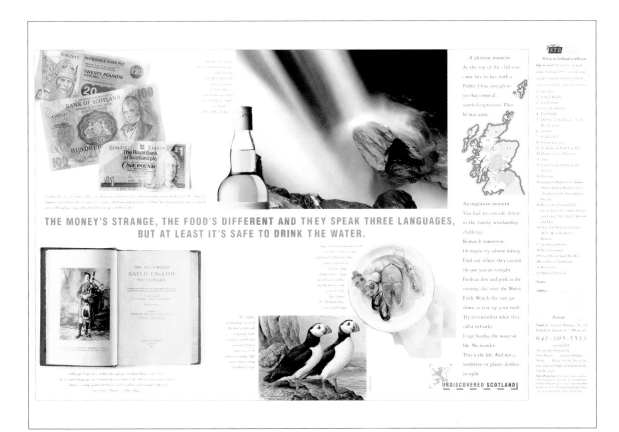

THE MONEY'S STRANGE, THE FOOD'S DIFFERENT AND THEY SPEAK THREE LANGUAGES,
BUT AT LEAST IT'S SAFE TO DRINK THE WATER.

**WHEN A CLOTHING STORE HAS A SALE ON SELECTED MERCHANDISE,
WHY IS IT ALWAYS MERCHANDISE YOU'D NEVER SELECT?**

All our clothes are 40-75% off regular retail prices, every day. Center City, 17th St. and Chestnut.

DAFFY'S®
CLOTHES THAT WILL MAKE YOU, NOT BREAK YOU.™

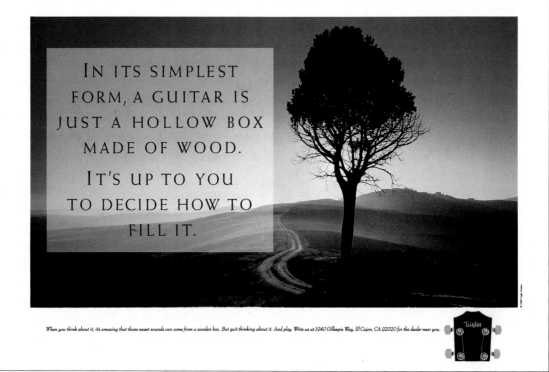

238

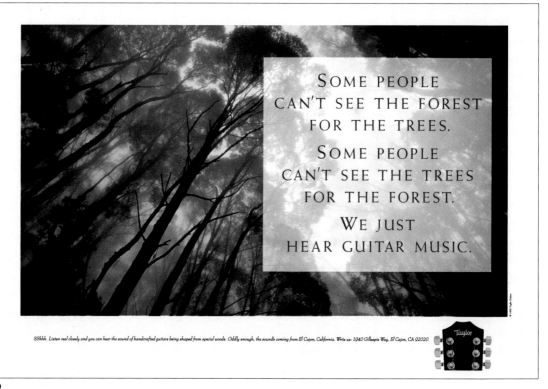

239

While you don't
necessarily dress for men,
it doesn't hurt,
on occasion,
to see one
drool like the
pathetic dog that he is.

BODYSLIMMERS™ by NANCY GANZ

240

If you weren't

the founder

of a railroad,

will you feel

comfortable

at J.P. Morgan?

Yesterday, it was steel and railroads. Today, it's biotech and microchips. New industries. New wealth. And as one might suspect, a new type of private banking client. The kind looking to preserve and build assets with creative investment opportunities. Global opportunities. Research-driven opportunities. And yet, someone who sees a trusted, financial relationship as a long-term opportunity. If you have assets of $5 million or more, call Thomas F. Shevlin at (212) 837-4343. **Private Banking** **JPMorgan**

241

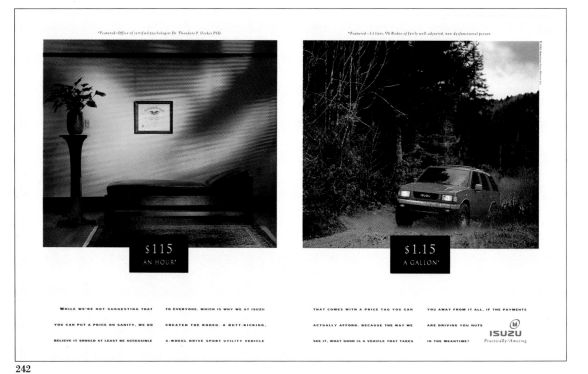

242

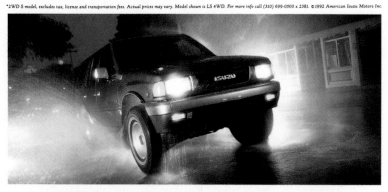

243

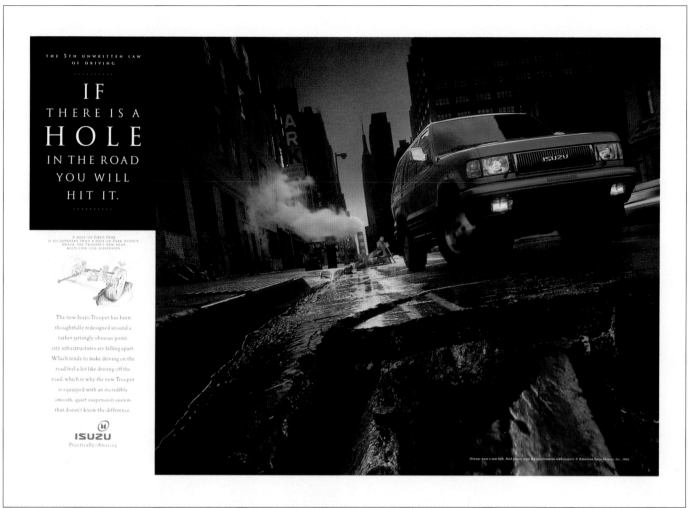

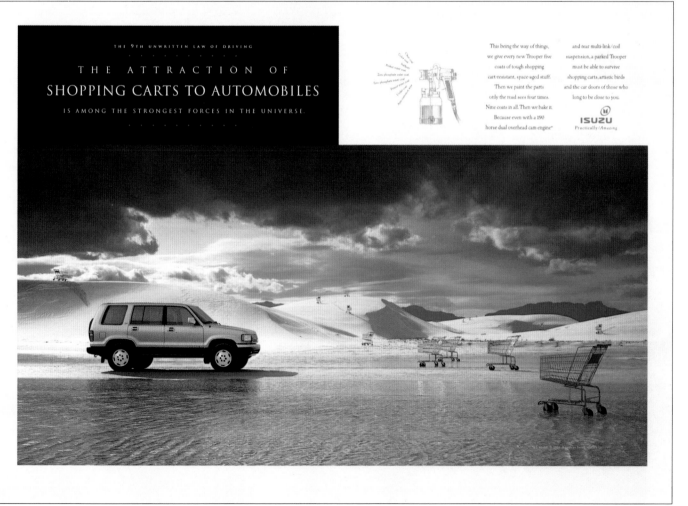

246

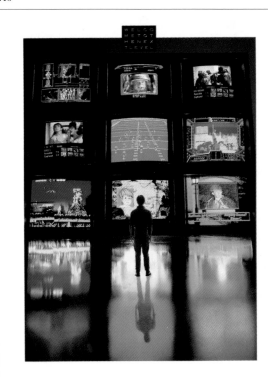

247

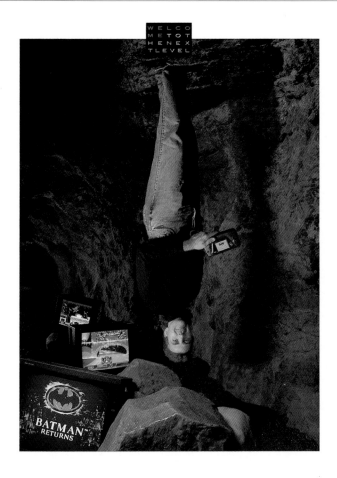

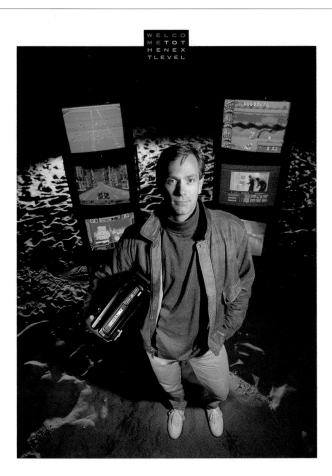

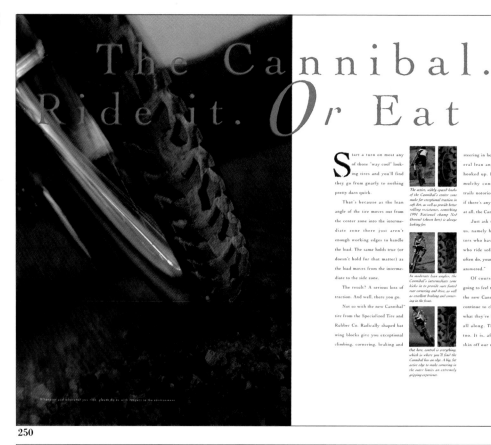

250

251

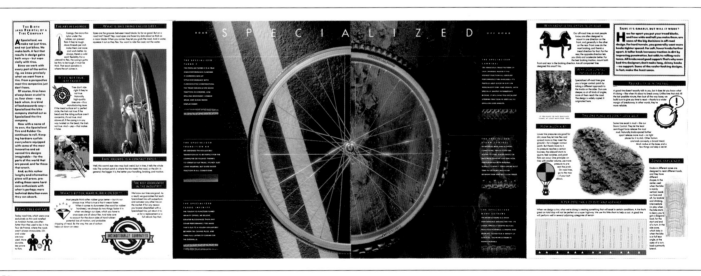

Stick to the back roads.

This traveler's advisory is brought to you by the people who make Range Rovers.

As a reminder that winter driving need not be confined to plowed thoroughfares, sanded avenues, and salted streets.

At least not when you're driving a Range Rover.

Because with its new electronic traction control system and advanced anti-lock brakes, a Range Rover will provide not only better traction than

ever before, but better traction than every other 4x4.

While its permanent four-wheel drive, formidable V-8 engine, and enviable off-

road capabilities will take you places snowplows either can't go, or won't.

So why not call 1-800-FINE 4WD today for one of our select Canadian dealers.

After all, whether you choose the County model or the even more evolved County LWB, you'll get a Range Rover that offers not only more features than other luxury cars, but infinitely more roads as well.

RANGE ROVER

253

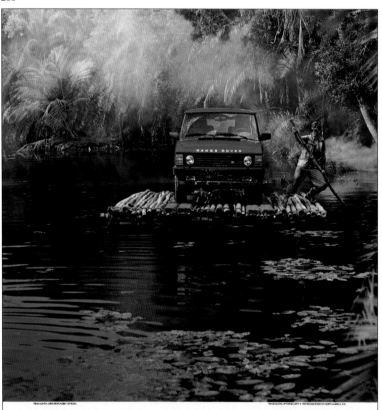

Sometimes you have to get out and push a Range Rover.

There are, we admit, things in this world that can quite capably stop a Range Rover in its tracks.

Active tar pits. Brick walls. And yes, ten feet of water.

Beyond these, however, a Range Rover's spirited 3.9 liter V-8 engine, fully-articulated suspension system, and permanent four-wheel drive are designed to steer you through equally

unpleasant, if far less far-fetched, driving conditions.

From sleet and freezing rain, to the occasional blizzard and monsoon.

In short, anything short of the impossible.

So why not call 1-800 FINE 4WD today for the dealer nearest you?

After all, for just under $39,000, you too could be driving off in a Range Rover.

And considering all that it has to offer, would you really want to be up the creek in anything less?

RANGE ROVER

254

Guts. Yours and ours. That's all it takes to ski the extreme. Our **totally new Extreme** was tested and refined by Scot Schmidt and Glen Plake. We added ABS/urethane sidewalls for strength and vibration absorption. The new Extreme gives you high torsional stiffness for edge hold and high speed stability. And it has an 8.3 sidecut for great edge grip and fast turn completion. (You'll have to decide what you're made of, but as you can see, our new Extreme has what it takes.)

Skier: Glen Plake. Photo: Mark Shapiro. Location: Chamonix, France

K2
An Anthony Industries company

IF YOU'RE STILL PAYING FULL COMMISSIONS TO YOUR BROKER, YOU'RE NOT AN INVESTOR. YOU'RE A PHILANTHROPIST.

IF YOU'RE DOING business with a full-cost broker, you may not like the term above.

But if you've started making your own investment decisions, you're paying your broker a substantial fee for something you don't need: advice.

That's because full-cost brokers charge you for investment advice, even if you made the pick yourself.

But is there a broker for the knowledgeable investor? Who charges you only for the services you need, not the ones you've outgrown?

Introducing A New Breed of Broker℠ from Quick & Reilly.

Like a full-cost broker, this New Breed of Broker is personally assigned to you. But instead of advice, our brokers give you what you're really looking for: information. Because our brokers give you only what you need, they can charge up to 76% less than full-cost brokers.

Of course, if you're new to investing and find your broker helpful, by all means stay where you are. You're not ready for Quick & Reilly.

But if you've been in the market and know how it works, stop giving money away for more than you need. And start saving it with us.

Call *1 800 222-0472 ext. 7000* today for complete information. Or stop by any one of our 75 Quick & Reilly offices nationwide.

MEMBER NYSE/SIPC

OUR GUARANTEE
Our commitment is to provide quality service to each of our clients. While we can't guarantee price or market conditions, if for any reason you are dissatisfied with our service when making a trade, write us within 45 days and we'll gladly refund the commission from that trade.

CALL **1 800 222-0472** EXT **7000**

COMPARE THE NEW BREED			
	100sh @ $40	300sh @ $30	1000sh @ $20
Quick & Reilly	$49	$82	$109
Merrill Lynch	100	204	374
Charles Schwab	55	107	144
Fidelity	54	106	144
Standard phone order. Telephone survey 2/92.			

QUICK & REILLY
A NEW BREED *of* BROKER℠

©1992 Quick & Reilly, Inc.

257
ART DIRECTOR
John Dodson
WRITER
Richard Cook
PHOTOGRAPHER
Martin Thompson
CLIENT
McDonald's Restaurants
AGENCY
Leo Burnett/London

258
ART DIRECTOR
John Dodson
WRITER
Richard Cook
PHOTOGRAPHER
Martin Thompson
CLIENT
McDonald's Restaurants
AGENCY
Leo Burnett/London

259
ART DIRECTOR
Kevin Kustra
WRITERS
Jeff Moore
Alex Kroll
PHOTOGRAPHER
Jim Erickson
CLIENT
Heinz USA
AGENCY
Leo Burnett Company/
Chicago

260
ART DIRECTOR
Kevin Kehoe
WRITER
Phil Calvit
PHOTOGRAPHER
Carol Kaplan
CLIENT
Keds Corporation
AGENCY
Leonard Monahan Lubars
& Kelly/Providence

Just what you would expect from McDonald's.
Chilled cardboard.

When you buy a Big Mac™ or McChicken™ Sandwich, you'll find that it is garnished with lettuce.

Iceberg lettuce. Fresh, crisp Iceberg lettuce every time.

We know it's fresh because we know where and when it was planted and picked.

To keep it fresh while it travels from the field to the bun, we keep it chilled at strictly controlled temperatures.

So strictly controlled that we pack it in cardboard boxes which have already been chilled to the same low temperature.

And if we take that much trouble with a few shreds of lettuce, think how much trouble we must take with something that's really important.

Mayonnaise, for example.

There's nothing quite like a McDonald's.

257

If it's green, we reject it.
If it's dirty, we reject it.

If it's too ripe, we reject it.
If it's just right, we squash it.

If it's bruised, we reject it.

If it's diseased, we reject it.

The tomato ketchup in a McDonald's hamburger is made only for McDonald's.

The tomatoes are, as you see, most carefully chosen. (You might think we are exaggerating, but every word is true.)

Turning them into tomato paste involves rather more than simply squashing them.

The best method is, as it happens, the most difficult and expensive.

 It is the method we use.

Then we add some sugar, vinegar, salt, cloves, chilli, bay and allspice.

We add no other flavouring, colouring, preservative or thickening, because we don't need to.

That is the amount of trouble we take over our tomato ketchup.

And this is the amount of tomato ketchup we put in a hamburger

There's nothing quite like a McDonald's.

258

Old Original Bookbinder's Restaurant—Philadelphia, PA

Same location for 127 years.

Same soup recipes for 118 years.

Same doorman for 45 years.

Same ketchup for 123 years.

4 out of 5 restaurants serve America's favorite ketchup. Heinz.

© 1992 H. J. Heinz Company

Keds Flexibles make it easier for a child to get around. Not that that's necessarily a good thing.

Keds® Flexibles help a beginning walker's feet move as
naturally as possible. Which is good. Mostly.

They Feel Good.

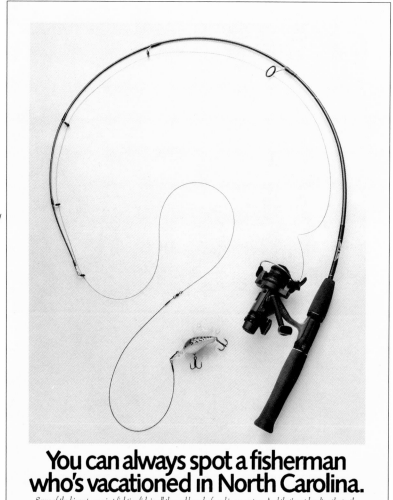

261

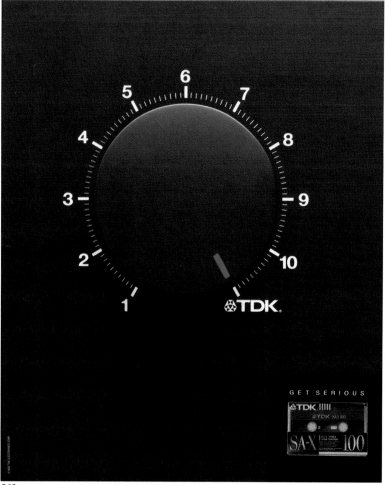

262

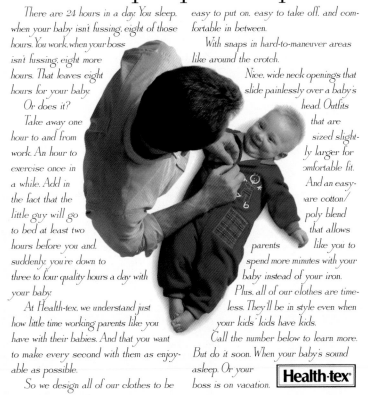

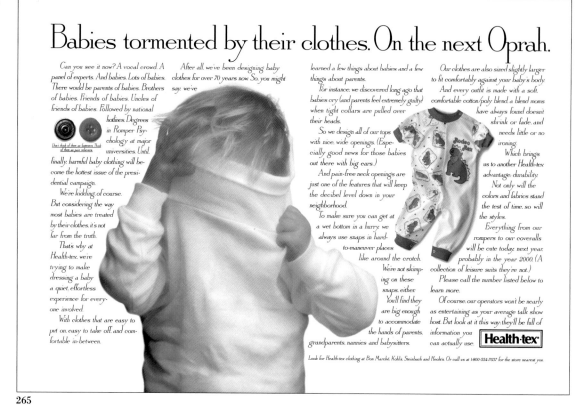

265

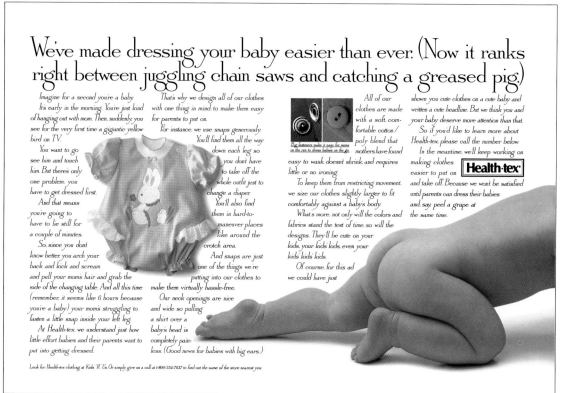

266

We make baby clothes even full-sized people can put on.

There are 24 hours in a day. You sleep when your baby isn't fussing, eight of those hours. You work, when your boss isn't fussing, eight more hours. That leaves eight hours for your baby.

Or does it?

Take away one hour to and from work. An hour to exercise once in a while. Add in the fact that the little guy will go to bed at least two hours before you and, suddenly, you're down to three to four quality hours a day with your baby.

At Health-tex, we understand just how little time working parents like you have with their babies. And that you want to make every second with them as enjoyable as possible.

So we design all of our clothes to be easy to put on, easy to take off, and comfortable in between.

With snaps in hard-to-maneuver areas like around the crotch.

Nice, wide neck openings that slide painlessly over a baby's head. Outfits that are sized slightly larger for comfortable fit.

And an easy-care cotton/poly blend that allows parents like you to spend more minutes with your baby instead of your iron.

Plus, all of our clothes are timeless. They'll be in style even when your kids' kids have kids.

Call the number below to learn more. But do it soon. When your baby's sound asleep. Or your boss is on vacation.

Health·tex®

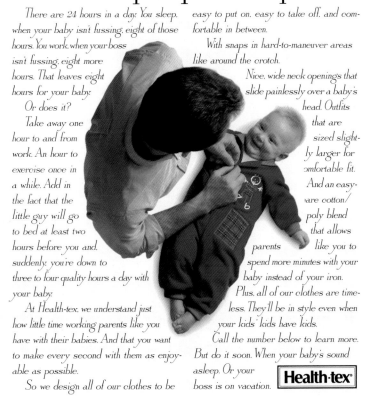

If you'd like to know where to find Health-tex, just give us a call at 1-800-554-7637 for the store nearest you.

Your baby's naked. Your phone's ringing. And your mother-in-law's walking up the driveway. Let's talk snaps.

Relatives, bless their hearts, do not possess a great sense of timing. And neither do people who sell storm windows over the phone. Or read meters for the power company.

They all seem to share this incredible ability to catch you with your pants down.

At Health-tex, we know exactly how tough it can be to dress a baby, even when there aren't relatives knocking on the door.

That's why we design all of our clothes with one thing in mind: to make them easy for parents to put on.

You see, after 70 years of making baby clothes, we've learned a few things about parents and a few things about their offspring.

For instance, we discovered long ago that big hands and small buttons don't work well together. So we use only snaps and easy-to-fasten buttons on all of our clothes. (The word "fastener" did come from the word "fast," didn't it?)

We're not skimping on these snaps, either. You'll find them all the way down each leg, so you don't have to take off the whole outfit just to change your baby's diaper.

For those tight spots we make our snaps and buttons big for big hands.

You'll also find them in hard-to-maneuver areas like around the crotch.

And snaps are just one of the things we put into our clothes to keep them hassle-free.

Our neck openings are nice and wide so pulling a shirt over a baby's head is completely painless. (Good news for babies with big ears.)

To keep them from restricting movement, we size our clothes slightly larger to fit comfortably against a baby's body.

What's more, everything from our rompers to our coveralls, are made with a soft, comfortable cotton/poly blend. A blend mothers have found is easy to wash, doesn't fade, and requires little or no ironing.

Which brings us to another Health-tex advantage: durability. Not only are the colors and fabrics designed to last for years to come, so are the styles.

They'll be cute today, cute next month, even cute after a couple more babies. (Phew!!)

We could go on and on about the new and improved Health-tex, but there isn't enough room in this ad to tell you everything.

So please call the number listed below to learn more about us.

And don't hesitate to pick up the phone and talk to us anytime.

Because unlike you, we won't have a naked baby on our hands and a mother-in-law walking up the driveway.

Health·tex®

Look for Health-tex at Bon Marché, Kohl's, Steinbach and Hecht's. Or call 1-800-554-7637 for the store nearest you.

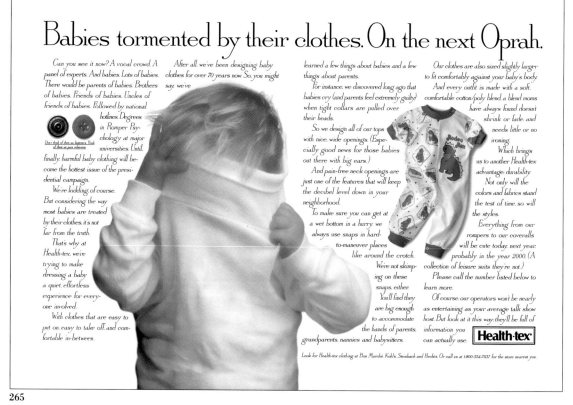

265

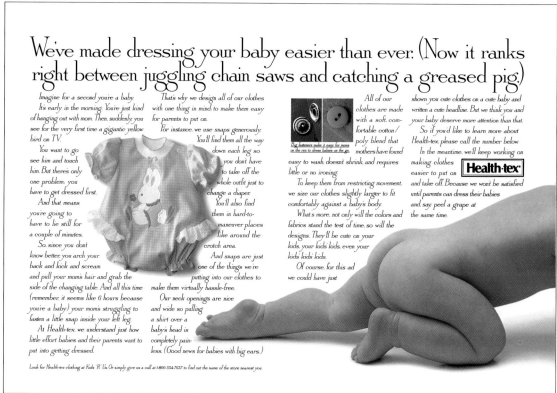

266

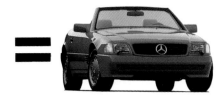

When it comes to performance, luxury, and driving pleasure, nothing equals the 500 SL. Nothing.

It's been that way ever since Mercedes-Benz introduced the first 300 SL back in 1954. With its gull-wing doors, lightweight design, and fuel-injection system, the 300 SL set the standards for automotive engineering like no other car before.

The same can be said of the 1992 500 SL.

Nothing equals its massive light-alloy 5.0 liter, 32-valve V-8 engine. Which sends out a headrest-pressing 322 horsepower and 332 pounds of torque. And is agile enough to go zero to 60 in a mere 6.2 seconds.

Nothing equals the level of comfort delivered by its innovative damper strut in the front and advanced multilink suspension in the rear.

Nothing equals the degree of luxury you'll find inside. With a driver's seat that adjusts to 10 different positions. And a sound system featuring 6 speakers.

Nothing equals the security of knowing that every SL has ABS brakes, dual air bags, automatic rollbar, and 24-hour roadside assistance anywhere in the country.

And, of course, nothing equals the exhilaration you'll feel the first time you cruise down the open road with the soft-top down. Just call 1-800-468-4001 for the authorized Mercedes-Benz dealer near you to test drive the 500 SL today.

And fill in the only factor that's missing from this equation: you.

Engineered like no other car in the world.

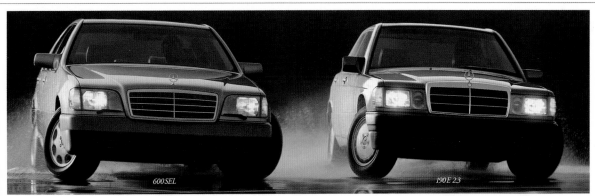

600 SEL

190 E 2.3

Proof that different bodies can possess the same soul.

At Mercedes-Benz we have a unique design philosophy. And its beauty lies in its simplicity. If you build one automobile to your highest standards, you build every automobile to those standards. Period.

We incorporate the same basic engineering, technology and construction methods in each of our automobiles, from our flagship 600 SEL to our most attainable 190 E 2.3.

To a driver this translates into an unparalleled blend of handling, safety and personal comfort.

In every Mercedes-Benz you'll find a front engine, rear drive layout that

Protective steel body combines with chassis to create a rigid platform for suspension and steering components.

provides superior handling and stability. Plus, a steel body structure with high-strength welds for extra rigidity. You'll also find something very few other cars have: Front seats designed to withstand the energy of a 30 mile per hour rear-end collision.

Which brings us to our final point: No

Multilink suspension provides precise wheel control and maximum tire adhesion.

matter which model you choose to lease or purchase, you'll own an automobile that is every inch a Mercedes-Benz. Body and soul. For more information call 1-800-648-9199 or visit your local authorized Mercedes-Benz dealer.

Seat backrest is designed to absorb crash energy and prevent seat from collapsing rearward.

Engineered like no other car in the world.

269
ART DIRECTOR
Doug Trapp
WRITER
Jeff Turner
CLIENT
**Dr. Greg Dahl,
Chiropractor**
AGENCY
**Martin/Williams,
Minneapolis**

270
ART DIRECTOR
Tim Ryan
WRITER
Cristina Gordet
PHOTOGRAPHER
Randy Miller
CLIENT
Bertram Yacht
AGENCY
**McFarland & Drier
Advertising/Miami**

271
ART DIRECTOR
Margaret McGovern
WRITER
Paul Silverman
PHOTOGRAPHERS
**Ray Meeks
John Holt Studios**
CLIENT
The Timberland Company
AGENCY
Mullen/Wenham, MA

272
ART DIRECTOR
Margaret McGovern
WRITER
Paul Silverman
PHOTOGRAPHERS
**John Holt Studios
Stock**
CLIENT
The Timberland Company
AGENCY
Mullen/Wenham, MA

Before. *After.*

Dr. Greg Dahl, Chiropractor

7500 Olson Mem. Hwy Suite 125 Golden Valley 545-8600 · The Conservatory Suite 540 800 Nicollet Mall 333-9144

269

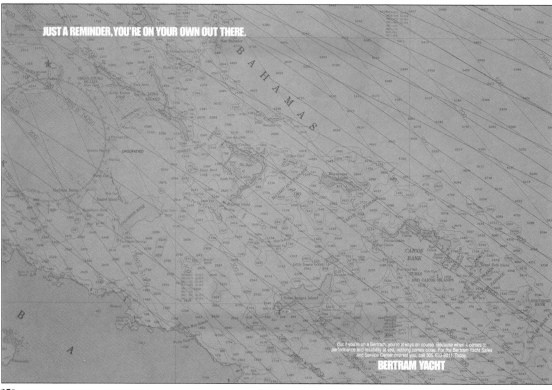

JUST A REMINDER, YOU'RE ON YOUR OWN OUT THERE.

BERTRAM YACHT

270

WHAT TO WEAR WHEN IT'S RAINING, IT'S POURING AND THE OLD MAN IS SNORING.

The guide who gave you fly-fishing lessons told you two things about the local trout.

One. They bite better when it's early. Two. They bite even better when it's early and it's raining.

Point One is quite easily addressed. All you need is the will to leave your dear snoring companion to his dreams. While you hit the streams.

To handle Point Two, you need only know one name. Timberland. Rugged gear made especially for days when it's pouring so hard the fish don't know where the stream

PEOPLE ONLY SNORE ON THEIR BACKS. SO TO CURE SNORING, SEW A MARBLE INTO THE BACK OF YOUR SPOUSE'S PAJAMA TOP.

ends and the frying pan begins.

So before you enter the drizzling dawn, you go to the closet and pull out his

Timberland® trekking shell. He's not going to need it where he is – and the classic styling looks as great on women as on men. You'll be as snug in the stormy outdoors as he is in that cozy sleeping bag.

Then put on a pair of your new boots or shoes – styled by Timberland for women, but as weatherproof as anything we make for men.

You'll find Timberland boots, shoes and apparel work overtime to protect you from the elements, and you'll get a whole different benefit when the sun finally

breaks through and you walk home. Looking every bit as good as you feel.

Why, even the old man will greet you smiling. Assuming you give him back his precious Timberland trekking shell, and you've caught enough fish for two.

Timberland

BOOTS, SHOES, CLOTHING, WIND, WATER, EARTH AND SKY.

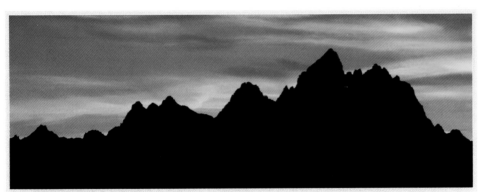

TIPTOE THROUGH THE TETONS.

We have a short message for everyone who thinks Timberland® only makes gear for conditions of 50° below zero.

Take a hike.

Take it in April, May or June. Take it on an August scorcher hot enough to fry your morning omelette. Take it wearing gear so durable and comfortable it will take miles off mountains.

In unpredictable summer weather, give your feet the extra protection of our waterproof Euro-hiker. Built of premium rough-out leather, this hiker features our exclusive Trail Grip™ rubber sole for extra traction, an SB rubber midsole,

anti-torque inner sole with steel shank, removable orthotic and latex-sealed seams. If you prefer general all-terrain trekking, the boot of choice is our all-leather waterproof Timberland Mountain Trainer (TMT), with

multi-directional diamond-cut rubber lug sole. The technological leader in its category, the TMT introduces the first internal fit system featuring stretch Gore-Tex® fabric. What's more, TMT technology is now available around the country in a classic women's oxford design, for good-looking performance at any altitude.

Although the song "Tiptoe through the Tulips" is nearly seventy years old, the Tetons are much older. They originated fifteen million years ago.

And for true Timberland protection above shoe level, don't leave home without our lightweight, trekking shell with ventilated mesh front and back pockets, roll-up storm hood, total drawcord system, action armholes and articulated sleeve construction.

Timberland earned its reputation helping mushers hike across 1,049 miles of frozen Alaskan tundra.

Now we're turning our technology towards anyone who hikes anywhere. The Grand Canyon, the Appalachian Trail, the local state park.

We won the Iditarod® Sled Dog Race. Can the Tetons be far behind?

Timberland

BOOTS, SHOES, CLOTHING, WIND, WATER, EARTH AND SKY.

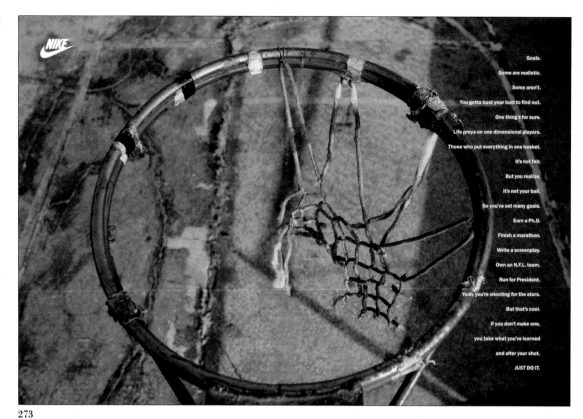

273

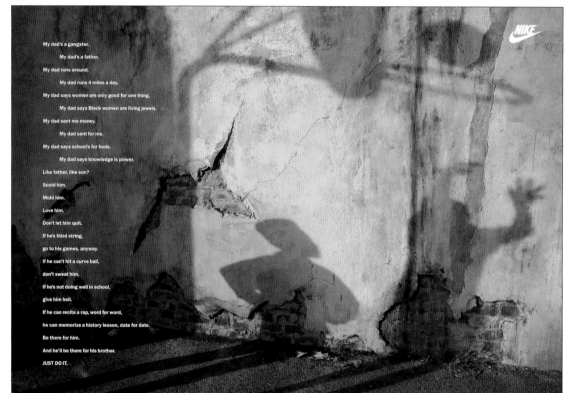

274

Once again
this season, we're
showing
what many men's
stores never do.
Restraint.

There's a subtle but important difference between style and fashion. The former exists apart from time; it has a currency in any given year. The latter, on the other hand, is time-bound; what is current one season may be dead-tired the next. It's easy to understand why some men's stores do their best to down-play this distinction. They're emporiums of fashion; their very identity depends upon their carrying the very latest clothing. This may all be well and good for them, but it is decidedly not the manner of business we run at Hillhouse. We're less impulsive. We favor what is known in clothing circles as an "updated traditional" look; it begins with traditional tailoring and adds refinements of one kind or another — pleated trousers, double-breasting, ventless jackets and so on — for a look that is at once contemporary and rich in style, but well to the right of "fashion." Our customers prefer it this way. In fact, it's one of the reasons they're unre-strained in their enthusiasm for the store.

Clothiers Haberdashers *Custom Tailoring*

135 THAYER STREET, PROVIDENCE RI 02906 421-8620 FREE PARKING

HILLHOUSE

The Thousand Words.

The Picture.

This page could very well be the advertising equivalent of Tolstoy's *War and Peace*. But if you're interested in purchasing a bicycle and can spare a few minutes, we urge you to read on. Because you'll learn something about a company named Mongoose, as well as a few things about the bikes we make. And at the very least, you'll end up being a thoroughly educated consumer. **67** Mongoose got into the bicycle business back in 1974, originally as a manufacturer of BMX bikes. While we've branched out considerably over the years, our philosophy has always been simple: a bike should be well made, last a long time, be reasonably priced and, above all, be a pleasure to ride. Combined, we think these qualities make our mountain, road and cross bicycles some of the better values in the industry. Needless to say, a claim like that needs to be backed up. But with some eight hundred and forty words left at our disposal, we don't think that's going to be a problem. **171** To start, we'd like to tell you about our mountain bikes. With the utmost confidence, we can say that these are among the best and most technologically advanced bicycles on the market. From the ten adult models we make, we've chosen three to profile here: the Rockadile, the IBOC Pro and the Amplifier Full Suspension. **226** The Rockadile is, quite simply, a lot of bike for the money. Priced at less than $550, it can handle trails with the finesse of bikes that cost hundreds of dollars more. The recipient of excellent reviews from both *Outside* and *Mountain Bike Action* magazines, the Rockadile comes with Shimano's all new Exage LT components, as well as their superb Multi-Condition brakes. You can even opt for the slightly higher priced Rockadile SX, a performance version that we've outfitted with SR's new Duo Track Suspension Fork. **313** If you're interested in burning up race courses, mastering technical single track or just grunting up nasty hills, check out the Mongoose IBOC Pro. Priced at less than $900, the Pro is one of four rides within our IBOC competition series. Designed to withstand the abuse of serious off road riding, it features aggressive 71° head tube and 73° seat tube angles, plus a 7005 series super hard alloy frame. **383** To see what the future of mountain biking looks like, we suggest you examine the Mongoose Amplifier Full Suspension. But hurry, because only a limited number of these frame and fork combinations will be available this year. Handmade here in the U.S.A., the Amplifier was created in conjunction with Horst Leitner, a legendary designer of motocross suspension systems. Up front is a revolutionary, 2 lb, 6 oz. fork that matches an oil piston with a spring/elastomer limiter. Total travel is two inches. In back is a completely suspended rear triangle that features a fully adjustable oil/oil hydraulic piston. Built up, this bike will weigh somewhere around 25 lbs., and offer unparalleled traction and handling in everything from rocky streambeds to root systems. Quite simply, the Amplifier is one of the lightest and best performing full suspension framesets in the world. At less than $1300, it's also one of the most affordable in the category. **539** Dirt and pavement are far different surfaces. And while Mongoose is perhaps best known for mountain bikes, we now call the road home, too. This year, our designers were given a free hand, which resulted in two of the better bicycles you can find, well, anywhere there's a stretch of asphalt. Both the IBOC Road and the IBOC World are incredibly responsive and fast, thanks to STI brake lever shifting and frames that are made from 7005 series ovalized aluminum tubing. Custom drawn, this tubing is "spiral bound", a Mongoose design feature that reduces weight and actually enhances the frame's handling characteristics. The difference between the bikes? Component groups and price. The IBOC Road comes with Shimano 105 and a price of less than $1250; the IBOC World has Shimano Ultegra 600 and is less than $1600. Whatever the choice, you can't go wrong. Because either will let you experience what riding a fine road bike is all about. **698** At Mongoose, we also make four great cross bicycles. As the name suggests, these are a "cross" between mountain bikes and road bikes. Essentially, this means you'll get a bicycle that's very durable yet lightweight. Called the Crossway Series, any of these bikes are ideal for fitness training, doing errands around town, or simply running over potholes without fear of bending a rim or getting a flat tire. They'll let you ride comfortably on a wide range of surfaces, from country dirt roads to paved bike paths. **785** One such bicycle is the Mongoose Crossway 850. Priced at less than $560, this bike won't break the bank. But with a high quality frame and Shimano's 400 CX "cross specific" components, it will provide you with many years of cycling enjoyment. **827** Our most affordable cross bike is the Crossway 425. Whether you're just getting into cycling, or simply need a nice looking, dependable form of transportation, the 425 is an excellent choice. It has 21 easy shifting speeds, Shimano Multi-Condition brakes for lots of stopping power, quick release wheels and more. Not to mention a price of less than $325. **887** If words haven't done these bikes justice yet, they probably never will. Which means a visit to an authorized Mongoose dealer is now in order. Where you can not only see some of the aforementioned bicycles in person, but take them out for test rides, too. And who knows, you might even end up owning one. **943** Well, as we close in on nine hundred and fifty four words, it's a good time to wrap things up. So if you'd like more information on any of our bicycles, or the name and address of the nearest Mongoose dealer, just give us a call at 1-800-645-5806. **994** And, oh yes, thanks for reading. **1000**

MONGOOSE
MONEY WELL SPENT.

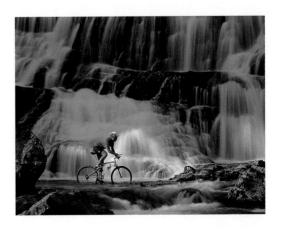

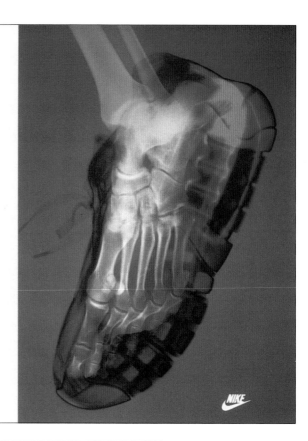

Fifty two moving parts go into a pair of Nikes. We know every one of them.

277

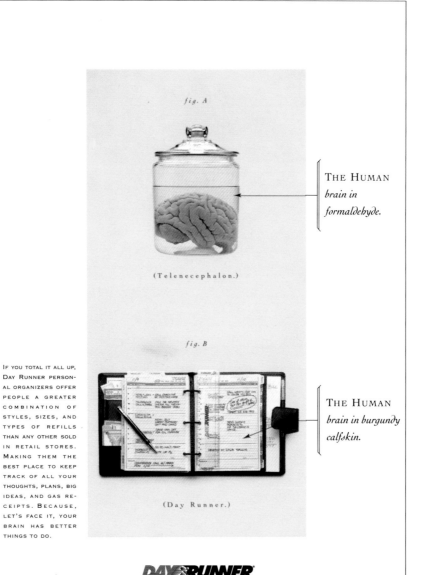

THE HUMAN *brain in formaldehyde.*

(Telenecephalon.)

THE HUMAN *brain in burgundy calfskin.*

IF YOU TOTAL IT ALL UP, DAY RUNNER PERSONAL ORGANIZERS OFFER PEOPLE A GREATER COMBINATION OF STYLES, SIZES, AND TYPES OF REFILLS THAN ANY OTHER SOLD IN RETAIL STORES. MAKING THEM THE BEST PLACE TO KEEP TRACK OF ALL YOUR THOUGHTS, PLANS, BIG IDEAS, AND GAS RECEIPTS. BECAUSE, LET'S FACE IT, YOUR BRAIN HAS BETTER THINGS TO DO.

(Day Runner.)

DAYRUNNER
PERSONAL ORGANIZERS

278

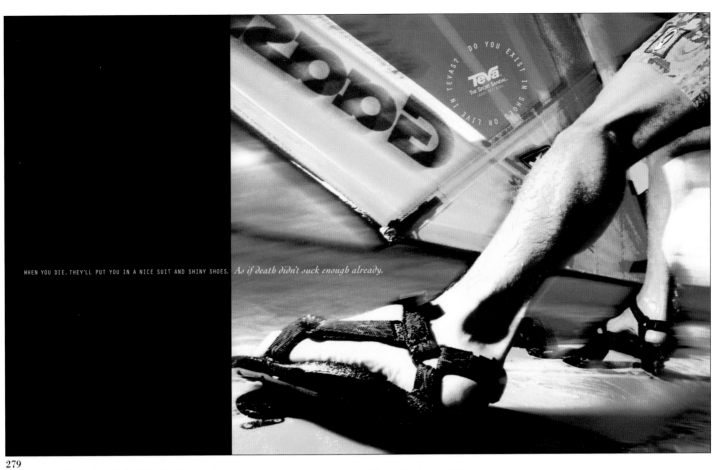

WHEN YOU DIE, THEY'LL PUT YOU IN A NICE SUIT AND SHINY SHOES. *As if death didn't suck enough already.*

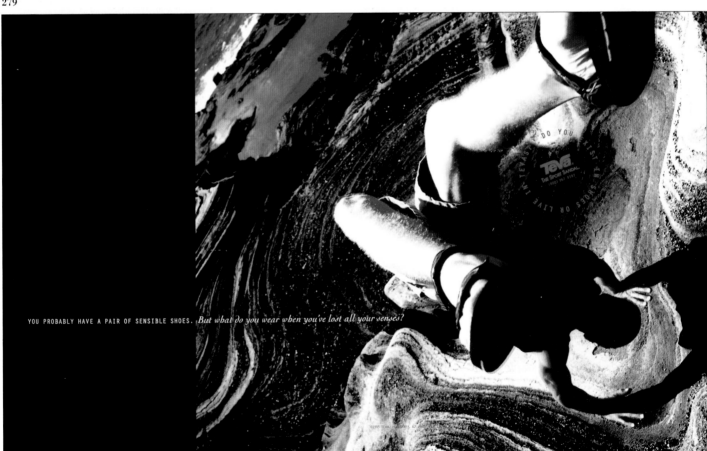

YOU PROBABLY HAVE A PAIR OF SENSIBLE SHOES. *But what do you wear when you've lost all your senses?*

These days more and more corporate decision makers are standing straight **YOU CAN ALWAYS SPOT THE SUCCESSFUL**

and tall and are walking with perfect **BUSINESS LEADER BY THE WAY HE CARRIES HIMSELF.**

posture up the ramp of our Beechcraft Starship." Why? They recognize it as an aircraft on the forefront of aerospace technology. The avionics were inherited from the newest

747 jet. The braking method was pioneered on space shuttle flights. And select components were constructed of the same dense material found in bulletproof vests. What's more, the new Starship 2000A boasts more speed, pay-

load, range and shorter field requirements than its predecessor. These details, including specifics on what may be the most elegantly appointed cabin in the sky, **Beechcraft STARSHIP**

are all in our brochure. To receive one, please call 800-835-7767, ext. 697. You'll find that what it says about the new Starship can also apply to what it says about you.

281

On the thoroughfares of corporate America, an executive's image can fade as quickly as week-old shoe polish. Which may explain why the decision makers of more and

YOU CAN TELL A LOT ABOUT A C.E.O. BY HIS WINGTIPS. more leading companies are considering

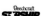

the Beechcraft Starship." What do they gain? Well, for starters, they have an aircraft that epitomizes the forefront of aerospace technology. Its avionics were inherited from the

newest 747. Its brakes were pioneered on space shuttle flights. And the new Starship 2000A boasts more speed, payload, range and shorter field requirements **Beechcraft STARSHIP**

than its predecessor. You'll find all these points detailed in our Starship brochure. To obtain one, just call 800-835-7767, ext. 694. We'll help you put your best foot forward.

282

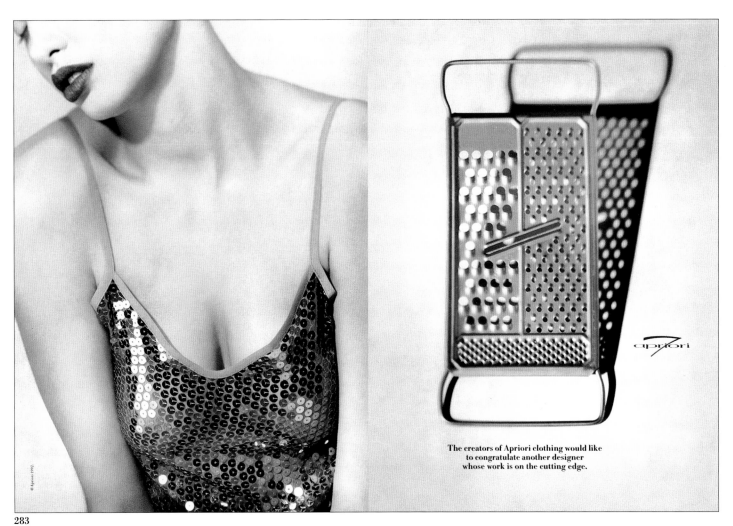

The creators of Apriori clothing would like
to congratulate another designer
whose work is on the cutting edge.

The creators of Apriori clothing
take pride in the fact that other companies
have been turned on by their designs.

Remember P.E. class?

Remember prison ball and jumping jacks and how your P.E. teacher made you try to climb that rope that hung from the ceiling and you never could, *never?*

Or how you had to do chin-ups and see how long you could hang and you could only hang something like 2.5 seconds but that wasn't good enough, *oh no,*

you had to hang something like 65 seconds and you could never do that and thank God it was only pass/no pass and you got a pass just for showing up and trying. Which was good.

But then you got older.

And P.E. teachers got smarter. Because now you got graded. You got graded and at least once you got the dreaded C or the equally dreaded C+ and there went your whole grade-point average and speaking of average that's what you were now: *plain-old-just-mediocre-better-luck-next-time-see-ya-later average* and you thought *(continued)*

Now wait just a gosh darn minute who, exactly, is average? And the answer came back ringing loud and clear over the top of that chin-up bar: Nobody.

You're not average because average is a lie. You're not average because average means stuck and you're not stuck, you're moving and becoming and trying and you're climbing over every bit of fear or opinion or "no you can't do that" you've ever heard.

So you scoff at average. You laugh. You guffaw. And you run and you play and you move and the more you tell your body that it is a well-oiled machine the more it starts to believe you.

And then one night you have the craziest dream.

You're in the middle of your old gym. Your P.E. teacher is standing there. She is grinning. There is a rope before you. So you climb it. You climb the living heck out of it. You reach the top. And there is absolutely no place to go but up.

Just do it.

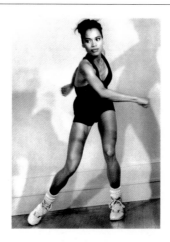

For more information about Nike Women's Products, call 1-800-254-3454.

285

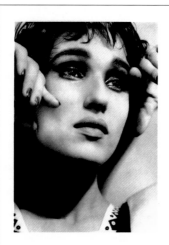

Oh you are so emotional.

There you are all caught up in your emotions, wearing your heart on your sleeve, wearing your heart on every piece of clothing you own. You cry at the drop of a hat. You cry absolute buckets. You cry me a river.

You're a woman (you can't help it) you're a girl (now don't get me wrong) you're a woman and you're *so emotional* about everything and

even at those times when you're *perfectly* rational and *perfectly* capable somebody somewhere will look at you and shake their head and say (like it's the worst thing in the world)

Oh you are so emotional

and of course that really makes you want to scream.

And then just as soon as you don't weep, which is most of the time anyway, and you're cool and calm and absolutely brilliant under pressure somebody somewhere will say you're too cool and too calm and then, of course, you're suddenly and forever called *insensitive.*

Ah, to be a woman. *(continued)*

Somewhere in the middle of all these assumptions and all these labels is the way you really are. You are kind (that's why we have hearts). You are strong (or you wouldn't have made it this far). You are fearless (or you would have hidden your heart long ago). And because you wear your heart so easily sometimes

you know how easily it is broken.

So, through time, you have learned to protect it. You learn to take it out for long walks. You learn to let it breathe deeply. You learn to treat it with respect.

And, through time, you have learned to move it and bend it and shake it and make it accountable, because the best way to keep a heart alive is to be unafraid to use it. And you are so very good at using it.

Listen.

Your heart is beating. This means you are alive. Your body is moving. This means you cannot be stopped. The world and all its labels are calling to you. You'd love to answer. But you're moving so fast you can't hear a thing.

Just do it.

For more information about Nike Women's Products, call 1-800-254-3454.

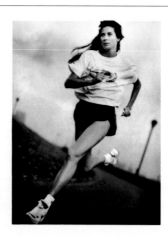

286

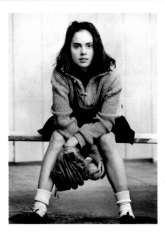

NIKE

Did you ever wish you were a boy?

Did you? Did you for one moment or one breath or one heartbeat beating over all the years of your life, wish, even a little, that you could spend it as a boy? Honest. Really. Even if you got over it.

Did you ever wish that you could be a boy just so you could do *boy things* and not hear them called *boy things*, did you want to climb trees and skin knees and be third base and not hear the boys say, Sure, play, but that means you have to *be* third base.

Oh *ha ha ha.*

But did you ever wish you were a boy

just because there were *boys*, and there were *girls* and they were *them*, and we were, well,

we weren't them, and we knew there must be a difference because everybody kept telling us there was. But what was it?

You never knew. Like you *knew* that you were a girl *(you run like a girl you throw like a girl you girl you)* and that was great, that was swell, but you *(continued)*

couldn't help wondering what it would be like if you... had been...a *boy*.

And if you could have been a boy, what difference would it have made? Would it have made you faster, cuter, cleaner? And if you *were* a boy, this incredibly bouncing boy, what boy would you have been? All the time knowing no two boys are alike any more than all girls are.

So you wake up. And you learn we all have differences (Yes!) You learn we all have similarities (Right!) You learn to stop lumping everybody in the world into two separate categories, or three, or four, or any at all (Finally!) And you learn to stop beating yourself over the head for things that weren't

wrong in the first place.

And one day when you're out in the world running, feet flying dogs barking smiles grinning, you'll hear those immortal words calling, calling inside your head *Oh you run like a girl*

and you will say shout scream whisper call back *Yes. What exactly did you think I was?*

Just do it.

For more information about Nike Women's Products, call 1-800-234-6356

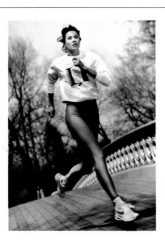

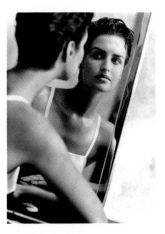

NIKE

Why are we so hard on ourselves

and so much easier on others? Did somebody say something once that stuck in our brains and won't go away? Did we mispronounce something in French, did we trip in front of some guy, did we make some huge mistake that we've never gotten over?

What haunts our fine bodies and our fine hearts and makes our heads spin with an image

of ourselves we can't accept? We tell our friends not to be so hard on themselves and we tell our loved ones not to be so hard on themselves and we tell ourselves

we're just not being hard enough.

We are such funny women sometimes. We blame ourselves when blame does not apply (terrible word, that *blame*). We feel guilty about what we should have done better (terrible word, that *should*). We are harder on ourselves, harder than we would be on anybody else, anybody. Complete strangers! Big dogs! *People we don't even like!*

And the things we expect are so darn *(continued)*

weird, things our mothers once said we should be able to do or our fathers wanted us to achieve or our great Aunt Charlotte wanted us to try and they didn't know that their words would stick

like glue to our hearts with a list of expectations wrapped around it. Look: all these requests and all these demands and all these great expectations get old, *real old*, and only you know when to yell uncle.

Uncle. Uncle. Uncle.

Because for one moment of your life you feel like feeling...perfect. You feel like dashing into those hills or those open roads or right into the air itself

and that's just what you might do

so *Ha.*

You feel like that rusty old image you carry is slipping away, right over the edge of a mirror and out of view. You feel like moving and if you trip, you trip, if you fall, you will get up. And the air feels like it will carry you and push you and it's like nothing you feared it would be. And of course everything you expected it would.

Just do it.

For more information about Nike Women's Products, call 1-800-234-6356

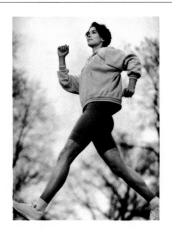

CONSUMER MAGAZINE
COLOR 1 PAGE OR
SPREAD: SINGLE

289
ART DIRECTOR
Susan Hoffman
WRITER
Stacy Wall
PHOTOGRAPHER
Enrique Badalescu
CLIENT
Nike
AGENCY
Wieden & Kennedy/
Portland

290
ART DIRECTOR
John Boiler
WRITER
Jamie Barrett
PHOTOGRAPHERS
Doug Petty
Lars Topelmann
CLIENT
Nike
AGENCY
Wieden & Kennedy/
Portland

291
ART DIRECTOR
Vince Engel
WRITER
Jerry Cronin
PHOTOGRAPHER
Lamb/Hall
ILLUSTRATOR
Andy Engel
CLIENT
Subaru of America
AGENCY
Wieden & Kennedy/
Portland

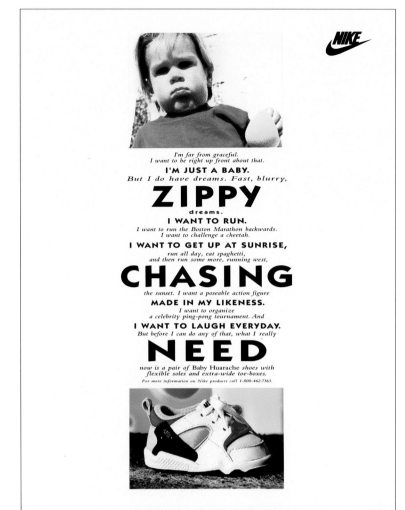

289

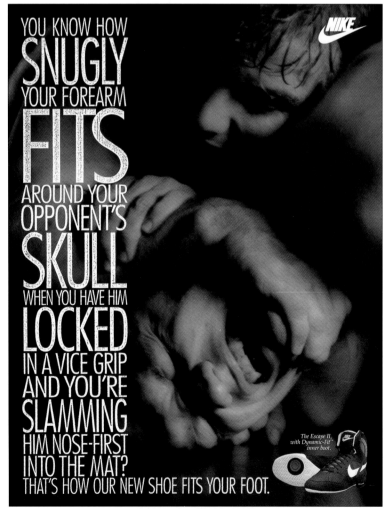

290

A sports car for both sides of your brain. The half that's seventeen, and the half that's retired and living in Miami.

THERE YOU ARE, both of you, considering a Subaru SVX. The younger, more adventurous you is taken aback by the Italian styling. And the SVX engine! A 6-cylinder, 230-horsepower monster capable of blasting from 0 to 60 in just over 7 seconds. The wilder you also goes on about the absurd top speed of 140 miles an hour and the fact the special window design allows you to drive in a rainstorm with the windows down without getting drenched. The windows down in a rainstorm without getting drenched, the crazy you shouts again.

And right then and there the conservative you, the joyless voice of reason, gets ready to reprimand such reckless thoughts, but then you pause and think—Hey, this is a practical car. It's a Subaru, and that means reliable, dependable transportation. Furthermore, the SVX has room for four beefy adults, and it comes with sensible All-Wheel Drive traction, 4-channel anti-lock brakes, a driver's-side air bag and a fully-independent suspension. Now both of you are smiling. Everything is beautiful. Until you're driving home. What to listen to on the optional 6-speaker CD player? Big band or heavy metal?

Subaru SVX

Subaru. What to drive.

©1992, Subaru of America, Inc.

292
ART DIRECTORS
Bill Boch
Tim Hanrahan
WRITER
Ron Lawner
PHOTOGRAPHERS
Kenji Toma
Robert Tardio
CLIENT
Kinney Shoes
AGENCY
**Arnold Fortuna Lawner
& Cabot/Boston**

293
ART DIRECTOR
Tim Hanrahan
WRITER
Ron Lawner
PHOTOGRAPHER
Robert Tardio
CLIENT
Kinney Shoes
AGENCY
**Arnold Fortuna Lawner
& Cabot/Boston**

Color blocking from the bottom up in yellow, red, green and marine. They sell for about forty dollars at Kinney. That's right, Kinney. The reason we didn't put a big Kinney logo on this ad is because there are some people who still don't think of Kinney as a place to buy fashionable leather shoes. Hey, fashion is where you find it.

These elegant leather T-straps now open up to more fluid lines and richer hues. And you'll find them at Kinney for about forty three dollars. That's right, Kinney. The reason we didn't put a big Kinney logo on this ad is because there are some people who still don't think of Kinney as a place to buy fashionable leather shoes. Hey, fashion is where you find it.

Politics aside, this year's most interesting platform is luscious kidskin, hot pink or ruby red. They sell for about fifty dollars at Kinney. That's right, Kinney. The reason we didn't put a big Kinney logo on this ad is because there are some people who still don't think of Kinney as a place to buy fashionable leather shoes. Hey, fashion is where you find it.

This luxurious washed silk slide stands on a leather sole with a short pedestal heel. They sell for about thirty dollars at Kinney. That's right, Kinney. The reason we didn't put a big Kinney logo on this ad is because there are some people who still don't think of Kinney as a place to buy fashionable leather shoes. Hey, fashion is where you find it.

This Spring opens with a V-strap flat with closed toe in the soft sheen of leather in lime. And you can find them for about thirty dollars at Kinney. That's right, Kinney. The reason we didn't put a big Kinney logo on this ad is because there are some people who still don't think of Kinney as a place to buy fashionable leather shoes. Hey, fashion is where you find it.

This sleek slingback is crafted in butter soft full grain leather and sells for about thirty dollars. Flings at Kinney. That's right, Kinney. The reason we didn't put a big Kinney logo on this ad is because there are some people who still don't think of Kinney as a place to buy fashionable leather shoes. Hey, fashion is where you find it.

294
ART DIRECTOR
Andy Clarke
WRITER
Antony Redman
PHOTOGRAPHERS
Charles Liddall
Alex Kaikeong
Hanchew's Studios
CLIENT
Cycle & Carriage/
Mitsubishi
AGENCY
The Ball Partnership
Euro RSCG/Singapore

295
ART DIRECTOR
Joanna Wenley
WRITER
Kim Papworth
PHOTOGRAPHER
Kevin Summers
CLIENT
H.J. Heinz
AGENCY
BMP DDB Needham
Worldwide/London

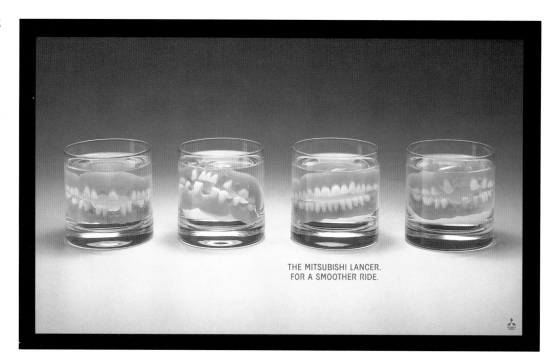

THE MITSUBISHI LANCER.
FOR A SMOOTHER RIDE.

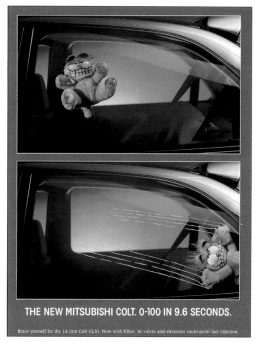

THE NEW MITSUBISHI COLT. 0-100 IN 9.6 SECONDS.

Brace yourself for the 1.6 litre Colt GLXi. Now with 83kw, 16 valves and electronic multi-point fuel injection.

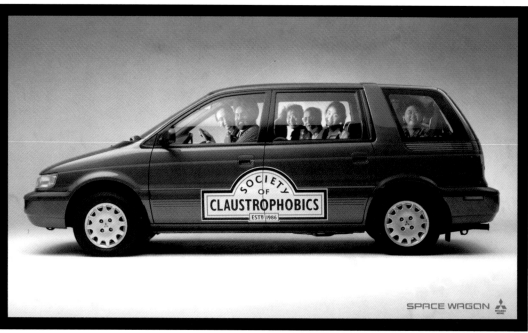

SOCIETY OF CLAUSTROPHOBICS ESTB 1986

SPACE WAGON

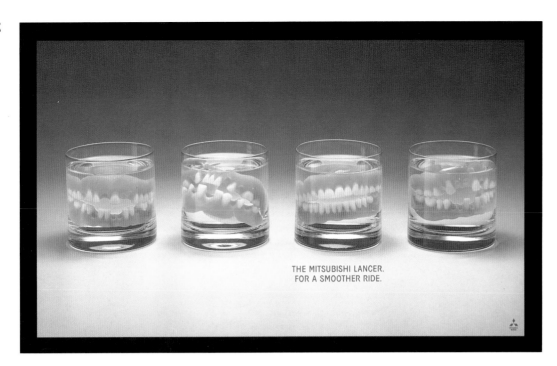

THE MITSUBISHI LANCER.
FOR A SMOOTHER RIDE.

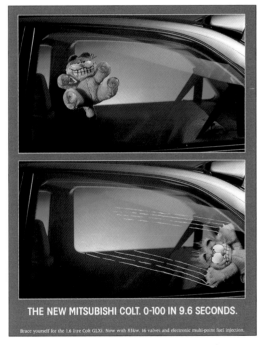

THE NEW MITSUBISHI COLT. 0-100 IN 9.6 SECONDS.

Brace yourself for the 1.6 litre Colt GLXi. Now with 83kw. 16 valves and electronic multi-point fuel injection.

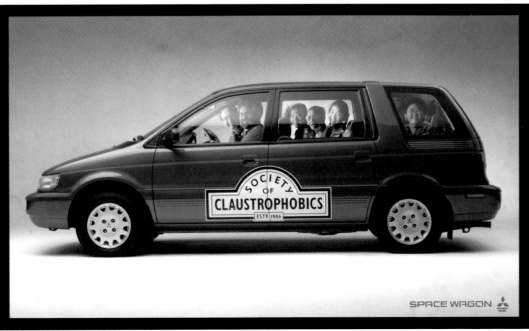

SOCIETY OF CLAUSTROPHOBICS
ESTB 1986

SPACE WAGON

This Spring opens with a V-strap flat with closed toe in the soft sheen of leather in lime. And you can find them for about thirty dollars at Kinney. That's right, Kinney. The reason we didn't put a big Kinney logo on this ad is because there are some people who still don't think of Kinney as a place to buy fashionable leather shoes. Hey, fashion is where you find it.

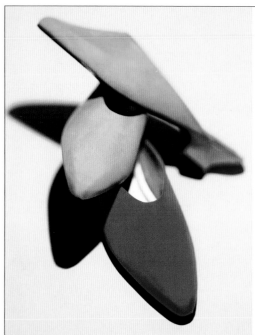

This luxurious washed silk slide stands on a leather sole with a short pedestal heel. They sell for about thirty dollars at Kinney. That's right, Kinney. The reason we didn't put a big Kinney logo on this ad is because there are some people who still don't think of Kinney as a place to buy fashionable leather shoes. Hey, fashion is where you find it.

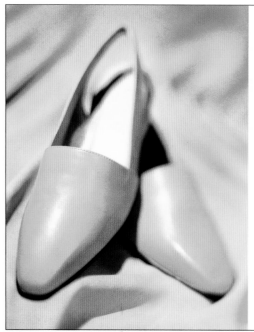

This sleek slingback is crafted in butter soft full grain leather and sells for about thirty dollars. Flings at Kinney. That's right, Kinney. The reason we didn't put a big Kinney logo on this ad is because there are some people who still don't think of Kinney as a place to buy fashionable leather shoes. Hey, fashion is where you find it.

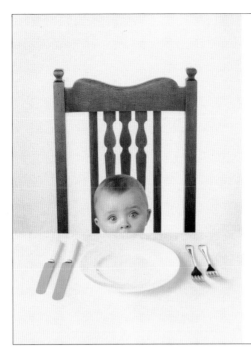

HOW LONG SHOULD YOU HAVE TO WAIT FOR YOUR FIRST SQUARE MEAL?

This little mite's not up to a three-course meal just yet.

Thanks to her Mum though, she got off to a good start.

But after about three months, it was time for something a little more solid than milk.

Heinz's Blue Label recipes have been carefully strained so that they are easier to eat.

From seven months she was ready for the next stage. Food with a bit more substance, food that taught her to chew rather than suck.

That's why our Pink Label recipes have a lumpier texture almost like a grown-up meal.

Lastly, our Green Label desserts can round off a hearty meal, whether you're three months or fifteen months old.

And, happily for this young lady, all our recipes come ready to eat.

Heinz. Taking care of little appetites.

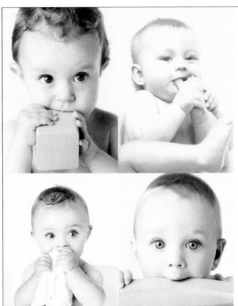

A RANGE OF RECIPES FOR PEOPLE WHO ARE FUSSY ABOUT WHAT THEY EAT.

You know how it is.

They'll eat anything and everything they can lay their hands on between meals.

But as soon as dinner-time comes along, that little mouth isn't always open for business.

Well at Heinz, we pride ourselves in knowing how to tempt a growing appetite. In fact, over the years we've found nearly a hundred different ways to do just that.

Ranging from the more traditional favourites like Chicken & Ham Dinner, to the more exotic Apple & Mango Fromage Frais.

And, of course, no artificial colouring, flavouring or preservatives in sight.

So now you won't have to explain why bath flannel hotpot is off the menu.

Heinz. Taking care of little appetites.

UNTIL NOW, SOME PEOPLE WEREN'T QUITE OLD ENOUGH TO ENJOY FROMAGE FRAIS.

Well you can't blame him for trying. Imagine having to sit there while the rest of the family tuck into their Fromage Frais. But none for you!

If there's one thing we don't like to see at Heinz, it's someone missing out. So thanks to our baby food experts, we now have the perfect answer.

Real Fromage Frais with no added sugar, preservatives or colouring.

Simple really and all part of a healthy nutritious diet.

Mind you with tempting flavours like Pear & Raspberry and Apple & Mango, we're afraid it's the grown-ups who will be missing out from now on.

Heinz. Taking care of little appetites.

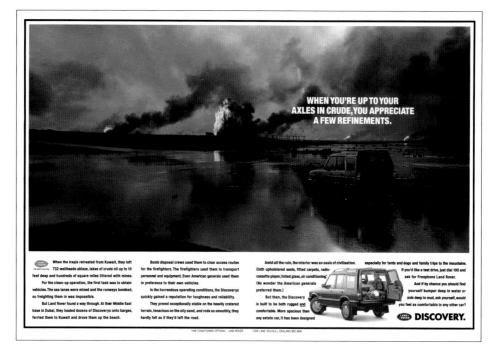

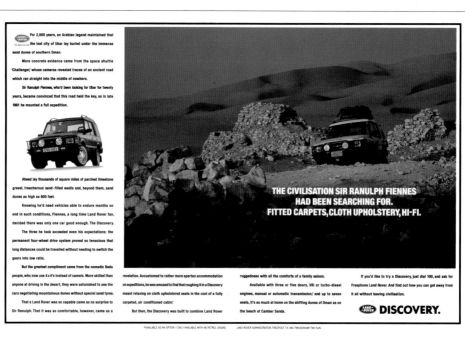

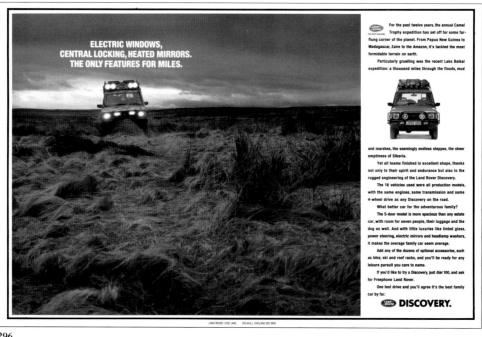

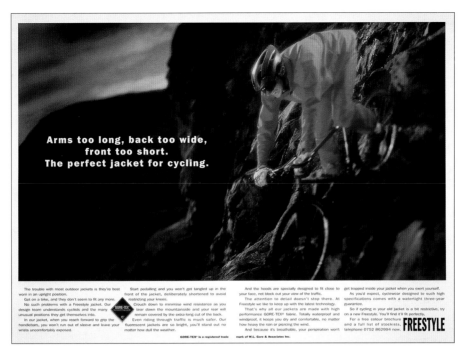

Arms too long, back too wide, front too short. The perfect jacket for cycling.

The trouble with most outdoor jackets is they're best worn in an upright position.

Get on a bike, and they don't seem to fit any more.

No such problems with a Freestyle jacket. Our design team understands cyclists and the many unusual positions they get themselves into.

In our jacket, when you reach forward to grip the handlebars, you won't run out of sleeve and leave your wrists uncomfortably exposed.

Start pedalling and you won't get tangled up in the front of the jacket, deliberately shortened to avoid restricting your knees.

Crouch down to minimise wind resistance as you tear down the mountainside and your rear will remain covered by the extra-long cut of the back.

Even riding through traffic is much safer. Our fluorescent jackets are so bright, you'll stand out no matter how dull the weather.

And the hoods are specially designed to fit close to your face, not block out your view of the traffic.

The attention to detail doesn't stop there. At Freestyle we like to keep up with the latest technology.

That's why all our jackets are made with high performance GORE-TEX® fabric. Totally waterproof and windproof, it keeps you dry and comfortable, no matter how heavy the rain or piercing the wind.

And because it's breathable, your perspiration won't get trapped inside your jacket when you exert yourself.

As you'd expect, cyclewear designed to such high specifications comes with a watertight three-year guarantee.

So if cycling in your old jacket is a bit restrictive, try on a new Freestyle. You'll find it'll fit perfectly.

For a free colour brochure and a full list of stockists, telephone 0752 862994 now. **FREESTYLE**

GORE-TEX® is a registered trade mark of W.L. Gore & Associates Inc.

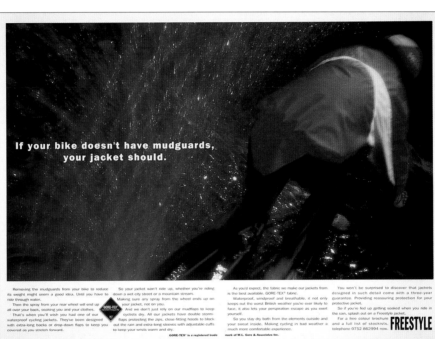

If your bike doesn't have mudguards, your jacket should.

Removing the mudguards from your bike to reduce its weight might seem a good idea. Until you have to ride through water.

Then the spray from your rear wheel will end up all over your back, soaking you and your clothes.

That's when you'll wish you had one of our waterproof cycling jackets. They've been designed with extra-long backs or drop-down flaps to keep you covered as you stretch forward.

So your jacket won't ride up, whether you're riding down a wet city street or a mountain stream.

Making sure any spray from the wheel ends up on your jacket, not on you.

And we don't just rely on our mudflaps to keep cyclists dry. All our jackets have double storm-flaps protecting the zips, close-fitting hoods to block out the rain and extra-long sleeves with adjustable cuffs to keep your wrists warm and dry.

As you'd expect, the fabric we make our jackets from is the best available. GORE-TEX® fabric.

Waterproof, windproof and breathable, it not only keeps out the worst British weather you're ever likely to face, it also lets your perspiration escape as you exert yourself.

So you stay dry both from the elements outside and your sweat inside. Making cycling in bad weather a much more comfortable experience.

You won't be surprised to discover that jackets designed in such detail come with a three-year guarantee. Providing reassuring protection for your protective jacket.

So if you're fed up getting soaked when you ride in the rain, splash out on a Freestyle jacket.

For a free colour brochure and a full list of stockists, telephone 0752 862994 now. **FREESTYLE**

GORE-TEX® is a registered trade mark of W.L. Gore & Associates Inc.

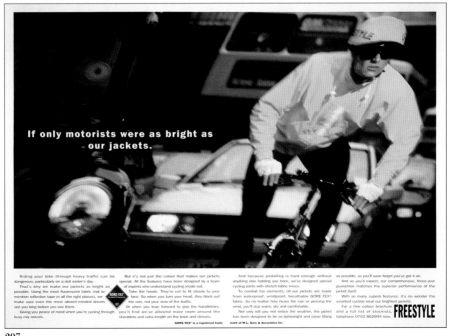

If only motorists were as bright as our jackets.

Riding your bike through heavy traffic can be dangerous, particularly on a dull winter's day.

That's why we make our jackets as bright as possible. Using the most fluorescent fabric (not to mention reflective tape in all the right places), we make sure even the most absent-minded drivers see you long before you see them.

Giving you peace of mind when you're cycling through busy city streets.

But it's not just the colour that makes our jackets special. All the features have been designed by a team of experts who understand cycling inside out.

Take the hoods. They're cut to fit closely to your face. So when you turn your head, they block out the rain, not your view of the traffic.

Or when you lean forward to grip the handlebars, you'll find we've allowed more room around the shoulders and extra length on the back and sleeves.

And because pedalling is hard enough without anything else holding you back, we've designed special cycling pants with stretch-fabric knees.

To combat the elements, all our jackets are made from waterproof, windproof, breathable GORE-TEX® fabric. So no matter how heavy the rain or piercing the wind, you'll stay warm, dry and comfortable.

Not only will you not notice the weather, the jacket has been designed to be as lightweight and close fitting as possible, so you'll soon forget you've got it on.

And as you'd expect, our comprehensive, three-year guarantee matches the superior performance of the jacket itself.

With so many superb features, it's no wonder the smartest cyclists wear our brightest jackets.

For a free colour brochure and a full list of stockists, telephone 0752 862994 now. **FREESTYLE**

GORE-TEX® is a registered trade mark of W.L. Gore & Associates Inc.

298
ART DIRECTORS
Yvonne Smith
Lee Clow
WRITER
Rob Siltanen
ILLUSTRATOR
Kevin Hulsey
PHOTOGRAPHERS
Bob Grigg
Smith/Nelson
CLIENT
Nissan Motor Corporation
AGENCY
Chiat/Day, Venice, CA

299
ART DIRECTOR
Steve Luker
WRITER
Mark Fenske
PHOTOGRAPHER
Dan Langley
CLIENT
Nike *i.e.*
AGENCY
Cole & Weber/Seattle

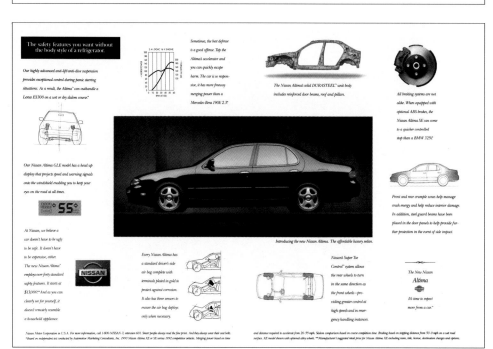

Everything
would be all right
she told him,
and he believed her,
but she was only
talking
about her feet.

i.e. shoes now have NIKE-AIR® cushioning.
Call 1-800-722-9050 for the store nearest your feet.

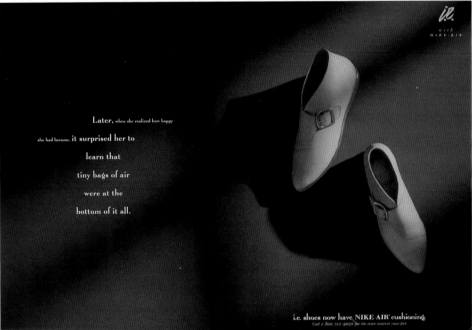

Later, when she realized how happy
she had become, it surprised her to
learn that
tiny bags of air
were at the
bottom of it all.

i.e. shoes now have NIKE-AIR® cushioning.
Call 1-800-722-9050 for the store nearest your feet.

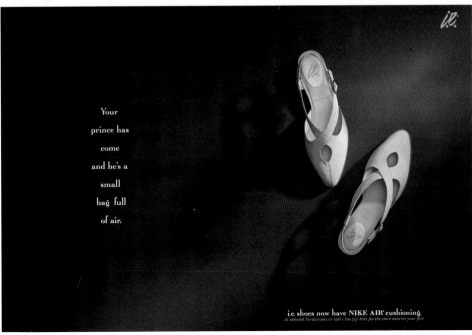

Your
prince has
come
and he's a
small
bag full
of air.

i.e. shoes now have NIKE AIR® cushioning.
At selected Nordstroms or call 1-800-727-8061 for the store nearest your feet.

NEVER CHANGE. NEVER ADAPT. NEVER IMPROVE. AND DIE NAKED, COLD AND ALONE.

The dinosaurs could have used this kind of wisdom. Instead they relied on tradition. They relied on old thinking. They relied on the weather forecast. Bad move.

With this in mind we designed the Weddington. It's one guitar that respects tradition. It captures the style and sound of vintage guitars without forgetting this simple fact; we've learned a lot since Ike was president.

Like what makes a vintage guitar sound so good. And what doesn't. And it's not about how old it is. And it's not about the color of the pick-ups. It's about wood.

The Weddington body is a single, solid piece of mahogany. And we're talking Honduran mahogany. The kind the classics were made from. Not the heavier, cheaper, more common, African variety. Go down to the music store and ask the sales person for a mahogany guitar. Now ask if it's African or Honduran. They love customers like you.

Stegosaurus ungulatus: Evolutionary fool.

The top is figured maple. It brings a bit of brightness to the Weddington's tone. And it's one of the pieces that was carefully selected by our own expert wood buyers. Their sole job requirement is to find beautiful wood for our guitars. The end result is spectacular. Look at the picture there. Nice job.

The neck is mahogany and maple, set-in to the body. The heel is beautifully sculpted so it's easier to play the higher frets. They didn't have this in the old days. This is progress.

The fingerboard is bound ebony. It's inlaid with sparkling abalone and mother-of-pearl. And it all looks good. But how does it sound?

Vintage. If you want it to. Actually, it'll sound just about any way you like. The pick-ups are genuine DiMarzio humbuckers. They're custom-designed and made in the USA. And the switch has five positions so you can choose from a variety of distinctly different and useful tones, all hum-cancelling.

By now you may feel a dull throbbing sensation at the base of your cerebellum, where your instincts used to be. You should go call 1-800-879-1131, ext. 200. We'll send you more information about the Weddington Custom, Classic and Special. Or go down to your local Yamaha Guitar Dealer and take a look at the Weddington. You can touch it. You can pick it up. Best of all, you can play it.

The dinosaurs cannot. There's a moral here somewhere.

YAMAHA
Weddington

NAKED GIRLS AND FLAMING SKULLS DON'T MAKE A GUITAR WORK BETTER. UNFORTUNATELY.

Good guitar parts play a lot better than paint. Read that again, it sounds vaguely important. Good guitar parts play a lot better than paint.

Sure, paint is nice. Look at the picture. That's an RGZ with our Big Flake, Three Color, Sunburst paint job. It's real nice. It's top quality. It protects the wood. We're awfully proud of it.

But.

It's just paint. It shouldn't determine which guitar you play. Because it's not going to help you crank out loud, long, painfully clear, screaming, shredding, wailing licks.

That's what the RGZ is for. It's got a stacked single coil and two humbucking pickups. They're high output, noise-free and loaded with Alnico magnets. They deliver a wide tonal range with tremendous sustain. And

Clever packaging can mislead the average consumer.

they do it without using a single naked flaming girl's skull. Impressive.

Now all self-respecting guitars have a Floyd Rose licensed locking vibrato. The RGZ's is a low-profile system so it's out of the way. And it delivers optimum resonance because it's milled from a solid block of steel.

The RGZ body is sculpted alder. And the neck joint is recessed so it's easier to play the higher frets. The neck is fast and fitted with 24 jumbo Dunlop® frets. If you don't know why 24 is a good thing you shouldn't be reading this fine publication.

At the top of the fingerboard is the height adjustable locking nut. It lets you make minor action adjustments without a trip down to the repair shop. Nobody but Yamaha has this. It is good. You will like it.

The headstock is tilted, using a Spanish luthier's joint. (Luthiers are those seriously expensive stringed instrument-making guys. This is their joint.) It's available in regular and reversed styles. The one in the picture is the reversed. Cool, right? Yes indeed.

The RGZ is for people whose hormone levels haven't taken over their ability to judge good guitars and art. If you count yourself among these fortunate few, call Yamaha at 1-800-879-1131, extension 300.

We'll send you a brochure full of information about RGZs in a variety of configurations and colors. Or just go to your local Yamaha guitar dealer and look for an RGZ.

It'll be the one with the plain old, top-quality paint job. But don't let that sell you.

YAMAHA
RGZ

TO SURVIVE YOU NEED FOUR THINGS: FOOD. SEX. SHELTER. GUITARS. MAKE THAT TWO THINGS.

This is the kind of thinking that's going on right now at Yamaha. Scary, huh? Well, we got this way from listening to a lot of guitar players.

It was for them we designed the Pacifica. A guitar so rich with the features guitar players love, that lo and behold, guitar players love it. Look at the picture there.

Look at the pickups. Those are genuine DiMarzios. They're custom-designed and made in the USA.

Look at the vibrato. It's a Floyd Rose licensed locking vibrato system. It has a low profile bridge milled from a single block of steel. It's set up so you can adjust intonation without detuning. And the strings can be loaded from the bottom, so you don't have to snip the balls off. Why didn't someone think of this sooner? We don't know.

*A Good Rule:
Give the people what they want.*

To go with the locking vibrato there's a height adjustable locking nut. So you can fine-tune the action without a trip to the repair shop.

Check the neck. It's slim. Real slim. Ultra slim, you might say. And it's reinforced with carbon-graphite rods to keep it straight and true. Forever.

The fingerboard has 24 jumbo Dunlop frets. And it has a compound radius. So it's slightly more curved in the lower frets, for easier chording. And it's slightly flatter in the higher frets for effortless string bending. This is a subtle thing. Most people never notice it. Won't your friends enjoy you pointing it out to them? Oh, yes.

Now take a look at the back of the neck, where it meets the body. Notice the absence of that annoying chunk of wood? It was called the heel. Nice name for it. It's gone. Goodbye.

In its place is the Total Access Neck Joint. It joins the neck to the body with an aircraft-grade aluminum plate. And it's solid as a rock. It makes it easier to play the higher frets, while improving sustain and resonance.

If you find that you rank guitars somewhere considerably higher than all-beef franks, you should go right now to your local Yamaha Dealer and play a Pacifica.

Or just call 1-800-879-1131, ext. 100 and we'll send you information about Pacificas in a variety of pickup configurations, body styles and colors.

Look at the picture again. Think about the important things in life. Go play one.

YAMAHA
Pacifica

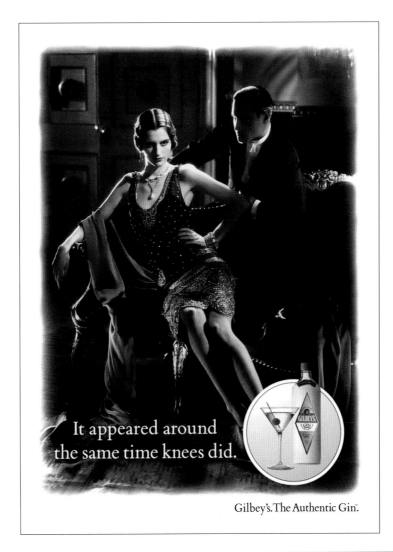

It appeared around
the same time knees did.

Gilbey's. The Authentic Gin.

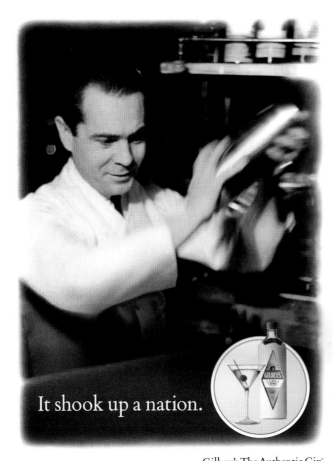

It shook up a nation.

Gilbey's. The Authentic Gin.

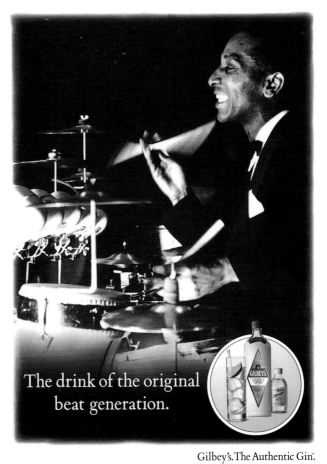

The drink of the original
beat generation.

Gilbey's. The Authentic Gin.

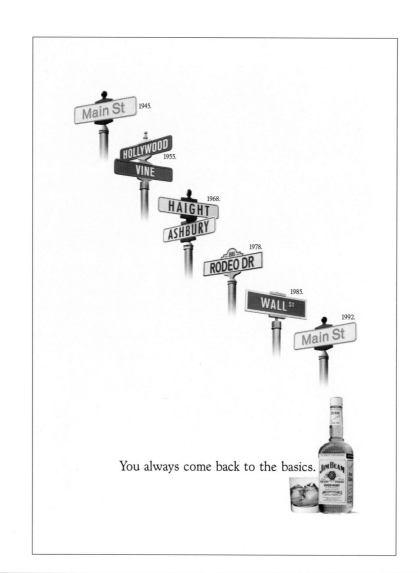

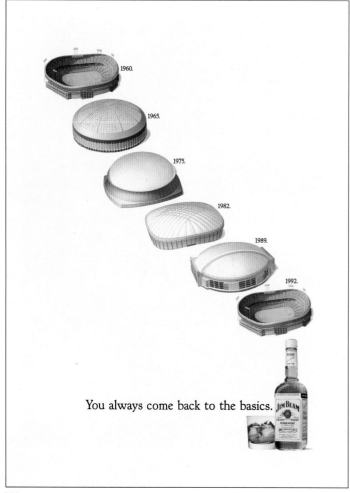

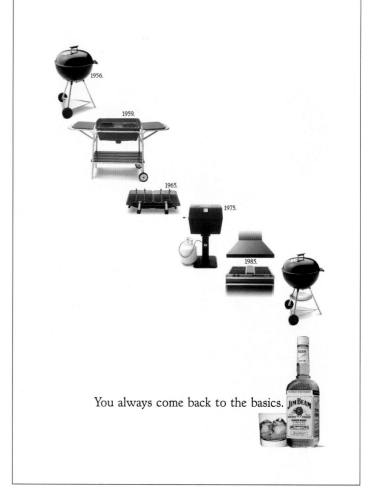

The most comfortable men's shorts since
those really ugly ones from Bermuda.

You could travel the world over and never find a better pair of shorts. Classic 5-pocket style with the comfort of a cool loose fit, in 100% cotton. They look good. You look good. And you can save yourself the trip to Bermuda. Lee Baggy Riders. Nobody fits your body...or the way you live...better than Lee.

B·A·G·G·Y·R·I·D·E·R·S·H·O·R·T

The brand that fits.

Lee Jeans shorts. No scissors required.

Shorts with all the trimmings. A sleek black belt and a relaxed fit combine for simplicity, comfort and style. So relax. Leave the scissors in the drawer and cut loose in Lee's Belted Baggy shorts. They're all you need to look as sharp as possible. Nobody fits your body...or the way you live...better than Lee.

B·E·L·T·E·D·B·A·G·G·Y·S·H·O·R·T

The brand that fits.

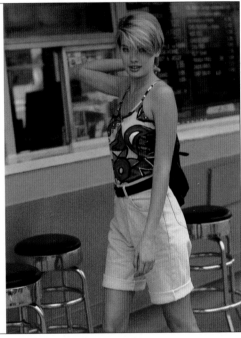

Lee presents jeans that will never
wear out in the knees.

Our Elastic Rider shorts give you infinite room in the knees and ankles. Not to mention relaxed comfort in the seat and legs. So bend, flex, run, walk, crawl, dance, jump and squat all you want. They'll hold up to whatever your knees can dish out. Nobody fits your body...or the way you live...better than Lee.

E·L·A·S·T·I·C·R·I·D·E·R·S·H·O·R·T

The brand that fits.

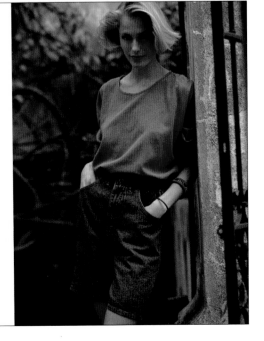

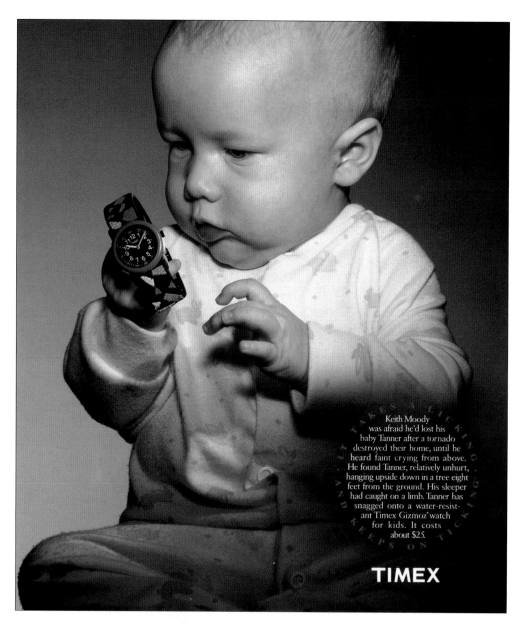

Keith Moody was afraid he'd lost his baby Tanner after a tornado destroyed their home, until he heard faint crying from above. He found Tanner, relatively unhurt, hanging upside down in a tree eight feet from the ground. His sleeper had caught on a limb. Tanner has snagged onto a water-resistant Timex Gizmoz watch for kids. It costs about $25.

TIMEX

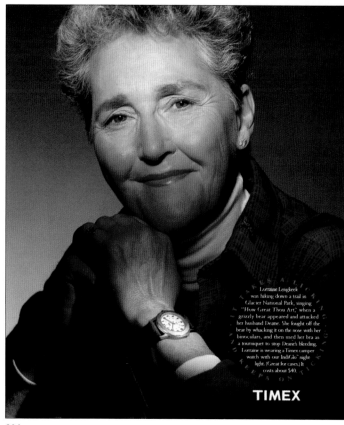

Lorraine Lengkeek was hiking down a trail in Glacier National Park, singing "How Great Thou Art," when a grizzly bear appeared and attacked her husband Deane. She fought off the bear by whacking it on the nose with her binoculars, and then used her bra as a tourniquet to stop Deane's bleeding. Lorraine is wearing a Timex camper watch with our IndiGlo night light. (Great for caves.) It costs about $40.

TIMEX

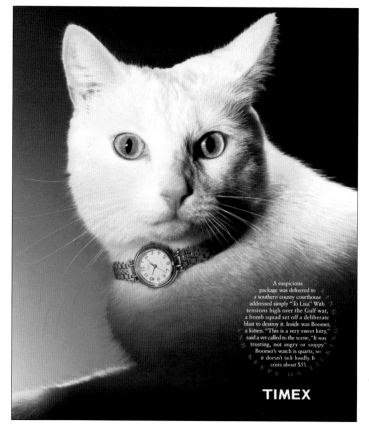

A suspicious package was delivered to a southern county courthouse addressed simply "To Lisa." With tensions high over the Gulf war, a bomb squad set off a deliberate blast to destroy it. Inside was Boomer, a kitten. "This is a very sweet kitty," said a vet called to the scene. "It was trusting, not angry or snippy." Boomer's watch is quartz, so it doesn't tick loudly. It costs about $55.

TIMEX

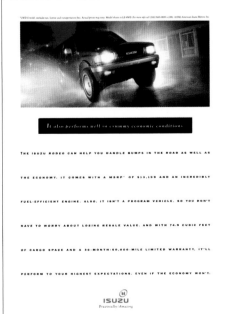
305

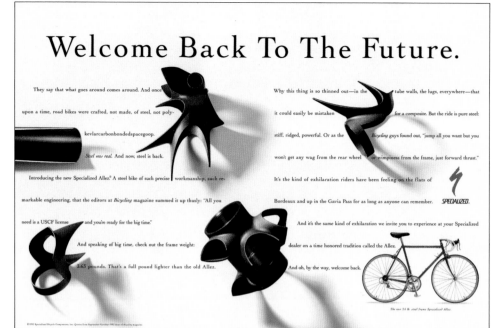

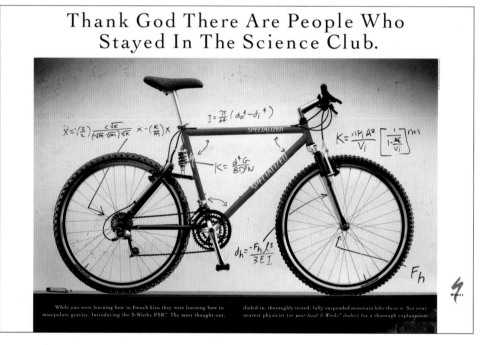

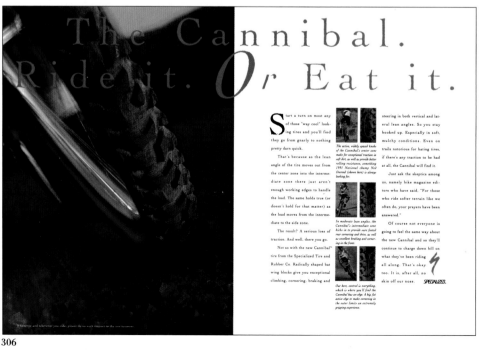

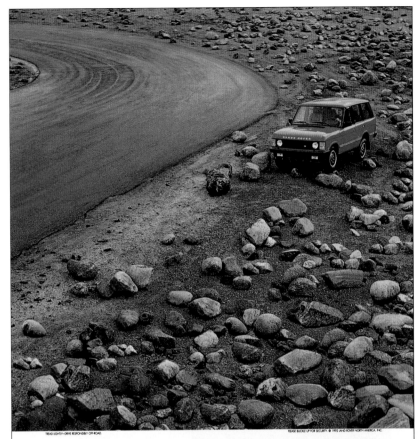

Once in a while we take a Range Rover around the test track.

Life, unfortunately, is not all paved roads and super highways.

It's also mud.

Rocks.

Hard-packed snow.

And a host of hazards that give new meaning to the term automotive excitement.

That's why we don't consider it sufficient for a Range Rover to fly along a test track, corner with finesse and generally handle with an ease and agility that rivals many road cars.

What makes a Range Rover truly

RANGE ROVER

impressive is that it also excels in conditions that would challenge a goat.

And at the same time affords you a level of understated luxury most luxury cars can't match. Which is why so many people consider Range Rover a value.

Even at just under $39,000.

Why not call 1-800-FINE 4WD for the dealer nearest you? And start moving in more impressive circles.

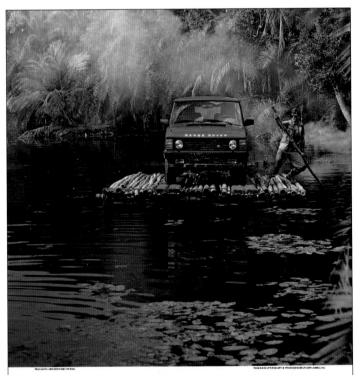

Sometimes you have to get out and push a Range Rover.

There are, we admit, things in this world that can quite capably stop a Range Rover in its tracks.

Active tar pits. Brick walls. And yes, ten feet of water.

Beyond these, however, a Range Rover's spirited 3.9 liter V-8 engine, fully-articulated suspension system, and permanent four-wheel drive are designed to steer you through equally unpleasant, if far less far-fetched, driving conditions.

From sleet and freezing rain, to the occasional blizzard and monsoon.

In short, anything short of the impossible.

So why not call 1-800-FINE 4WD today for the dealer nearest you?

After all, for just under $39,000, you too could be driving off in a Range Rover.

And considering all that it has to offer, would you really want to be up the creek in anything less?

RANGE ROVER

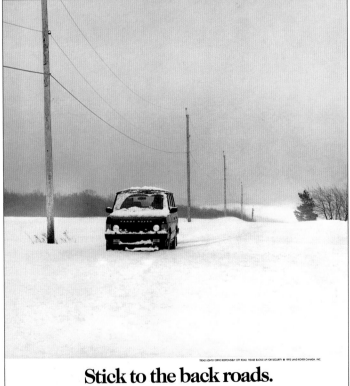

Stick to the back roads.

This traveler's advisory is brought to you by the people who make Range Rovers.

As a reminder that winter driving need not be confined to plowed thoroughfares, sanded avenues, and salted streets.

At least not when you're driving a Range Rover.

Because with its new electronic traction control system and advanced anti-lock brakes, a Range Rover will provide not only better traction than ever before, but better traction than every other 4x4.

While its permanent four-wheel drive, formidable V-8 engine, and enviable off-road capabilities will take you places snowplows either can't go, or won't.

So why not call 1-800-FINE 4WD today for one of our select Canadian dealers.

After all, whether you choose the County model or the even more evolved County LWB, you'll get a Range Rover that offers not only more features than other luxury cars, but infinitely more roads as well.

RANGE ROVER

308
ART DIRECTOR
Stefan Sagmeister
WRITER
Stuart D'Rozario
ILLUSTRATOR
Brian Lau
PHOTOGRAPHER
Ringo Tang
CLIENT
Regent International Hotels
AGENCY
Leo Burnett/Hong Kong

309
ART DIRECTOR
Jelly Helm
WRITER
Joe Alexander
PHOTOGRAPHER
Dublin Productions
CLIENT
Healthtex
AGENCY
**The Martin Agency/
Richmond**

The supercilious concierge.
As examined by The Regent, London.

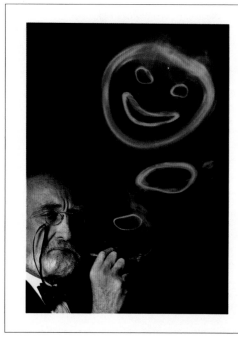

Visitors to The Regent, London
are permitted to laugh.

What happens if the guest is not dressed
as well as the lobster?

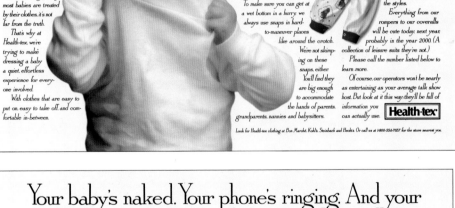
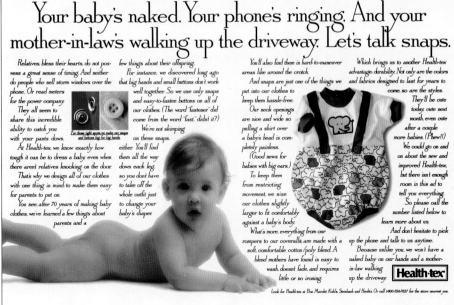

**CONSUMER MAGAZINE
COLOR 1 PAGE OR
SPREAD: CAMPAIGN**

310
ART DIRECTOR
Mark Fuller
WRITER
Steve Bassett
PHOTOGRAPHER
Dublin Productions
CLIENT
Healthtex
AGENCY
The Martin Agency/
Richmond

311
ART DIRECTOR
Jelly Helm
WRITER
Joe Alexander
PHOTOGRAPHERS
Kerry Peterson
Rick Dublin
CLIENT
Healthtex
AGENCY
The Martin Agency/
Richmond

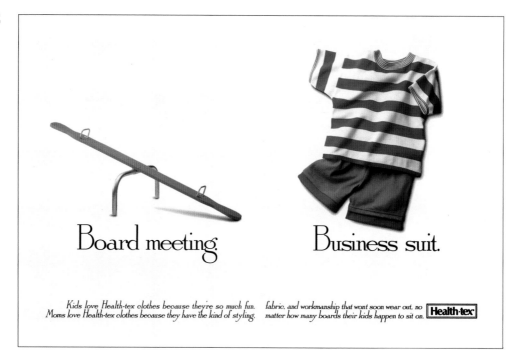

Board meeting. Business suit.

Kids love Health-tex clothes because they're so much fun. Moms love Health-tex clothes because they have the kind of styling, *fabric, and workmanship that wont soon wear out, no matter how many boards their kids happen to sit on.* **Health-tex**

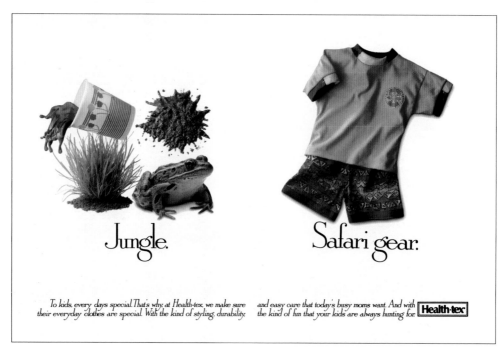

Jungle. Safari gear.

To kids, every day's special. That's why, at Health-tex, we make sure their everyday clothes are special. With the kind of styling, durability, *and easy care that today's busy moms want. And with the kind of fun that your kids are always hunting for.* **Health-tex**

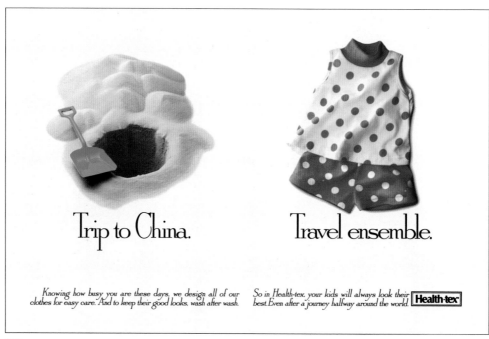

Trip to China. Travel ensemble.

Knowing how busy you are these days, we design all of our clothes for easy care. And to keep their good looks, wash after wash. *So in Health-tex, your kids will always look their best. Even after a journey halfway around the world.* **Health-tex**

There must be a million reasons a baby cries so much. We just eliminated five.

She hasn't had a nap. She had too long a nap. She wants to nap with her teddy bear. She can't find her teddy bear. Her Uncle Teddy made that face. She has a cold. She's cold. Her bottle is too cold. Her bottle is empty. She misses her mom. She misses her dad. She misses the Misses at day care. She just had a shirt pulled over her head with a very tight collar.

Ah, something the designers at Health-tex can actually do something about. (Sorry, parents, you're on your own with Uncle Teddy and the rest.)

1. Cotton/poly is soft, never scratchy.

2. Outfits are sized larger for a comfortable fit.

3. Buttons are big for big hands. 4. Snaps make it easy to get to wet diapers.

You see, at Health-tex, we realize babies can sometimes get ornery about the littlest things.

That's why we take extra care of the littlest things, and design our clothes to be easy to put on, easy to take off, and comfortable in between.

Of course, our clothes keep parents from crying, too. You'll find our cotton/poly blend is a breeze to wash, doesn't shrink or fade and needs little or no ironing.

Just call the number listed below to learn more about Health-tex. Like you, our operators have great shoulders to cry on.

5. Neck opening too tight? It's not Health-tex.

Health·tex

If you'd like to know where to find Health-tex, just give us a call at 1-800-554-7637 for the store nearest you.

Babies tormented by their clothes. On the next Oprah.

Can you see it now? A vocal crowd. A panel of experts. And lots of babies. Then, national hotlines. Self-help books. Until, finally, harmful baby clothes become the most-talked-about issue of the presidential campaign.

We're kidding, of course. But considering the way babies are treated by their clothes, it's not far from the truth.

That's why here at Health-tex, we try to make dressing your baby easy.

With nice, wide neck openings. Snaps in hard-to-maneuver places like the crotch.

And a soft, durable cotton/poly blend that doesn't shrink or fade, and requires little or no ironing.

Just call the number listed below to learn more. Of course, our operators won't be nearly as entertaining as your average talk show host. But, they'll be full of information that you can actually use.

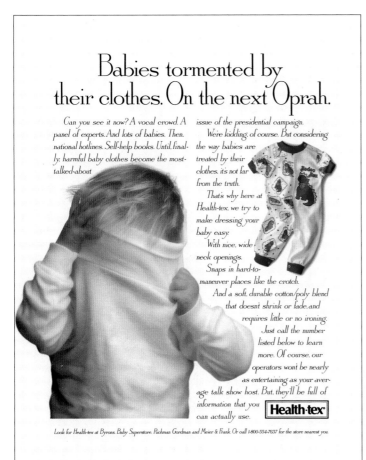

Health·tex

Look for Health-tex at Byrons, Baby Superstore, Richman Gordman and Meier & Frank. Or call 1-800-554-7637 for the store nearest you.

We make baby clothes even full-sized people can put on.

There are 24 hours in a day. You sleep when your baby isn't fussing, eight of those hours. You work, when your boss isn't fussing, eight more hours. That leaves eight hours for your baby. Or does it?

Take away one hour to and from work. An hour to exercise once in a while. Add in the fact that the little guy will go to bed at least two hours before you and, suddenly, you're down to three to four quality hours a day with your baby.

At Health-tex, we understand just how little time working parents like you have with their babies. And that you want to make every second with them as enjoyable as possible.

So we design all of our clothes to be easy to put on, easy to take off, and comfortable in between.

With snaps in hard-to-maneuver areas like around the crotch.

Nice, wide neck openings that slide painlessly over a baby's head. Outfits that are sized slightly larger for a comfortable fit. And an easy-care cotton/poly blend that allows parents like you to spend more minutes with your baby instead of your iron.

Plus, all of our clothes are timeless. They'll be in style even when your kids' kids have kids.

Call the number below to learn more. But do it soon. When your baby's sound asleep. Or your boss is on vacation.

Health·tex

If you'd like to know where to find Health-tex, just give us a call at 1-800-554-7637 for the store nearest you.

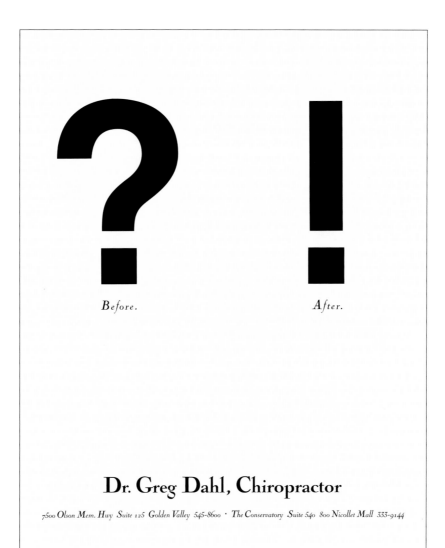

Before. *After.*

Dr. Greg Dahl, Chiropractor

7500 Olson Mem. Hwy Suite 125 Golden Valley 545-8600 · The Conservatory Suite 540 800 Nicollet Mall 333-9144

Before. *After.*

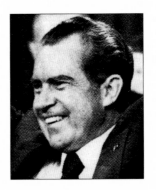

Before. *After.*

Dr. Greg Dahl, Chiropractor

7500 Olson Mem. Hwy Suite 125 Golden Valley 545-8600 · The Conservatory Suite 540 800 Nicollet Mall 333-9144

Dr. Greg Dahl, Chiropractor

7500 Olson Mem. Hwy Suite 125 Golden Valley 545-8600 · The Conservatory Suite 540 800 Nicollet Mall 333-9144

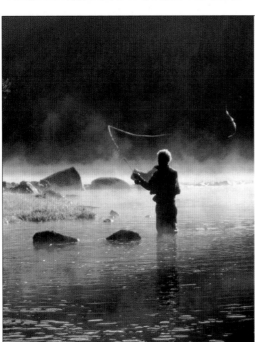
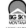

**CONSUMER MAGAZINE
COLOR 1 PAGE OR
SPREAD: CAMPAIGN**

314
ART DIRECTOR
Tim Ryan
WRITER
Cristina Gordet
PHOTOGRAPHER
Randy Miller
CLIENT
Bertram Yacht
AGENCY
McFarland & Drier
Advertising/Miami

315
ART DIRECTOR
Karen MacDonald Lynch
WRITER
Edward Boches
PHOTOGRAPHERS
Jack Richmond
Stock
CLIENT
Reebok International
AGENCY
Mullen/Wenham, MA

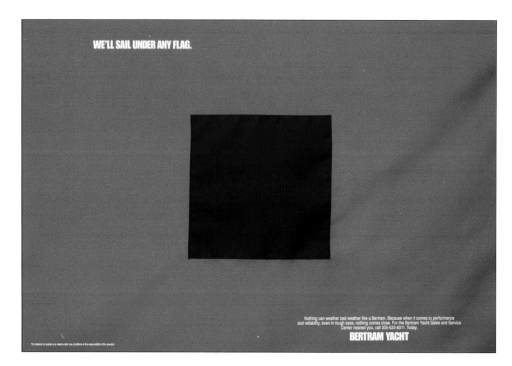

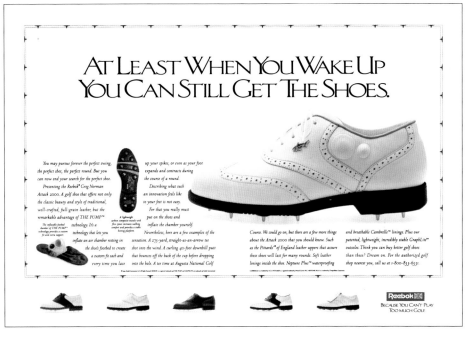

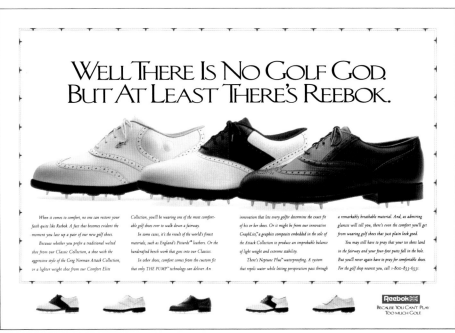

WHAT TO WEAR WHEN IT'S RAINING, IT'S POURING AND THE OLD MAN IS SNORING.

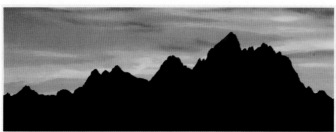

TIPTOE THROUGH THE TETONS.

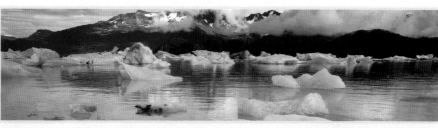

HOW TO SURVIVE A MELTDOWN.

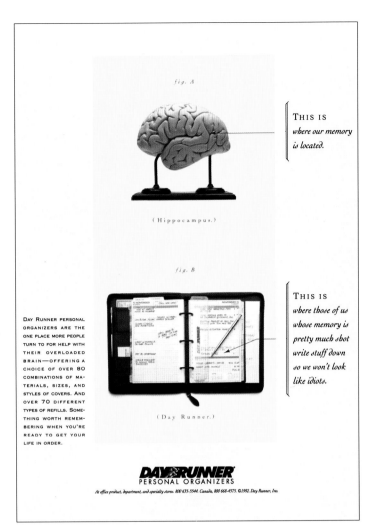

fig. A

THIS IS *where our memory is located.*

(Hippocampus.)

fig. B

DAY RUNNER PERSONAL ORGANIZERS ARE THE ONE PLACE MORE PEOPLE TURN TO FOR HELP WITH THEIR OVERLOADED BRAIN—OFFERING A CHOICE OF OVER 80 COMBINATIONS OF MATERIALS, SIZES, AND STYLES OF COVERS. AND OVER 70 DIFFERENT TYPES OF REFILLS. SOMETHING WORTH REMEMBERING WHEN YOU'RE READY TO GET YOUR LIFE IN ORDER.

THIS IS *where those of us whose memory is pretty much shot write stuff down so we won't look like idiots.*

(Day Runner.)

DAYRUNNER
PERSONAL ORGANIZERS

At office product, department, and specialty stores. 800 635-5544. Canada, 800 668-4575. ©1992. Day Runner, Inc.

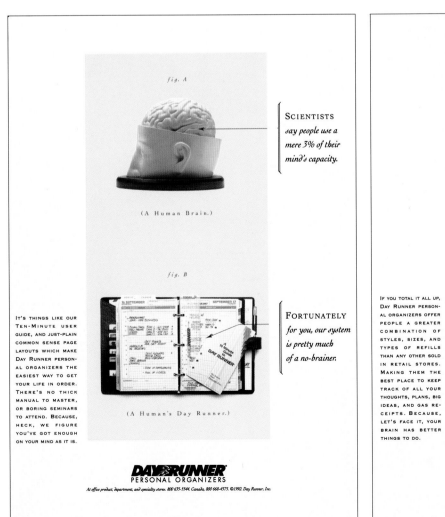

fig. A

SCIENTISTS *say people use a mere 3% of their mind's capacity.*

(A Human Brain.)

fig. B

IT'S THINGS LIKE OUR TEN-MINUTE USER GUIDE, AND JUST-PLAIN COMMON SENSE PAGE LAYOUTS WHICH MAKE DAY RUNNER PERSONAL ORGANIZERS THE EASIEST WAY TO GET YOUR LIFE IN ORDER. THERE'S NO THICK MANUAL TO MASTER, OR BORING SEMINARS TO ATTEND. BECAUSE, HECK, WE FIGURE YOU'VE GOT ENOUGH ON YOUR MIND AS IT IS.

FORTUNATELY *for you, our system is pretty much of a no-brainer.*

(A Human's Day Runner.)

DAYRUNNER
PERSONAL ORGANIZERS

At office product, department, and specialty stores. 800 635-5544. Canada, 800 668-4575. ©1992. Day Runner, Inc.

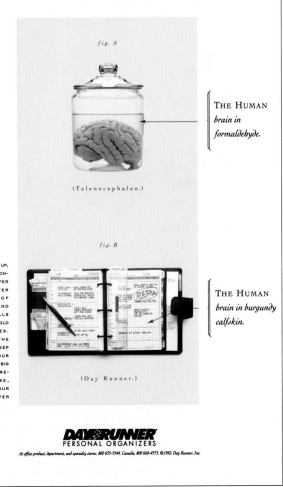

fig. A

THE HUMAN *brain in formaldehyde.*

(Telenecephalon.)

fig. B

IF YOU TOTAL IT ALL UP, DAY RUNNER PERSONAL ORGANIZERS OFFER PEOPLE A GREATER COMBINATION OF STYLES, SIZES, AND TYPES OF REFILLS THAN ANY OTHER SOLD IN RETAIL STORES. MAKING THEM THE BEST PLACE TO KEEP TRACK OF ALL YOUR THOUGHTS, PLANS, BIG IDEAS, AND GAS RECEIPTS. BECAUSE, LET'S FACE IT, YOUR BRAIN HAS BETTER THINGS TO DO.

THE HUMAN *brain in burgundy calfskin.*

(Day Runner.)

DAYRUNNER
PERSONAL ORGANIZERS

At office product, department, and specialty stores. 800 635-5544. Canada, 800 668-4575. ©1992. Day Runner, Inc.

317

318
ART DIRECTOR
Ellen Steinberg
WRITERS
Paula Dombrow
David Statman
PHOTOGRAPHER
Guzman
CLIENT
Escada USA/Apriori
AGENCY
**Weiss Whitten Carroll
Stagliano/New York**

319
ART DIRECTOR
David Fox
WRITER
Stacy Wall
PHOTOGRAPHER
John Huet
CLIENT
Nike
AGENCY
**Wieden & Kennedy/
Portland**

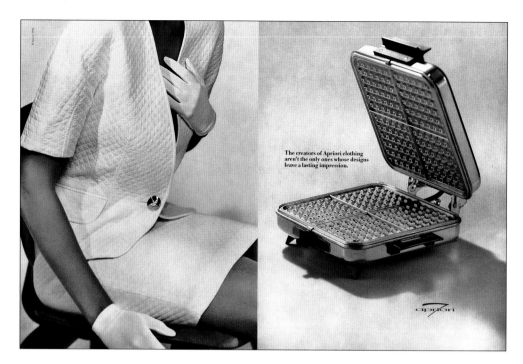

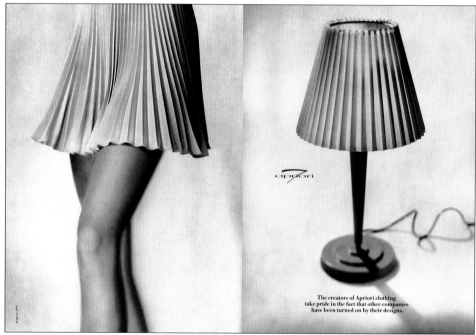

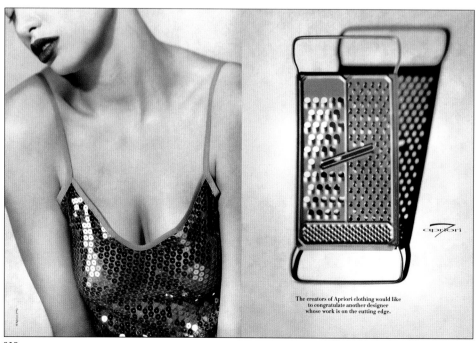

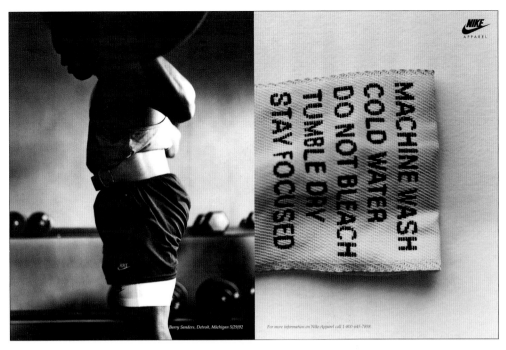

MACHINE WASH
COLD WATER
DO NOT BLEACH
TUMBLE DRY
STAY FOCUSED

Barry Sanders, Detroit, Michigan 5/29/92

For more information on Nike Apparel call 1-800-645-7898.

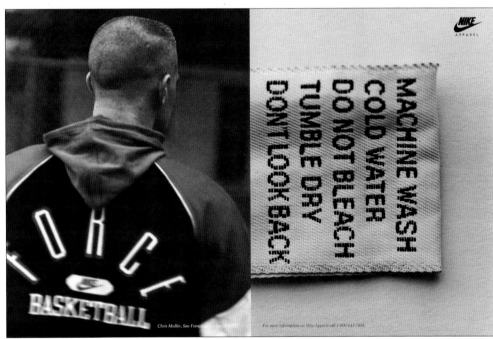

MACHINE WASH
COLD WATER
DO NOT BLEACH
TUMBLE DRY
DON'T LOOK BACK

Chris Mullin, San Francisco

For more information on Nike Apparel call 1-800-645-7898.

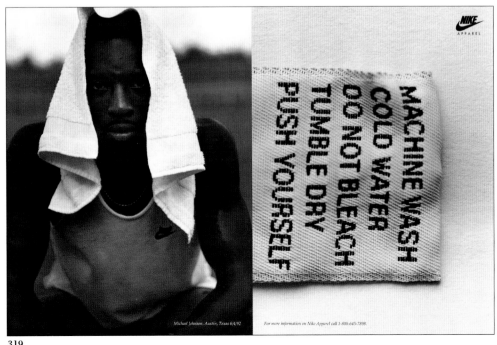

MACHINE WASH
COLD WATER
DO NOT BLEACH
TUMBLE DRY
PUSH YOURSELF

Michael Johnson, Austin, Texas 6/4/92

For more information on Nike Apparel call 1-800-645-7898.

319

"I could have done that."

—Dave Stockdale, President.
Edgework Builders

Retaining walls, decks, home improvements, additions. Masters of design and construction since 1976. 368-3511.

320

Art school.

Art Center.

Introduction to Drawing is just one of the courses you can take after hours at one of the nation's premier design colleges. All classes, including many others in painting, graphics, and advertising, begin Sept. 14. For a brochure, call 818-584-5023. Or write to Art Center At Night, 1700 Lida St., Pasadena, CA 91103. **ArtCenter at Night**

321

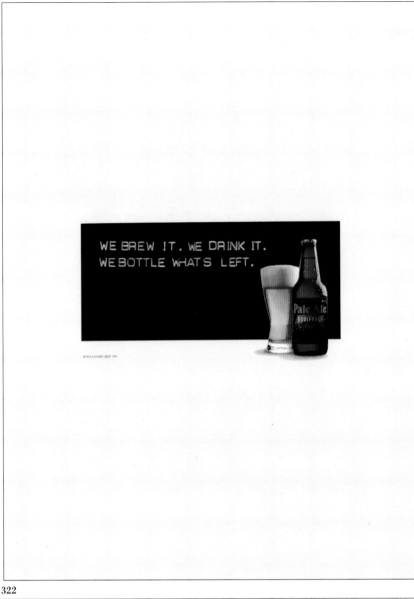

SOME PEOPLE THINK ALL WE CAN TALK ABOUT IS BICYCLES. NONSENSE. JUST YESTERDAY, WE HAD A THRILLING DISCUSSION ABOUT HELMETS.

ADMITTEDLY, WE DO SPEND A LOT OF TIME TALKING SHOP, BUT WE'VE ALWAYS FOUND THAT OUR CUSTOMERS APPRECIATE OUR PERSONAL OBSESSION WITH CYCLING. IF YOU WANT TO TALK ABOUT BIKES, WE'RE WAITING. IF YOU WANT TO TALK ABOUT POLITICS OR RELIGION, CALL A TALK RADIO STATION.

SCHWINN CYCLING AND FITNESS

1451 W. WEBSTER (WEBSTER AT CLYBOURN/FREE PARKING). MON-FRI 10-9. SAT 9-6. SUN 10-5. (312) 528-2700.
MAJOR CREDIT CARDS ACCEPTED. (ASK ABOUT OUR 30 DAY NO HASSLE BUY BACK)

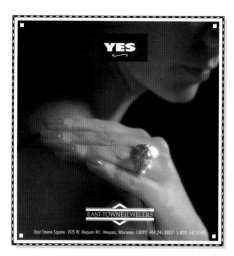

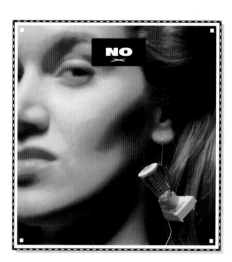
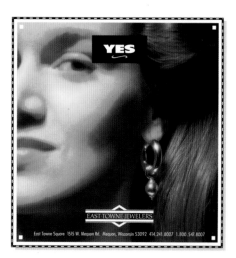

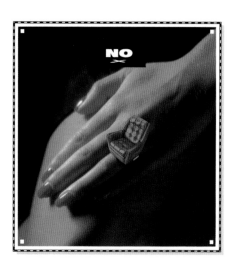
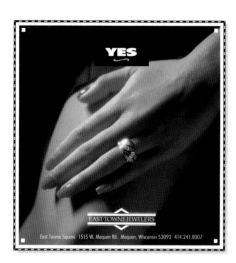

Art school.

Art Center.

Introduction to Drawing is just one of the courses you can take after hours at one of the nation's premier design colleges. All classes, including many others in painting, graphics, and advertising, begin Sept. 14. For a brochure, call 818-584-5023. Or write to Art Center At Night, 1700 Lida St., Pasadena, CA 91103.

ArtCenter at Night

Take a course where you design a chair for the final, not sit in one.

Introduction to Environmental Design is just one of the courses you can take after hours at one of the nation's premier design colleges. All classes, including many others in industrial drawing and product design, begin Sept. 14. For a brochure, call 818-584-5023. Or write to Art Center At Night, 1700 Lida St., Pasadena, CA 91103.

ArtCenter at Night

If you'd like to take a course in lettering, here's your first assignment.

Yes, I'd like to know more about your lettering class.

Name _____

Address _____

City _____

State _____ Zip _____

ArtCenter at Night

Art Center At Night, 1700 Lida St., Pasadena, CA 91103

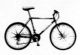

ON SATURDAYS, WE OPEN AT 9:00.
(OR A LITTLE EARLIER IF THERE'S A STRONG TAIL WIND.)

EVERYONE WHO WORKS IN OUR BIKE SHOP RIDES. WHICH MEANS WE'RE MORE THAN EQUIPPED TO HELP YOU FIND THE RIGHT BIKE OR ANSWER ANY OF YOUR QUESTIONS. DROP BY THIS SATURDAY. OH, IF WE'RE A LITTLE LATE, DON'T WORRY. WE PROBABLY JUST RAN INTO A FIERCE HEAD WIND. **SCHWINN** CYCLING AND FITNESS

1451 W. WEBSTER (WEBSTER AT CLYBOURN/FREE PARKING). MON-FRI 10-9. SAT 9-6. SUN 10-5. (312) 528-2700.
MAJOR CREDIT CARDS ACCEPTED. (ASK ABOUT OUR 30 DAY NO HASSLE BUY BACK)

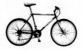

SOME PEOPLE THINK ALL WE CAN TALK ABOUT IS BICYCLES. NONSENSE. JUST YESTERDAY, WE HAD A THRILLING DISCUSSION ABOUT HELMETS.

ADMITTEDLY, WE DO SPEND A LOT OF TIME TALKING SHOP, BUT WE'VE ALWAYS FOUND THAT OUR CUSTOMERS APPRECIATE OUR PERSONAL OBSESSION WITH CYCLING. IF YOU WANT TO TALK ABOUT BIKES, WE'RE WAITING. IF YOU WANT TO TALK ABOUT POLITICS OR RELIGION, CALL A TALK RADIO STATION. **SCHWINN** CYCLING AND FITNESS

1451 W. WEBSTER (WEBSTER AT CLYBOURN/FREE PARKING). MON-FRI 10-9. SAT 9-6. SUN 10-5. (312) 528-2700.
MAJOR CREDIT CARDS ACCEPTED. (ASK ABOUT OUR 30 DAY NO HASSLE BUY BACK)

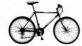

WE TREAT ALL OF OUR CUSTOMERS AS TRUE BIKE ENTHUSIASTS. EVEN IF THEY DON'T SHAVE THEIR LEGS.

SOME OF OUR CUSTOMERS SPECIFY A 26", 23-SPOKE, GRAPHITE RIM. OTHERS JUST ASK FOR A WHEEL. THE POINT IS, WE SHOW BOTH TYPES THE SAME AMOUNT OF RESPECT. DROP BY ONE DAY. YOU WON'T HAVE TO COME IN WEARING BICYCLE SHORTS AND A LITTLE CAP TO GET OUR ATTENTION. **SCHWINN** CYCLING AND FITNESS

1451 W. WEBSTER (WEBSTER AT CLYBOURN/FREE PARKING). MON-FRI 10-9. SAT 9-6. SUN 10-5. (312) 528-2700.
MAJOR CREDIT CARDS ACCEPTED. (ASK ABOUT OUR 30 DAY NO HASSLE BUY BACK)

How to win at board games.

327

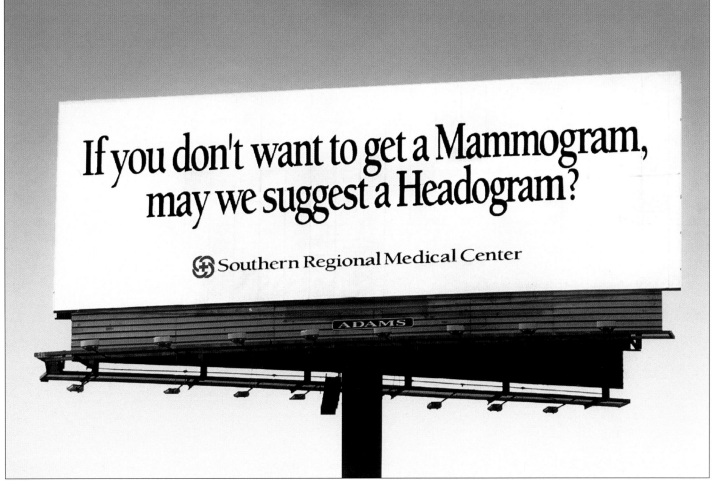

328

OUTDOOR: SINGLE

329
ART DIRECTOR
Andy Cheetham
WRITER
Tony Veazey
CLIENT
David Auerbach
AGENCY
Broadbent Cheetham
Veazey/Cheshire, England

330
ART DIRECTORS
Richard Flintham
Paul Shearer
WRITERS
Rob Jack
Andy McLeod
CLIENT
IPA Society
AGENCY
Butterfield Day Devito
Hockney/London

331
ART DIRECTOR
Dave Cook
WRITER
Dion Hughes
PHOTOGRAPHER
Rick Dublin
TYPOGRAPHER
Graham Clifford
CLIENT
NYNEX Information
Resources
AGENCY
Chiat/Day, New York

332
ART DIRECTOR
Randy Hughes
WRITER
Josh Denberg
ILLUSTRATOR
Randy Hughes
CLIENT
St. Paul Pioneer Press
AGENCY
Clarity Coverdale Rueff/
Minneapolis

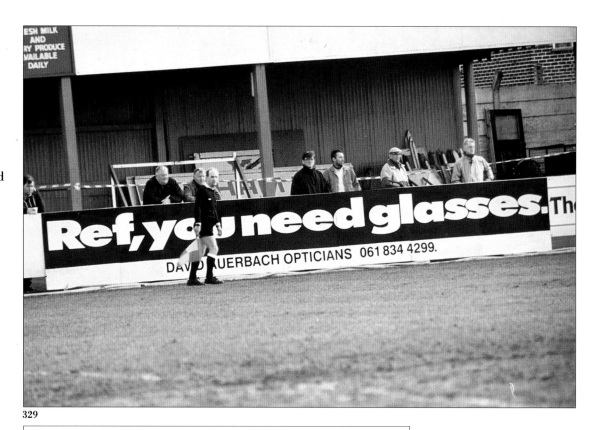

329

330

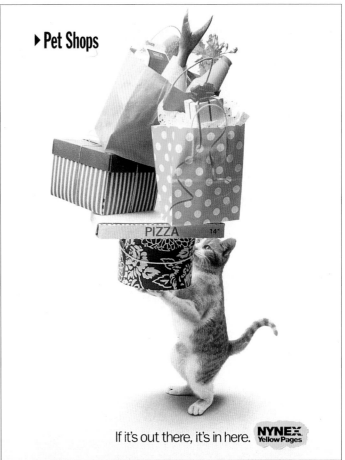

▶ Pet Shops

If it's out there, it's in here. **NYNEX** Yellow Pages

331

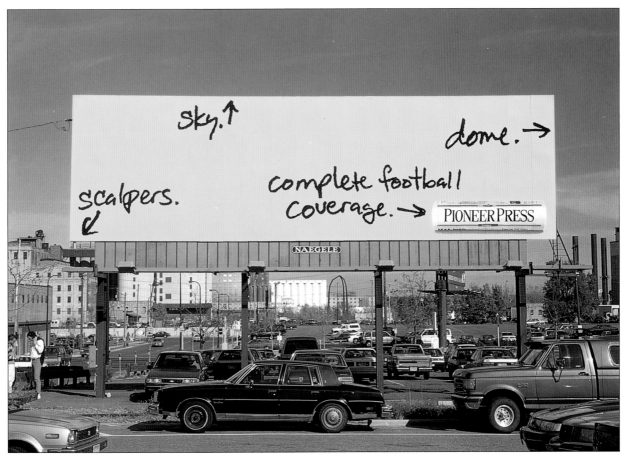

sky. ↑

dome. →

scalpers. ↙

complete football coverage. → PIONEER PRESS

NAEGELE

332

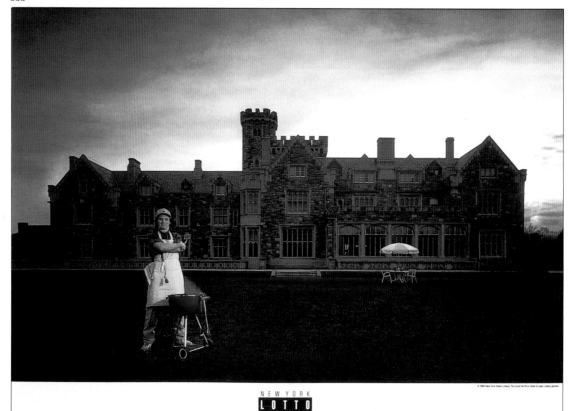

333

334

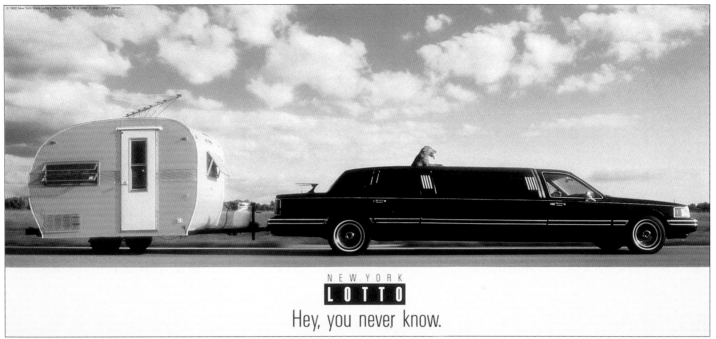

NEW YORK
LOTTO
Hey, you never know.

335

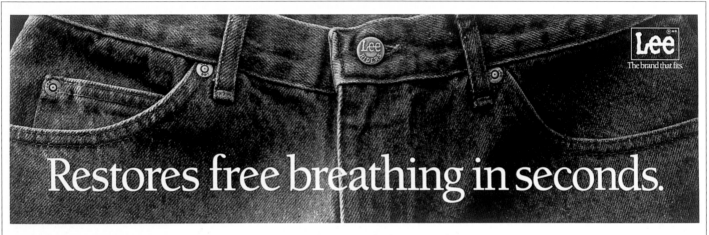

Lee
The brand that fits.

Restores free breathing in seconds.

336

SEE COLLEGE STUDENTS EARN THEIR NBA's.

Road to The Final Four. Star Tribune

337

OUTDOOR: SINGLE

338
ART DIRECTOR
Bob Brihn
WRITER
Dean Buckhorn
PHOTOGRAPHER
Joe Lampi
CLIENT
Star Tribune
AGENCY
Fallon McElligott/
Minneapolis

339
ART DIRECTORS
Gerard Vaglio
Brian Wright
WRITERS
Brian Wright
Gerard Vaglio
PHOTOGRAPHER
Cailor/Resnick
CLIENT
Daffy's
AGENCY
Follis DeVito Verdi/
New York

340
ART DIRECTOR
Peter Holmes
WRITER
Peter Holmes
CLIENT
Metropolitan Toronto
Ambulance Services
AGENCY
Franklin Dallas/Toronto

341
ART DIRECTOR
Barb Paulini
WRITER
Mark Catterson
CLIENT
Evelyn Wood Reading
Dynamics
AGENCY
Hoffman York & Compton/
Milwaukee

338

339

OUTDOOR: SINGLE

342
ART DIRECTOR
Mike Fetrow
WRITER
Doug Adkins
CLIENT
Mystic Lake Casino
AGENCY
Hunt Murray/Minneapolis

343
ART DIRECTOR
Mike Fetrow
WRITER
Doug Adkins
CLIENT
Mystic Lake Casino
AGENCY
Hunt Murray/Minneapolis

344
ART DIRECTOR
Tim Hannell
WRITERS
Barton Landsman
Jim Noble
PHOTOGRAPHER
Kurt Andersen
CLIENT
Lee's Field
AGENCY
Jaded Angry &
Disillusioned/New York

345
ART DIRECTOR
Tim Hannell
WRITERS
Barton Landsman
Jim Noble
PHOTOGRAPHER
Kurt Andersen
CLIENT
Lee's Field
AGENCY
Jaded Angry &
Disillusioned/New York

YOU CAN WIN MORE IN ONE MINUTE
THAN YOU MAKE ALL YEAR. SICK, ISN'T IT?
MYSTIC LAKE CASINO

342

WALK IN A NOBODY. WALK OUT A RICH NOBODY.
MYSTIC LAKE CASINO

343

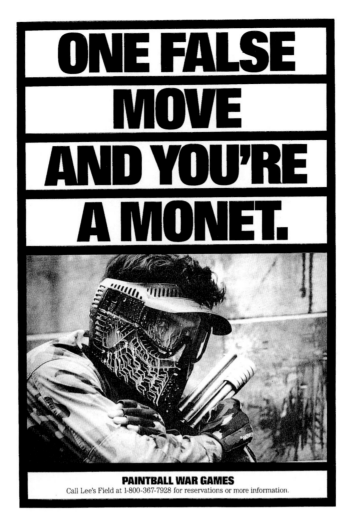

ONE FALSE MOVE AND YOU'RE A MONET.

PAINTBALL WAR GAMES
Call Lee's Field at 1-800-367-7928 for reservations or more information.

344

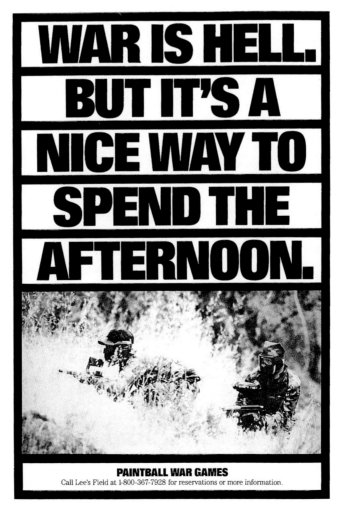

WAR IS HELL. BUT IT'S A NICE WAY TO SPEND THE AFTERNOON.

PAINTBALL WAR GAMES
Call Lee's Field at 1-800-367-7928 for reservations or more information.

346
ART DIRECTORS
Gill Witt
Scott Bailey
WRITER
Risa Mickenberg
PHOTOGRAPHER
Ron Chapple
CLIENT
Kenneth Cole
AGENCY
Kirshenbaum & Bond/
New York

347
ART DIRECTOR
Ann Lemon
WRITERS
Andy Spade
Craig Simpson
CLIENT
Charivari
AGENCY
Kirshenbaum & Bond/
New York

348
ART DIRECTOR
Rick Kemp
WRITER
Jeff Finkler
PHOTOGRAPHER
Nigel Dickson
CLIENT
William Neilson/
Cadbury
AGENCY
Leo Burnett Company/
Toronto

349
ART DIRECTOR
Tracy Wong
WRITER
Rob Bagot
CLIENT
Seattle SuperSonics
AGENCY
Livingston & Company/
Seattle

350
ART DIRECTOR
Len Zimmelman
WRITER
Lee Kovel
ILLUSTRATOR
Dennis Doheny
CLIENT
Buzz Magazine
AGENCY
Lord Dentsu & Partners/
Los Angeles

Dan Quayle

"Don't forget to vot."
–Kenneth Cole

"Come by our Pre-Election Sale going on now."

353 Columbus Ave. at 77th 95 Fifth Ave. at 17th

346

ripped jeans. pocket tees. back to basics.

wake us when it's over
CHARIVARI

347

How to conceal a
Crunchie from your friends.

348

$$\left[\left(\quad \right) \times \quad \right]^{10} = \begin{bmatrix} Coach \\ KARL \end{bmatrix}$$

S O N I C S

349

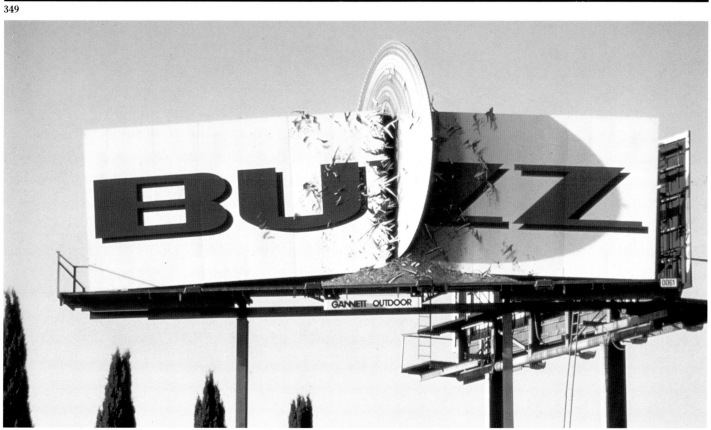

350

9
Number of Economist
subscribers who
have run the country.

220,659
Number of Economist
subscribers who
feel they could have
done a better job.

The Economist

351

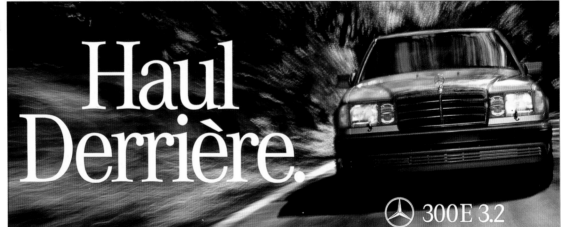

Haul Derrière.

Mercedes 300E 3.2

352

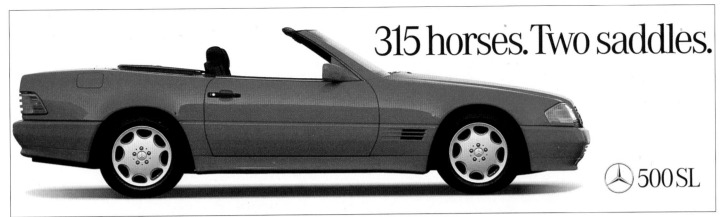

353

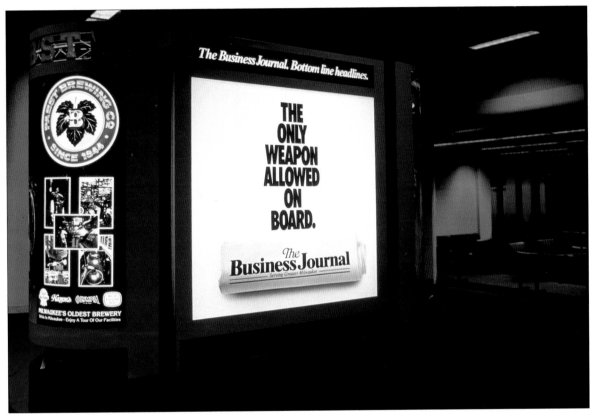

354

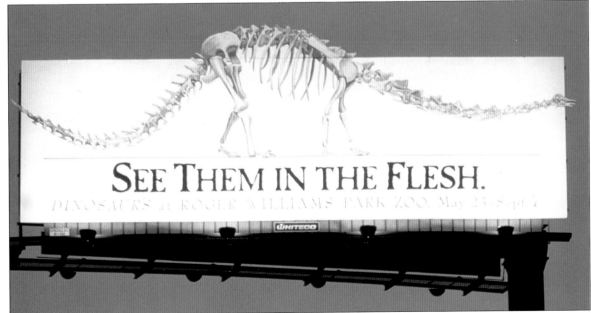

355

356
ART DIRECTOR
Vivian Walsh
WRITER
Jo Tanner
PHOTOGRAPHER
Bob Fyffe
CLIENT
The London Natural Health Clinic
AGENCY
Saatchi & Saatchi/London

357
ART DIRECTOR
Kirk Souder
WRITER
Court Crandall
CLIENT
IKEA
AGENCY
Stein Robaire Helm/ Los Angeles

358
ART DIRECTOR
Steve Chetham
WRITER
Trevor Beattie
ILLUSTRATOR
Steve Chetham
CLIENT
Nissan Motor
AGENCY
TBWA/Holmes Knight Ritchie, London

359
ART DIRECTORS
Steve Chetham
Ray Howard
WRITERS
Trevor Beattie
John Vinton
ILLUSTRATOR
Steve Chetham
CLIENT
Nissan Motor
AGENCY
TBWA/Holmes Knight Ritchie, London

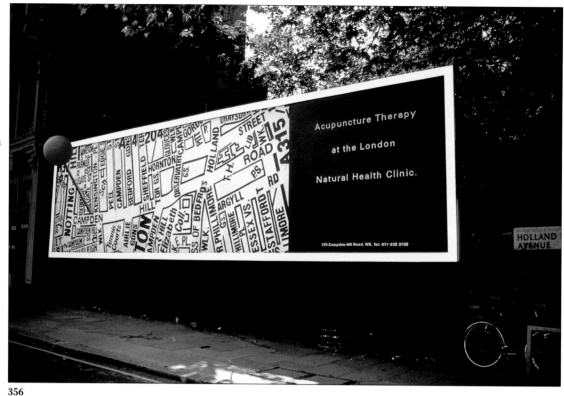

356

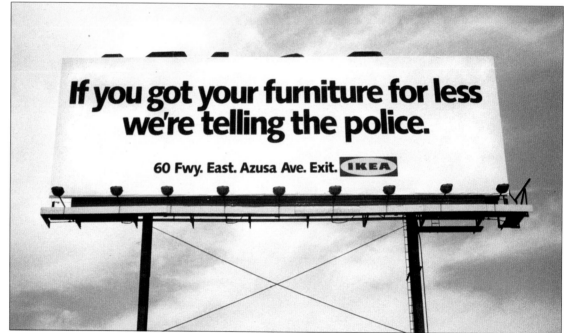

357

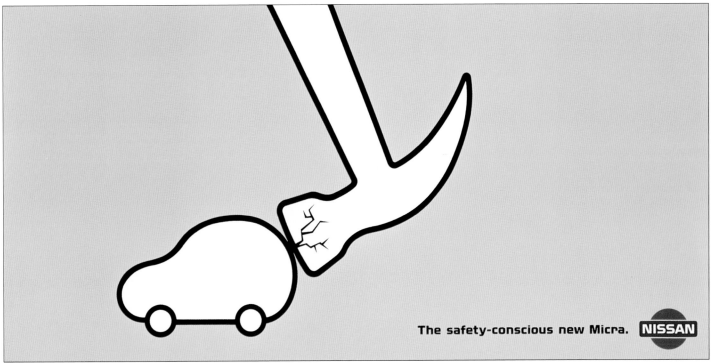

358

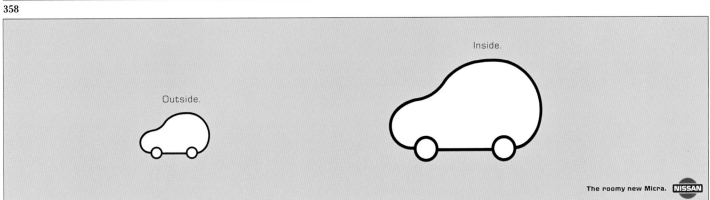

359

OUTDOOR: SINGLE

360
ART DIRECTOR
Marilee Fogeltanz
WRITER
Richard Link
CLIENT
Global Fitness
AGENCY
Turner & Turner
Communications/Atlanta

OUTDOOR: CAMPAIGN

361
ART DIRECTORS
Dave Cook
Eric Houseknecht
WRITERS
Dion Hughes
Tom Miller
PHOTOGRAPHER
Rick Dublin
TYPOGRAPHER
Graham Clifford
CLIENT
NYNEX Information
Resources
AGENCY
Chiat/Day, New York

They Have All Kinds Of Things To Get You In Shape. Like Lifecycles, Free Weights And Aerobics Programs.

Have You Ever Considered Joining A Health Club?

Oh Yeah, They Also Have Stairmasters.

No Really. If You Exercised More Often, You Wouldn't Even Be Breathing Hard Right Now.

Of Course, You Could Wait To Join. The Elevator Will Be Working Fine Tomorrow.

Did We Mention There's A Global Fitness Around The Corner?

Trouble Is, Can You Say The Same For Your Heart?

Global Fitness
925-0563

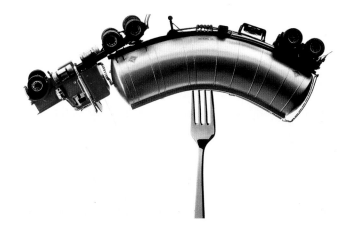

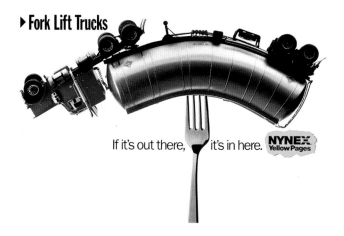

▶ Fork Lift Trucks

If it's out there, it's in here. **NYNEX Yellow Pages**

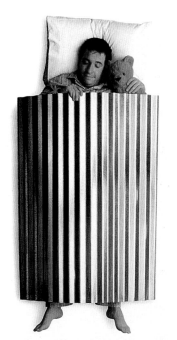

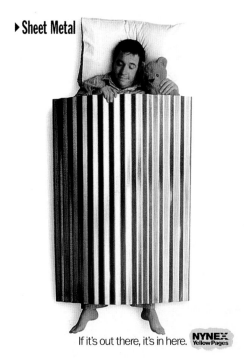

▶ Sheet Metal

If it's out there, it's in here. **NYNEX Yellow Pages**

▶ Pest Control

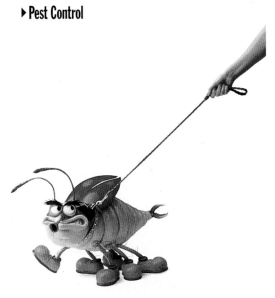

If it's out there, it's in here. **NYNEX Yellow Pages**

362
ART DIRECTOR
David Angelo
WRITER
Paul Spencer
PHOTOGRAPHERS
Lamb & Hall
Neil Slavin
Joe Baraban
CLIENT
New York State Lottery
AGENCY
DDB Needham Worldwide/
New York

363
ART DIRECTOR
Mike Fetrow
WRITER
Doug Adkins
CLIENT
Mystic Lake Casino
AGENCY
Hunt Murray/Minneapolis

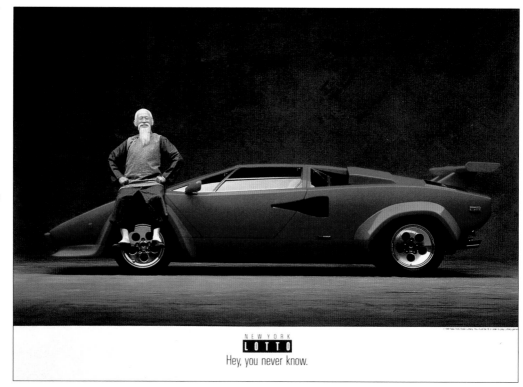

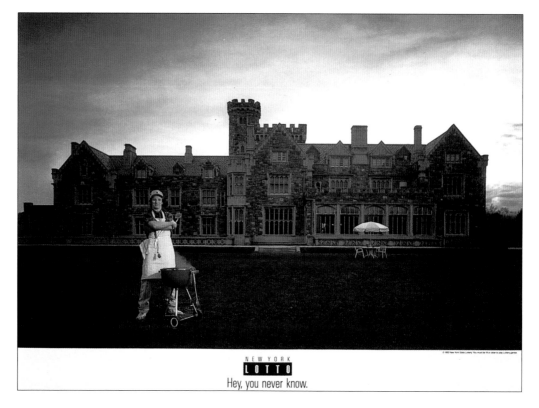

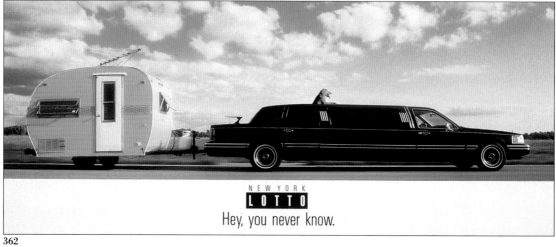

YOU CAN WIN MORE IN ONE MINUTE THAN YOU MAKE ALL YEAR. SICK, ISN'T IT?

MYSTIC LAKE CASINO

WALK IN A NOBODY. WALK OUT A RICH NOBODY.

MYSTIC LAKE CASINO

HAVE A BLUE BLOOD TRANSFUSION.

MYSTIC LAKE CASINO

364
ART DIRECTOR
Mike Fetrow
WRITER
Doug Adkins
CLIENT
Mystic Lake Casino
AGENCY
Hunt Murray/Minneapolis

365
ART DIRECTOR
Tim Hannell
WRITERS
Barton Landsman
Jim Noble
PHOTOGRAPHER
Kurt Andersen
CLIENT
Lee's Field
AGENCY
Jaded Angry &
Disillusioned/New York

MARRIED FOR LOVE? THERE'S STILL HOPE.
MYSTIC LAKE CASINO

**WE'RE OPEN LATE
SO YOU CAN RETIRE EARLY.**
MYSTIC LAKE CASINO

CALL IN RICH TOMORROW.
MYSTIC LAKE CASINO

"I LOVE THE SMELL OF LATEX IN THE MORNING."

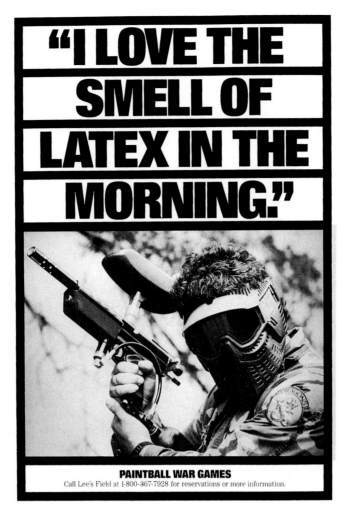

PAINTBALL WAR GAMES
Call Lee's Field at 1-800-367-7928 for reservations or more information.

ONE FALSE MOVE AND YOU'RE A MONET.

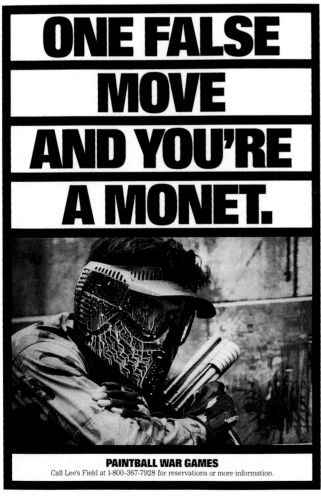

PAINTBALL WAR GAMES
Call Lee's Field at 1-800-367-7928 for reservations or more information.

IT'S KIND OF LIKE PATTON AND ROMMEL MEET DUTCH BOY.

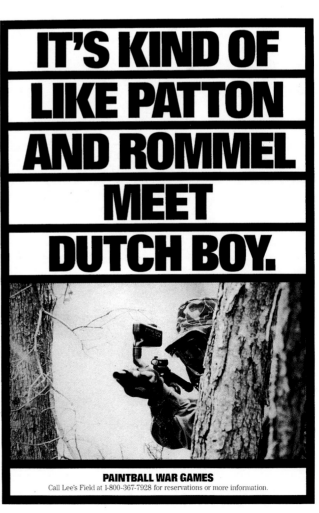

PAINTBALL WAR GAMES
Call Lee's Field at 1-800-367-7928 for reservations or more information.

366
ART DIRECTOR
Ann Lemon
WRITERS
Andy Spade
Craig Simpson
CLIENT
Charivari
AGENCY
Kirshenbaum & Bond/
New York

367
ART DIRECTOR
Steve Dunn
WRITER
Tim Delaney
PHOTOGRAPHER
Daniel Jouanneau
CLIENT
Harrods
AGENCY
Leagas Delaney/London

goatees. backward baseball caps. 90210.

wake us when it's over
CHARIVARI

ripped jeans. pocket tees. back to basics.

wake us when it's over
CHARIVARI

flannel shirts. chinos. nesting.

wake us when it's over
CHARIVARI

366

THERE

IS ONLY ONE

HARRODS.

———————

THERE

IS ONLY ONE

SALE.

COMMENCES JANUARY 6TH.

THERE

IS ONLY ONE

HARRODS.

———————

THERE

IS ONLY ONE

SALE.

COMMENCES JANUARY 1ST.

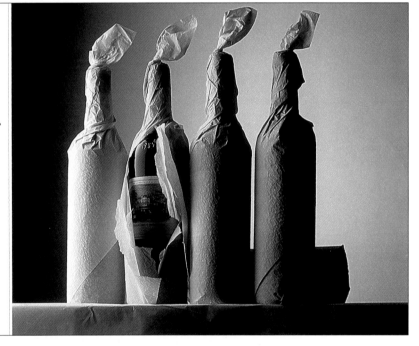

THERE

IS ONLY ONE

HARRODS.

———————

THERE

IS ONLY ONE

SALE.

COMMENCES JANUARY 6TH.

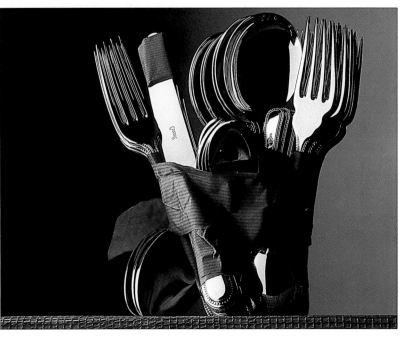

368
ART DIRECTOR
Mark Fuller
WRITER
Tripp Westbrook
PHOTOGRAPHER
Craig Anderson
CLIENT
AAA Pawn
AGENCY
The Martin Agency/
Richmond

369
ART DIRECTOR
John Boiler
WRITER
Jamie Barrett
PHOTOGRAPHER
Doug Petty
CLIENT
Nike
AGENCY
Wieden & Kennedy/
Portland

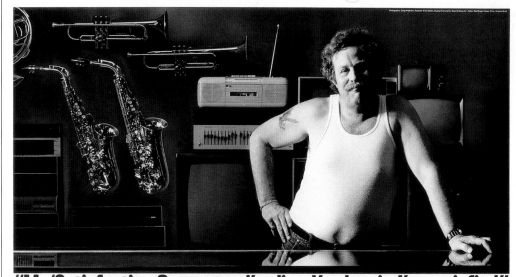

"My 'Satisfaction Guaranteed' policy: You buy it. I'm satisfied."

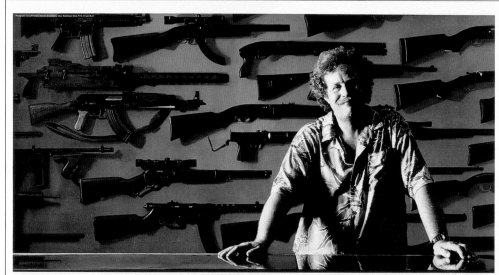

"For some reason I've never had much of a problem with shoplifters."

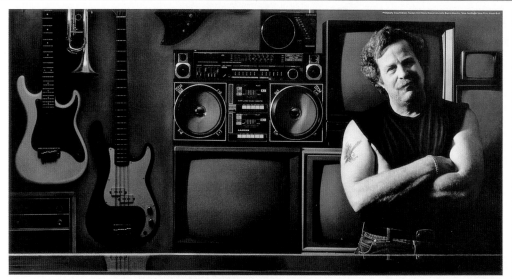

"My shop is like a bank. It's got a lobby, a safe, and an S.O.B. in the loan department."

DRIVE LIKE A MANIAC.

Air Magnum Force 3/4.

DEALER NAME

SPECIFICALLY DESIGNED FOR WHATEVER.

Air Trainer Accel Mid.

DEALER NAME

LIGHTER THAN A LINESMAN'S BRAIN.

Air Challenge Huarache.™

DEALER NAME

IS THIS A CLEVER HEADLINE?

Conventional advertising wisdom would probably say no.

There's not, after all, the slightest whiff of a pun. And where, for that matter, is the ingenious 'double entendre', guaranteed to leave the reader musing long after he's turned the page?

If this alone isn't damning enough, we've also failed to include the client's name (a capital offence in most agencies).

More importantly still, where is the offer? The big promise? The sole reason for interrupting you in the first place?

Indeed, you could be forgiven for asking what in God's name we're advertising for at all.

Well, perhaps simply the fact that to produce clever advertising sometimes involves ignoring certain so-called fundamentals.

That, in the ever more cluttered advertising arena, the best route to getting noticed (one particular fundamental that it pays not to ignore) is invariably to disregard convention, rather than adhere to it.

It would seem that impertinence has its rewards. To date, finding the exception to the rule has found us more creative awards than any other agency in Asia.

Alas, finding exceptional people is often more of a challenge. Which brings us to the whole point of writing this ad. (See? It had one all along.)

If you think you know a clever idea when you see one, then you might make a good account executive. In which case you should call Peter Stening, Managing Director at The Ball Partnership EURO RSCG.

If, on the other hand, you think you can write a cleverer ad. than this one, fax it to Titania Yuen, Creative Director, on 544 9896.

But remember, we're all desperately overworked and underpaid, so the smartest thing of all might be to become a client.

370

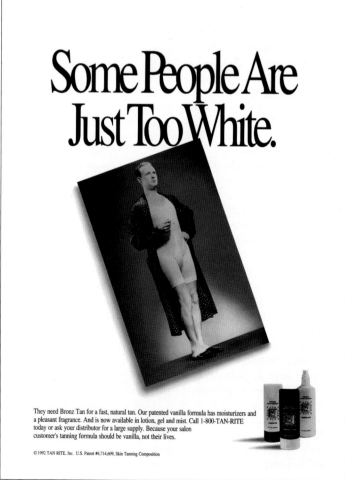

Some People Are Just Too White.

They need Bronz Tan for a fast, natural tan. Our patented vanilla formula has moisturizers and a pleasant fragrance. And is now available in lotion, gel and mist. Call 1-800-TAN-RITE today or ask your distributor for a large supply. Because your salon customer's tanning formula should be vanilla, not their lives.

© 1992 TAN RITE, Inc. U.S. Patent #4,714,609, Skin Tanning Composition

371

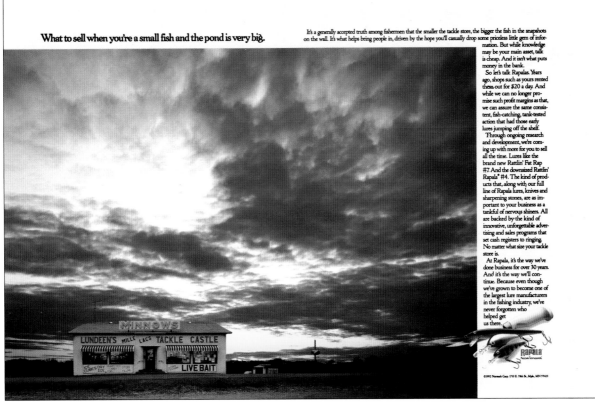

374
ART DIRECTOR
Jac Coverdale
WRITER
Jerry Fury
PHOTOGRAPHER
Steve Umland
CLIENT
Northwestern National Life
Insurance
AGENCY
Clarity Coverdale Rueff/
Minneapolis

375
ART DIRECTOR
Bob Barrie
WRITER
Mike Gibbs
PHOTOGRAPHER
Shawn Michienzi
CLIENT
Continental Bank
AGENCY
Fallon McElligott/
Minneapolis

376
ART DIRECTOR
Michael Fazende
WRITER
Mike Gibbs
PHOTOGRAPHER
Shawn Michienzi
CLIENT
The Lee Company
AGENCY
Fallon McElligott/
Minneapolis

377
ART DIRECTOR
Michael Fazende
WRITER
Mike Gibbs
PHOTOGRAPHER
Dave Jordano
CLIENT
The Lee Company
AGENCY
Fallon McElligott/
Minneapolis

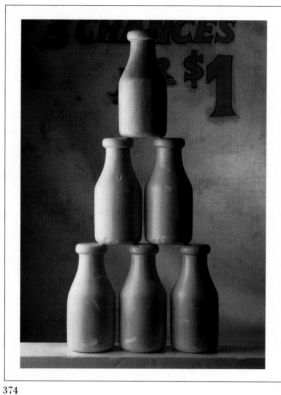

JUST HOW ACCURATE IS YOUR HEALTH CLAIM SERVICE?

According to many benefit managers, the trouble with claim-paying services is they're missing something.

It seems they're either accurate and slow, or they're fast but sometimes miss the mark.

Let's do something about it.

At Northwestern National Life, we're doing something about the inconsistencies in claim service. For example, we guarantee 98% financial and 95% payment accuracy on claims. And we guarantee 80% of your claims will be paid in 14 calendar days. All of which are standards you asked for.

The heart of our guarantee is our claim data reports that detail how well we perform and a report card which you fill out to grade our performance and your total satisfaction.

On top of that, we also guarantee your complete satisfaction on all we do. Or we credit your account up to 5% in each of these areas.

To help you better review your current claim service, we'd like to send you our special booklet—Getting the Most Out of Your Claim Service.

For your free copy, call or write Rick Naymark, Northwestern National Life, Box 20, Minneapolis, MN 55440. (612) 342-7137. And remember, with our service guarantees you know you won't get thrown a curve.

Northwestern National Life

374

Business banking cut from a different cloth.

More often than not, the day-to-day activities in the worlds of equity financing, portfolio management and capital funding could be described as something akin to war.

It's not a battleground for the faint of heart. Nor is it for rigid, inflexible automatons. Ironically, though, many business bankers are as straight and narrow as the pinstripes they wear. Which, to us, doesn't make a whole lot of sense.

We've learned that the road to victory often requires insightful, anticipatory strategies, followed by bold, sometimes guerrilla-like tactics. All deployed by aggressive, forward-thinking bankers.

We have an army of those bankers at Continental. And each is eager to advance your cause in the face of seemingly insurmountable odds.

So eager, in fact, that some are even planning to make contact with you this very minute. Just so we can help you and your business be all that you can be.

Continental Bank
Anticipating the needs of business.™

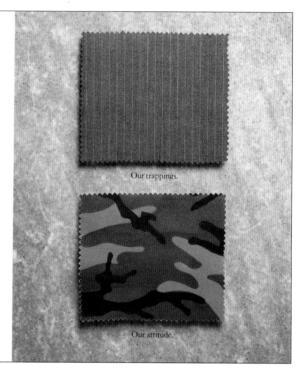

375

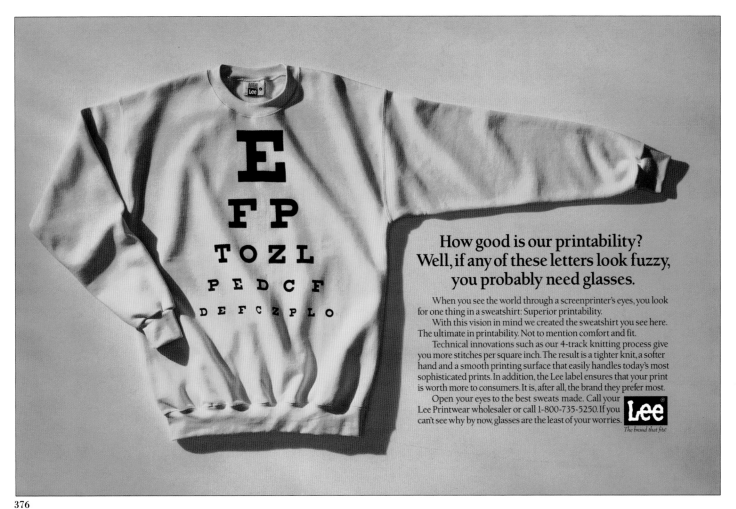

How good is our printability? Well, if any of these letters look fuzzy, you probably need glasses.

When you see the world through a screenprinter's eyes, you look for one thing in a sweatshirt: Superior printability.

With this vision in mind we created the sweatshirt you see here. The ultimate in printability. Not to mention comfort and fit.

Technical innovations such as our 4-track knitting process give you more stitches per square inch. The result is a tighter knit, a softer hand and a smooth printing surface that easily handles today's most sophisticated prints. In addition, the Lee label ensures that your print is worth more to consumers. It is, after all, the brand they prefer most.

Open your eyes to the best sweats made. Call your Lee Printwear wholesaler or call 1-800-735-5250. If you can't see why by now, glasses are the least of your worries.

Lee
The brand that fits

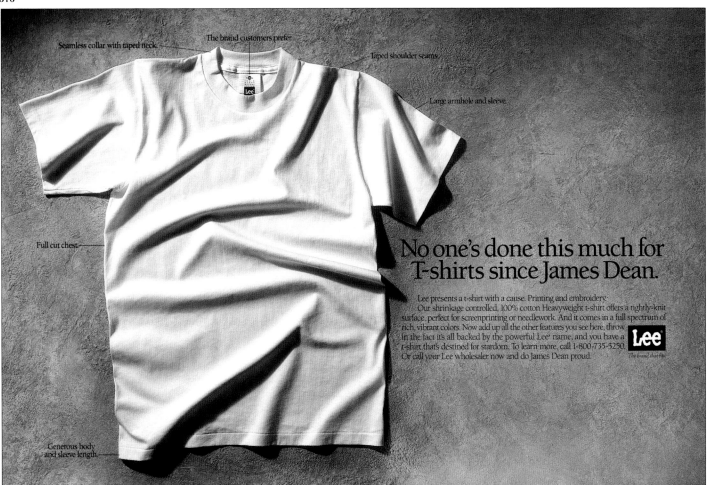

Seamless collar with taped neck.
The brand customers prefer.
Taped shoulder seams.
Large armhole and sleeve.
Full cut chest.
Generous body and sleeve length.

No one's done this much for T-shirts since James Dean.

Lee presents a t-shirt with a cause. Printing and embroidery.

Our shrinkage controlled, 100% cotton Heavyweight t-shirt offers a tightly-knit surface, perfect for screenprinting or needlework. And it comes in a full spectrum of rich, vibrant colors. Now add up all the other features you see here, throw in the fact it's all backed by the powerful Lee® name, and you have a t-shirt that's destined for stardom. To learn more, call 1-800-735-5250. Or call your Lee wholesaler now and do James Dean proud.

Lee
The brand that fits

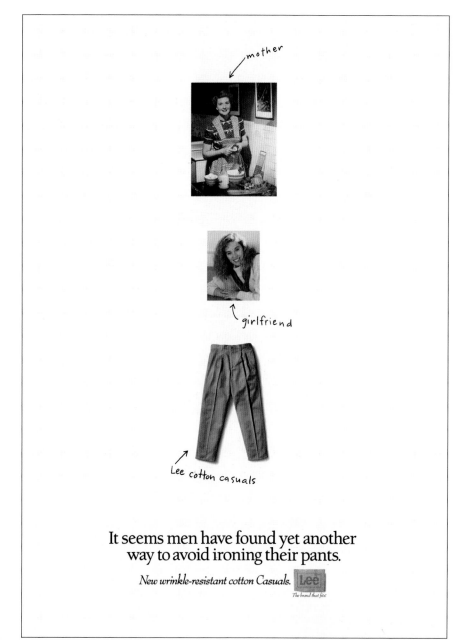

378

379

Everyone knows, yellow and blue make green.

The best-selling tennis ball plus the best-selling racquetball equals money. It's so simple, it's elementary.

380

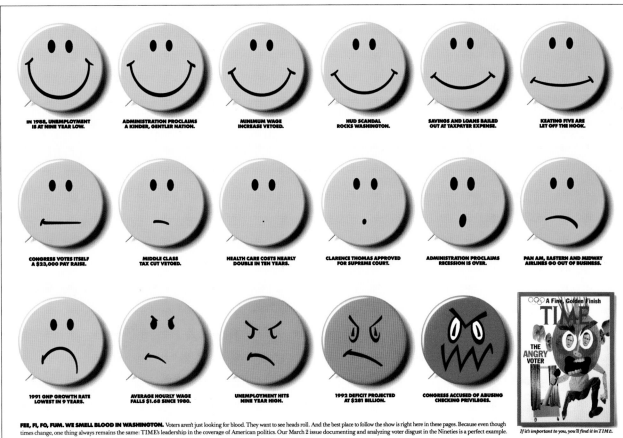

381

Oh beautiful *for spacious skies* *for amber waves of grain* *for purple mountain majesties*

above the fruited plain *America* *America* *God shed his grace on thee*

and crown thy good *with brotherhood* *from sea* *to shining sea.*

MAYBE IT'S TIME WE CHANGED OUR TUNE. The U.S. seemed oddly off key at the Earth Summit in Rio last June. With only 5% of the world's population, our country uses 25% of the world's energy and emits 22% of all CO₂ produced. Yet of the 178 countries present, we were the most reluctant to make meaningful changes. Some say we were being practical; others say we were being selfish. Only our children will know for sure. *If it's important to you, you'll find it in TIME.*

382

Page 16 ADWEEK/August 17, 1992

CHIP SHOT

Largely because the gang on Capitol Hill loves its golf,
an IRS ruling on event sponsorship didn't stand a chance.

You'll see them on pickup trucks, in appalling taste but telling nonetheless: MY WIFE? YES. MY DOG? MAYBE. MY GUN? NEVER. Substitute the words GOLF CLUBS for GUN, and the resulting bumper stickers could be issued with congressional license plates. Our elected representatives would no doubt display them with pride.

The love affair between lawmakers and the links—which until now has made little contribution to the public good—may finally benefit someone other than politicians. After a frenzy of last-minute politicking, the House acted this month to continue to exempt charitable organizations from taxes on the proceeds they receive from corporate sponsors. The legislation is expected to sail through the Senate as well.

The big winners are pro golf tournaments and college bowl games (and the non-profit organizations that depend on such shindigs for revenue), along with the ad agencies that plan, promote and profit from them. Capitol Hill insiders say it was the legislators' passion for golf outings that carried the day.

DOSSIER
D.C.

BY ALAN PELL CRAWFORD

Here's the scoop. Late last year, the IRS ruled that Mobil Oil's $1.5-million sponsorship of the Cotton Bowl, having little connection to the educational aims of the participating colleges, was an advertising purchase, not a charitable donation. A similar decision regarding John Hancock's Sun Bowl sponsorship followed, as did new guidelines for IRS auditors who exam[...]ities receiving such corporate la[...] w contracts in which a [...]

time and say we need 34% more, or they'll have to raise their prices."

That puts sponsors in a bind. "In this economy, every project our members has going is under review," says Dan Jaffe, executive vp for the Association of National Advertisers. "I wouldn't say that all the non-profits in the country are going to go out of business as a result, but the IRS ruling certainly makes things more difficult for them."

Big money's involved, any way you slice it. Non-profit events rake in $1.1 billion a year from corporate sponsors. Grazio says the Hartford Jaycees received $1.6 million from Canon in 1991, which accounted for 95% of their funding. To protect such revenues, non-profits nationwide mobilized to protest the IRS action and pressure their elected representatives.

When the IRS scheduled hearings on the matter, more than 300 groups issued angry statements of opposition. If you don't back off, the protestors pleaded, we'll have to shut our doors, and the world will be a colder, meaner place for it.

When the matter came before Congress, however, less high-minded considerations prevailed. In mid-summer, while millions of Americans were watching the Nike-Reebok-Kodak Olympics, the House Ways and Means committee, making last-minute additions to the tax bill, took up Democrat Ed Jenkins' legislation to exempt the non-profits.

There was not much question how the vote would go. Committee chairman Dan Rostenkowski is a golf addict. Back in 1982, *The Washington Post* found that between [...]er and April of that year, Rosty spent at least 45 [...] the expense of [...] During that [...] by [...]

LETTERS

Best Western

Regarding "The Holt Truth" [June 29]: Why didn't you also talk to the small agencies that utilize Western International Media? WIMC's buying power keeps many of us in business.

During eight years as a station executive rep calling on WIMC, three as a WIMC account executive, and seven as a client using its media buying and research resources, I've noticed that (big surprise!) Holt's detractors are his competitors. They snipe because they can't compete in the most important area, the client's bottom line. They snipe about what WIMC earns on the business (which I believe your article exaggerated), about "whited out" affidavits.

Who cares? Certainly not the client.

The WIMC client cares about the clout provided by market-wise, professional buyers with many years' experience. In most agencies the position of buyer is merely a step up the ladder; at Western, it's a long-term commitment.

Any firm in the West, if not elsewhere, which employs any agency or media service other than WIMC to do its buying is a firm that may not care about improving its bottom line. Why doesn't WIMC have all the business? If the economy doesn't [...] soon, it just might.

account you've "won," plus you've lost a year's income on three other accounts in your shop to pay for the pitches you've lost. This will grind you down faster than an Atlantic City slot machine.

I don't know a precise formula that avoids this trap, but my guess is that it would have to be tempered with the agency's *actual* average pre-tax profit over the past couple of years plus its growth goals for the future, and not just a prospect's *potential* value.

Ms. Kalmanson saved some excellent advice for the end of her piece, however, in stating that "the ideal form of cost control is to pick your best shots."

ROBERT V. RYAN
President
Horatio Marketing Inc.
New York

Misunderstood Board

I was disappointed to read your negative comments about our highly successful Moos[...] outdoor campa[...]

exactly what these boards are.

I'm sorry that you didn't find the lines very catchy; fortunately, research shows that our drinkers do. In fact, one of the lines has become a beach towel—with our dripping bottle and the line "Dry yourself off"—and we are struggling to keep them in stock. Let me know if you'd like one.

BRIAN HARROD
Executive vp/creative director
Harrod & Mirlin
Toronto

The Forgotten Producer

It is with great respect and enthusiasm that I look forward to the annual naming of the ADWEEK Creative All-Stars [June 15]. As I read this year's preamble, I was struck by such statements as "proving that great creative work can be done wherever there are great ideas" and "they all simply know how to play as a team."

These thoughts are truer than ever [...]day in[...], and therefore I [...]dst the [...]

WE HAVE SEEN THE ENEMY AND IT IS US. As the world changes and as TIME changes with it, one thing regrettably remains the same. Racial hatred and injustice continue to take an incredible toll in lives, human dignity, and economic opportunity. And we're all to blame. Black, yellow, white, red, and brown. What will it take to get along? Until someone finds the answer, we promise to keep asking the question. *If it's important to you, you'll find it in TIME.*

383

FOR US, A DRY RUN LASTS A THOUSAND MILES.

386

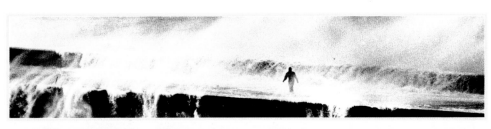

TIMBERLAND. BECAUSE NATURE IS A MOTHER.

387

Here's the deal. You run an ad in The Show Book '92. The creative community sees

your ad while drooling over this year's award winners. You get rich off new business.

RUN AN AD IN THIS YEAR'S SHOW BOOK. IF IT'S ANY GOOD, WE'LL RUN IT FREE NEXT YEAR.

You think, "Hey, that ad made me rich. It must have been great." So you enter it in next

year's show. That's when you realize that just because an ad sells, doesn't mean it's

good. To reserve space call Dave or Kerry, 339-5470. Show Book Ad Space For Sale.

388

If you really want to see great creative, let me do your taxes.

I'VE BEEN WORKING WITH ADVERTISING PEOPLE SO LONG, I COULD DO YOUR RETURN IN MY SLEEP.
NOT THAT I WOULD. BUT I COULD. JUST SO YOU KNOW.

MILT SANFORD
FINANCIAL MANAGEMENT AND TAX CONSULTATION
213 965 5420

389

390

TRADE
LESS THAN A PAGE
B/W OR COLOR: SINGLE

390
ART DIRECTOR
Hal Curtis
WRITER
Tom Camp
ILLUSTRATOR
Skidmore Sahratian
PHOTOGRAPHER
Tony Garcia
CLIENT
JBL
AGENCY
Livingston + Keye/
Venice, CA

391
ART DIRECTOR
Richard Page
WRITER
Bob Guard
CLIENT
The Advertising Club of
Cincinnati
AGENCY
Northlich Stolley LaWarre/
Cincinnati

TRADE ANY SIZE
B/W OR COLOR:
CAMPAIGN

392
ART DIRECTOR
Bob Barrie
WRITER
Mike Gibbs
PHOTOGRAPHER
Shawn Michienzi
CLIENT
Continental Bank
AGENCY
Fallon McElligott/
Minneapolis

391

We took the starch out of business banking.

These days, business bankers cannot afford to be inflexible, dyed-in-the-worsted-wool bureaucrats.

There's simply not enough time for repetitiously redundant rehashings of given scenarios. Or layer after layer after layer of approvals. Or, for that matter, ad copy that takes its own sweet time to get to the point.

Well, the point is, Continental bankers are more efficient. More effective. More aggressive. You see, we've loosened our collars and rolled up our sleeves. We've learned to look out for you, to anticipate your needs, instead of worrying about how we look to ourselves.

Part of it's our Midwestern no-nonsense, common sense disposition. And part of it's our powerful work ethic. But what it all boils down to is that we're able to give you precision-crafted, customized business banking products—exactly when, and in many cases before you need them.

In fact, to prove it, we'll be contacting you soon. You'll discover that with plain talk, common sense and a little elbow grease, we can iron all of your problems out.

Continental Bank
Anticipating the needs of business.™

Business banking cut from a different cloth.

More often than not, the day-to-day activities in the worlds of equity financing, portfolio management and capital funding could be described as something akin to war.

It's not a battleground for the faint of heart. Nor is it for rigid, inflexible automatons. Ironically, though, many business bankers are as straight and narrow as the pinstripes they wear. Which, to us, doesn't make a whole lot of sense.

We've learned that the road to victory often requires insightful, anticipatory strategies, followed by bold, sometimes guerrilla-like tactics. All deployed by aggressive, forward-thinking bankers.

We have an army of those bankers at Continental. And each is eager to advance your cause in the face of seemingly insurmountable odds.

So eager, in fact, that some are even planning to make contact with you this very minute. Just so we can help you and your business be all that you can be.

Continental Bank
Anticipating the needs of business.™

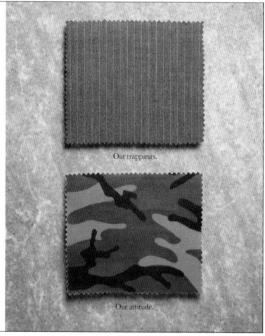

Our trappings.

Our attitude.

It's not uncommon for Continental Bankers to become a part of your business.

Continental Bank relationship managers will do everything it takes to learn your business inside and out. (Even if it means contorting themselves into small spaces throughout your office.)

Inside, they'll analyze how your business is run. Scrutinize your strengths and weaknesses. Absorb your company's culture. And adopt your mission as their own.

Outside, they'll examine your business' overall climate. Put themselves in your customers' shoes. And wear your competitors' hats.

Then, once back in their own clothes, they'll show you exactly why they've earned their pinstripes, by creating customized, anticipatory financial tools. Long-term solutions to match your long-range goals.

The truth is, there really is no telling how far a Continental relationship manager will go to anticipate your needs. So after you start working with us, please open your file drawers carefully. **Continental Bank**
Anticipating the needs of business.™

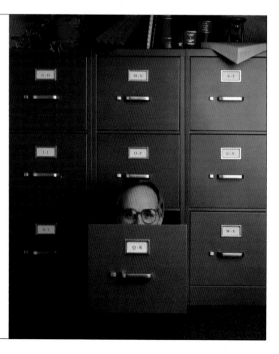

**TRADE ANY SIZE
B/W OR COLOR:
CAMPAIGN**

393
ART DIRECTOR
Mark Johnson
WRITER
Bill Miller
PHOTOGRAPHER
Shawn Michienzi
CLIENT
Rolling Stone Magazine
AGENCY
Fallon McElligott/
Minneapolis

394
ART DIRECTOR
Bob Brihn
WRITER
Phil Hanft
PHOTOGRAPHER
Joe Lampi
CLIENT
Time Magazine
AGENCY
Fallon McElligott/
Minneapolis

Perception. Reality.

For a new generation of Rolling Stone readers, the cold war is on ice. Mushrooms appear in salads
instead of on horizons. And that's no hallucination. For twenty five years, Rolling Stone magazine
has reflected the changing attitudes, ideas and lifestyles of the people who are changing the world.
Your advertising can reach seven million of those people, safely, in the pages of Rolling Stone.

Perception. Reality.

For a new generation of Rolling Stone readers there is a new world order. And it comes with
a whole new view of our future. We see a global economy, a healthier rain forest, an ozone layer
without a hole, and peace to guide the planet. For twenty five years, Rolling Stone magazine
has reflected the changing attitudes, ideas and lifestyles of the people who are changing the world.
Your advertising can reach 7 million of those people every issue in the pages of Rolling Stone.

Perception. Reality.

Anti-war. Pro-active.

Anti-establishment. Pro-environment.

Anti-government. Prophylactics.

For a new generation of Rolling Stone readers, the future is not burdened with blaming the past.
This is a generation of people who just do it. And their actions speak louder than words. For 25 years,
Rolling Stone magazine has reflected the changing attitudes, ideas and lifestyles of the people who are
changing the world. Your advertising can reach 7 million of those people in the pages of Rolling Stone.

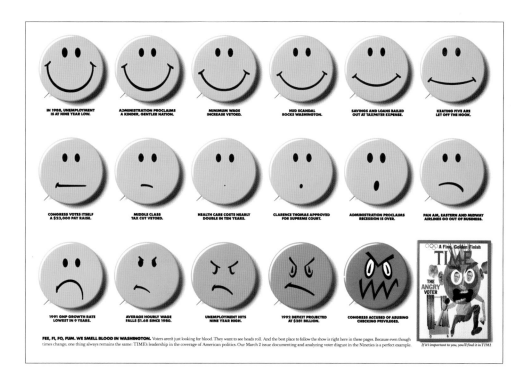

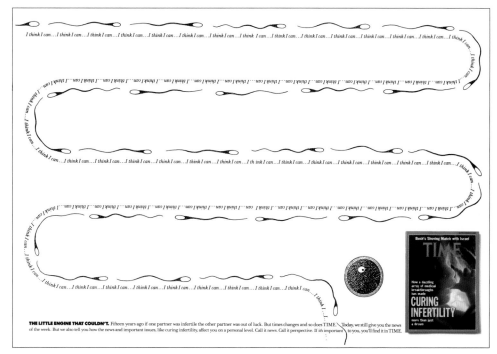

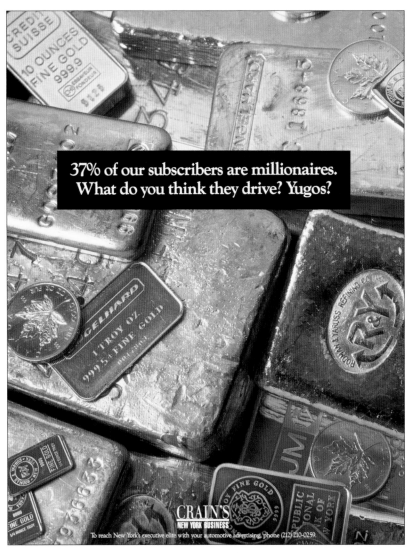

37% of our subscribers are millionaires. What do you think they drive? Yugos?

CRAIN'S
NEW YORK BUSINESS
To reach New York's executive elite with your automotive advertising, phone (212) 210-0259.

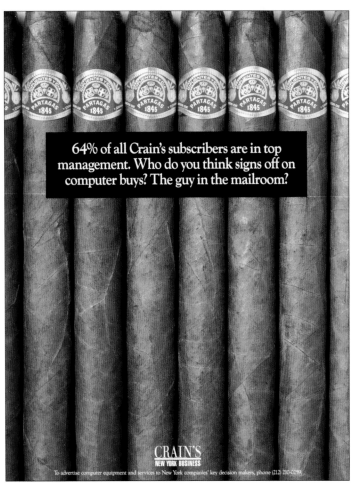

64% of all Crain's subscribers are in top management. Who do you think signs off on computer buys? The guy in the mailroom?

CRAIN'S
NEW YORK BUSINESS
To advertise computer equipment and services to New York companies' key decision makers, phone (212) 210-0259.

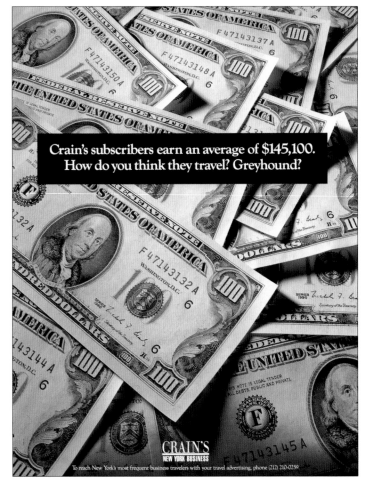

Crain's subscribers earn an average of $145,100. How do you think they travel? Greyhound?

CRAIN'S
NEW YORK BUSINESS
To reach New York's most frequent business travelers with your travel advertising, phone (212) 210-0259.

For those who

buy a product based

on its trendiness

rather than

its inherent virtues,

we offer two words.

Mood Rings.

Sutter Home 1990 Chardonnay. Rated an
84 and called a "Best Buy" in The Wine Spectator.
The right wine for the right reason.

Some wineries

describe wines as

"untamed ambrosia,

lavish in perfection,

the joyous epiphany

of a well-tended

harvest."

Huh?

Sutter Home 1989 Cabernet Sauvignon. Rated an
83 and called a "Best Buy" in The Wine Spectator.
The right wine for the right reason.

Choosing a wine

by its label and

price guarantees

nothing.

Except the

everlasting social

approval of

shallow people.

Sutter Home 1989 Cabernet Sauvignon. Rated an
83 and called a "Best Buy" in The Wine Spectator.
The right wine for the right reason.

TRADE ANY SIZE
B/W OR COLOR:
CAMPAIGN

397
ART DIRECTOR
Jim Mountjoy
WRITER
Ed Jones
PHOTOGRAPHERS
Jim Arndt
Jim Erickson
CLIENT
Verbatim
AGENCY
Loeffler Ketchum Mountjoy/
Charlotte

398
ART DIRECTOR
Margaret McGovern
WRITER
Paul Silverman
PHOTOGRAPHERS
Michelle MacDonald
Charles Mason
Paul Souders
John Holt Studios
CLIENT
The Timberland Company
AGENCY
Mullen/Wenham, MA

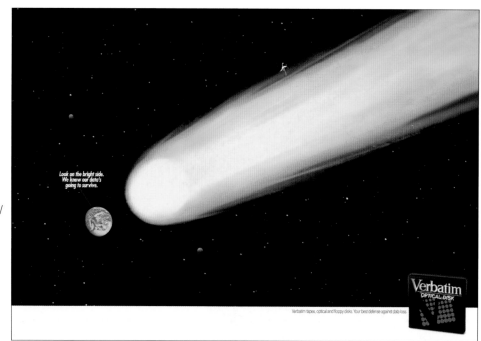

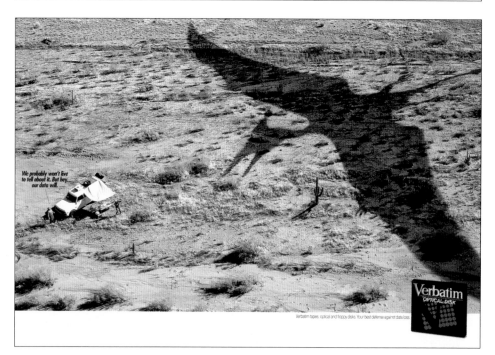

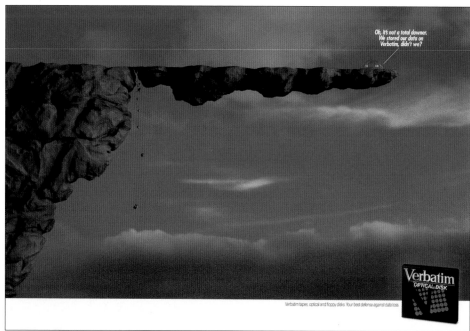

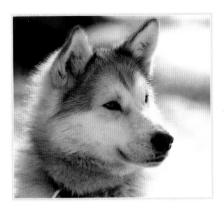

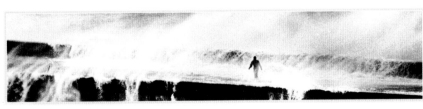

399
ART DIRECTOR
Ed McGrady
WRITER
Ed Tettemer
CLIENT
**Turner Cable
Network Sales**
AGENCY
**Earle Palmer Brown &
Spiro/Philadelphia**

400
ART DIRECTORS
**James Spindler
Amy Haddad**
WRITERS
**Vicky Oliver
Susan Lieber**
PHOTOGRAPHER
Guzman
CLIENT
**Revlon/Fermodyl
Interactives**
AGENCY
**Kirshenbaum & Bond/
New York**

401
ART DIRECTORS
**Aird McKinstrie
Oliver Haas**
WRITER
Aird McKinstrie
CLIENT
Syntax
AGENCY
Millhouse/Edinburgh

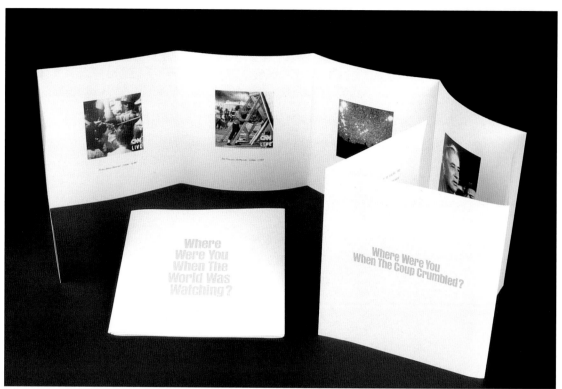

399

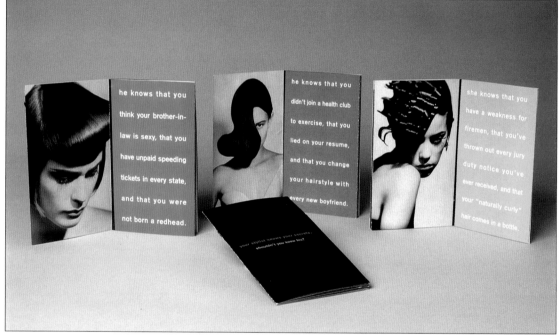

400

the

ay

to

zɛd

of

s y n t a x

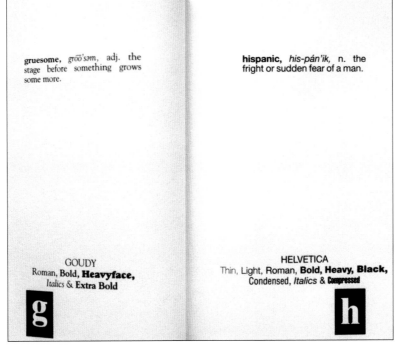

gruesome, *grōō'səm,* adj. the stage before something grows some more.

GOUDY
Roman, Bold, **Heavyface,** *Italics* & **Extra Bold**

g

hispanic, *his-pán'ik,* n. the fright or sudden fear of a man.

HELVETICA
Thin, Light, Roman, **Bold, Heavy, Black,** Condensed, *Italics* & **Compressed**

h

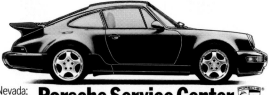

For an appointment at the Porsche Service Center, call or stop by. (Whichever is faster.)

We have the only Porsche-trained technicians in northern Nevada; not to mention the biggest inventory of Porsche parts in North America.

Porsche Service Center
4775 Aircenter Circle · East side of Reno Airport · 825-6926

402

403

404

405

COLLATERAL DIRECT
MAIL: CAMPAIGN

406
ART DIRECTOR
Tom Lichtenheld
WRITER
Luke Sullivan
PHOTOGRAPHERS
Vic Huber
Porsche Archives
CLIENT
Porsche Cars North America
AGENCY
Fallon McElligott/
Minneapolis

407
ART DIRECTOR
Bryan Burlison
WRITER
Todd Tilford
PHOTOGRAPHER
Richard Reens
CLIENT
Wearabout
AGENCY
The Richards Group/Dallas

Don't let any mechanic get his Porsche training on your Porsche. Bring it to the Porsche Service Center. Where you'll find the only Porsche-trained technicians in northern Nevada, as well as the largest inventory of Porsche parts in North America. For an appointment, call us at 825-6926; or drive on out. Whichever is faster. **Porsche Service Center** 4775 Aircenter Circle · East side of Reno Airport · 825-6926

That's German, of course, for wrench. Meaning, there's no one more qualified to work on your Porsche than the factory-trained Porsche technicians you'll find at our Service Center. They're all qualified to do any repair work—warranty, body and paint work. For an appointment, call us at 835-6926; or drive out. Whichever is faster. **Porsche Service Center** 4775 Aircenter Circle · East side of Reno Airport · 825-6926

For an appointment at the Porsche Service Center, call or stop by. (Whichever is faster.)

We have the only Porsche-trained technicians in northern Nevada; not to mention the biggest inventory of Porsche parts in North America. **Porsche Service Center** 4775 Aircenter Circle · East side of Reno Airport · 825-6926

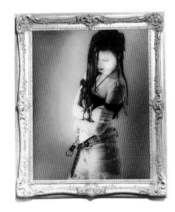

When it came to clothing, she
only had one rule: Never wear anything
you can picture on your parents.

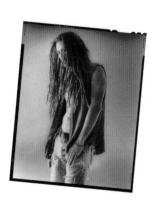

There was only one store standing
between him and a nudist colony.

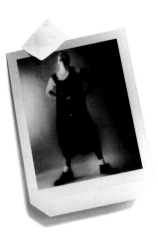

He usually wears a starched white
shirt, a navy blazer and khaki pants.
On Halloween.

408
ART DIRECTOR
Craig Tanimoto
WRITER
Jean Rhode
PHOTOGRAPHER
William McKenzie-Smith
CLIENT
La Cage Aux Folles
AGENCY
The Ad Hut/Portland

409
ART DIRECTOR
Andy Clarke
WRITER
Antony Redman
PHOTOGRAPHER
Charles Liddall
CLIENT
Cycle & Carriage/
Mitsubishi
AGENCY
The Ball Partnership
Euro RSCG/Singapore

410
ART DIRECTOR
Andy Clarke
WRITER
Antony Redman
CLIENT
Singapore Dance Theatre
AGENCY
The Ball Partnership
Euro RSCG/Singapore

411
ART DIRECTOR
Andy Clarke
WRITERS
Danny Higgins
Jim Aitchison
PHOTOGRAPHERS
Alex Kaikeong
Andy Clarke
CLIENT
Yet Con Restaurant
AGENCY
The Ball Partnership
Euro RSCG/Singapore

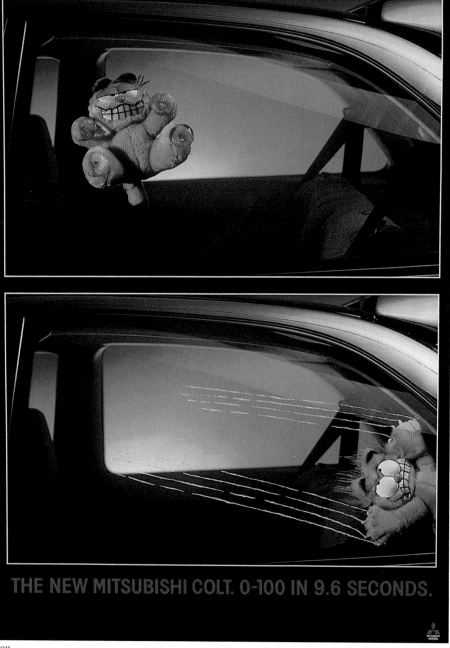

408

409

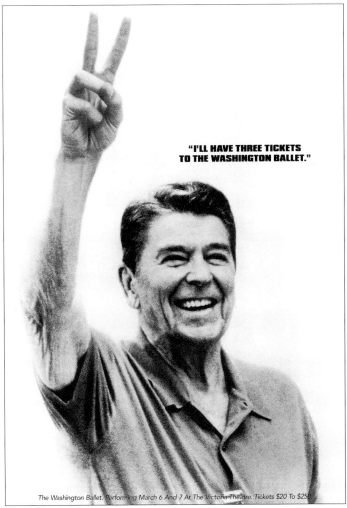

"I'LL HAVE THREE TICKETS TO THE WASHINGTON BALLET."

The Washington Ballet. Performing March 6 And 7 At The Victoria Theatre. Tickets $20 To $250.

410

SEE, WE DO EVERYTHING IN OUR POWER TO ENSURE YOU HAVE A GOOD MEAL.

Alas, we spend so much money procuring the best chicken and pork that there's precious little left over to spend on other things.

Like furniture.

Or the rest of our decor, for that matter.

Which is actually a blessing in disguise.

It means there is absolutely nothing to distract you from our superbly steamed, contentedly plump chicken.

Or our pork, which we roast, religiously, according to a time-honoured recipe. (It's still pinned behind the dresser.)

So why worry if your table slants a little?

It only means you'll get more than your fair share of our nutritious chicken rice.

And, if your chair should rock occasionally, there is absolutely no cause for alarm.

None whatsoever, may we hasten to add.

In fact, we haven't lost a customer in over forty years.

Besides, there's probably some nice Hainanese music coming from the Kitchen which you can rock your chair to.

Fortunately, with their usual foresight, our founding fathers selected tables and chairs of uncommon durability.

Consider, for a moment, the tables around the walls.

Their tops are solid marble.

Their legs are teak, built like battleships.

(The kind of tables you wouldn't find at the Dorchester.)

In the centre of our dining room are highly functional, neo-Ordinaire tables.

No cheap veneers, you'll notice. All made, respectably, from wood.

We have to admit, generations of diners have probably taken their toll.

And our cleaners have perhaps been less-than-gentle.

But we do value tradition.

Even down to an odd wobble or two on Table 8.

Or a wonky leg on the third chair of Table 9. (Blame the man who stands on it to read the electricity meter.)

But, please, dear reader, bear with us.

Certainly, we'll get round to fixing them one day.

Just as soon as we find the original manufacturer's guarantee card.

411

FEEL FREE TO FLIRT WITH OUR WAITRESSES. BUT WHY LOSE YOUR APPETITE?

What is the world coming to?

We've just heard there are restaurants employing waitresses to wander around wearing absolutely nothing from the belly up.

And open flirting with the patrons is encouraged.

How could anyone possibly be expected to enjoy the food?

Thankfully, you'll never spy such sillyness at the Yet Con. All our girls are clad, top to toe, in sensible floral frocks handed down from generation to generation to generation.

And the only skin you'll see is that on our beautifully steamed, contentedly plump chickens.

We believe nothing should distract you from our succulent roast pork, served drenched in our own secret gravy, sprinkled with peas and thick with flavour.

Of course, when it comes to girls who parade past your table dressed in rubber, we are quite in step with the times.

Our ladies wear rubber too.

Rubber gumboots, mind you, when they hose the floors. But still.

Even our chairs and tables pay scant attention to modern fads.

No cheap veneers. Just respectable marble tops with comfortable little elbow grooves worn away by 50 years of satisfied diners.

Nor do we indulge in crisply-starched napkins. And definitely no expensive china underfood.

(Sterling silver, however, abounds aplenty. Out in the kitchen. Filling most of our chef's teeth).

And the only music you'll hear is the symphony of clanging plastic plates and bowls in the enamel sink.

We've never had any time for fancy hullabaloo.

And guess what? It hasn't affected the taste of our food one bit.

Which is why so many people keep returning to the Yet Con.

Unfortunately, it will all change in fifteen years time.

That's when our waitresses frocks come back into fashion.

412

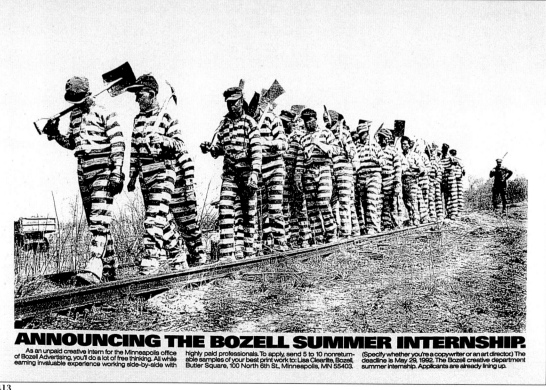

ANNOUNCING THE BOZELL SUMMER INTERNSHIP.

As an unpaid creative intern for the Minneapolis office of Bozell Advertising, you'll do a lot of free thinking. All while earning invaluable experience working side-by-side with highly paid professionals. To apply, send 5 to 10 nonreturnable samples of your best print work to: Lisa Clearlite, Bozell, Butler Square, 100 North 6th St., Minneapolis, MN 55403. (Specify whether you're a copywriter or an art director.) The deadline is May 29, 1992. The Bozell creative department summer internship. Applicants are already lining up.

413

CAN EATING BUGS CURE MUSCULAR DYSTROPHY?

Join Harley-Davidson® in riding the National MDA Poker Run on June 13th and 14th. It's not only fun, but it's your chance to add to the millions of dollars we're raising for the Muscular Dystrophy Association. Call your local Harley-Davidson dealer for all the details.

414

Welcome to the 1992 Lee National Marketing Meeting.

June 22-26 · Marriott Plaza Hotel · Kansas City **Lee**

415

416
ART DIRECTOR
Tom Lichtenheld
WRITER
John Stingley
PHOTOGRAPHER
Shawn Michienzi
CLIENT
The Lee Company
AGENCY
Fallon McElligott/
Minneapolis

417
ART DIRECTOR
Geoffrey B. Roche
WRITER
Jim Ranscombe
PHOTOGRAPHERS
George Simhoni
Michael Day
CLIENT
Audio Products
International
AGENCY
Geoffrey B. Roche &
Partners/Toronto

418
ART DIRECTORS
Jeremy Postaer
Ruthie Sakheim
WRITER
Scott Aal
ILLUSTRATOR
John Burgoyne
CLIENT
Norwegian Cruise Line
AGENCY
Goodby Berlin &
Silverstein/San Francisco

419
ART DIRECTOR
Mike Bevil
WRITER
Tim Bauer
PHOTOGRAPHER
Richard Reens
CLIENT
XO@..#! Alternative
Clothing
AGENCY
GSD&M Advertising/
Austin

416

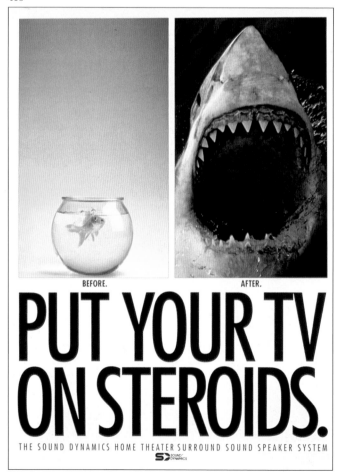

417

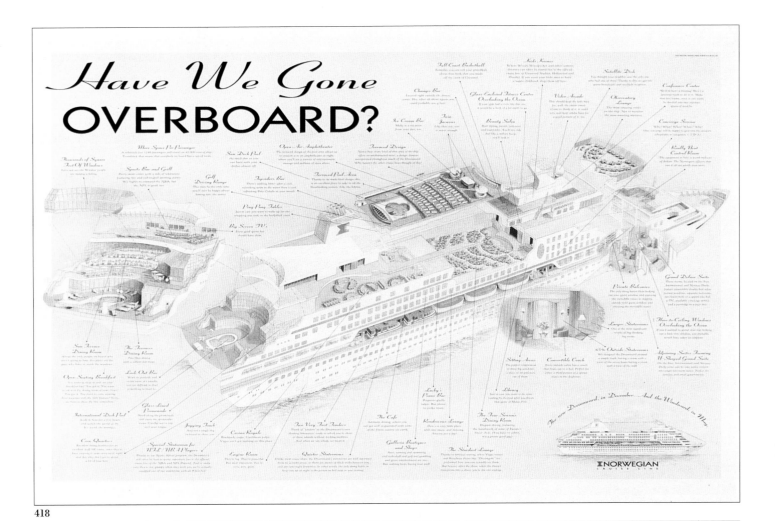

COLLATERAL P.O.P.

420
ART DIRECTOR
Kenny Sink
WRITER
Roy Davimes
PHOTOGRAPHER
Dean Hawthorne
CLIENT
Mill Mountain Zoo
AGENCY
**Hawley Martin Partners/
Richmond**

421
ART DIRECTOR
Mike Fetrow
WRITER
Doug de Grood
PHOTOGRAPHER
Steve Umland
CLIENT
Hed Design
AGENCY
Hunt Murray/Minneapolis

422
ART DIRECTOR
Tim Hannell
WRITERS
**Barton Landsman
Jim Noble**
PHOTOGRAPHER
Kurt Andersen
CLIENT
Lee's Field
AGENCY
**Jaded Angry &
Disillusioned/New York**

423
ART DIRECTOR
Tim Hannell
WRITERS
**Barton Landsman
Jim Noble**
PHOTOGRAPHER
Kurt Andersen
CLIENT
Lee's Field
AGENCY
**Jaded Angry &
Disillusioned/New York**

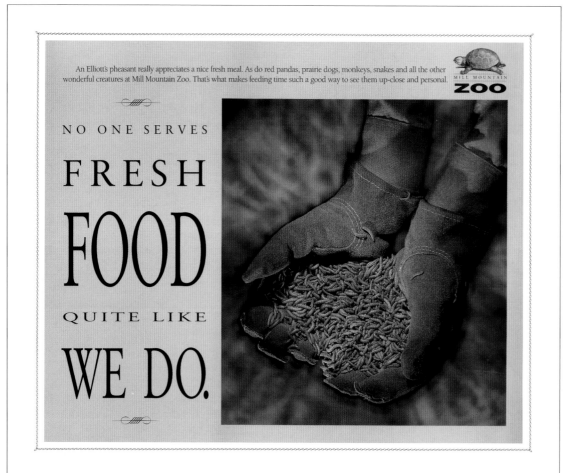

420

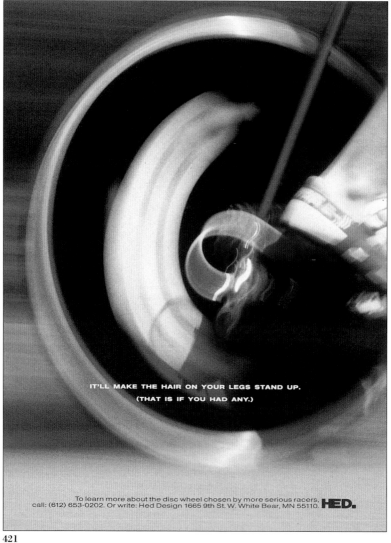

421

IT'S KIND OF LIKE PATTON AND ROMMEL MEET DUTCH BOY.

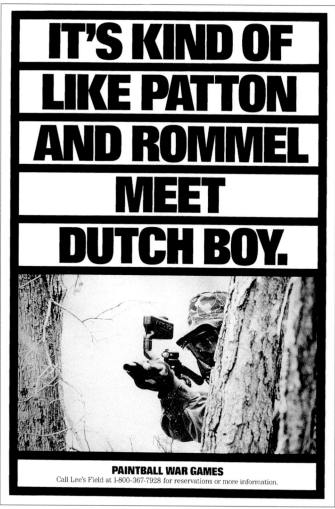

PAINTBALL WAR GAMES
Call Lee's Field at 1-800-367-7928 for reservations or more information.

422

"I LOVE THE SMELL OF LATEX IN THE MORNING."

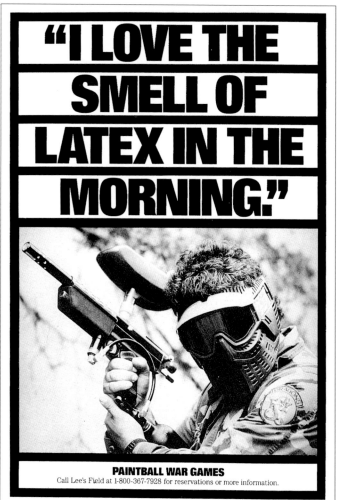

PAINTBALL WAR GAMES
Call Lee's Field at 1-800-367-7928 for reservations or more information.

COLLATERAL P.O.P.

424
ART DIRECTORS
Gordon Smith
Andy Azula
WRITER
Steve Lasch
PHOTOGRAPHER
Steve Murray
CLIENT
North Carolina Travel
& Tourism
AGENCY
Loeffler Ketchum Mountjoy/
Charlotte

425
ART DIRECTOR
Mark Fuller
WRITER
Tripp Westbrook
PHOTOGRAPHER
Craig Anderson
CLIENT
AAA Pawn
AGENCY
The Martin Agency/
Richmond

426
ART DIRECTOR
Mark Fuller
WRITER
Tripp Westbrook
PHOTOGRAPHER
Craig Anderson
CLIENT
AAA Pawn
AGENCY
The Martin Agency/
Richmond

427
ART DIRECTOR
Mark Fuller
WRITER
Tripp Westbrook
PHOTOGRAPHER
Craig Anderson
CLIENT
AAA Pawn
AGENCY
The Martin Agency/
Richmond

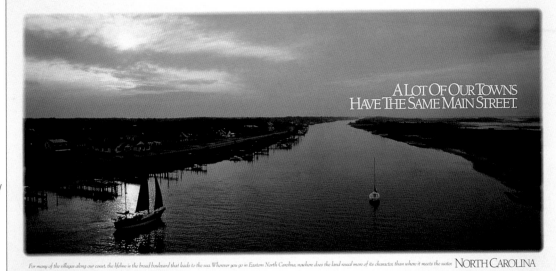

424

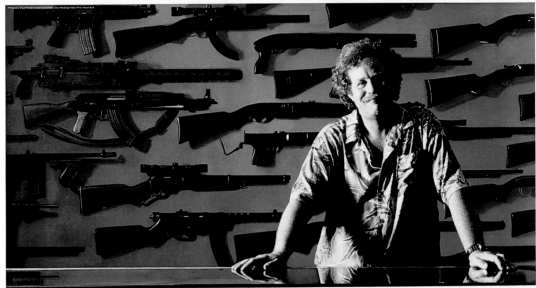

425

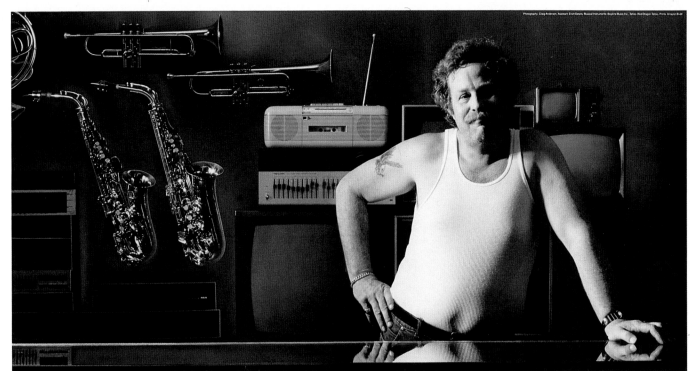

"My 'Satisfaction Guaranteed' policy: You buy it. I'm satisfied."

AAA PAWN

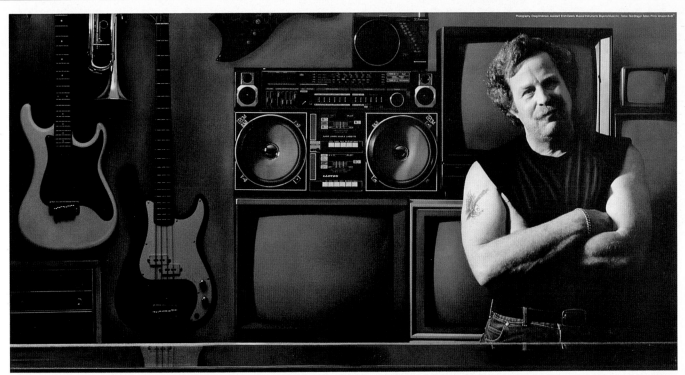

"My shop is like a bank. It's got a lobby, a safe, and an S.O.B. in the loan department."

AAA PAWN

COLLATERAL P.O.P.

428
ART DIRECTOR
Mark Fuller
WRITER
John Mahoney
PHOTOGRAPHER
Tony Sylvestro
CLIENT
Farm at Mt. Walden
AGENCY
The Martin Agency/ Richmond

429
ART DIRECTOR
Mark Fuller
WRITER
John Mahoney
PHOTOGRAPHER
Tony Sylvestro
CLIENT
Farm at Mt. Walden
AGENCY
The Martin Agency/ Richmond

430
ART DIRECTOR
Cliff Sorah
WRITER
Ken Hines
PHOTOGRAPHER
Robert Stevens
CLIENT
Mercedes-Benz
AGENCY
The Martin Agency/ Richmond

431
ART DIRECTOR
Cliff Sorah
WRITER
John Mahoney
PHOTOGRAPH
Stock
CLIENT
Richmond National Battlefield
AGENCY
The Martin Agency/ Richmond

DECEPTION. TRICKERY. ARTIFICIAL INGREDIENTS. THINGS YOU BUILD A BUSINESS ON.

428

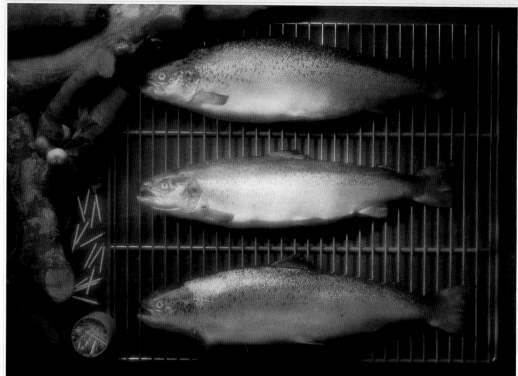

WHAT HUCK FINN WOULD'VE DONE. IF HE'D GONE TO HARVARD BUSINESS SCHOOL.

429

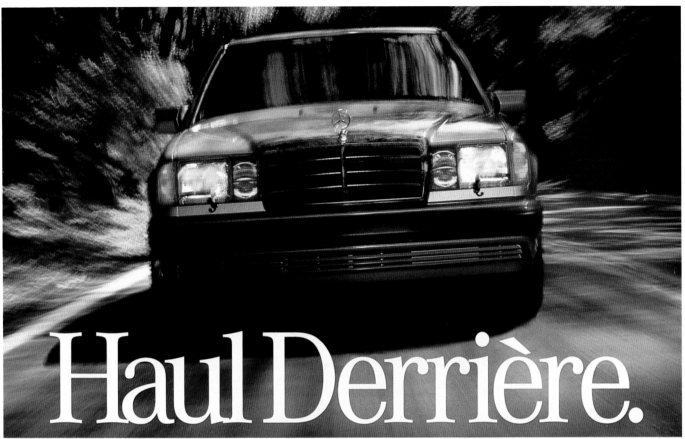

Haul Derrière.

With its new 217-hp engine, the Mercedes-Benz 300E will turn your neighbors' heads faster than ever.

 Sacrifice nothing.

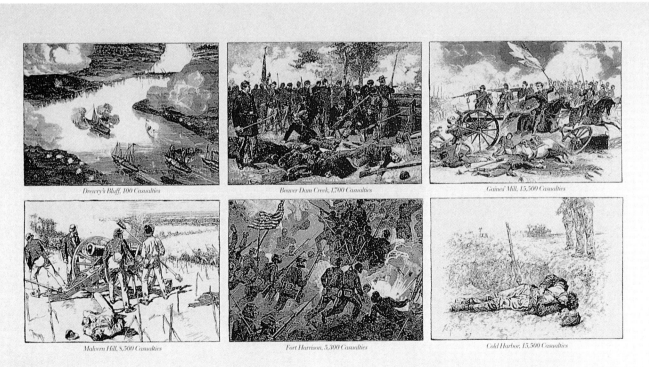

Drewry's Bluff, 100 Casualties *Beaver Dam Creek, 1,700 Casualties* *Gaines' Mill, 15,500 Casualties*

Malvern Hill, 8,500 Casualties *Fort Harrison, 5,300 Casualties* *Cold Harbor, 15,500 Casualties*

WITHIN 30 MILES OF RICHMOND LIES THE MOST EXPENSIVE REAL ESTATE IN AMERICA.

RICHMOND NATIONAL BATTLEFIELD PARK TOUR

Take The Richmond Battlefield Tour. 226-1981.

432
ART DIRECTOR
Cliff Sorah
WRITER
Steve Bassett
PHOTOGRAPHER
Brian Lanker
CLIENT
Wrangler
AGENCY
The Martin Agency/
Richmond

433
ART DIRECTOR
Cliff Sorah
WRITER
Steve Bassett
PHOTOGRAPHER
Brian Lanker
CLIENT
Wrangler
AGENCY
The Martin Agency/
Richmond

434
ART DIRECTOR
Cliff Sorah
WRITER
Steve Bassett
PHOTOGRAPHER
Brian Lanker
CLIENT
Wrangler
AGENCY
The Martin Agency/
Richmond

435
ART DIRECTOR
Kristy Willson
WRITER
Alan Yamamoto
CLIENT
Toshi's Teriyaki
AGENCY
McCann-Erickson/Seattle

432

433

434

435

436

437

Hello.

I'm one of the people who shares the road with you.
You know, the other guy. I'm easy to spot.

That's because I know only two speeds, full-throttle,
nuclear, break-neck, go -- and slam-on-it, brake-
squealing, splatter coffee all over the windshield
stop.

Someday soon, you'll look in your rear view mirror
and there I'll be. About seven and three-eights
inches off your back bumper.

SOME PEOPLE DESERVE HIGH INSURANCE PREMIUMS.
WE SPECIALIZE IN THOSE WHO DON'T.

★ **AMERICAN SPIRIT**

Smart Insurance For Smart Drivers

438

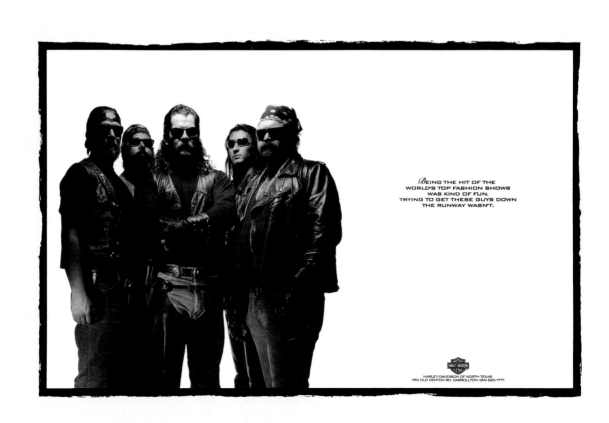

*B*EING THE HIT OF THE
WORLD'S TOP FASHION SHOWS
WAS KIND OF FUN.
TRYING TO GET THESE GUYS DOWN
THE RUNWAY WASN'T.

HARLEY-DAVIDSON OF NORTH TEXAS
190 OLD DENTON RD. CARROLLTON (214) 620-7777

439

440
ART DIRECTOR
Bryan Burlison
WRITER
Todd Tilford
PHOTOGRAPHER
Richard Reens
CLIENT
Harley-Davidson
of Texas
AGENCY
The Richards Group/Dallas

441
ART DIRECTOR
Bryan Burlison
WRITER
Todd Tilford
PHOTOGRAPHER
Tom Ryan
CLIENT
Optique International
Eyeware
AGENCY
The Richards Group/Dallas

442
ART DIRECTOR
Jeff Hopfer
WRITERS
Todd Tilford
Vinnie Chieco
PHOTOGRAPHER
Holly Stewart
CLIENT
Tabu Lingerie
AGENCY
The Richards Group/Dallas

443
ART DIRECTOR
Jeff Hopfer
WRITERS
Todd Tilford
Vinnie Chieco
PHOTOGRAPHER
Holly Stewart
CLIENT
Tabu Lingerie
AGENCY
The Richards Group/Dallas

444
ART DIRECTOR
Jeff Hopfer
WRITERS
Todd Tilford
Vinnie Chieco
PHOTOGRAPHER
Holly Stewart
CLIENT
Tabu Lingerie
AGENCY
The Richards Group/Dallas

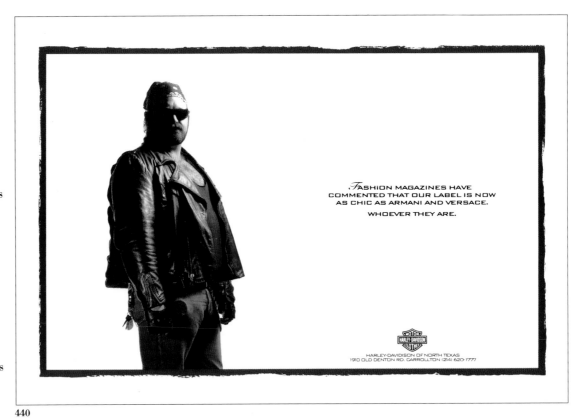

440

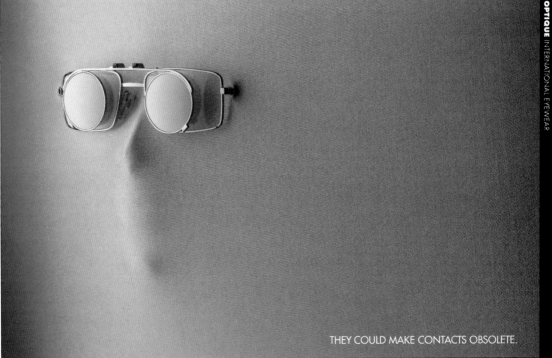

441

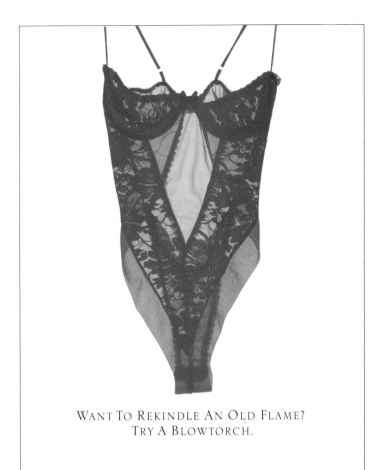

WANT TO REKINDLE AN OLD FLAME?
TRY A BLOWTORCH.

TABU
LINGERIE

442

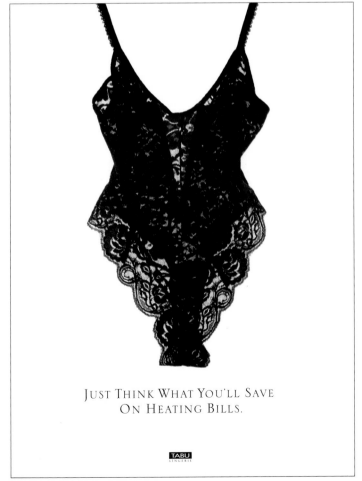

JUST THINK WHAT YOU'LL SAVE
ON HEATING BILLS.

TABU
LINGERIE

443

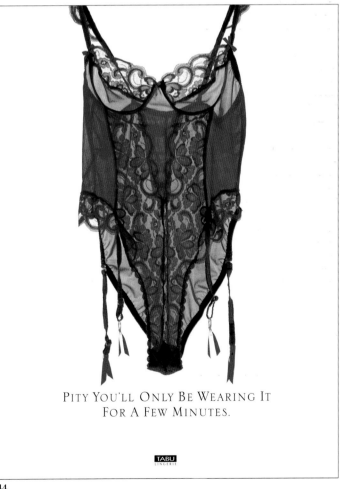

PITY YOU'LL ONLY BE WEARING IT
FOR A FEW MINUTES.

TABU
LINGERIE

444

445

ART DIRECTOR
Ron Brown

WRITER
David Abbott

PHOTOGRAPH
Stock

CLIENT
RSPCA

AGENCY
Abbott Mead Vickers.
BBDO/London

446

ART DIRECTOR
Trevor Kennedy

WRITER
Steve Spence

PHOTOGRAPHER
Mike Parsons

CLIENT
RSPCA

AGENCY
Abbott Mead Vickers.
BBDO/London

447

ART DIRECTOR
Carol Henderson

WRITER
Doug de Grood

PHOTOGRAPHER
Jim Arndt

CLIENT
Children's Defense Fund

AGENCY
Fallon McElligott/
Minneapolis

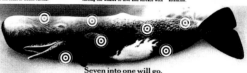

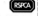

445

Cruelty to animals?
These were used on
our inspectors.

One chilly November evening Bob Phillips' answered a knock on his front door.

Seconds later, he was fighting off a vicious attack by a man armed with a large spanner.

The reason for the assault? He was an RSPCA Inspector.

His assailant? A dog-owner whose house he had visited earlier that day investigating a cruelty complaint.

Although he did escape injury this time, Bob Phillips knows full well that it could happen again.

Because he is not the first of our Inspectors to be attacked.

And, sadly, he's not likely to be the last.

It's the job of an RSPCA Inspector to respond to reports of cruelty to animals.

While making determined efforts to prevent cruelty in the first place.

When an Inspector follows up a report of ill-treatment, he has no idea of what he's likely to face.

Relief? Guilt? Anger?

Will he get verbal abuse or, as in Inspector Jim Smith's case, a shotgun thrust into his ribs?

Our Officers never know. They're not psychic, they're human.

And they've been assaulted with a variety of weapons that would not be out of place in Scotland Yard's infamous Black Museum.

Yet they carry on because their first duty is to animals.

Rabbits that have been stabbed. Cats that have been maimed. Dogs that have been starved or beaten to death.

Last year the RSPCA received over a million calls for help.

Unfortunately we only have 287 Inspectors. We need to increase that number to 300.

But, like most things in life, it will take money. A lot of it.

The total cost of training, equipping and keeping one new Inspector on the road for the first year is £31,088.

After that it costs us £7 an hour to keep him, or her, on active duty.

We do our best, it's true, but we could do far more.

We could investigate more cases, protect more animals, prevent more deaths.

We need your help. Please fill in the coupon.

Because we need to show those people who mistreat, torture and kill animals that we too have a weapon.

A very powerful one. Your support.

The idea of hungry children should no longer be foreign to Americans. Currently, an estimated 5.5 million kids in this country don't regularly get enough to eat. And they're not just in the cities; they're in the rural communities as well, all over this otherwise rich nation.

And while the thought of hungry children on U.S. soil might be hard to stomach, that's not the worst of it. As these statistics point out, our children want for more than just food.

— One in five American children lives below the official poverty level. (The majority are from rural and suburban communities.)

— 29 percent of American children have no private health insurance.

— In immunizing infants against polio, the United States ranks behind 16 other nations — including Mexico.

— 23 nations have lower infant mortality rates than the United States.

— Approximately 2.5 million American children were reported abused or neglected last year.

Many of these kids don't do well in school. (You try and concentrate when you haven't eaten all day.) As a result, when they grow up, they're less able to compete for good jobs. Which leads to higher unemployment. And, along with it, increased welfare and crime.

REMEMBER THOSE HUNGRY KIDS IN CHINA? NOW THEY'RE IN OMAHA.

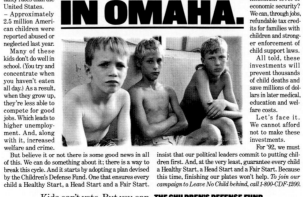

1. A Healthy Start. Children need basic health care to grow into healthy, productive adults. Yet many families simply cannot afford it. Congress has voted to extend health care to all poor children by the year 2002. But what about those who get sick in the meantime? Clearly, these children cannot wait for basic health care.

2. A Head Start. Quality preschools, child care and Head Start programs give children a tremendous boost in school. The president and Congress already have expressed support for these programs. Now they must put their money where their mouths are. Only by getting children ready for school can we begin to achieve other national education goals.

3. A Fair Start. Poor children need a level playing field to succeed. Should we be the only industrialized nation not to ensure families a minimum level of economic security? We can, through jobs, refundable tax credits for families with children and stronger enforcement of child support laws.

All told, these investments will prevent thousands of child deaths and save millions of dollars in later medical, education and welfare costs.

Let's face it. We cannot afford not to make these investments.

For '92, we must insist that our political leaders commit to putting children first. And, at the very least, guarantee every child a Healthy Start, a Head Start and a Fair Start. Because this time, finishing our plates won't help. *To join our campaign to Leave No Child behind, call 1-800-CDF-1200.*

But believe it or not there is some good news in all of this. We can do something about it; there is a way to break this cycle. And it starts by adopting a plan devised by the Children's Defense Fund. One that ensures every child a Healthy Start, a Head Start and a Fair Start.

Kids can't vote. But you can. **THE CHILDREN'S DEFENSE FUND**

448
ART DIRECTOR
Mark Johnson
WRITER
Bill Miller
ILLUSTRATOR
Simms Taback
CLIENT
**Democratic National
Committee**
AGENCY
**Fallon McElligott/
Minneapolis**

449
ART DIRECTOR
Paul Asao
WRITER
Neville De Souza
PHOTOGRAPHER
Christian Peacock
CLIENT
United Way
AGENCY
**Goldberg Moser O'Neill/
San Francisco**

450
ART DIRECTOR
Gary Woodward
WRITER
Ivor Jones
CLIENT
Friends of the Earth
AGENCY
Leo Burnett/Hong Kong

451
ART DIRECTOR
Jelly Helm
WRITER
Steve Dolbinksi
CLIENT
American Cancer Society
AGENCY
**The Martin Agency/
Richmond**

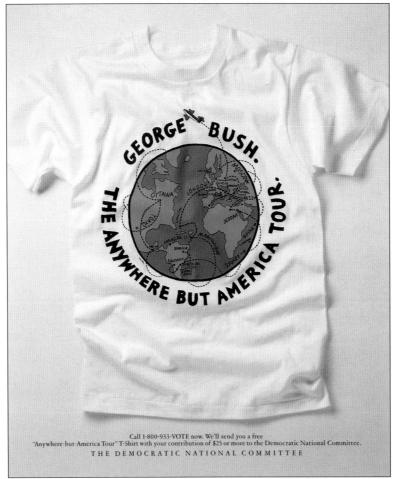

Call 1-800-933-VOTE now. We'll send you a free
"Anywhere-but-America Tour" T-Shirt with your contribution of $25 or more to the Democratic National Committee.
THE DEMOCRATIC NATIONAL COMMITTEE

448

MINUTES AFTER SHE WAS BORN, HER PARENTS THREW HER OUT OF A SPEEDING CAR. AMAZINGLY, SHE MANAGED TO LAND ON HER FEET.

Elizabeth was found in a brown paper bag on a San Francisco street. Her umbilical cord draped around her, she bore all the marks of a newborn baby. And some other ones, too.

Her skull was fractured from hitting the pavement. But if Elizabeth's parents had been cruel to her, they had started even before she was born. Because, as the tests revealed, she had drugs in her system. The worst, however, was yet to come.

Before she was 2 weeks old, the tiny infant went into cardiac arrest and had to be put on life-support. By then, she didn't need a doctor, but a miracle.

Providence sent her one, by the name of Cathie Behrendt. As Elizabeth's foster mother, Cathie saw the fragile infant through every crisis: the agony of withdrawal, the seizures caused by her terrible head injuries. When things would seem hopeless, Cathie would find

support at a local United Way agency. Eventually, Elizabeth became well again. She also became Cathie's adopted child.

As incredible as this story may seem, you hear one like it almost daily. Although not always with such a happy ending. Last

year, seventy-three abandoned babies were found in the city of San Francisco alone. But if that figure seems overwhelming, so is your generosity. Please continue to give through your local United Way; your gift helps provide much-needed services ranging from infant respite care, adoption and foster care placement to training for children with special needs. And, just as important, rehabilitation, education and counseling programs for thousands of parents.

While it may be hard to understand how some people could just throw away a part of their lives, it's reassuring to know there are others who will come forward to help.

Yes, Elizabeth was thrown from a speeding car. But the way we see it, you were there to catch her. United Way

YOUR LOCAL UNITED WAY. IT'S WORKING.

449

Leaded petrol causes brain damage.

Which may explain why some people are still using it.

528-5588

IF YOU THINK YOU LOOK FUNNY WITHOUT A TAN, IMAGINE HOW YOU'D LOOK WITHOUT A NOSE.

Who could possibly think of not working on a tan? Any of the 600,000 people who contracted skin cancer last year. To learn how you can protect yourself, just call 1-800-ACS-2345. **AMERICAN CANCER SOCIETY**

FINALLY, A CANDIDATE MORE INTERESTED IN KISSING THE DEFICIT GOOD-BYE THAN A LOBBYIST'S YOU-KNOW-WHAT.

The United States government is 4 trillion dollars in debt. We owe another 1 trillion dollars in unfunded federal pension liabilities. The additional debt we've already piled up in 1992 will actually exceed the total expenditures of the federal government the first 155 years of the country's existence.

"REAGAN CALLED IT VOODOO ECONOMICS. WHATEVER IT WAS, WE'RE IN DEEP VOODOO NOW, I'LL TELL YOU THAT."

Ross Perot isn't a professional politician. He has never even run for public office. What he is is a businessman who understands the problems facing the country. Problems like the deficit.

In 1992, while we were increasing our tax base by $166 billion, we also increased spending by a staggering $304 billion, or $1.83 in new spending for every new tax dollar raised.

Like so many, he believes the only way we can solve the deficit problem and others like unemployment, taxes, education and the trade imbalance is with strong leadership. He has no 17-point programs. No thousand points of light. No invisible promises. Ross Perot is simply willing to roll up his sleeves, take a tough look at the problem, and do something about it. That's why he's running for president.

"IF YOU CAN'T STAND A LITTLE PAIN, WE'RE NEVER GOING TO STRAIGHTEN THIS COUNTRY OUT."

Ross Perot believes the only way we're going to stop the U.S. deficit from growing is by being tough. For starters, he'd cut over $180 billion alone just by eliminating fraud, abuse and waste. Waste like taking Air Force 1 to golf outings. He believes another $100 billion could be cut simply by asking Germany and Japan to pay for U.S. troops in their countries.

Ross Perot also thinks, for most politicians, raising taxes is like taking dope. After the initial euphoria, the same old problems still exist. That's why Ross Perot proposes no new taxes, except in the rare case of a national emergency.

"IT'S ABOUT TIME ELECTED OFFICIALS STOPPED CASHING IN ON PUBLIC SERVICE."

To get the economy moving now, Ross Perot would take the shackles off American business. He'd tighten trade quotas and restrictions on imported goods to match all those that are placed on our American goods by other countries.

He'd like to see our elected officials working side by side with our business people, not high paid lobbyists.

In fact, Ross Perot would make it a criminal offense for any foreign company to influence laws or policies with money. He'd also pass a law that no former president, vice president, cabinet director, CIA director, Federal Reserve Board member, Senate majority leader, Speaker of the House, just to name a few, can ever lobby for any domestic or foreign interests. He'd limit political contributions to $1000. He'd eliminate PACS and discourage any special interest group from giving money to candidates. He'd require the President and the Congress to turn in all excess funds from each campaign. Ross Perot simply believes elected officials came to serve the people, not to prey on them.

But these are just a few of Ross Perot's many ideas. To find out more, simply call 1-800-685-7777 and talk to a Perot volunteer. Because it's about time an American president stopped puckering up. And started putting up.

CITIZENS FOR PEROT FOR PRESIDENT

STUBBORN. COMPETITIVE. UNCOMPROMISING. HONEST. JUST LIKE PRESIDENTS USED TO BE.

Harry Truman once said the buck stops here, at his desk. Unfortunately today, the buck isn't stopping anywhere. The deficit is growing by the second. Taxes are being raised by the quarter. And the trade imbalance simply grows wider and wider by the year.

"RAISING TAXES IS LIKE TAKING DOPE FOR MOST POLITICIANS. THE MORE MONEY YOU GIVE THEM, THE MORE THEY'LL SPEND."

Ross Perot believes taxes should only be raised in the event of a national emergency. And the power to raise them should lie not with Congress, but with the people who have to pay them. Us. But if we don't raise taxes, we have to cut spending. Ross Perot truly believes the deficit can be eliminated. At least $100 billion could be cut just by taking out the waste in Washington. Waste like flying Air Force 1 to a golf outing at tax payers' expense.

Of course, Ross Perot's concerns aren't just economic. His stance on abortion is simple. It's a woman's right. But he opposes its use for birth control.

He's always been a leader in educational reform. In Texas, he helped bring about the "no pass, no play" rule for student athletes.

When it comes to affirmative action, the country should be "color blind and sex blind." But Ross Perot opposes the promotion of the less qualified over the more qualified.

These are just a few of Ross Perot's many views. If you'd like to learn more, just call 1-800-685-7777 and talk to a Ross Perot volunteer. He or she will give you honest, no-bull answers to your questions. Just like their boss would.

The single constant in American politics has been the desire for change. Today, that yearning has never been stronger. According to recent polls more than 80% of Americans believe that the country is on the wrong track. 1 out of 3 are dissatisfied with the current leadership. 75% say the government is run for the benefit of a few big businesses.

"ACTION, ACTION, ACTION."

Ross Perot isn't a professional politician. In fact, he's never run for public office. Simply put, he's a businessman who happens to understand many of the problems facing the country.

Like a handful of past presidents, he sees the role of leadership as identifying the problem and then making the tough decisions to solve it.

He has no 17-point programs. No claims that he has the best answers. Ross Perot simply has the willingness to tackle the deficit, unemployment, taxes, health care and many more issues by rolling up his sleeves and doing something about them. That's why he's running for president.

CITIZENS FOR PEROT FOR PRESIDENT

ONCE AGAIN, ROSS PEROT IS SPENDING HIS OWN MONEY TO RESCUE INNOCENT PEOPLE FROM AN OPPRESSIVE GOVERNMENT.

Franklin Roosevelt once said "Take a method and try it. If it fails, admit it and simply try another. But above all, try something."

In recent polls, the majority of Americans feel the current administration is doing little or nothing to end the recession, stop unemployment, and balance the budget.

"IF YOU CAN'T STAND A LITTLE PAIN, WE'RE NEVER GOING TO STRAIGHTEN THIS COUNTRY OUT."

Ross Perot is not a professional politician. In fact, he's never run for public office. He's simply a businessman who realizes the country can't follow it's current course. That's why he's running for president.

Like many, he believes the political system in America is broken, unable to address both economic and social issues because of red tape, lobbyists, and laziness.

To solve these problems, the country needs a strong leader who can identify problems and make tough decisions to solve them. Ross Perot isn't a stranger to this kind of leadership.

In 1969, disregarding White House objections, he sent a relief plane to the POWs in Hanoi.

In 1979, after the United States Government failed, he hired a paramilitary team that freed two of his EDS employees from Teheran's Gasr prison.

"WE'RE GOING TO GET RID OF THE WASTE. IF YOU WANT LAWRENCE WELK MUSIC, THEN I'M NOT YOUR MAN."

Cutting the deficit is not going to easy, but it has to be done. Ross Perot would pass a law to stop deficit spending. Then he'd pass another one to balance the budget. He believes billions of dollars can be rescued just by cutting the waste. Like the 1,200 planes worth $2 billion that fly politicans around like royalty. Or the $100 billion used each year to defend Asia and Europe that the U.S. isn't reimbursed for.

"ACTION, ACTION, ACTION."

Economic issues aren't the only issues. Ross Perot wants to toughen the standards of our educational system. He proposes longer school years, merit pay raises for teachers, and equal funding for rich and poor school districts.

Ross Perot will fight "night and day" to get the guns out of the hands of violent people. He wants much harsher punishment for crimes involving guns and supports the death penalty.

And when it comes to affirmative action, he believes the country should be "color-blind" and "sex-blind." It's that simple. He opposes, however, the hiring of less-qualified over more-qualified.

Perot Hires Paramilitary Team For Jail Break

EDS Employees Freed From Iranian Prison

Joe Anderson

Perot Sends Christmas Meals To POWs In Hanoi

Shannon Mackenzie

President Perot?

Businessman Says He'll Run If He's Put On All 50 Ballots

Of course, Ross Perot has taken a tough look at many more issues. To learn about them, just call 1-800-685-7777 and talk to a Perot volunteer. But do it soon. Because like all rescue efforts, time is of the essence.

CITIZENS FOR PEROT FOR PRESIDENT

454

To Partake
In The Bizarre Ritual
Of Drowning Young Bears
In Boiling Water Before
Eating Their Meat,
The Natives Had To Travel
Hundreds Of Miles.

What Was
The Journey Like?

Not Bad. The Tour Bus Was Air Conditioned.

To anyone with a humane bone in his body, the brutal, insensitive act described on the previous page probably sounds like some sort of ancient tribal custom.

But it's not. It's a contemporary practice. And a quite popular one, as well.

This is how it came to be. Throughout parts of Asia, it's believed that bear parts, such as gall bladders, are aphrodisiacs. It's also thought that eating bear paws will bolster sexual prowess.

The result is a lucrative market for bear parts. In fact, a gram of a bear's dried gall blad-der fetches more money than a gram of cocaine. And just as with the drug market, fake products abound. So in order to assure that high-priced bear parts are authentic, buyers want them fresh.

Such craving inspired the creation of bear banquets, now popular among the rich. To attend them, tour parties travel all the way to Thailand from Korea and Taiwan to partake in a ceremony where, as an eye witness recalls, "young bears are slowly lowered into tanks of hot water and drowned while the guests look on.

"The bears know they're going to die, so they cry. A crying that lingers on and on." The guests, assured that their bear is authentic, eat its paws and flesh and take the gall bladder home to dry.

To keep these banquets going, populations of Asian bears, both sloth and black bears, are being slaughtered at a catastrophic rate.

Worse yet, an increased poaching of bears in the United States suggests that this continent's brown bears are feeding the excessive Asian demand.

The World Society for the Protection of Animals is hard at work to stop the slaughter of endangered bears.

To find out more, to make a contribution, or to become a member, contact WSPA at PO Box 190, Boston, MA 02130. Or please call us at (617) 522-7000.

World Society for the Protection of Animals

455

HOW MANY TIMES DO YOU HAVE TO BE REMINDED TO GET YOUR PET FIXED?

Every year, 14 million unwanted pets are destroyed. So please, spay or neuter your pets. And call 649-6168 by July 23 to sponsor a pet in our July 30 Adopt-A-Pet ad.

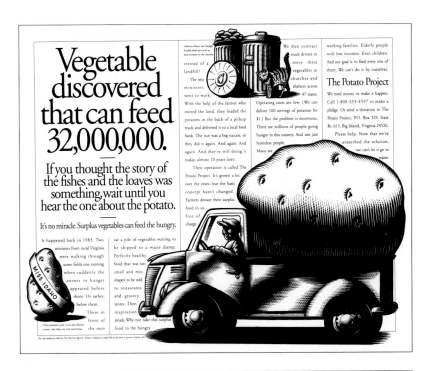

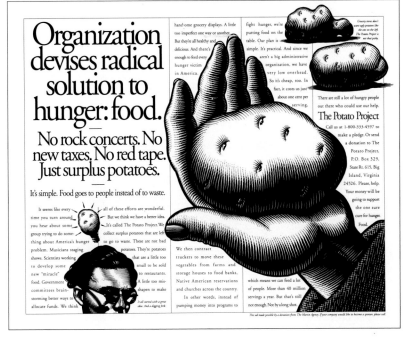

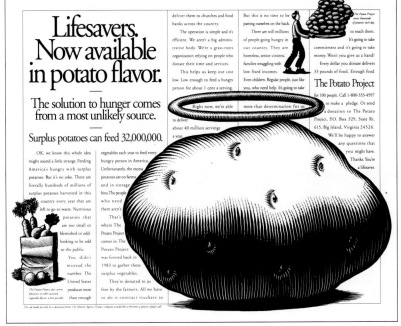

458
ART DIRECTORS
Mark Bell
Barton Landsman
WRITERS
Jeff Odiorne
Barton Landsman
PHOTOGRAPHER
Rainforest Action Network
CLIENT
Rainforest Action Network
AGENCY
Bait Tackle and an
Occasional Screenplay/
San Francisco

459
ART DIRECTORS
Dave Hernandez
Diana Barich
WRITER
Ann Coyle
CLIENT
The Children's Project
AGENCY
DDB Needham Worldwide/
Chicago

460
ART DIRECTOR
Steve Cardon
WRITER
Scott Hardy
CLIENT
Humane Society
of Utah
AGENCY
EvansGroup/Salt Lake City

461
ART DIRECTOR
Carol Henderson
WRITER
Doug de Grood
PHOTOGRAPHER
Jim Arndt
CLIENT
Children's Defense Fund
AGENCY
Fallon McElligott/
Minneapolis

462
ART DIRECTOR
Tom Routson
WRITER
Bob Kerstetter
PHOTOGRAPH
Stock
CLIENT
Amnesty International
AGENCY
Goodby Berlin &
Silverstein/San Francisco

Rapists usually operate in secluded places. Maybe that explains why Chevron is building a pipeline in the rainforest.

Chevron's new pipeline is threatening to destroy the rainforests of Papua, New Guinea. That's something to think about the next time you decide where to fill up your gas tank.

Rainforest Action Network
4 1 5 - 3 9 8 - 4 4 0 4

458

3200 SHELTERS FOR DOGS.

1200 SHELTERS FOR CHILDREN.

WHAT A COUNTRY.

In America, a stray dog's chances of finding shelter are three times better than those of a helpless, battered child. At what point did we lose our capacity for human decency? To help save our children, call 1-708-918-0303 THE CHILDREN'S PROJECT

459

A Stitch In Time Saves Nine.

LOW COST SPAY / NEUTER SURGERY.

HUMANE SOCIETY OF UTAH

460

REMEMBER THOSE HUNGRY KIDS IN CHINA? NOW THEY'RE IN OMAHA.

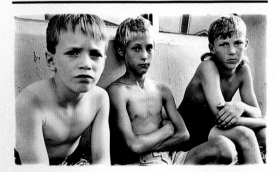

Currently, an estimated 5.5 million American kids don't regularly get enough to eat. Still for most people, the idea of hungry children is a foreign one. To join our campaign to Leave No Child Behind, call 1-800-CDF-1200. Kids can't vote. But you can. **THE CHILDREN'S DEFENSE FUND**

461

"Oh, I get it…they use _poisonous_ gas."

SOME PEOPLE have no idea what's happening in this country. The gas chamber is _still_ with us. The death penalty is _alive and well_. Wake up. Get involved. Nobody has the right to _kill_ another human being. **AMNESTY INTERNATIONAL**

462

463
ART DIRECTOR
Rohitash Rao
WRITER
Eric Silver
CLIENT
Greenpeace
AGENCY
Larsen Colby/Los Angeles

464
ART DIRECTOR
Hal Tench
WRITER
Joe Alexander
PHOTOGRAPH
Stock
CLIENT
Citizens for Perot for
President
AGENCY
The Martin Agency/
Richmond

465
ART DIRECTOR
Shari Hindman
WRITER
Raymond McKinney
ILLUSTRATOR
Mark Weakley
CLIENT
Society of
Saint Andrews
AGENCY
The Martin Agency/
Richmond

466
ART DIRECTORS
Chris Poulin
Dana Edwards
WRITER
Jonathan Plazonja
PHOTOGRAPHER
Jim Mason
CLIENT
C.E.A.S.E.
AGENCY
Two Hacks and a Mac/
Boston

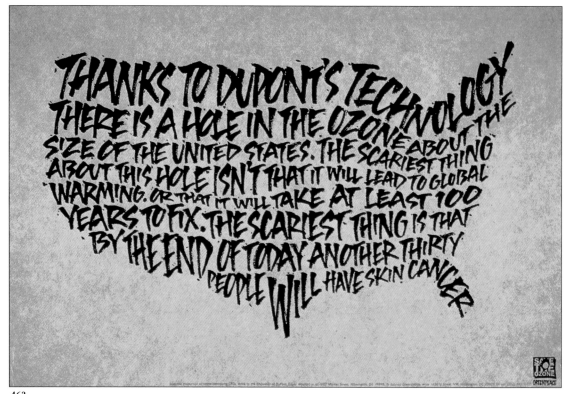

463

INEXPERIENCED. POLITICALLY NAIVE. AND HE DOESN'T REALLY WANT THE JOB. THE PERFECT CANDIDATE.

Representative democracy is really an agreement: citizens give up their power with the understanding that the officials they've elected will represent their concerns, ideas and values.

Easy, right? Wrong. These days, it seems most career politicians are more concerned with their own interests than the interests of their constituents.

"WE'VE GOT TO COMPLETELY RESTRUCTURE THE SYSTEM. COULD I SOUND BITE IT? NO, COULD SOLOMON SOUND BITE IT?"

Ross Perot isn't a career politician. In fact, he's never run for public office. He's a businessman who understands the problems facing the country. It's that simple. And that's why he's running for the presidency. Like many, he believes that the current political system is broken and can't address the problems of unemployment, violence, discrimination, taxes, the recession, or the deficit.

To change course, he believes people have to be lead once again in Washington. Not with a thousand points of light. Not with 17 point programs. Not with invisible promises. Ross Perot believes the only way we can address the issues is to confront them head-on with fresh solutions.

"IF YOU CAN'T STAND A LITTLE PAIN, WE'RE NEVER GOING TO STRAIGHTEN THIS COUNTRY OUT"

The budget deficit is Ross Perot's number one priority. For starters, he'd cut over $180 billion alone just by eliminating fraud, abuse and waste. Waste like taking Air Force 1 to golf outings. He believes another $100 billion could be cut simply by asking Germany and Japan to pay for U.S. troops in their countries.

Ross Perot also believes, for most politicians, raising taxes is like taking dope. After the initial euphoria, the same old problems still exist. That's why he proposes no new taxes, except in the case of a national emergency.

To get the economy moving, Ross Perot would take the shackles off American business. He'd like to see elected officials working side by side with businesspeople in an intelligent, supportive relationship.

Of course, these are just a few of Ross Perot's ideas. He has many more. About health care, abortion, and ethnic violence. Just call 1-800-685-7777 and talk to a Ross Perot volunteer to learn more, or to find out how you can help.

And if you get a recording, relax. It will be the only time you'll ever get a stock answer from Ross Perot.

CITIZENS FOR PEROT FOR PRESIDENT

464

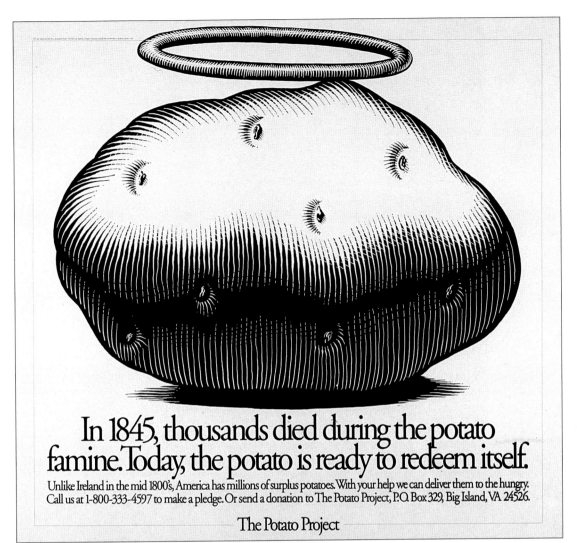

In 1845, thousands died during the potato famine. Today, the potato is ready to redeem itself.

Unlike Ireland in the mid 1800's, America has millions of surplus potatoes. With your help we can deliver them to the hungry. Call us at 1-800-333-4597 to make a pledge. Or send a donation to The Potato Project, P.O. Box 329, Big Island, VA 24526.

The Potato Project

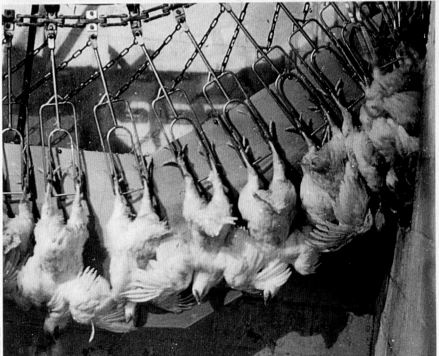

No wonder they say it takes a tough man to make a tender chicken.

These chickens aren't dead, but they will be shortly. For once they pass through that hole in the wall, they're going to be stunned, have their throats slit, and bled.

Ironically, however, killing may very well be the most humane thing poultry farmers do to their birds. How so?

Well, by nature, chickens are ranging, foraging animals. Like people, they need fresh air, sunshine and exercise to stay healthy. And they thrive best in small, social flocks.

But today's chickens aren't raised outdoors. Instead, they spend their brief lives in animal factories, where the health of bird and consumer alike takes a back seat to profits.

Here, as many as 75,000 birds are crammed into a huge, darkened building.

To reduce violence in such dangerously overcrowded conditions, the beaks of the baby chicks are seared off with a hot knife (a process so painful, that many just die of shock).

The birds live in the filthy, unchanged droppings that have accumulated from a number of previous flocks. The resulting concentration of excretory ammonia causes severe respiratory problems.

In addition, the chickens are genetically overweight, which causes other diseases.

At slaughterhouses, live chickens are hung upside down on conveyor lines. After they're killed, they are mechanically defeathered, disemboweled and processed.

The eviscerating machine often ruptures their intestines, spilling bacteria-laden feces into the carcasses. Then the birds—feces and all—are dumped into a refrigerated chiller that cools thousands of birds per hour.

To make matters worse, producers routinely salvage meat and parts from the pus-ridden carcasses of infected birds. Why not? It's profitable.

Not surprisingly, the FDA says that as much as 70% of all chicken sold to the public is contaminated with salmonella, campylobacter and other kinds of harmful bacteria.

Unfortunately, it is the relaxation of federal regulations that has allowed farmers to raise animals in these conditions, and meat packers to speed up their processing lines.

If reading this makes you queasy, call us at (617) 628-9030 to learn about the alternatives.

And the next time that some guy in a commercial tell you his chickens live better than people do, just remember.

You know better.

C E A S E

Citizens to End Animal Suffering And Exploitation, P.O. Box 44-136, Somerville, MA 02144

PUBLIC SERVICE/ POLITICAL TELEVISION: SINGLE

467
ART DIRECTOR
Lynn Farthing
WRITER
Tom Reilly
PRODUCTION COMPANY
Gootsan Komnenich Oakes Productions
DIRECTOR
John Komnenich
CLIENT
City of Evanston, IL/ Human Relations Commission
AGENCY
CME KHBB/Chicago

468
ART DIRECTOR
Michael Kadin
WRITER
Jim Garaventi
AGENCY PRODUCER
Jeannie Priest
PRODUCTION COMPANY
Dublin Productions
DIRECTOR
Rick Dublin
CLIENT
Izaak Walton League
AGENCY
Leonard Monahan Lubars & Kelly/Providence

469
ART DIRECTOR
Wendy Hanson
WRITER
Lyle Wedemeyer
AGENCY PRODUCER
Becky Keller
PRODUCTION COMPANY
Dublin Productions
DIRECTOR
Rick Dublin
CLIENT
Minnesota Department of Health
AGENCY
Martin/Williams, Minneapolis

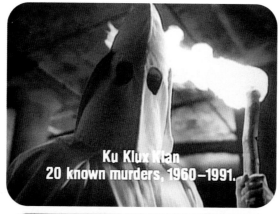

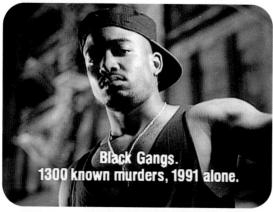

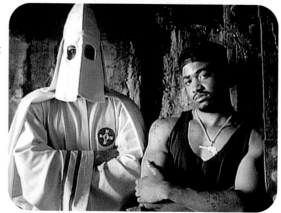

467
ANNCR: If they gave medals for killing black people, this gang would win the bronze.
SUPER: NEO-NAZIS. 12 KNOWN MURDERS, 1981-1991.
ANNCR: This gang the silver.
SUPER: KU KLUX KLAN. 20 KNOWN MURDERS, 1960-1991.
ANNCR: But this gang would win the gold.
SUPER: BLACK GANGS. 1300 KNOWN MURDERS, 1991 ALONE.
ANNCR: If you're in a gang, you're not a brother. You're a traitor.

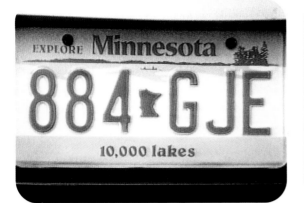

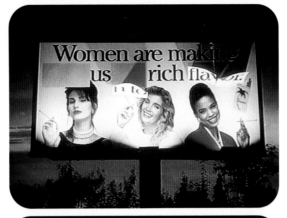

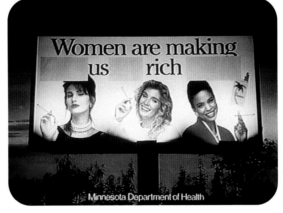

468

ANNCR: Leaky septic systems.

(SFX: NUMBERS SPINNING, STOPPING)

ANNCR: Fertilizer runoff.

(SFX: NUMBERS SPINNING, STOPPING)

ANNCR: Acid rain.

(SFX: NUMBERS SPINNING, STOPPING)

ANNCR: Minnesotans have to act today against the pollution that's killing our lakes.

(SFX: NUMBERS SPINNING, STOPPING)

ANNCR: Because if we don't stop it now, when will it stop?

(SFX: NUMBERS SPINNING)

SUPER: THE IZAAK WALTON LEAGUE.

469

(SFX: OUTDOOR SOUNDS)

ANNCR: Cigarette companies spend a lot of money on advertising to women. And on the surface, they make it all look so good.

(SFX: WIND NOISE)

ANNCR: But you have to ask yourself . . . what are their real intentions?

470
ART DIRECTOR
Wendy Hanson
WRITER
Lyle Wedemeyer
AGENCY PRODUCER
Becky Keller
PRODUCTION COMPANY
Dublin Productions
DIRECTOR
Rick Dublin
CLIENT
**Minnesota Department of
Health**
AGENCY
**Martin/Williams,
Minneapolis**

471
ART DIRECTORS
**Jon Terzis
Didier Cremieux
Jim Suhre**
WRITERS
**David DeSmith
David Shih**
AGENCY PRODUCER
Jenny Gooch
PRODUCTION COMPANY
Emerald Films
DIRECTOR
Jack Churchill
CLIENT
**Board of Elections/
City of New York**
AGENCY
Mezzina/Brown, New York

472
ART DIRECTOR
Chris Brunt
WRITER
Stephanie Gruber
AGENCY PRODUCER
Pat Douglass
PRODUCTION COMPANY
Woodshed
DIRECTOR
Chris Brunt
CLIENT
**Chicago Coalition for the
Homeless**
AGENCY
Woodshed/La Grange, IL

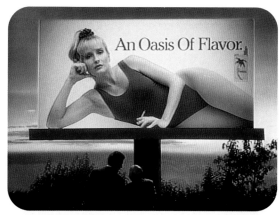

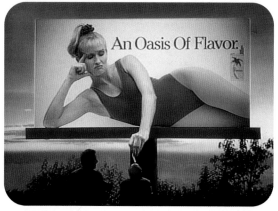

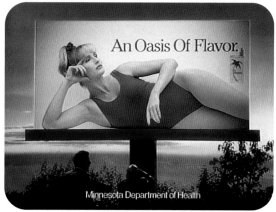

470
MAN 1: That's a great ad.
ANNCR: Women are a major target for cigarette company
 advertising.
MAN 2: It'll sell a lot of cigarettes for us.
ANNCR: Because cigarette companies count on making
 millions of dollars a year on women smokers.
MAN 1: Women will love it.
ANNCR: Maybe it's time women snuffed that idea out
 for good.

471

FISH MARKET WORKER: My name is Michael Michaels, and I live in Staten Island, New York.
(SFX: BUZZER)
MAN IN TIMES SQUARE: Melvin Williams, Brooklyn.
(SFX: BUZZER)
WOMAN IN GRAND CENTRAL STATION: Itilia Tyner, Bronx.
(SFX: BUZZER)
WOMAN AT UNION SQUARE CAFE: Sybil Tempshen, Manhattan.
(SFX: BUZZER)
SUPER: YOU DON'T COUNT.
MAN IN ASTORIA: Dennis Paris . . .
(SFX: BUZZER)
WOMAN IN CHINATOWN: Mini Hong, China . . .
(SFX: BUZZER)
SUPER: YOU DON'T COUNT.
WOMAN ON 16TH STREET: Evelyn . . .
(SFX: BUZZER)
MAN ON SUBWAY: Billy Col . . .
(SFX: BUZZER)
MAN IN FISH MARKET: Joe Cof . . .
(SFX: BUZZER)
SUPER: YOU DON"T COUNT . . .
MAN AT STATEN ISLAND FERRY TERMINAL: King Williams, homeless.
(SFX: BUZZER)
SUPER: IF YOU DON'T VOTE.
(SFX: SERIES OF BUZZERS)
SUPER: USE THE POWER. VOTE. FOR INFO CALL 212-VOTE-NYC.

472

SUPER: PAT DOUGLASS'S HOME.
SUPER: CHRIS BRUNT'S HOME.
SUPER: DON NELSON'S HOME.
SUPER: STEPHANIE GRUBER'S HOME.
SUPER: GORDON MEYER'S HOME.
SUPER: THE PRESIDENT'S HOME.
ANNCR: Over the last ten years, the government has cut aid to low-income housing by 77 percent. Amazing that a lot of people still don't get it.
SUPER: THE CHICAGO COALITION FOR THE HOMELESS.

PUBLIC SERVICE/ POLITICAL TELEVISION: SINGLE

473
ART DIRECTOR
Jim Mochnsky
WRITER
John Parlato
AGENCY PRODUCER
Sandy Mislang
PRODUCTION COMPANY
The Production Company
CLIENT
Enoch Pratt Free Library
AGENCY
W.B. Doner & Company/ Baltimore

PUBLIC SERVICE/ POLITICAL TELEVISION: CAMPAIGN

474
ART DIRECTOR
Tim Hannell
WRITER
Jim Noble
AGENCY PRODUCER
Jan Ushijima Frei
PRODUCTION COMPANY
Pelorus Films
DIRECTOR
Lol Creme
CLIENT
Lindsay Museum
AGENCY
Goldberg Moser O'Neill/ San Francisco

473
CLERK 1: Is this cash, check or charge?
SPOKESMAN: Oh, no. I just want to borrow them.
CLERK 1: Borrow them?
SPOKESMAN: Yeah, I don't want to pay for them. I just want to borrow them for a couple hours.
CLERK 1: We don't let people borrow books.
SPOKESMAN: I don't want to pay for them. I just want to borrow them.
CLERK 3: No, you can't borrow them.
SPOKESMAN: Please?
CLERK 3: You have to pay for them. Are you willing to pay for them?
SPOKESMAN: I just want to borrow your book.
LADY AT STATION: For what?
SPOKESMAN: To read it.
LADY: Why? I was reading it.
SPOKESMAN: Could I just borrow the one magazine.
CLERK 4: No.
SPOKESMAN: The paper?
CLERK 4: No.
SPOKESMAN: So, you're not going to let me borrow the book.
LADY AT STATION: That's right.
SPOKESMAN: So if I can't borrow it, could you at least sing to me "Flight of Icharis"?
CLERK 5: No.

SPOKESMAN: Could I borrow it from from you and then give it back to you?
MAN AT STATION: How long? I have a train to make.
SPOKESMAN: Two weeks.
MAN AT STATION: That's a little bit too long.
SPOKESMAN: I have to buy it.
CLERK 6: Yeah. It's a store.
SPOKESMAN: Hi. I just wanted to remind you if you wanted to borrow a book, a paper, a video or a recording, only one place lends them to you free. The Pratt Free Library. Hey, Free is their middle name. Of course, Library is their last name.

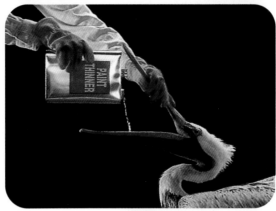

474

ANNCR: Last year, Americans dumped three million pounds of toxic chemicals down storm drains which lead directly to wildlife areas. Please don't feed the animals.
SUPER: CALL 1-800-LINDSAY FOR SOLUTIONS. THE LINDSAY MUSEUM.

RADIO FINALISTS

475
WRITERS
Kiki Kendrick
David Alberts
PRODUCTION COMPANY
Commercial Breaks
CLIENT
Hutchison
AGENCY
Chiat/Day, London

476
WRITERS
Arthur Bijur
Don Austen
AGENCY PRODUCER
Deed Meyer
PRODUCTION COMPANY
Clacks Recording
CLIENT
Little Caesar Enterprises
AGENCY
Cliff Freeman & Partners/
New York

477
WRITERS
Molly Ivins
Steve Wright
AGENCY PRODUCER
Steve Wright
PRODUCTION COMPANY
Big Fish Films
CLIENT
Fort Worth
Star-Telegram
AGENCY
Dally Advertising/
Fort Worth

478
WRITER
Jan Pettit
AGENCY PRODUCERS
Jan Pettit
Scott Mackey
CLIENT
Virginia Lottery
AGENCY
Earle Palmer Brown/
Norfolk

475
ANNCR: When Hutchison Telecom, the new name in personal communications, asked me to talk to the man in the street, the obvious thing to do was to start ringing public phones.
(SFX: PHONE RINGING)
CYCLE COURIER: Hello.
ANNCR: You're a difficult man to pin down, I've been trying for days.
CYCLE COURIER: No mate, you've got the wrong bloke.
ANNCR: I don't think I have, do you have a mobile phone?
CYCLE COURIER: Yeh, mate, I'm a cycle courier. I just picked up the phone.
ANNCR: Do you have a telephone on your bike?
CYCLE COURIER: No, I don't.
ANNCR: How are you contactable?
CYCLE COURIER: I'm contactable by my beeper!
ANNCR: You have a beeper?
CYCLE COURIER: Yes.
ANNCR: We're talking bingo.
(SFX: PHONE RINGS)
INDIAN MAN: Hello, you are in a phone box.
ANNCR: That's right.
INDIAN MAN: There is nobody here.
ANNCR: There is, you're there.
INDIAN MAN: Hello.
(SFX: PHONE RINGS)
LIVERPOOL MAN: Hello.
ANNCR: Hello, can you help me please?
LIVERPOOL MAN: Err . . . this is a public phone box you're ringing.
ANNCR: Slow down, slow down, you have a funny voice.
LIVERPOOL MAN: It's my Liverpool accent.
ANNCR: Listen. I need your help. Can I contact you on a pager?
LIVERPOOL MAN: On a what?
(SFX: PHONE RINGS)
ANNCR: What were you expecting when you picked up the phone?
YOUNG WOMAN: Wrong number probably. Ha ha ha.
ANNCR: You can pick up a phone at Hutchison Telecom's new store in the Arndale Centre.
(SFX: PHONE RINGS)
CHINESE MAN: You've got a long number.
ANNCR: I've got a very long number.

476
ROGER: The human mind responds to good news with happy thoughts. To demonstrate, Phil here . .
BILL: It's Bill . . .
ROGER: . . . is strapped in a chair with a galvanic skin response helmet on his head . . .
(SFX: BUZZ)
BILL: Listen, the helmet's buzzing.
ROGER: I'm tightening up the chin strap and body restraints.
(SFX: CREAKY LEATHER BELTS)
BILL: The chin strap's too tight . . .
ROGER: Are you thinking happy thoughts, Phil?
BILL: No, not right now . . .
ROGER: Good . . . now if the helmet senses happy thoughts, this bell will ring . . .
(SFX: DING)
ROGER: Followed by a brief electric shock . . .
BILL: What . . . ?
ROGER: Let's begin. Inga . . .
SWEDISH WOMAN: I love you, Phil.
BILL: Mmmm . . .
(SFX: DING)
(SFX: ELECTRIC JOLT)
BILL: Aagh!!!
ROGER: Good, it's working.
(SFX: WHIMPERS)
ROGER: Listen carefully, Phil—now at Little Caesar's, you can get Toozy Doozy.
BILL: Toozy Doozy . . .
ROGER: Two pizzas with cheese and pepperoni . . .
Bill: Pepperoni . . .
ROGER: For only $5.99!!
BILL: $5.99
(SFX: DING)
(SFX: ELECTRIC JOLT)
BILL: Aaaaaagghh!!! . . .
ROGER: You like Little Caesar's, Phil?!?
BILL: Uh, yes . . .
(SFX: DING)
(SFX: ELECTRIC JOLT)
BILL: Mmmmmgggghhhhhh . . .
ROGER: Two pizzas for $5.99, Phil!!
(SFX: DING)
(SFX: ELECTRIC JOLT)
BILL: Whoaaaaaaa!
ROGER: $5.99. It's shocking, isn't it?!
SWEDISH WOMAN: I love you, Phil.
(SFX: SEVERAL DINGS AND ELECTRICAL JOLTS)
BILL: Whhaaaaahhhhh!!! . . .

477
MOLLY: Jimmy Maddox is a politician so mean, he wouldn't spit in your ear if your brain were on fire. I remember when he—
(SFX: CENSOR'S BLEEP)
MOLLY: Well, I guess I finally gave up on Gib the day he asked the crippled people to stand and—
(SFX: CENSOR'S BLEEP)
MOLLY: I myself am not anti-gun, I'm pro-knife. And knives really have a lot to be said for them. In the first place you have to catch somebody before you can stab him, and I think that would promote physical fit—
(SFX: CENSOR'S BLEEP)
MOLLY: I get a lot of mail from people in the National Rifle Association, most of it comes on Big Chief Tablets written in red crayons. Bunch of fascist gun nuts with sex hang—
(SFX: CENSOR'S BLEEP)
ANNCR: Starting Sunday, March first, you'll see something in the Fort Worth Star-Telegram you'll never hear on radio, Molly Ivins . . . uncensored. To subscribe, dial DELIVER or call 1-800-776-STAR.
MOLLY: Anyone out there who was ever saved from drugs by Nancy Reagan, please raise his hand.

478
INTERVIEWER: Today we're talking with Dave Haycox of Luck International. Tell us about your company, Dave.
DAVE: Well Tom, we're the exclusive distributors of more than 500 luck products. Here's a catalog.
INTERVIEWER: So you sell crystals, charms, amulets . . .
DAVE: The turkey wishbone amulet is very nice. An extraordinary value at $29.99.
INTERVIEWER: Thirty bucks for a bone on a string?
DAVE: Leatherette thong, Tom. Read the description.
INTERVIEWER: So Dave, how did you get into luck distribution?
DAVE: Actually, a home luck party. I ordered the Luck bath gelee . . . page 32. I was hooked.
INTERVIEWER: So, what are your big sellers, Dave?
DAVE: Well, the four-leaf clover suspended in lucite . . . page 19, the lucky-seven bath mat and this.
INTERVIEWER: A Virginia lottery ticket?
DAVE: Not just any lottery ticket, this is Instant Luck. You scratch the play area; if your charm has a match, you win. Up to four times per ticket, up to a thousand dollars. At $4.99, it's an exceptional value.
INTERVIEWER: It's an even better value down the street for a buck, Dave.
DAVE: Someone else is selling Instant Luck tickets?
INTERVIEWER: A few thousand places, uh huh.
DAVE: Well, you haven't seen any of these bones on a string, have you?
ANNCR: Chances of winning, 1 in 4.26.

479

(SFX: COMPUTERIZED "BING")

VOICE: Welcome to your computerized dictionary. You have requested explanations of common basketball expressions.

(SFX: COMPUTERIZED "BING")

VOICE: The "lay-up" . . . a simple shot taken from beneath the basket.
The "air ball" . . . to miss both the backboard and the rim completely.
"Gorilla jam" . . . a delicacy in South America usually eaten on sliced bread.

(VOICE BEGINS TO SPEED UP)

"Crash the boards" . . . to attend a law school exam, uninvited.
"Pump fake" . . . the act of pulling into the full service lane at the gas station when you really want self service.
"Full court press" . . . to lift a judge and twelve jurors over your head.
"Shot at the buzzer" . . .

ANNCR: If you want basketball information from people who really know the game, try the *Star Tribune*. Complete Timberwolves recaps. In-depth interviews. Player profiles. And more.

VOICE: "Three pointers" . . . a famous sister singing act whose hits include, "I'm So Excited," "Jump," "Fire."

481

ANNCR: Today's round table discussion opens with a letter from one Bob Larson of Menlo Park who writes, "Round Table's new BBQ Chicken Pizza sounds unusual, well I like it." Well, Bob, let's do it like the pros and call a random consumer.

(SFX: PUSH BUTTON PHONE)

ANNCR: I'm dialing at random now.

(SFX: SOUND OF TAPE PLAYER BEING STARTED)

TAPED CONSUMER: Hello.

(SFX: TAPE PLAYER BUTTON PUSHED)

ANNCR: Hello. I'm calling for Round Table Pizza and have we ever spoken?

TAPED CONSUMER: I have no idea who you are.

(SFX: TAPE PLAYER BUTTON PUSHED)

ANNCR: Good. I'd like to describe Round Table's new BBQ Chicken Pizza.

(SFX: TAPE PLAYER BUTTON PUSHED)

TAPED CONSUMER: Okay.

ANNCR: Good.

TAPED CONSUMER: Strips of barbecue . . .

(SFX: TAPE PLAYER BUTTON PUSHED)

ANNCR: Instead of tomato sauce they use a tangy barbecue sauce on fresh crust, blend of three cheeses, topped with scallions, red onions and marinated . . .

TOGETHER: . . . strips of barbecue chicken . . .

ANNCR: How does that sound, Mr. Random Consumer?

(SFX: TAPE PLAYER PUSHED AND BIG BAND MUSIC COMES ON, TAPE PLAYER STOPPED THEN REWOUND)

CONSUMER: Strips of barbecue chicken? Sounds great. I'll try it.

ANNCR: There you have it, Mr. Larson. We've proved to you that Round Table's BBQ Chicken Pizza is great. If a consumer chosen completely at random will try it, why not you? Get real, sir. Get Round Table.

480

(MUSIC: THROUGHOUT)

VOICE: You're eating beans, your forehead is slightly sunburnt, and you've never been happier. You're dancing in $7 shoes, your wife just bought her favorite perfume, and you already forgot your boss's name. Watching a little jai alai, all excited because you actually saw the ball this time, just a couple more games before you go back to your room. Your sombrero's big enough to swim in, you're thumb-wrestling a shrimp bigger than your hand, and you just saw Aztec dancers do the deer dance ballet. You must be in Tijuana.

ANNCR: Mention Tijuana and your brain thinks, "fun." So why not call us and we'll send you maybe the coolest city guide you've ever seen. Call 1-800-255-5555.

482

ANNCR: Lately, there have been several alarming reports about the CIA's deteriorating ability to access vital news and data in advance of other sources. One obvious way to rectify the situation would be for the new CIA director to recruit individuals with ample experience retrieving, analyzing and disseminating information before others even get close. However, it is with deep regret that we inform Washington that the 22 full-time reporters at *Crain's New York Business* are extremely happy in their current jobs.

CONSUMER RADIO: SINGLE

479
WRITER
Dean Buckhorn
AGENCY PRODUCER
Kathy Jydstrup
CLIENT
Star Tribune
AGENCY
Fallon McElligott/ Minneapolis

480
WRITERS
Keith Klein
Rick Casteel
AGENCY PRODUCER
Amy Krause
CLIENT
Tijuana Tourism
AGENCY
Franklin Stoorza/San Diego

481
WRITERS
Jeff Odiorne
Craig Wiese
AGENCY PRODUCER
Marguerite Meuris
PRODUCTION COMPANY
Craig Wiese & Company
CLIENT
Round Table Franchise Corporation
AGENCY
Goldberg Moser O'Neill/ San Francisco

482
WRITER
Dean Hacohen
AGENCY PRODUCER
Dean Hacohen
CLIENT
Crain's New York Business
AGENCY
Goldsmith/Jeffrey, New York

CONSUMER RADIO: SINGLE

483

WRITER
Erica Horstmeyer
AGENCY PRODUCER
Judy Haruki
CLIENT
Center Theatre Group
AGENCY
Larsen Colby/Los Angeles

484

WRITERS
David Shane
George Logothetis
AGENCY PRODUCER
David Shane
PRODUCTION COMPANY
Are These My Shoes? Productions
CLIENT
Zebra Books
AGENCY
Mad Dogs & Englishmen/ New York

485

WRITER
Joe Alexander
AGENCY PRODUCER
Pam Campagnoli
CLIENT
Mercedes-Benz
AGENCY
The Martin Agency/ Richmond

486

WRITER
Joe Alexander
AGENCY PRODUCER
Julie Basham-Smith
CLIENT
The Richmond Symphony
AGENCY
The Martin Agency/ Richmond

483

MAN: Repeat after me . . . shmooze. Shh-mooze. Shmooze. I'm shmoozing. You're a shmoozer. Let's go shmmooze.
ANNCR: If you want to go to a big opening night party, you'll need to pick up a couple of phrases.
MAN: Ciao. Beeg kiiissses. Ciao. Repeat after me: Beeg kiiisses . . .
ANNCR: Or, you could pick up a couple of tickets to Terrence McNally's hilarious comedy, *It's Only A Play.*
MAN: Let's do lunch. We should do lunch. "Do lunch" is a popular verb.
ANNCR: It's just like being at an opening night party, but all you have to do is listen.
MAN: Love ya babe . . . don't ever change.
ANNCR: Don't miss Terrence McNally's *It's Only A Play,* directed by John Tillinger at the Doolittle Theatre.
MAN: When greeting others, kiss the air, not their cheeks. Pucker your lips and say "mwoowa." Repeat after me: "Mwoowa."
ANNCR: Buy tickets now at all Ticketmaster Ticket Centers. Or call 213-365-3500. And find out how everyone really acts after the curtain goes down.

485

WOMAN (READING SLOWLY): My name is Phyllis. I'm visually impaired. But when it comes to describing the advantages of Mercedes-Benz 300 E 4MATIC traction, I have a big advantage over you. You see, when I read Braille, just like I am now, I feel the page with my fingertips. I can go fast and still sense every word without making a mistake. That's the way 4MATIC works. It's an all-wheel-drive system that's designed to read road conditions electronically. It can tell the difference between a tire that's slipping and one that isn't the same way I can tell the difference between a colon and a semi-colon. So, in slippery conditions, 4MATIC gives you more control. In fact, you can almost say 4MATIC understands. And take it from me, understanding is just about as important as seeing.
ANNCR: Test-drive the 300 E 4MATIC today.

484

WOMAN: So I'm waiting at the bus stop and I'm reading Janelle Taylor's new romance from Zebra books called *Midnight Secrets,* and I'm thinking if only she could script my life . . .
(MUSIC: DREAMY HARP)
WOMAN: How different it would be.
(SFX: AMBIENT STREET NOISE, BUS PULLS UP, DOORS SWING OPEN)
BUS DRIVER (IN TARZAN VOICE): Get in.
WOMAN: But . . .
BUS DRIVER: Get in.
WOMAN: Uh, okay.
BUS DRIVER: Sit down.
WOMAN: W-where?
BUS DRIVER: Here.
WOMAN: On your loincloth?
BUS DRIVER: Sit down.
(SFX: DOORS CLOSE, BUS PULLS OUT)
WOMAN: Who are you?
BUS DRIVER: I am Thonga, half-breed son of Mongo the elder.
WOMAN: Where are you from?
BUS DRIVER: Where wind meets water.
WOMAN: Wow.
BUS DRIVER: We go there now in iron horse.
WOMAN: But my family . . .
BUS DRIVER: We make new one. Thonga seed strong.
ANNCR: Zebra Romances. They're just like life, only interesting.
WOMAN: Thonga?
BUS DRIVER: Shut up.

486

(MUSIC: HANDEL'S "HALLELUJAH" THROUGHOUT)
ANNCR: Laundry detergents. Imitation Bacon Bits. Wood epoxy. Diet soda. Fax machines. Flea and tick collars. Over the years, advertisers have used this music in their commercials to sell just about everything. We at The Richmond Symphony thought it was time somebody used it for the product it was intended to sell. Handel's "Messiah." December 6, 3:00 p.m. Call 782-3900 for tickets.

487

GUY: Wanna keep Californians from moving to Portland? Change the street names. Lovejoy, for example. It's too warm, too welcoming. And Yamhill. Conjures up images of sweet potatoes rolling down gently sloping streets. Why no names that capture true Portland living? Like "Torrential Downpour" Drive, "High State Income Taxes" Lane. Or, "We Have No Pro-Football Team And We're Very Bitter About It" Road. The second problem is Nike Town. Who wouldn't move to Portland when they can shop next to a life-like statue of Bo Jackson? Or choose from the newest and widest selection of merchandise in an ever-changing retail environment? You're sending out the wrong message, Portland. Stop looking so content. Let the shoulders sag a bit. Trust me, you'll be much happier. Nike Town on Sixth and Salmon. Yeah.

488

(MUSIC: THROUGHOUT)
DONALD SUTHERLAND: It was a Saturday and Joe was in the bar with Eddie. But Eddie wasn't necessarily with Joe. He was staring deeply into his glass of Beamish. He fancied he saw the girl with the dark, ebony-colored hair. And the moonlight skin. And the wild, wild eyes. But in no time at all, like the Beamish, she was gone. "She was beautiful," said Eddie quietly. "Buy me a Beamish then," Joe said, "so I can have a look too."
ANNCR: Beamish Stout. Easy going, easy gone.

489

(SFX: CHATTERING TEETH)
ANNCR: Today's Round Table discussion comes to us from a Mrs. Susan Berry of Weaverville. She knows, like millions of others, that Round Table uses fresh dough instead of frozen dough. But she writes, simply, "Why?"—a fair question. Clearly, the only possible way on earth for me to illustrate this is to float around Antarctica on an iceberg.
So here I am on an iceburg. And my teeth are chattering. I said my teeth are chattering. Brrr. It's cold. These are roughly the temperatures other pizza places freeze their dough. In other words, their dough is frozen, this iceburg is frozen, thus, their pizza must taste like this iceberg. So I'll just press my tongue against this iceberg. There, now which would you rather have, Mrs. Berry? A pizza made with dough that's frozen like this iceberg I'm stuck to . . .
(SFX: SUCTION POP SOUND)
ANNCR: Ouch. That really hurts when you pull your tongue off an iceberg like that . . . or a hot and steamy Round Table Pizza made with fresh dough. Get Real. Get Round Table. Get me off this iceberg.

490

(MUSIC: RAVEL'S "BOLERO" PERFORMED ON KAZOO THROUGHOUT)
ANNCR: Deciding to feature an unusual instrument with our symphony orchestra was easy. Finding the right one wasn't. Until we found Paul Cohen and his saxophone and we booked him for two nights with The Richmond Symphony, November 16 and 18. Of course, a sax playing a concerto isn't nearly as unusual as a kazoo playing "Bolero." But then again, what is? The Richmond Symphony. For tickets, call 788-1212.

491

SALESMAN: Welcome to Ed Kelly's, sir.
MAN: Yes, I understand that if I watch a Home Theater demonstration, I can get a free high-grade VCR tape.
SALESMAN: That's right. Here, let me strap you in.
(SFX: CLICK)
SALESMAN: Let's say you're watching . . . oh, I don't know . . . auto racing!!!
(SFX: AUTO RACING)
MAN: Whoa!
SALESMAN: Down a mountain!!!
(SFX: WIND & SNOW)
SALESMAN: With planes trying to shoot you as you sit in your chair!!!
(SFX: PLANES & EXPLOSIONS)
MAN: Alright!! That's right!! That's enough!!!! Stop it!!! This is too real.
SALESMAN: But we just started.
MAN: Tell that to my underwear, buddy!
ANNCR: Experience Home Theater with Surround Sound and get a free high-grade VCR tape only at Ed Kelly's. The home theater experts.

CONSUMER RADIO: SINGLE

487
WRITER
Jamie Barrett
AGENCY PRODUCER
Jennifer Smieja
CLIENT
Nike Town
AGENCY
Wieden & Kennedy/ Portland

488
WRITERS
Anita Davis
Paul Domenet
AGENCY PRODUCER
Lucy Westmore
CLIENT
Courage-Beamish
AGENCY
Young & Rubicam/London

CONSUMER RADIO: CAMPAIGN

489
WRITERS
Jeff Odiorne
Craig Wiese
AGENCY PRODUCER
Marguerite Meuris
PRODUCTION COMPANY
Craig Wiese & Company
CLIENT
Round Table Franchise Corporation
AGENCY
Goldberg Moser O'Neill/ San Francisco

490
WRITER
Joe Alexander
AGENCY PRODUCERS
Morty Baron
Pam Campagnoli
CLIENT
The Richmond Symphony
AGENCY
The Martin Agency/ Richmond

491
WRITER
Lonnie Hicks
AGENCY PRODUCER
Sara March Barber
PRODUCTION COMPANY
Videofonics
CLIENT
Ed Kelly's
AGENCY
Trone Advertising/ Greensboro, NC

492

ART DIRECTOR
Bill Boch

WRITER
Ron Lawner

AGENCY PRODUCER
Marge Sullivan

PRODUCTION COMPANY
Propaganda Films

DIRECTOR
David Kellogg

CLIENT
Kinney Shoes

AGENCY
**Arnold Fortuna Lawner
& Cabot/Boston**

493

ART DIRECTOR
Susan Westre

WRITER
Chris Wall

AGENCY PRODUCER
Barbara Mullins

PRODUCTION COMPANY
Pytka Productions

DIRECTOR
Joe Pytka

CLIENT
Apple Computers

AGENCY
BBDO/New York

494

ART DIRECTOR
Michael Fazende

WRITER
Mike Lescarbeau

AGENCY PRODUCER
Judy Brink

PRODUCTION COMPANY
A&R Group

DIRECTOR
Tarsem

CLIENT
The Lee Company

AGENCY
**Fallon McElligott/
Minneapolis**

495

ART DIRECTOR
Michael Fazende

WRITER
Mike Lescarbeau

AGENCY PRODUCER
Judy Brink

PRODUCTION COMPANY
A&R Group

DIRECTOR
Tarsem

CLIENT
The Lee Company

AGENCY
**Fallon McElligott/
Minneapolis**

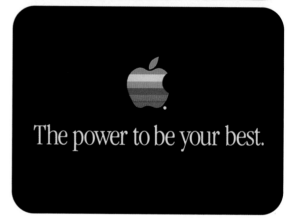

492

(MUSIC: THROUGHOUT)
CLOTHING RETAILER: We only carry black.
ANNCR: There is no deceit in black.
TWIN 1: What is black?
ANNCR: Black is the true absence of color. There is no color in black.
CLOTHING RETAILER: Because black is black.
SUPER: THAT'S WHY HE MAKES THE BIG BUCKS.
CLOTHING RETAILER: Forget black, everything brown.
TWIN 2: Brown?
SUPER: BROWN.
COSMETICS CLERK: I don't think brown is your color.
DESIGNER 3: Green.
DESIGNER 4: Red.
CLOTHING RETAILER: White.
ANNCR: Now the latest fashion from Paris, Milan, Funabashi.
SUPER: WHERE?
WOMAN 1: I got this hand-painted number at this great little shop. You know the one down the alley. I think it used to be a slaughterhouse.
SUPER: SLAUGHTERHOUSE?
WOMAN 2: You won't believe where I got these shoes.
SUPER: KINNEY. THAT'S RIGHT KINNEY.
DESIGNER: Fashion is . . . it's what you do . . . it's where you go.
SUPER: HEY, FASHION IS WHERE YOU FIND IT.

493

SAM: Using the text editor open to system INI file . . .
DON: You mean the system INI file . . .
SAM: Type the dire command to see how much space is available: C-colon-backslash-windows-backslash-system . . .
DON: Finder 386.
MYRA: Need any help?
SAM & DON: No!!
SAM: 386 ENH section. The device command in this example sets up the H-I-M-E-M DOT SYS device driver.
DON: I did something wrong.
SAM: What?
DON: We're back in DOS.
SAM: If you're printing to the LPT1, try printing to the LPT1 DOT DOS file instead.
DON: Oops!!!!
SAM: What?
DON: What did I do?
SAM: I don't know . . .
DON: Page 99 . . .
MYRA: What are you guys doing? You've been fooling with that thing for three days now.
DON: Making it easy to use.
SAM: So we'll be more productive.
MYRA: If you're this productive much longer, we'll go out of business.
ANNCR: If you want a computer that's easy to use, there's still only one way to go.
SUPER: APPLE. APPLE MACINTOSH.
SUPER: APPLE. THE POWER TO BE YOUR BEST.

494

MAN: Some days I wake up in the morning and it's just
bad vibes. No way, I'm not working today.
Hey, can't we get any cold water over here?
Of course I'm a perfectionist, look at me. I'm a
professional model.
Twice I've asked for cold water.
What's my most attractive part? Some women,
ya know, like my eyebrows, ya know? They're real
thick. A lot of women like my lips. I haven't met a
woman who doesn't like my body. I think you get a
complete package, ya know. I look good in jeans.
How's my hair doing? I mean anyone looks good in
jeans, but I look tough in jeans. I think in a past life I
might have been that Joe Louis guy. Cause I'm a real
good boxer. Lightening quick speed. Two years
I was champ.
I like astronomy and space.
That's supposed to be a martian? It looks like a little
kid in a silver sock. Apollo 10 come on in. One step
for mankind.
This is the third time I've asked for cold water.
Thank you.
Martians would think I was cool.
I think when I'm done modeling I'm gonna be
an astronaut.
This bottle is leaking.

495

WOMAN: I'm a model, but that doesn't mean other girls
should be jealous. I mean it's hard work staying perfect.
(SFX: CLOCK GONG)
WOMAN: For whom the bell tolls.
I wanna be an actress. I want to play the life of
Mother Theresa.
Aahhh!
My goals? To end violence throughout the world, and
find a really easy-to-manage hairstyle.
I love dogs. I love little small ones that you can take
to work with you. You walk in with your dog leash
and you look very cool. You look very chic.
I love spending money. Spend, spend, spend, spend,
spend.
Um, ah, a cappucino.
I look good in jeans, but most everybody looks good
in jeans, but I look perfect.
You know if mascara is not important, how come
there's a rear view mirror in every car?
I don't like reading books. I think that it's very boring
and if it's work I mean, reading, then make it into a movie.
Excuse me but I'd like an espresso.
You can't be a model your whole life. I mean it's not
like oh, my brain hurts, but . . . you can't eat anything.
Cellulite is not my cup of tea.
Speaking of tea, where's my waiter?
Can I change my order?
(SFX: DOG GROWLING)

496
(MUSIC: "FRAUD SQUAD" THEME)
ANNCR: Fraud Squad!
ANNCR: Tonight's Episode: "Smell my whispie nightie."
NIELSEN: Yes?
JOCKEY: Two cones, please.
NIELSEN: A hot tip led Sergeant Dohray and me to Ascot . . .
We mingled unobtrusively for a while before dividing forces. Dohray checked the horse boxes. I checked the restaurant.
DOHRAY: Okay, come on out, you're surrounded.
TANNOY: Starters orders.
NIELSEN: I'll have the Mediterranean prawns.
TANNOY: They're off.
NIELSEN: Okay, I'll have the asparagus then.
TANNOY: Fifty to one. Bar!
NIELSEN: That bar sounds crowded Sergeant.
NIELSEN: What's this?
BARMAID: Just cider.
NIELSEN: That's not just cider. Fraud Squad! Hey, you over there, in the shadows. This is Red Rock draught cider. It's less gassy with no aftertaste. It's different kind of cider. I'm afraid I'm going to have to ask you to accompany me.
NIELSEN & HANK (SINGING): *This is Red Rock draught cider. Less gassy, no strong aftertaste. It's a different kind of ci-der der der der der der.*
NIELSEN: Okay Dohray, take her down to the station.
DOHRAY: Right Chief.
(SFX: TRAIN WHISTLE)
ANNCR: Red Rock Cider. It's not red and there's no rocks in it.

497
SHE: Honey, I really think that was the exit back there.
HE: Don't worry, honey, I know exactly where we're going.
SHE: Okay, but I don't want to be late. You did call Chuck and get the directions, right?
HE: Will you relax? It's just up here another mile or so.
SHE: I'd feel a whole lot more comfortable if we could just call and double check the directions.
HE: Look, I know exactly where we are, okay? I am not going to get us lost.
SHE: Look, will you stop and ask this guy for directions.
ANNCR: The new Isuzu Trooper has been completely redesigned.
HE: Okay, this is looking real familiar.
ANNCR: To include everything from a new suspension and powerful V6 engine, right down to the smallest detail . . . like, his and her map lights.

498

JUDY: Dear Saturn team members who are building my car, my name is Judith Reusswig. And I'm a third-grade teacher. Last week, I placed an order for a Saturn SL2. After reading the *Time* magazine article and seeing them around town, I had decided my new car would be a Saturn. I liked the whole idea of what Saturn was about. It's one of those things I try to instill in my kids. So I hope it's true. It reminded me a little bit of a mom and pop operation in the old days where you made a car for this person. And this person was happy with the car they got. I wanted you to know you are building that Saturn with the blue-green exterior and gray interior for me. And so you know who I am, I'm enclosing my school picture. I'm looking forward to my new car. I'm sure if everything I've read is true, I won't be disappointed.

499

VICTOR: You'll never take us alive!

LENNY: Victor, before we go out there, I gotta say one thing.

VICTOR: What's that?

LENNY: I like you.

VICTOR: Yeah, I like you too, Lenny.

LENNY: I mean I really appreciate all the little things you've done for me.

VICTOR: Oh yeah.

LENNY: You're a very special person in my life, Victor.

VICTOR: I am?

LENNY: Yes.

VICTOR: What is a friend? Lenny, I had no idea . . . this is beautiful.

LENNY: I guess I'm not gonna have time to buy you a gift.

500
ART DIRECTOR
Bob Shallcross
WRITER
Jim Ferguson
AGENCY PRODUCER
Glant Cohen
PRODUCTION COMPANY
Steve & Linda Horn
DIRECTOR
Steve Horn
CLIENT
McDonald's
AGENCY
**Leo Burnett Company/
Chicago**

501
ART DIRECTORS
**Rick Boyko
Debby Lucke**
WRITER
Michael Ward
AGENCY PRODUCER
Ed Kleban
PRODUCTION COMPANY
Lovinger/Cohn & Associates
DIRECTOR
Jeff Lovinger
CLIENT
American Express
AGENCY
Ogilvy & Mather/New York

502
ART DIRECTORS
**Rick Boyko
Debby Lucke**
WRITER
Michael Ward
AGENCY PRODUCER
Ed Kleban
PRODUCTION COMPANY
Lovinger/Cohn & Associates
DIRECTOR
Jeff Lovinger
CLIENT
American Express
AGENCY
Ogilvy & Mather/New York

503
ART DIRECTOR
Charlie Herbstreith
WRITER
Alan Blum
AGENCY PRODUCER
Amy Shore
DIRECTOR
Herve Lachize
CLIENT
Air France
AGENCY
**TBWA Advertising/
New York**

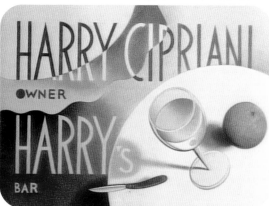

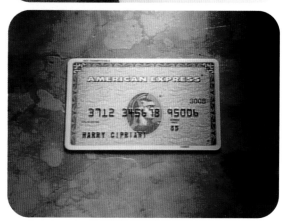

500
CHEERLEADERS: Tony, Tony he's our man, if he can't do it, Bob can. Steve, Steve he's our man, if he can't do it . . .
COACH: A great man once said, "Winning, gentleman, isn't everything . . . it's the only thing."
KID: Look, a grasshopper.
COACH: Remember . . . I formation, 34 sweep, on two. Got it? . . . Give the ball to Matt and tell him to run towards his daddy. Got it?
ANNCR: It starts every September with teams like the Turkey Creek Hawks, the Bronx Eagles and the Newport Richie Giants. On fields where dads weren't only coaches, and oak trees marked the endzones. And a good day wasn't determined by if you won or lost, but where you went after the game. So McDonald's would like to salute the players, the coaches, the families, everyone who helped make this season a perfect season.
KID: Can we go to McDonald's now coach?
COACH: After the game, Linnie. This is only halftime. Now go sit down.

501
HARRY CIPRIANI: I think I'm the only man in the world to be named after a bar—Harry's Bar in Venice. My father, Giuseppe, opened for business in 1931. In all my life, all I know has been told to me by watching my father. He was a man that never gave importance to money. He gave importance to the customers. He gave importance to the business. Because he knew that the money would come after that. My mother didn't agree very much, but there he was. We now have two restaurants in Venice and two restaurants in New York. My world ends at my door. I believe that people that appreciate a place like this are inclined to visit more places and to see more of the world. I think having the card, the world becomes smaller.
ANNCR: American Express is welcomed at Harry's Bar and just about anywhere else Harry's been.

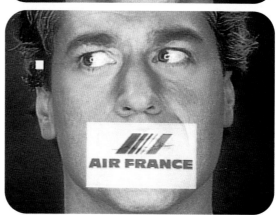

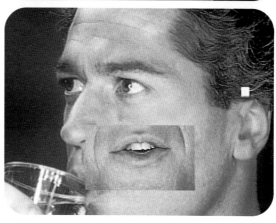

502

TED BALESTRERI: The Sardine Factory is one of the oldest restaurants on Cannery Row. It was a condemned old building on the wrong side of the tracks. I pretty much worked the front of the house; my partner worked the back of the house. We didn't have any money but we had a real thirst for this business. We built a loyal customer that has stayed with us through all the different fads. And we never advertised home-cooked meals because if we couldn't do a better job than the house, then why would they bother coming out? You have to be creative. You have to try new dishes. You gotta experiment. The sure way to fail is don't do anything—play it safe. I think American Express customers overall are by far the higher profile customer for fine dining, second to none. I've been a member since 1962, one of the originals I think.

ANNCR: American Express is welcomed at the Sardine Factory and other fishy places.

503

(SFX: TENNIS SOUNDS)

ANNCR: Okay, imagine it's the French Open Tennis Championship, the final round, you've got the top player in the world on one side, the number two seed on the other . . . and there you are following the action on this little box in your living room . . . little tiny players whacking a ball that's barely visible to the naked eye. Not exactly like being there. Which is why you should enter the 1992 French Open Sweepstakes. If you win, you'll get two roundtrip first-class tickets from New York to Paris and seven days' accomodations courtesy of Air France. Tickets to the men's and women's finals, courtesy of ESPN. And, a year's supply of Evian Natural Spring Water from the French Alps. To enter, send your name, address and phone number to 1992 French Open Sweepstakes, P.O. Box 790, Madison Square Station, New York, New York, 10159. It's worth entering. Anything's better than being glued to the TV.

(SFX: CROWD APPLAUSE)

**CONSUMER TELEVISION
OVER :30 (:45/:60/:90)
SINGLE**

504
ART DIRECTOR
Darryl McDonald
WRITER
Jim Riswold
AGENCY PRODUCER
Donna Portaro
PRODUCTION COMPANY
Pytka Productions
DIRECTOR
Joe Pytka
CLIENT
Nike
AGENCY
**Wieden & Kennedy/
Portland**

**CONSUMER TELEVISION
OVER :30 (:45/:60/:90)
CAMPAIGN**

505
ART DIRECTORS
**Charlie McQuilkin
Keith Goldberg**
WRITERS
**Keith Goldberg
Charlie McQuilkin
Peter Angelos**
AGENCY PRODUCERS
**Dan Barbieri
Andrew Schulze**
PRODUCTION COMPANY
Stripes
DIRECTORS
**Dan Barbieri
Charlie McQuilkin
Keith Goldberg**
CLIENT
**Toronto Ford/
Lincoln-Mercury Dealers**
AGENCY
**Young & Rubicam/
San Francisco**

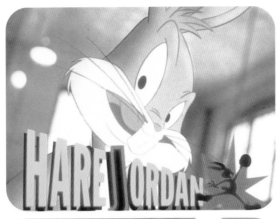

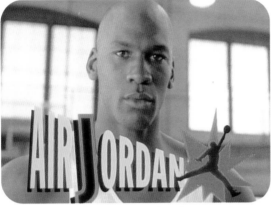

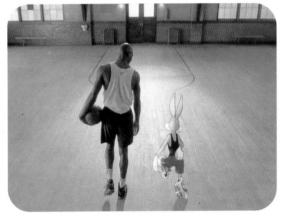

504
BUGS: Can't a rabbit get any sleep around here?
What's all the racket?
Eh, what's up . . . Jock?
YEEEOOWW! Gruesome, ain't it? YEEOOWW!
Of course you know this means war.
Hare Jordan . . . and Air Jordan.
JORDAN: Who'd you expect? Elmer Fudd?
BUGS: Yoo-hooz!
(SFX: PLAYERS WHISTLE)
BUGS: Nice shorts.
(SFX: BIRDS CHIRPING)
'BUGS: This could be the beginning of a
beautiful friendship!
(MUSIC: CLASSIC "LOONEY TUNES" THEME)
JORDAN: That's all folks!
PORKY PIG: Hey, That's my line!

505

INTERVIEWER: Excuse me sir. Sir, how ya doing, what's your name?

ZAMBONIE DRIVER: Redhead.

INTERVIEWER: Head, what do you do for a living?

ZAMBONIE: Drive the Zambonie here . . .

INTERVIEWER: You drive the Zambonie.

ZAMBONIE: Yup.

INTERVIEWER: Have you ever driven a Ford Explorer?

ZAMBONIE: No, I haven't.

INTERVIEWER: Well, we thought we'd get you to take it for a test drive because you seem to be an expert on how things handle on the ice.

ZAMBONIE: Yeah.

INTERVIEWER: Now do you have independent suspension on this?

ZAMBONIE: No, we don't.

INTERVIEWER: You've got shift on the fly though don't you?

ZAMBONIE: No.

INTERVIEWER: You've got a radio?

ZAMBONIE: No radio.

INTERVIEWER: So you just sing do you? What's your favorite song?

ZAMBONIE: I like "Fly me to the Moon" from Frank Sinatra.

INTERVIEWER: Oh can we hear a bit of it?

ZAMBONIE: I don't really . . . you know I just . . . I'm a . . .

INTERVIEWER: Come on, I'll lead you in

(SINGS) *Fly me . . .*

ZAMBONIE AND INTERVIEWER (SINGING): . . . *to the moon . . . and we can play amongst the stars.*

INTERVIEWER: So how's she feel?

ZAMBONIE: Feels great, handles great. Better than the Zambonie.

INTERVIEWER: Is that right?

ZAMBONIE: Really hugs those corners. Four-wheel drive really kicks in nice.

INTERVIEWER: All right let's speed this thing up and then try the breaks. Whaddya' think?

ZAMBONIE: Okay, let's give it a shot. Gee that's fantastic, eh? If it does that on the ice like this could you imagine what it does on the roads of Toronto?

INTERVIEWER: Take a look at us now.

ZAMBONIE AND INTERVIEWER (SINGING): *Fly me to the moon*

CONSUMER TELEVISION
:30/:25 SINGLE

506
ART DIRECTOR
Jonathan Teo
WRITER
Danny Searle
AGENCY PRODUCER
Kerry Widin
PRODUCTION COMPANY
Film Graphics
ANIMATION
Arthur Filoy
CLIENT
Australian Consolidated Press
AGENCY
The Campaign Palace/ Melbourne, Australia

507
ART DIRECTOR
Jeff Terwilliger
WRITER
Tom Gabriel
AGENCY PRODUCER
LuAnn Truso
PRODUCTION COMPANY
James Production
DIRECTOR
Denny Carlson
CLIENT
Minnesota State Lottery
AGENCY
Carmichael Lynch/ Minneapolis

508
ART DIRECTOR
Gill Witt
WRITER
George Logothetis
AGENCY PRODUCER
Amy Saunders
PRODUCTION COMPANY
Johns + Gorman Films
DIRECTOR
Jeff Gorman
CLIENT
Reebok
AGENCY
Chiat/Day, New York

509
ART DIRECTOR
Bill Schwab
WRITER
Dick Sittig
AGENCY PRODUCERS
Peter Cline
Diane Rowell
PRODUCTION COMPANY
Johns + Gorman Films
DIRECTOR
Gary Johns
CLIENT
Reebok
AGENCY
Chiat/Day, New York

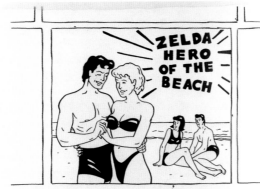

506
GIRL: Hey! Quit kicking sand in our faces.
BOYFRIEND: Hey!
SHOW-OFF: Listen here, I might rip that towel off and show everyone your hideous body.
GIRL: Show-off!
BOYFRIEND: Don't let it bother you.
GIRL: Darn it. I'm sick of being soft and flabby. The 100-page *Cleo* Beauty Book will get me ready for summer.
SUPER: LATER.
BOYFRIEND: Boy, that didn't take long.
GIRL: Hey, here's something I owe you.
SHOW-OFF: Arghh!
BOYFRIEND: Oh Zelda, you are a real woman after all.
SUPER: HERO OF THE BEACH.
ANNCR: The *Cleo* Summer Beauty Book. Free with October *Cleo*.

507
(MUSIC: "SCRATCH AND RIFF")
(SFX: GLASS BREAKING)
(SFX: CRACK OF BAT, CLUNK OF BOUNCING BALL)
ANNCR: Now you can play baseball anytime, any place . . . with the new instant game from The Minnesota State Lottery. Scratch off nine innings, add 'em up and beat the other team's score to win up to $9,000. That should give you all the excitement you can handle.

508

DAN: Now that I've got some free time, I'm helping Dave train. Faster, Dave! Push it!

Dave's wearing the new Reebok Running Crosstrainer. It's the first crosstrainer designed for running.

Come on Dave, faster!

After he's done with his sprints he's gonna climb stairs and then hit the weight room.

Come on Dave, pick it up. He's gonna have to work harder than that if he wants to win the gold.

Just kidding, Dave.

SUPER: LIFE IS SHORT.

SUPER: PLAY HARD.

SUPER: REEBOK.

509

DAN: Dave doesn't know about this, but Reebok gave me this top secret running . . .

DAVE: . . . shoe. It's called the Pump GraphLite. This arch design makes them very light, supportive, and I have . . .

DAN: . . . the only pair in existence. They won't be available to the public until . . .

DAVE: . . . spring, but I get special treatment because Reebok . . .

DAN: . . . really wants me to win . . .

DAVE: . . . in Barcelona.

DAVE: Heh, heh, heh.

DAN: Heh, heh, heh.

(SFX: PUMP)

(SFX: PUMP)

SUPER: TO BE SETTLED IN BARCELONA.

ANNCR: To be settled in Barcelona.

SUPER: LIFE IS SHORT.

SUPER: PLAY HARD.

SUPER: REEBOK.

CONSUMER TELEVISION :30/:25 SINGLE

510
ART DIRECTOR
Chris Hooper
WRITER
Scott Vincent
AGENCY PRODUCER
David Verhoef
PRODUCTION COMPANY
Pittman Hensley
DIRECTORS
Chris Hooper
Scott Vincent
David Verhoef
Donna Pittman
Mark Hensley
CLIENT
TV Guide
AGENCY
Chiat/Day, Venice, CA

511
ART DIRECTOR
Randy Hughes
WRITER
Jerry Fury
AGENCY PRODUCER
Jenee Schmidt
PRODUCTION COMPANY
Wilson-Griak
DIRECTOR
Steve Griak
CLIENT
Malt-O-Meal
AGENCY
**Clarity Coverdale Rueff/
Minneapolis**

512
ART DIRECTOR
Jac Coverdale
WRITER
Josh Denberg
AGENCY PRODUCER
Jenee Schmidt
PRODUCTION COMPANY
Wilson-Griak
DIRECTOR
Greg Winter
CLIENT
United Recovery Center
AGENCY
**Clarity Coverdale Rueff/
Minneapolis**

513
ART DIRECTOR
Steve Callen
WRITER
Steve Callen
AGENCY PRODUCER
Julee Callen
PRODUCTION COMPANY
Anifex
PHOTOGRAPHER
Richard Chataway
DIRECTOR
Michael Cusack
CLIENT
**Lotteries Commission of
South Australia**
AGENCY
**Clemenger Adelaide/
Eastwood, Australia**

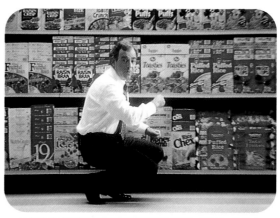

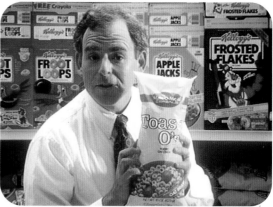

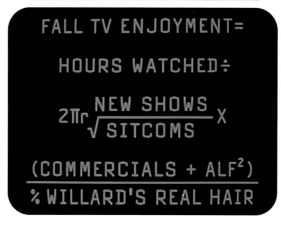

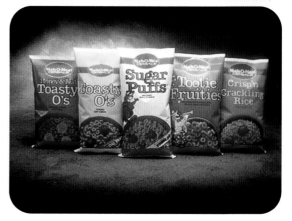

510
TV: Hey, it's me again. Your TV. You know, the new fall shows are coming. Now you can find out which ones you're gonna like using this simple equation . . .
SUPER:

FALL TV ENJOYMENT=

HOURS WATCHED÷

$2\pi r \sqrt{\dfrac{\text{NEW SHOWS}}{\text{SITCOMS}}}$ X

$\dfrac{(\text{COMMERCIALS} + \text{ALF}^2)}{\%\ \text{WILLARD'S REAL HAIR}}$

TV: Hmmm . . . or you can pick up *TV Guide*, cause the Fall Preview issue has the scoop on all the new shows. So you'll definitely find something you like. And we have a better time together. You know, I don't wanna scare you, but one minor miscalculation, and you could end up watching something like this. I wouldn't risk it. Don't watch TV in the dark.
SUPER: TV GUIDE.
SUPER: $e=mc^2$

511
(MUSIC: THROUGHOUT)
SPOKESMAN: Ya know, when you're shopping for cereal, I suggest you walk this way. Because it keeps the expensive cereals out of reach and puts you in a better position to find Malt-o-Meal cereals. You see, they're usually down here . . . well, in a bag and yet they're every bit as good as these, see? And they usually costs about a dollar less. A dollar!
ANNCR: Malt-o-Meal. The savings are in the bag.
SPOKESMAN: You really ought to come down here.

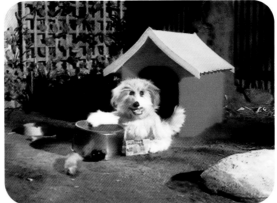

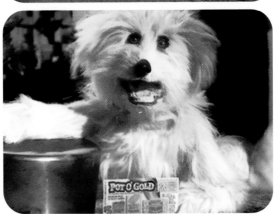

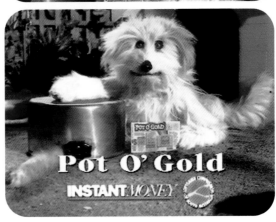

512

(MUSIC: "TEAR IN MY BEER" BY HANK WILLIAMS SR.)

HANK WILLIAMS (SINGING): *I'm gonna keep drinkin' until I'm petrified. And then maybe these tears would leave my eyes.*

SUPER: HANK WILLIAMS SR. WROTE THIS SONG AT THE AGE OF 28.

HANK WILLIAMS (SINGING): *There's a tear in my beer cause I'm crying for you dear, you were on my lonely mind.*

SUPER: ONE YEAR LATER, HE DIED OF ALCOHOLISM.

SUPER: IF SOMEONE YOU CARE ABOUT HAS A PROBLEM WITH ALCOHOL.

SUPER: SINGING ABOUT IT WON'T HELP.

SUPER: TALKING ABOUT IT JUST MIGHT.

SUPER: UNITED RECOVERY CENTER. 780-5900.

513

FRANK: Well the Lotteries Commission have finally got it right. A new instant money game that every dog and his man can play. It's called Pot of Cat. Pot of Cat is an exciting new game where $5 gives you four chances to win up to $250,000. Sorry? Are you sure? It's called Pot O' Gold?

(SFX: MEOW)

FRANK: Oh look, if you have to scratch . . . scratch some cash. Here kitty, kitty, kitty.

CONSUMER TELEVISION :30/:25 SINGLE

514
ART DIRECTOR
Donna Weinheim
WRITERS
Cliff Freeman
Arthur Bijur
AGENCY PRODUCER
Melanie Klein
PRODUCTION COMPANY
Crossroads Films
DIRECTOR
Mark Story
CLIENT
Little Caesar Enterprises
AGENCY
Cliff Freeman & Partners/ New York

515
ART DIRECTOR
Bruce Hurwit
WRITERS
Cliff Freeman
Arthur Bijur
Jeff Alphin
AGENCY PRODUCER
Anne Kurtzman
PRODUCTION COMPANY
Harmony Pictures
DIRECTOR
Charles Wittenmeier
CLIENT
Little Caesar Enterprises
AGENCY
Cliff Freeman & Partners/ New York

516
ART DIRECTORS
Donna Weinheim
Cliff Freeman
WRITERS
Cliff Freeman
Donna Weinheim
AGENCY PRODUCER
Melanie Klein
PRODUCTION COMPANY
Crossroads Films
DIRECTOR
Mark Story
CLIENT
Little Caesar Enterprises
AGENCY
Cliff Freeman & Partners/ New York

517
ART DIRECTOR
Ken Grimshaw
WRITER
John Donnelly
AGENCY PRODUCER
Clare Hunter
PRODUCTION COMPANY
Saunders Milburn-Foster
DIRECTOR
Mike Milburn-Foster
CLIENT
Pentax
AGENCY
CME KHBB/London

514
ANNCR: This is crazy!
MAN OWNER: They never . . . they don't seem to . . .
WOMAN OWNER: There's no chemistry.
DOG PSYCHOLOGIST: Ah, I understand. Now Billy, we must ask ourselves the basic question. Do you find Lucille attractive?
Oh, we have got some problem here.
ANNCR: This is Crazy! Crazy! Two pizzas with any topping, two free crazy breads, two free soft drinks all for $7.98 at Little Caesars.
LITTLE CAESAR'S: Pizza! Pizza!

515
ANNCR: Wouldn't it be great to have X-ray vision?
(SFX: WHISTLE)
COACH: Men, you've come here today dressed for battle.
TEENAGER: Boy!! You've got a lot of pepperoni in your bread!
ANNCR: Get Little Caesar's new Pepperoni Bread . . . and two pizzas with extra pepperoni for $7.98.
LITTLE CAESAR: Pizza! Pizza!
ANNCR: And get free Chocolate! Chocolate!

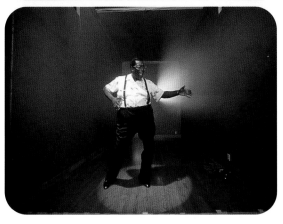

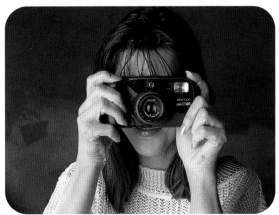

516

ANNCR: Upon learning Little Caesar's is offering two
pizzas for $5.99 . . .

(SFX: OLD PROJECTOR CLICKING)

ANNCR: . . . the mind enters five stages . . .
shock . . . disbelief . . . confusion . . .

(SFX: SHOES STOMPING ON FLOOR)

ANNCR: . . . denial . . . and . . . finally, acceptance . . .

(MUSIC: 1930s STYLE)

ANNCR: Now let's watch the subject registering denial
again in extreme slow motion. Two medium pizzas
with cheese and pepperoni or your favorite topping . . .

(SFX: OLD PROJECTOR CLICKING)

ANNCR: All for $5.99. It's a Toozy Doozy of a deal.

LITTLE CAESAR: TOOZY! DOOZY!

517

ANNCR: Under conditions like these the Pentax
WeatherZoom doesn't break . . . it snaps.

CONSUMER TELEVISION
:30/:25 SINGLE

518
ART DIRECTOR
Dan Willey
WRITER
Gary Topolewski
AGENCY PRODUCER
John Van Osdol
PRODUCTION COMPANY
Sandbank & Partners
DIRECTOR
Jeff Zwart
CLIENT
Chrysler Corporation
AGENCY
CME KHBB/Southfield, MI

519
ART DIRECTOR
Scott O'Leary
WRITERS
Bob Powers
John Krueger
AGENCY PRODUCER
John Seaton
PRODUCTION COMPANY
Dennis Manarchy Films
DIRECTOR
Dennis Manarchy
CLIENT
Anheuser-Busch/
Budweiser
AGENCY
D'Arcy Masius Benton
& Bowles/St. Louis

520
ART DIRECTOR
David Angelo
WRITER
Paul Spencer
AGENCY PRODUCER
Eric Herrmann
PRODUCTION COMPANY
Limelight Productions
DIRECTOR
John Lloyd
CLIENT
New York State Lottery
AGENCY
DDB Needham Worldwide/
New York

521
ART DIRECTOR
Ty Harper
WRITER
Rob Schapiro
AGENCY PRODUCER
Frank Soukup
PRODUCTION COMPANY
Slavin Schaffer Films
DIRECTOR
Neal Slavin
CLIENT
Water Country USA
AGENCY
Earle Palmer Brown/
Richmond

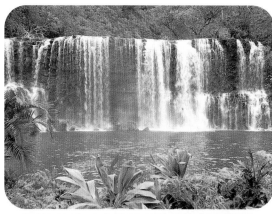

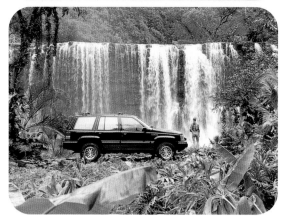

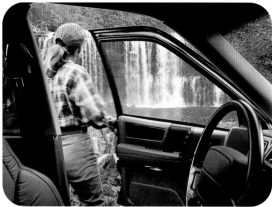

518
(SFX: SLIGHT WATERFALL SOUND)
(SFX: RAGING WATERFALL)
(SFX: SLAM OF DOOR, THEN SLIGHT WATERFALL SOUND)
(SFX: RAGING WATERFALL)
SUPER: THE NEW JEEP GRAND CHEROKEE.

519
(SFX: BACKGROUND SOUND OF A SPORTING EVENT)
(SFX: FOOTSTEPS, REFRIGERATOR DOOR OPENING, BOTTLE
OPENING, POURING INTO GLASS)

520

MUSIC: THROUGHOUT

WOMAN: This is Bradford Manor. Ah, notice the 19th century Italian marble.
This is the Bradford armory, the finest collection of its kind in North America.
This is the Bradford library. Fifty-thousand volumes, all extremely rare. And this is the Bradford living room. Ahh! and these are the Bradfords.

MR. BRADFORD: Hey, how ya doin? Grab a chair, we got a million of them.

ANNCR: New York Lotto. Hey, you never know.

521

(SFX: INSECT-HUMMING NOISE OF VERY HOT DAY)

(SFX: SQUEAK OF SWEATY LEGS STICKING ON A SLIDE)

ANNCR: It's gonna be a long summer.

BOY: Mom-m-m.

SUPER: WATER COUNTRY USA.

ANNCR: Take the kids to Water Country USA.

522
ART DIRECTOR
Michael Fazende
WRITER
Mike Lescarbeau
AGENCY PRODUCER
Judy Brink
PRODUCTION COMPANY
Park Village Productions
DIRECTOR
Roger Woodburn
CLIENT
The Lee Company
AGENCY
Fallon McElligott/
Minneapolis

523
ART DIRECTOR
Michael Fazende
WRITER
Mike Lescarbeau
AGENCY PRODUCER
Judy Brink
PRODUCTION COMPANY
Park Village Productions
DIRECTOR
Roger Woodburn
CLIENT
The Lee Company
AGENCY
Fallon McElligott/
Minneapolis

524
ART DIRECTOR
Michael Fazende
WRITER
Mike Lescarbeau
AGENCY PRODUCER
Judy Brink
PRODUCTION COMPANY
A&R Group
DIRECTOR
Tarsem
CLIENT
The Lee Company
AGENCY
Fallon McElligott/
Minneapolis

525
ART DIRECTOR
Michael Fazende
WRITER
Mike Lescarbeau
AGENCY PRODUCER
Judy Brink
PRODUCTION COMPANY
Park Village Productions
DIRECTOR
Roger Woodburn
CLIENT
The Lee Company
AGENCY
Fallon McElligott/
Minneapolis

 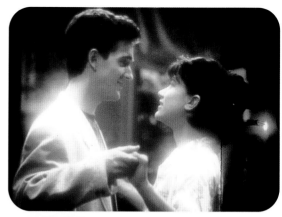

 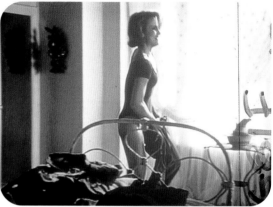

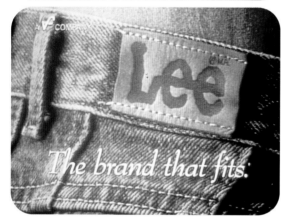 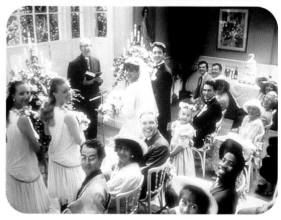

522
ANNCR: When most jeans makers look at women, they
 see men.
GUY 1 (WOMAN'S VOICE): I need jeans with a little more
 room in the hips.
ANNCR: Why else would they keep trying to sell men's
 jeans to women?
GUY 2 (WOMAN'S VOICE): More snug in the waist.
GUY 3 (WOMAN'S VOICE): I like a looser fit in the thighs.
GUY 4 (WOMAN'S VOICE): I need jeans designed for
 a woman.
ANNCR: At Lee we make jeans that fit the unique contours
 of a woman's body. Lee Relaxed Jeans.
SUPER: LEE, THE BRAND THAT FITS.

523
WOMAN: I'll be right down . . . oh, that's my roommate.
ROOMMATE: Hi.
ANNCR: Does it take you too long to find jeans that fit?
 Get the jeans that fit the first time. Relaxed Fit Jeans,
 from Lee.

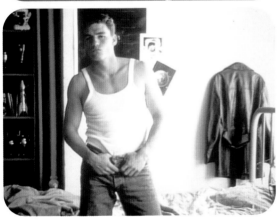

524

MAN: It's funny, 'cause I never have a bad hair day, ya
know?
Hello! I need to speak to my agent. I am not wearing
this.
I gotta wear a space suit?
Look at me, I'm a professional model and you won't
be able to see my body.
How's my hair doin'?
I don't need an education. Not with this face. I mean
anyone looks good in jeans, but I look tough in jeans.
I like space, ya know. Apollo 10 come in. One step
for mankind.

SUPER: LOOK LIKE A MODEL.

MAN: Martians would think I'm cool.

(SFX: CROWD CHEERING)

SUPER: DON'T THINK LIKE ONE.

MAN: I think when I'm done modeling, I'm gonna be
an astronaut.

SUPER: LEE BASIC JEANS.

(SFX: COMPUTER SPACE NOISE)

525

(SFX: BACKGROUND TV NOISE)

(SFX: "BANG" OF BUTTON FLYING OFF)

(SFX: COWBOY MOVIE "RICOCHETS")

ANNCR: Need a little more room in your jeans? Try
Relaxed Fit Jeans, from Lee.

SUPER: THE BRAND THAT FITS.

526
ART DIRECTOR
Bob Brihn
WRITER
Phil Hanft
AGENCY PRODUCER
Char Loving
PRODUCTION COMPANY
Young & Company
DIRECTOR
Eric Young
CLIENT
Time Magazine
AGENCY
**Fallon McElligott/
Minneapolis**

527
ART DIRECTOR
Bob Brihn
WRITER
Phil Hanft
AGENCY PRODUCER
Char Loving
PRODUCTION COMPANY
Young & Company
DIRECTOR
Eric Young
CLIENT
Time Magazine
AGENCY
**Fallon McElligott/
Minneapolis**

528
ART DIRECTOR
Bob Brihn
WRITER
Phil Hanft
AGENCY PRODUCER
Char Loving
PRODUCTION COMPANY
Young & Company
DIRECTOR
Eric Young
CLIENT
Time Magazine
AGENCY
**Fallon McElligott/
Minneapolis**

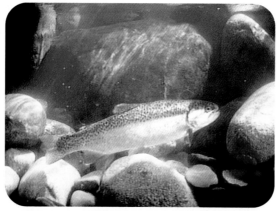

526
(SFX: TOILET FLUSH).
ANNCR: As the water of the Colorado River goes . . . so
go the Western states . . . and as the Western states go . .
(SFX: TOILET FLUSH)
ANNCR: So goes the country. We just thought you'd like
to know. The Colorado. . . . If it's important to you,
you'll find it in *Time.*
SUPER: TIME.

ABORTION IS MURDER.

ABORTION IS A CONSTITUTIONAL RIGHT.

ABORTION

527

(MUSIC: DRAMATIC)

(SFX: GUNFIRE)

ANNCR: More than 12,000 innocent people have died. Tens of thousands are missing and wounded. Millions have been forced to flee their homes. It seems, despite the fall of communism . . . Yugoslavia is more red than ever. Can anyone stop the killing? If it's important to you, you'll find it in *Time*.

SUPER: TIME.

528

SUPER: ABORTION IS A MORTAL SIN.

SUPER: ABORTION IS BETWEEN A WOMAN AND HER DOCTOR.

SUPER: ABORTION IS MURDER.

SUPER: ABORTION IS A CONSTITUTIONAL RIGHT.

ANNCR: No matter which side of the abortion issue you're on, we've got news for you.

SUPER: ABORTION IS NOT AVAILABLE IN 83% of the U.S.

ANNCR: It may already be decided. Why *Roe v. Wade* is moot. If it's important to you, you'll find it in *Time*.

SUPER: TIME.

**CONSUMER TELEVISION
:30/:25 SINGLE**

529
ART DIRECTORS
**Sal DeVito
Gerard Vaglio**
WRITER
Brian Wright
AGENCY PRODUCER
Pat Quaglino
DIRECTOR
Phil Marco
CLIENT
Daffy's
AGENCY
**Follis DeVito Verdi/
New York**

530
ART DIRECTOR
Leslie Caldwell
WRITER
Mike Koelker
AGENCY PRODUCER
Anna Frost
PRODUCTION COMPANY
Pytka Productions
DIRECTOR
Joe Pytka
CLIENT
Levi Strauss & Company
AGENCY
**Foote Cone & Belding/
San Francisco**

531
ART DIRECTOR
Corey Stolberg
WRITER
Tim Price
AGENCY PRODUCER
Jim Phox
PRODUCTION COMPANY
Schofield Films
DIRECTOR
Stan Schofield
CLIENT
Armor All
AGENCY
**Foote Cone & Belding/
San Francisco**

529
(SFX: SEXY SAXAPHONE MUSIC THROUGHOUT)
ANNCR: At $79 it's sexy. At $320 it's obscene.
SUPER: WOMEN'S DESIGNER CLOTHING. 40-75%
OFF EVERY DAY.
SUPER: DAFFY'S. CLOTHES THAT WILL MAKE YOU,
NOT BREAK YOU.

530

(MUSIC: THROUGHOUT)

ANNCR: Blue. A color that reached for the sky. And got it. Dignified. Versatile. Always proper. Blue. The color of choice. For every ocean . . . and Royal Navy. And nobody does blue . . . like Dockers.

531

ANNCR: If you thought Banana George Blair had found the fountain of youth . . .

GEORGE: I'm seventy-seven and still barefooting.

ANNCR: You'd be half right. Because the one he's found is actually for his car. With a little Armor All Protectant, George restores the beauty of his dashboard and seats. And in minutes it helps protect his tires from fading and aging.

GEORGE: It keeps my car looking almost as good as me.

ANNCR: There is a fountain of youth and we own the patent. Armor All.

**CONSUMER TELEVISION
:30/:25 SINGLE**

532
ART DIRECTOR
Jeff Eamer
WRITER
Michael O'Reilly
AGENCY PRODUCER
Louise Blouin
PRODUCTION COMPANY
Imported Artists
DIRECTOR
Richard D'Alessio
CLIENT
Fisons Consumer Health
AGENCY
Franklin Dallas/Toronto

533
ART DIRECTORS
John Butler
Mike Shine
WRITERS
Mike Shine
John Butler
AGENCY PRODUCER
Shelley Predovich
PRODUCTION COMPANY
American Artists
Commercial Production
DIRECTOR
Barry Sonnenfeld
CLIENT
American Isuzu Motors
AGENCY
Goodby Berlin &
Silverstein/San Francisco

534
ART DIRECTOR
Jeremy Postaer
WRITER
Steve Simpson
AGENCY PRODUCER
Ben Latimer
PRODUCTION COMPANY
In-House
DIRECTORS
Steve Simpson
Jeremy Postaer
CLIENT
Chevys Mexican Restaurants
AGENCY
Goodby Berlin &
Silverstein/San Francisco

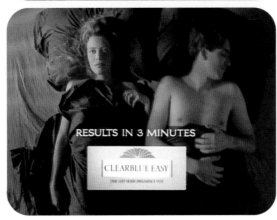

532
(SFX: MAN'S CONTENTED SIGH)
(SFX: RUSTLING OF SHEETS)
ANNCR: There is now a home pregnancy test that takes
 as long to work as it can take to perform the act of
 lovemaking itself.
SUPER: CLEARBLUE EASY. 99% ACCURATE. 100%
 EASIER TO DO.
(SFX: MAN BEGINS SNORING)

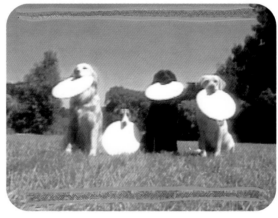

533

(MUSIC: 1960s STYLE)

ANNCR: They say our personality traits are formed at an early age.

(MUSIC: SPEEDY ROCK)

ANNCR: Presenting the 3.1 liter, V6 Rodeo from Isuzu. After all, growing up does have its rewards.

SUPER: ISUZU. PRACTICALLY AMAZING.

534

(MUSIC: THROUGHOUT)

(SFX: DOGS BARKING)

ANNCR: It's incredible, but true. Some restaurants use pre-packaged tortillas.

SUPER: UGH!

ANNCR: And while you wouldn't wanna eat them, they are good for some things.

SUPER: YIKES.

ANNCR: At Chevys we make all of our food fresh everyday. In fact, we make our tortillas fresh every 53 seconds. So Chevys tortillas never become hard or aerodynamic. Hey, you can't please everybody.

SUPER: CHEVYS FRESH MEX.

CONSUMER TELEVISION
:30/:25 SINGLE

535
ART DIRECTOR
Steve Stone
WRITER
Bob Kerstetter
AGENCY PRODUCER
Debbie King
PRODUCTION COMPANY
HKM Productions
DIRECTOR
Michael Karbelnikoff
CLIENT
Norwegian Cruise Line
AGENCY
Goodby Berlin &
Silverstein/San Francisco

536
ART DIRECTOR
Roy Grace
WRITER
Diane Rothschild
AGENCY PRODUCER
Rosemary Barre
PRODUCTION COMPANIES
Stonecutters
Carl Furuta
DIRECTOR
Carl Furuta
CLIENT
Land Rover North America
AGENCY
Grace & Rothschild/
New York

537
ART DIRECTOR
Craig Hadorn
WRITER
Dory Toft
AGENCY PRODUCER
Shelley Winfrey
PRODUCTION COMPANIES
Alpha Video
Steve Lawson Recording
CLIENT
The Museum of Flight
AGENCY
Livingston & Company/
Seattle

535
(MUSIC: "I'M GETTING SENTIMENTAL OVER YOU" INSTRUMENTAL)
SUPER: ELEGANT, YES.
SUPER: SHIP'S REGISTRY: BAHAMAS.
SUPER: STUFFY NEVER.
SUPER: NORWEGIAN CRUISE LINE.
SUPER: THE DREAMWARD & WINDWARD.
 COMING SOON.

MUSEUM OF FLIGHT
Exit 158 from I-5.

536

(MUSIC: AFRICAN)

ANNCR: Of all the creatures that have mastered this hostile, unrelentingly brutal world, only one comes with a horn that works.

ANNCR: The Land Rover Defender. A limited number of these highly evolved vehicles are now available at select Range Rover dealers.

537

ARMSTRONG: Okay, Houston. I'm on the porch.

HOUSTON: Roger, Neil. Okay, Neil, we can see you coming down the ladder now.

ARMSTRONG: I'm gonna step off the limb now. That's one small step for man. One block west of I-5.

SUPER: THE APOLLO EXHIBIT. MUSEUM OF FLIGHT. EXIT 158 FROM I-5.

HOUSTON: Roger, Neil. Is there free parking out there?

ARMSTRONG: Uh, that's affirmative, Houston.

538
ART DIRECTOR
Mark Haumersen
WRITER
Tom Kelly
AGENCY PRODUCER
Becky Keller
PRODUCTION COMPANY
Dublin Productions
DIRECTOR
Jerry Pope
CLIENT
Play it Again Sports
AGENCY
**Martin/Williams,
Minneapolis**

539
ART DIRECTORS
**Rick Boyko
Debby Lucke**
WRITER
Michael Ward
AGENCY PRODUCER
Ed Kleban
PRODUCTION COMPANY
Lovinger/Cohn & Associates
DIRECTOR
Jeff Lovinger
CLIENT
American Express
AGENCY
Ogilvy & Mather/New York

540
ART DIRECTOR
Beth Kosuk
WRITER
Julie Newton-Cucchi
AGENCY PRODUCER
Linda Morgenstern
PRODUCTION COMPANY
Johns + Gorman Films
DIRECTOR
Gary Johns
CLIENT
Maidenform
AGENCY
Ogilvy & Mather/New York

538
ANNCR: If you're finished with your sports equipment,
don't throw it away. Bring it into Play it Again Sports
and we'll buy it from you.
Play it Again Sports. Sports equipment that's used,
but not used up.

 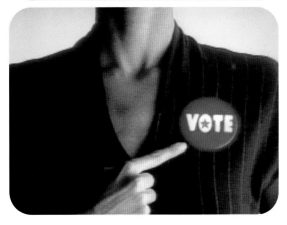

539

HARRY CIPRIANI: It took me about 25 years to see things the way I do now, and I think I'm still learning. One thing that a customer should get is the feeling that he is the most important person in the place. You open your place to people more with American Express. It's easier. I don't know, I couldn't really put it any other way.

ANNCR: American Express is welcomed at Harry's Bar and just about anywhere else Harry's been.

540

ANNCR: If you've got something to say, now's the time to get it off your chest.

PARASAUROLOPHUS

DEINONYCHUS

PACHYCEPHALOSAURUS

Copyright 1992, Motel 6

Copyright 1992, Motel 6

For reservations call
505-891-6161

541
SUPER: PARASAUROLOPHUS.
WOMAN 1: Paaa . . .
MAN 1: Para . . .
WOMAN 2: Paraulasourf . . .
SUPER: APATOSAURUS
MAN 2: Apaa . . .
WOMAN 3: Apatwirus . . .
WOMAN 4: I have to say that?
MAN 3: Hippapodina
SUPER: DEINONYCHUS.
MAN 4: Deeenon . . .
WOMAN 5: Diane . . .
WOMAN 6: Dineenonchuss.
MAN 5: One word looks like nachos ya know . . .
WOMAN 7: Deinonychus.
SUPER: DINOSAURS. ROGER WILLIAMS PARK ZOO.
 MAY 23 - SEPTEMBER 7.
ANNCR: SOME BIG NAMES ARE COMING TO
 ROGER WILLIAMS PARK ZOO.
SUPER: PACHYCEPHALOSAURUS.

542
TOM: Hi. Tom Bodett for Motel 6 with some insight for
 the traveler. This is what one of our rooms looks like
 when you're sleeping. And you know, it looks just
 like those big fancy hotels. Only difference is ours
 only costs you around 25 bucks. More in some places,
 less in others, but always the lowest prices of any
 national chain on a clean, comfortable room. Makes
 you sleepy just looking at it. I'm Tom Bodett for Motel
 6 and we'll leave the light on for you.

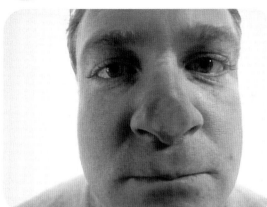

He's about to save $452.

She's about to save $644.

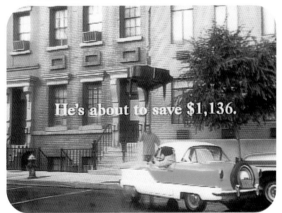

He's about to save $1,136.

543

(SFX: APPROACHING FOOTSTEPS)
(SFX: MAN'S NOSE SMACKING AGAINST TV SCREEN)
MAN: You need some new furniture!
ANNCR: The new IKEA catalog is here. And not a moment too soon.

544

(MUSIC: THROUGHOUT)
ANNCR: With health coverage at HIP you can save on medical care. We can cover you so you never have to pay medical bills or deductibles. You get comprehensive, quality care you can afford, no matter what happens. Which might explain why HIP is independently rated New York's number one HMO for the fourth year in a row.

CONSUMER TELEVISION :30/:25 SINGLE

545
ART DIRECTOR
Larry Jarvis
WRITER
Lloyde Wolfe
PRODUCTION COMPANY
Dublin Productions
DIRECTOR
Jarl Olsen
CLIENT
Grandpa's
AGENCY
**TBWA Kerlick Switzer/
St. Louis**

546
ART DIRECTOR
Susan Hoffman
WRITER
Evelyn Monroe
AGENCY PRODUCERS
**Renee Raab
Elinor Shanklin**
PRODUCTION COMPANY
Crossroads Films
DIRECTOR
Pascal Baes
CLIENT
Morgan Hotel Group
AGENCY
**Wieden & Kennedy/
Portland**

547
ART DIRECTOR
Susan Hoffman
WRITER
Evelyn Monroe
AGENCY PRODUCERS
**Renee Raab
Elinor Shanklin**
PRODUCTION COMPANY
Crossroads Films
DIRECTOR
Pascal Baes
CLIENT
Morgan Hotel Group
AGENCY
**Wieden & Kennedy/
Portland**

548
ART DIRECTOR
Larry Frey
WRITER
Bob Moore
AGENCY PRODUCER
Derek Ruddy
PRODUCTION COMPANY
Pytka Productions
DIRECTOR
Joe Pytka
CLIENT
Nike
AGENCY
**Wieden & Kennedy/
Portland**

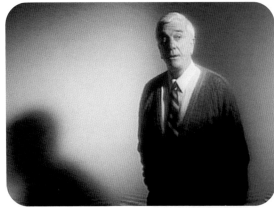

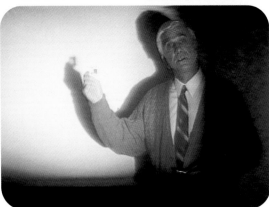

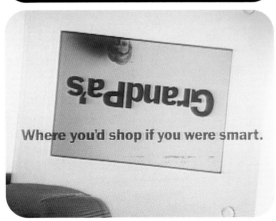

545
NIELSEN: You know, people ask am I as dumb as some
 of the characters I play in movies, so I've decided to
 show you these slides. Lights.
(SFX: PROJECTOR FAN)
Nielsen: Here's a picture of me graduating from Harvard
 University. Here I am accepting the Nobel Prize for
 physics . . . and literature. And here I am going into
 that store only smart people go into SAPDNARG.
 SAPDNARG?

546
(MUSIC: FLAT DUO JETS)
SUPER: GREAT ROOM SERVICE.

GREAT BEDS

Kids & Kubs.
Minimum age 75.

547
(MUSIC: ANGELO BADALAMENTI)
SUPER: GREAT BEDS.

548
(MUSIC: THROUGHOUT)
SUPER: KIDS & KUBS. MINIMUM AGE 75.
GEORGE: If Babe Ruth were alive, he'd be two years
 younger than me.
SUPER: GEORGE BAKEWELL. 100 YEARS OLD.
GEORGE: It's gotta be the shoes . . . well, maybe it's
 the oysters.
SUPER: JUST DO IT.
SUPER: NIKE.

CONSUMER TELEVISION
:30/:25 CAMPAIGN

549
ART DIRECTOR
Ty Harper
WRITER
Rob Schapiro
AGENCY PRODUCER
Frank Soukup
PRODUCTION COMPANY
Slavin Schaffer Films
DIRECTOR
Neal Slavin
CLIENT
Water Country USA
AGENCY
Earle Palmer Brown/
Richmond

550
ART DIRECTOR
Bob Brihn
WRITER
Phil Hanft
AGENCY PRODUCER
Char Loving
PRODUCTION COMPANY
Young & Company
DIRECTOR
Eric Young
CLIENT
Time Magazine
AGENCY
Fallon McElligott/
Minneapolis

551
ART DIRECTOR
Jeremy Postaer
WRITER
Steve Simpson
AGENCY PRODUCER
Ben Latimer
PRODUCTION COMPANY
In-House
DIRECTORS
Steve Simpson
Jeremy Postaer
CLIENT
Chevys Mexican Restaurants
AGENCY
Goodby Berlin &
Silverstein/San Francisco

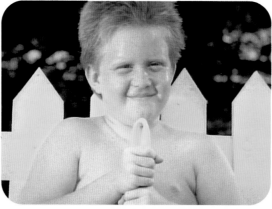

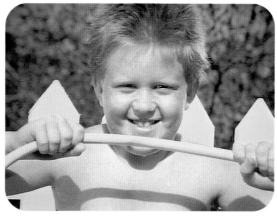

549
ANNCR: It's gonna be a long summer.
GIRL: Mom-m-m.
SUPER: WATER COUNTRY USA.
ANNCR: Take the kids to Water Country USA.

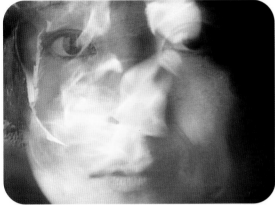

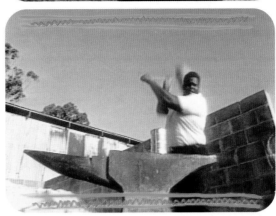

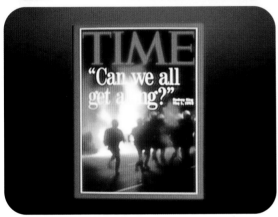

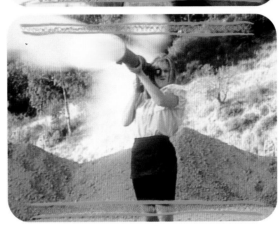

550

ANNCR: In the May 11 issue of Time, we reported what we saw during the recent riots in South Central Los Angeles. What we saw was the enemy . . . and the enemy was us. All of us. Can't we all get along. If it's important to you, you'll find it in *Time.*

SUPER: TIME.

551

(MUSIC: THROUGHOUT)

ANNCR: At Chevys, we, uh . . . don't like cans.

(SFX: SAFE FALLING)

ANNCR: No, we can't stand cans.

(SFX: CANS SQUASHING)

ANNCR: In fact, we really hate cans. That's because at Chevys we make everything fresh every day, from the freshest ingedients. Like our salsa, made from the freshest tomatoes, jalapenos and onions. So we think by now our position on cans oughtta be pretty clear.

SUPER: CHEVYS. FRESH MEX.

CONSUMER TELEVISION
:30/:25 CAMPAIGN

552

ART DIRECTOR
Steve Whittier
WRITER
Ted Nelson
AGENCY PRODUCER
Win Peniston
PRODUCTION COMPANIES
Edit Works
Catspaw
CLIENT
Rocky Mountain College of Art & Design
AGENCY
The Joey Reiman Agency/ Atlanta

553

ART DIRECTOR
Bob Meagher
WRITERS
Raymond McKinney
Tripp Westbrook
AGENCY PRODUCER
Randy Shreve
PRODUCTION COMPANY
1/33 Productions
DIRECTOR
Gary Weis
CLIENT
Bank One
AGENCY
The Martin Agency/ Richmond

554

ART DIRECTOR
Craig Anderson
WRITER
James Rosene
AGENCY PRODUCER
Julie Enos
DIRECTOR
Steve McWilliams
CLIENT
The Ben Hogan Company
AGENCY
Tracy-Locke/Dallas

555

ART DIRECTOR
Susan Hoffman
WRITER
Evelyn Monroe
AGENCY PRODUCERS
Renee Raab
Elinor Shanklin
PRODUCTION COMPANY
Crossroads Films
DIRECTOR
Pascal Baes
CLIENT
Morgan Hotel Group
AGENCY
Wieden & Kennedy/ Portland

552

(MUSIC: "POMP AND CIRCUMSTANCE")
SUPER: IF YOU GO TO ENGINEERING SCHOOL, IT WILL COST $45,000.
SUPER: IF YOU GO TO LAW SCHOOL, IT WILL COST $70,000.
SUPER: IF YOU GO TO MEDICAL SCHOOL, IT WILL COST $120,000.
SUPER: IF YOU GO TO ART SCHOOL, YOU WON'T BE POOR UNTIL AFTER GRADUATION.
SUPER: ROCKY MOUNTAIN COLLEGE OF ART AND DESIGN. 1-800-123-4567.

553

SUPER: THERE'S A SMARTER WAY TO GET MONEY.
SUPER: A LOW-INTEREST BANK ONE HOME EQUITY LOAN.
SUPER: USE IT FOR ANYTHING.
SUPER: DEBT CONSOLIDATION.
SUPER: A NEW CAR.
SUPER: OR CAREER COUNSELING, PERHAPS.

554

SUPER: WE'VE CONSISTENTLY SET THE STANDARDS THAT ALL GOLF EQUIPMENT IS JUDGED BY.

BEN HOGAN: I would like to pat every one of our workmen on the back and thank them every day for the work that they do.

ANNCR: For nearly 40 years, the Ben Hogan Company has crafted its clubs to the uncompromising standards of the players who use them . . . and to the man who created them.

BEN HOGAN: No one makes a golf club like we do.

555

(MUSIC: JOHN ZORN)

SUPER: GREAT LOBBY.

CONSUMER TELEVISION :30/:25 CAMPAIGN

556

ART DIRECTORS
Larry Frey
John Boiler

WRITER
Jim Riswold

AGENCY PRODUCERS
Donna Portaro
Derek Ruddy

PRODUCTION COMPANY
Pytka Productions

DIRECTOR
Joe Pytka

CLIENT
Nike

AGENCY
**Wieden & Kennedy/
Portland**

CONSUMER TELEVISION :20 AND UNDER SINGLE

557

ART DIRECTOR
Sig Gross

WRITER
Bertrand Garbassi

PHOTOGRAPHER
Robert Ammirati

AGENCY PRODUCER
Fran Cosentino

PRODUCTION COMPANY
B.F.C.S.

CLIENT
Saab Cars USA

AGENCY
**Angotti Thomas Hedge/
New York**

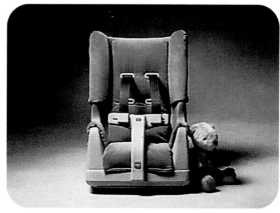

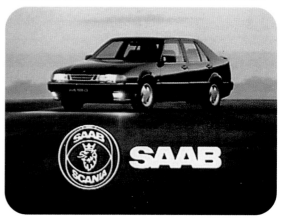

556
(MUSIC: THROUGHOUT)
DENIS LEARY: Hey, you think you're busy?
 Two words . . . Deion Sanders. He's scoring
 touchdowns. He's hitting triples. He's getting his hair
 done. He's buying seven thousand pounds worth of
 clothing. He's hanging with his posse.
 He's out of control. He's washing his cars. He's riding
 his helicopter. He's babysitting his daughter.
 He's tying his shoes. He's still out of control.
 He's so busy he needs two nicknames. Prime Time and
 Neon Deion. Okay? But he's still hitting the bike,
 the weights, the road . . .
DEION SANDERS: And the pool.
DENIS LEARY: And you know what, he's still out of control.
 I think you hear me knockin' and I'm
 comin' in and I got Deion and his twenty-seven
 nicknames with me. Need a nickname? Maybe he'll lend
 you one. Wrong!
SUPER: JUST DO IT.

557
ANNCR: All 50 states now require safety seats for children.
 But there's no law against taking further precautions.

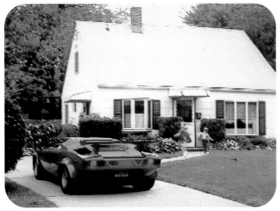

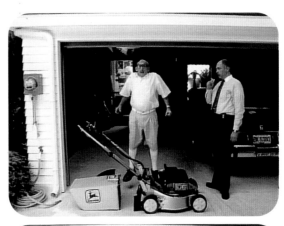

**CONSUMER TELEVISION
:20 AND UNDER
SINGLE**

558
ART DIRECTOR
David Angelo
WRITER
Paul Spencer
AGENCY PRODUCER
Eric Herrmann
PRODUCTION COMPANY
Limelight Productions
DIRECTOR
John Lloyd
CLIENT
New York State Lottery
AGENCY
**DDB Needham Worldwide/
New York**

559
ART DIRECTOR
Bob Green
WRITER
Howard Peck
AGENCY PRODUCERS
**Kelly Lose
Kitty Rothschild**
PRODUCTION COMPANY
Sedelmaier Films
DIRECTOR
Joe Sedelmaier
CLIENT
Deere & Company
AGENCY
**Hal Riney & Partners/
Chicago**

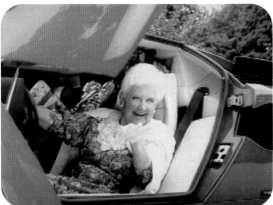

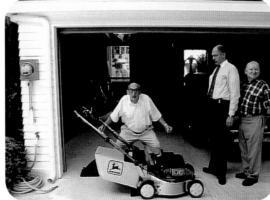

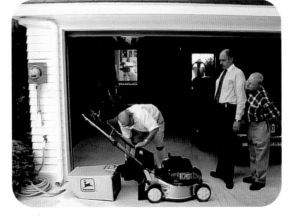

558
(SFX: CAR ENGINE)
KIDS: Grandma's here. Grandma's here.
(SFX: DOG BARKS)
ANNCR: New York Lotto. Hey, you never know.

559
ANNCR: How fast can you change a John Deere
Tricycler mower from a mulcher to a rear bagger?
Then a side discharger? Under ten seconds!
MAN: I think I could have done it faster.
ANNCR: The Tricycler mower, from John Deere.

CONSUMER TELEVISION
:20 AND UNDER
SINGLE

560
ART DIRECTOR
Michael Fazende
WRITER
Mike Lescarbeau
AGENCY PRODUCER
Judy Brink
PRODUCTION COMPANY
Young & Company
DIRECTOR
Eric Young
CLIENT
The Lee Company
AGENCY
**Fallon McElligott/
Minneapolis**

561
ART DIRECTOR
Erich Joiner
WRITER
Jeffrey Goodby
AGENCY PRODUCER
Ed Galvez
PRODUCTION COMPANY
Colossal Pictures
DIRECTOR
Gary Gutierrez
CLIENT
Sega of America
AGENCY
**Goodby Berlin &
Silverstein/San Francisco**

562
ART DIRECTOR
Christine Jones
WRITER
Giles Montgomery
AGENCY PRODUCER
Nicky Gregorowski
PRODUCTION COMPANY
Helen Langridge Associates
DIRECTOR
Gerard De Thame
CLIENT
The Guardian
AGENCY
Leagas Delaney/London

563
ART DIRECTOR
Danny Boone
WRITER
Joe Alexander
AGENCY PRODUCER
Pam Campagnoli
PRODUCTION COMPANY
BES
CLIENT
The Richmond Symphony
AGENCY
**The Martin Agency/
Richmond**

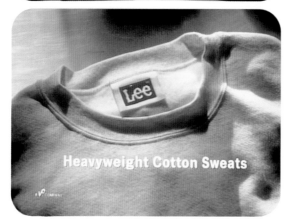

560
(SFX: FAN TURNING ON)
(SFX: FAN SWOOSHING)
(SFX: SCRAPING)
ANNCR: Nothing is heavier than Lee
 Heavyweight Sweats.
SUPER: HEAVYWEIGHT COTTON SWEATS.

561
(MUSIC: THROUGHOUT)
ANNCR: SEGA!!!
SUPER: SONIC 2 IS COMING NOVEMBER 24.
(SFX: CAR HORNS, TRAFFIC NOISE)
(SFX: CRASH, THEN DOORBELL)
SUPER: SO REMEMBER TO LEAVE A DOOR OPEN.
SUPER: WELCOME TO THE NEXT LEVEL.
SUPER: GENESIS AND GAME GEAR.

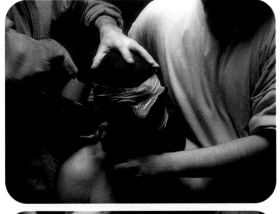

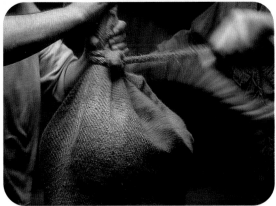

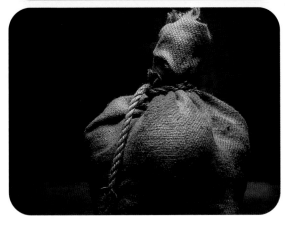

562
ANNCR: Brian Keenan went through four years of unimaginable hell in Beirut. Then he went through it all again. Read his story this Saturday in the new *Weekend Guardian.*
SUPER: THE WEEKEND.

563
SUPER: HOW MANY ADVERTISERS CAN GET BEETHOVEN TO DO THEIR JINGLE.
(MUSIC: BEETHOVEN'S "5TH")
SUPER: THE RICHMOND SYMPHONY. CALL 788-1212.

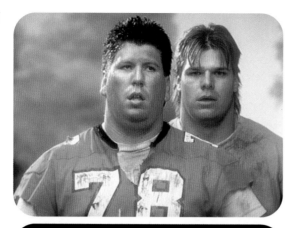

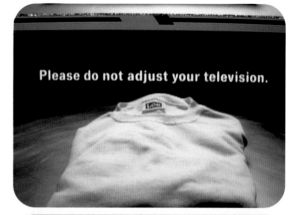

564
ANNCR: Hey, fellas would you pay $125 for a football?
JOCK: $125 for a football? Sure. Why not?
SUPER: NO WONDER THEY CALL THEM DUMB JOCKS.
SUPER: PLAY IT AGAIN SPORTS. EQUIPMENT
THAT'S USED, BUT NOT USED UP.

565
(MUSIC: JAZZ THROUGHOUT)
SUPER: PLEASE DO NOT ADJUST YOUR TELEVISION.
SUPER: LEE SWEATS ARE JUST VERY, VERY HEAVY.
SUPER: HEAVYWEIGHT COTTON SWEATS.

**CONSUMER TELEVISION
:20 AND UNDER
CAMPAIGN**

566
ART DIRECTORS
Jeremy Postaer
Erich Joiner
WRITERS
Scott Aal
Jeffrey Goodby
Harry Cocciolo
AGENCY PRODUCERS
Elizabeth O'Toole
Ed Galvez
Betsy Flynn
PRODUCTION COMPANIES
Red Sky Films
Colossal Pictures
Johns + Gorman Films
DIRECTORS
Erich Joiner
Gary Gutierrez
Gary Johns
CLIENT
Sega of America
AGENCY
Goodby Berlin &
Silverstein/San Francisco

**CONSUMER TELEVISION
VARYING LENGTHS
CAMPAIGN**

567
ART DIRECTOR
David Page
WRITER
Dave O'Hare
AGENCY PRODUCER
Cindy Fluitt
PRODUCTION COMPANY
HKM Productions
DIRECTOR
Michael Karbelnikoff
CLIENT
American Isuzu Motors
AGENCY
Goodby Berlin &
Silverstein/San Francisco

566
(SFX: EKG MONITOR)
SUPER: WELCOME TO THE NEXT LEVEL.
DR. 1: Where do we start?
NURSE: How about his knee?
DR. 2: That's his face.
SUPER: MORE MOVES.
DR. 1: If that's his face, what's this?
SUPER: MORE CHARACTERS.
(SFX: COMPUTER)
SUPER: DIAGNOSIS: STREETS OF RAGE 2.
SUPER: ONLY ON SEGA GENESIS.
DR. 2: SEGA!!

567
ANNCR: The Isuzu Trooper . . .
HE: Hey, you're right on time.
ANNCR: . . . has been completely redesigned to include
 a new suspension system.
HE: Honey, pothole.
SHE: I see it.
ANNCR: Making for a smooth, quiet ride on the road, as
 well as off. 'Course these days, what's the difference?

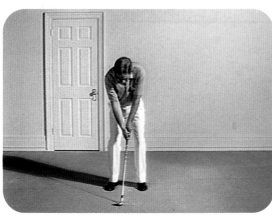

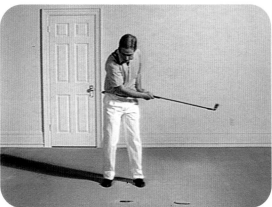

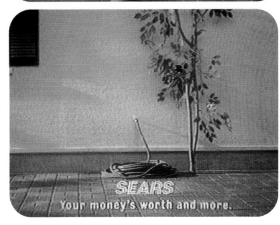

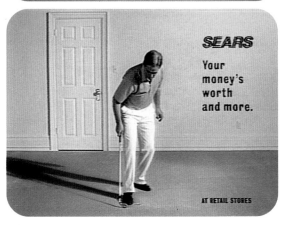

568
ANNCR: This week at Sears, you'll find Canadian-
made resin folding chairs for just $14.99. They're light.
They're strong.
(SFX: PHONE RINGS)
ANNCR: And you can take them anywhere.
SUPER: SEARS. YOUR MONEY'S WORTH AND MORE.

569
ANNCR: This week for Father's Day, Sears has a large
selection of Arnold Palmer shirts for as little as $19.99.
Fortunately, Sears also has a large selection of carpeting.
SUPER: SEARS. YOUR MONEY'S WORTH AND MORE.

If you go to medical school, it will cost $120,000.

If you go to art school,

You won't be poor until after graduation.

570

(MUSIC: "POMP AND CIRCUMSTANCE")

SUPER: IF YOU GO TO ENGINEERING SCHOOL, IT WILL COST $45,000.

SUPER: IF YOU GO TO LAW SCHOOL, IT WILL COST $70,000.

SUPER: IF YOU GO TO MEDICAL SCHOOL, IT WILL COST $120,000.

SUPER: IF YOU GO TO ART SCHOOL, YOU WON'T BE POOR UNTIL AFTER GRADUATION.

SUPER: ROCKY MOUNTAIN COLLEGE OF ART AND DESIGN. 1-800-123-4567.

571

ANNCR: How'd you like to come home to this every day?

(SFX: CHARGING RHINOCEROS)

ANNCR: Roseanne. Every weekday at 5:30 on WLNE-6.

SUPER: WLNE-6.

CONSUMER TELEVISION UNDER $50,000 BUDGET

572
ART DIRECTOR
Craig Hadorn
WRITER
Dory Toft
AGENCY PRODUCER
Shelley Winfrey
PRODUCTION COMPANIES
Alpha Video
Steve Lawson Recording
CLIENT
The Museum of Flight
AGENCY
Livingston & Company/ Seattle

573
ART DIRECTOR
Greg Bokor
WRITER
Steve Bautista
AGENCY PRODUCER
Jeannie Priest
PRODUCTION COMPANY
East Films
DIRECTOR
Geoff Adams
CLIENT
Roger Williams Park Zoo
AGENCY
Pagano Schenck & Kay/ Providence

NON-BROADCAST: OUT-OF-HOME

574
ART DIRECTOR
Jerry Pope
WRITER
Greg Pope
PRODUCTION COMPANY
Dublin Productions
DIRECTOR
Jerry Pope
CLIENT
Jerry Pope

INTERNATIONAL FOREIGN LANGUAGE COMMERCIAL: TELEVISION

575
ART DIRECTOR
Alvaro Fernandez Mendy
WRITER
Carlos Bayala
AGENCY PRODUCER
Luis Pompeo
PRODUCTION COMPANY
Contemporaneos
DIRECTOR
Flavia Moraes
CLIENT
Channel 13
AGENCY
Young & Rubicam/ Buenos Aires

572
ARMSTRONG: Okay, Houston. I'm on the porch.
HOUSTON: Roger, Neil. Okay, Neil, we can see you coming down the ladder now.
ARMSTRONG: I'm gonna step off the limb now. That's one small step for man. One block west of I-5.
SUPER: THE APOLLO EXHIBIT. MUSEUM OF FLIGHT. EXIT 158 FROM I-5.
HOUSTON: Roger, Neil. Is there free parking there?
ARMSTRONG: Uh, that's affirmative, Houston.

573
SUPER: PARASAUROLOPHUS
WOMAN 1: Paaa . . .
MAN 1: Para . . .
WOMAN 2: Paraulasourf . . .
SUPER: APATOSAURUS
MAN 2: Apaa . . .
WOMAN 3: Apatwirus . . .
WOMAN 4: I have to say that?
MAN 3: Hippapodina
SUPER: DEINONYCHUS.
MAN 4: Deeenon . . .
WOMAN 5: Diane . . .
WOMAN 6: Dineenonchuss.
MAN 5: One word looks like nachos ya know . . .
WOMAN 7: Deinonychus.
SUPER: DINOSAURS. ROGER WILLIAMS PARK ZOO. MAY 23 - SEPTEMBER 7.
ANNCR: SOME BIG NAMES ARE COMING TO ROGER WILLIAMS PARK ZOO.
SUPER: PACHYCEPHALOSAURUS.

JERRY POPE
director/camera

574
(SFX: WHISPERS)
JERRY: Bless me Father, I have sinned. It's been about . . .
 14 years since my last confession.
PRIEST: Go on my son.
JERRY: Well, Father, I've had impure thoughts.
PRIEST: Two Hail Marys.
JERRY: And I . . . I touched myself.
PRIEST: Three Hail Marys.
JERRY: A lot.
PRIEST: Four Hail Marys.
JERRY: And also Father, I direct TV commercials.
PRIEST: Mmmph.
JERRY: Uh, Father? . . . Father?

575
(SFX: BOUNCING BALL SOUND)
SUPER: WOMEN'S TENNIS TOUR ON CHANNEL 13.

COLLEGE COMPETITION

Assignment: Tourism in student's home state.

576
ART DIRECTOR
Margaret Johnson
WRITERS
Ginnie Read
Gary Pascoe
COLLEGE
Portfolio Center/Atlanta

577
ART DIRECTOR
Randy Freeman
WRITERS
Ginnie Read
Gary Pascoe
COLLEGE
Portfolio Center/Atlanta

578
ART DIRECTOR
Carol Holsinger
WRITERS
Sally Hogshead
David Huntington
COLLEGE
Portfolio Center/Atlanta

579
ART DIRECTOR
Mark Wenneker
WRITER
Steve Howard
COLLEGE
Portfolio Center/Atlanta

576

577

VIRGINIA WASN'T ALWAYS FOR LOVERS.

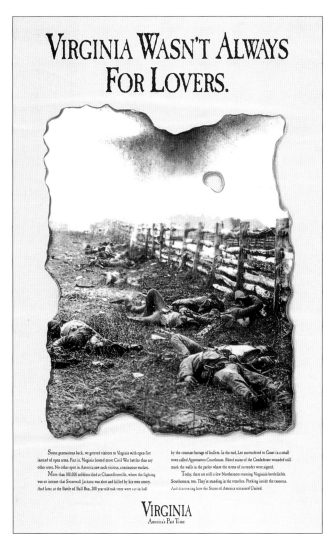

Some generations back, we greeted visitors to Virginia with open fire instead of open arms. Fact is, Virginia hosted more Civil War battles than any other state. No other spot in America saw such vicious, continuous warfare.

More than 100,000 soldiers died at Chancellorsville, where the fighting was so intense that Stonewall Jackson was shot and killed by his own sentry. And later, at the Battle of Bull Run, 200 year old oak trees were cut in half by the constant barrage of bullets. In the end, Lee surrendered to Grant in a small town called Appomattox Courthouse. Blood stains of the Confederate wounded still mark the walls in the parlor where the terms of surrender were signed.

Today, there are still a few Northerners roaming Virginia's battlefields. Southerners, too. They're standing in the trenches. Peeking inside the cannons. And discovering how the States of America remained United.

VIRGINIA
America's Past Time

THERE ARE OVER 525,000 MINUTES IN A YEAR, WE JUST HAPPEN TO HAVE THE MOST EXCITING TWO.

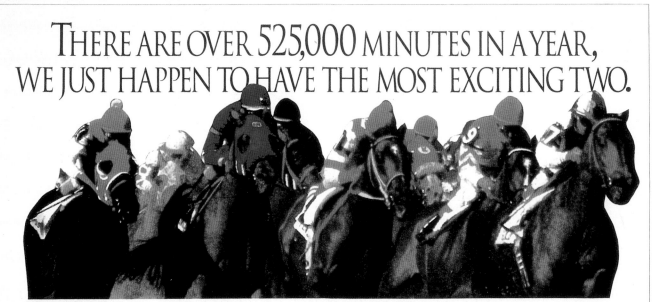

Secretariat, Seattle Slew, Man O' War and Affirmed. They weren't your average horses and the Kentucky Derby is far from your average race.

For over 120 years people have converged on Churchill Downs to be part of an event steeped in sporting tradition. Since it's inception, hoop skirts, Cuban cigars and mint juleps have been the order of the day. And each year, on the first Saturday in May the hands of time turn back once again. You see, in Kentucky, the Derby is not only a matter of tradition, it's a matter of pride. As you probably know, Kentucky is the thoroughbred capital of the world. Take a drive down Frankfort or Paris Pike. As the road unfolds before you so will some of the most beautiful country on earth. As far as the eye can see, oceans of bluegrass will give way to white picket fences and pastoral horse farms.

But it's Derby Day so find a seat and wait for the pageantry to begin. Start the day off with a mint julep if you like. At first you may question the fascination others have with this intriguing mix of bourbon, sugar water and mint leaves. But after a couple sips you'll understand.

Before you know it the 8th race will be upon you. Dressed in vividly colored silks, the jockeys parade the finest racehorses in the world past the majestic twin spires which frame the grandstand.

Please stand as they prepare to enter their marks. Sing along as we welcome you back to our "Old Kentucky Home." And they're off. Which three year old will garner the first jewel of this year's triple crown and join the ranks of the greatest racehorses in the world? The answer's only a mile and a quarter away. And Kentucky's really not that much farther.

Kentucky

For more information call the Kentucky Department of Parks at 1-800-525-0063.
© 1995 partyfolk center - Mark and Steve

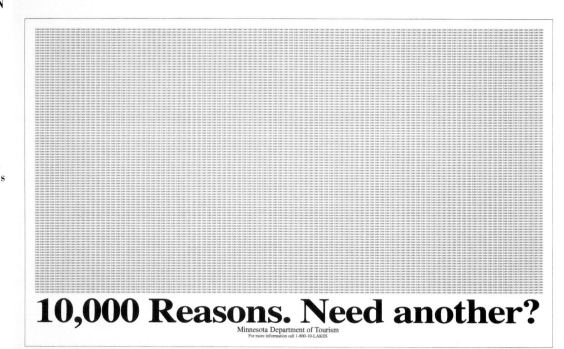

10,000 Reasons. Need another?

Minnesota Department of Tourism
For more information call 1-800-10-LAKES

580

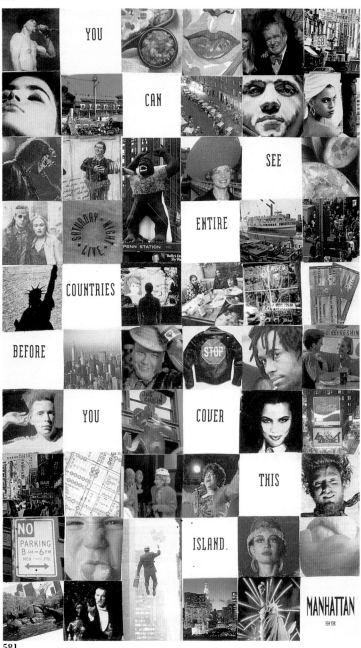

581

Just think of it as nature's Disneyland.

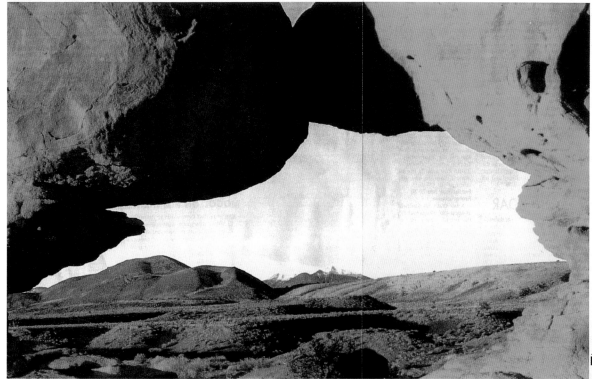

Discover a playground for the true outdoor

enthusiast, where a less than 2 hour drive

can transport you from the desert warmth

to snow capped peaks. We appologize for

not having a monorail. But, whether

you're looking for raging white water

rapids, the extreme ski slope or a 1 mile

descent into the grandest of canyons, you'll

find it in Arizona. The best part is, we

won't even charge you admission.

ARIZONA
The way nature was meant to be enjoyed.
For more information call 1-800-ARIZONA.

582

AGENCY PRODUCERS

ANIMATOR

ART DIRECTORS